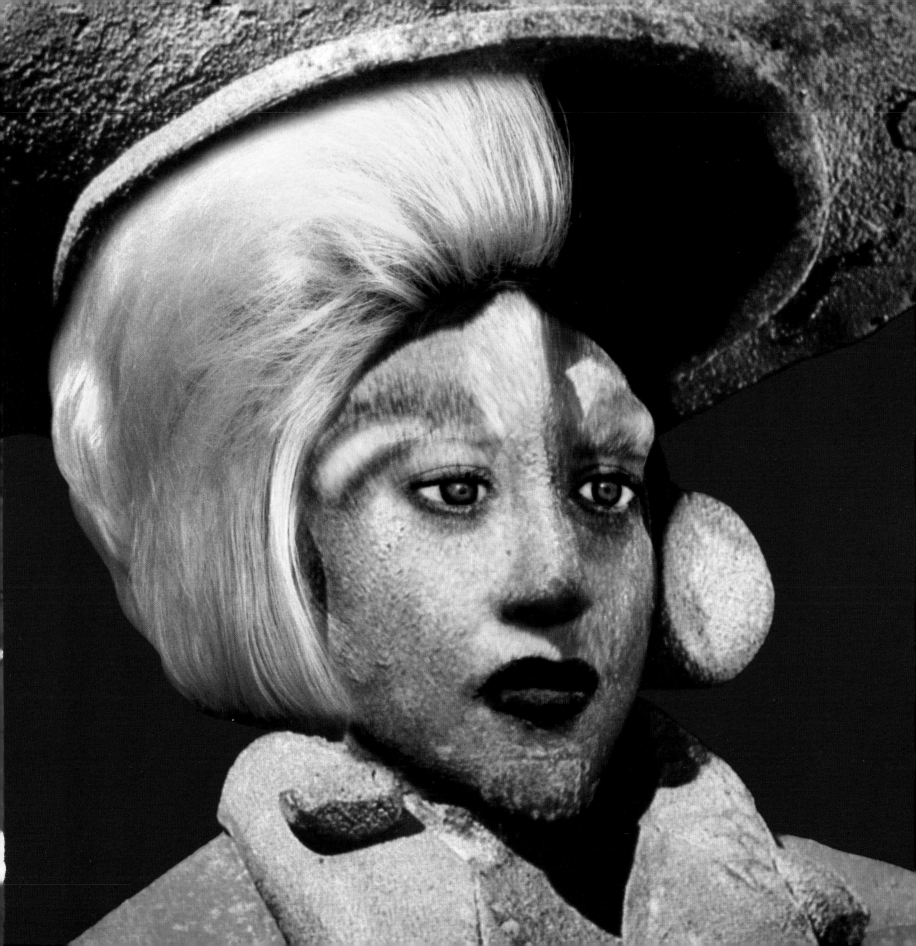

Copyediting
Christine Schultz-Touge

Typesetting
Studio X-Act

Proofreading
Linda Gardiner

Color Separation
Dupont, Paris

Simultaneously published in French as *Orlan*
© Éditions Flammarion, 2004
English-language edition
© Éditions Flammarion, 2004
© ADAGP for Orlan's works

www.editions.flammarion.com

04 05 06 4 3 2 1

FC0431-04-V
ISBN: 2-0803-0431-3
Dépôt légal: 05/2004

Printed by Canale in Italy

**This book was published with the help of a grant from the Fonds régional d'art contemporain
in Pays de la Loire, France following the exhibition *Eléments favoris* (November 28, 2002–February 16, 2003)
and from the Centre national de la photographie in Paris to coincide with the exhibition
Orlan, méthodes de l'artiste (March 31–June 28, 2004).**

ORLAN

Translated from the French by Deke Dusinberre

Flammarion

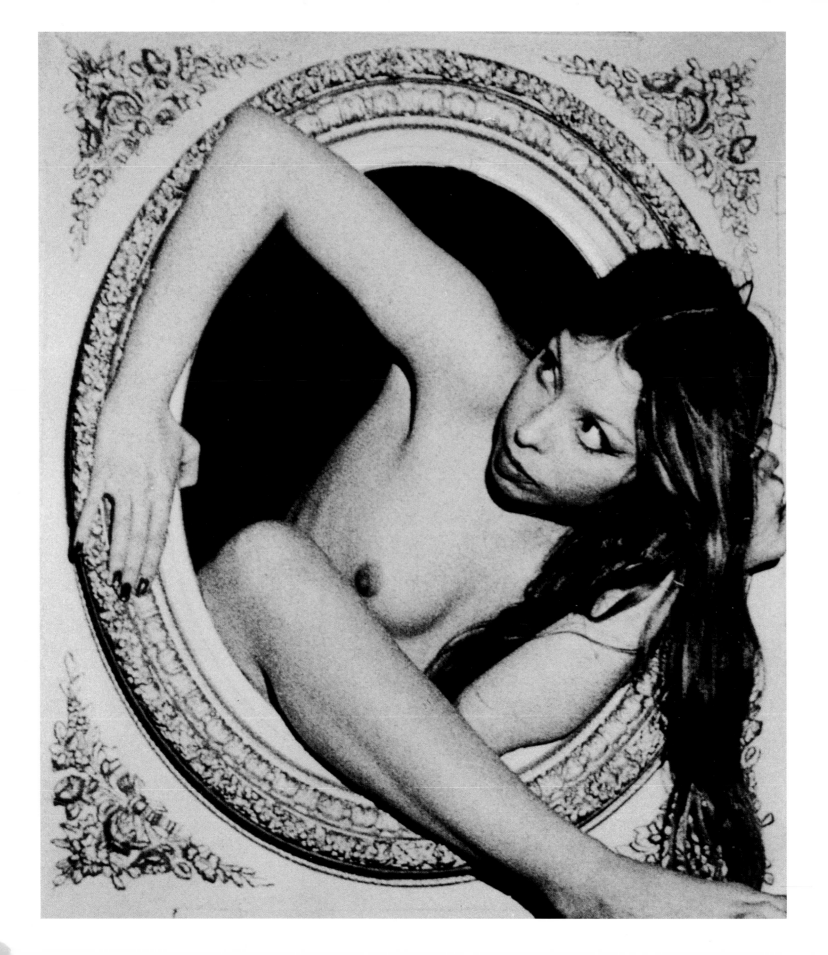

Contents

Extreme Makeover

Within the French art scene, Orlan is the artist whose work is perhaps the most conductive to media coverage. Paradoxically, however, her oeuvre is poorly known or is misconstrued as merely a series of extravagant events—the best example being the exclusive focus on her surgical performances—rather than as a coherent whole in which each element assumes specific meaning. Yet as early as the 1960s Orlan had begun turning her body into "a site of public debate" through a series of works and performances presented in leading cultural institutions.

Orlan's complex work could be described as "polyphonic" since she orchestrates its components to follow an evolving, complex score. She looks simultaneously to the past (through frequent references to art history and to her own artistic history) and to the future (drawing new inspiration for her art from the realms of medicine and biotechnology), and she subverts, in ironic fashion, the very ideas and worlds she moves in, composing her art in all kinds of media, ranging from performance and video to photography, installations, and even her own body.

Orlan's oeuvre has hinged, ever since 1964, on recurring issues that serve as a unifying thread. These issues can also be found in her essays, notably "Le Manifeste de l'Art Charnel" (Manifesto of Carnal Art), "Virtuel et réel: dialectique et complexité" (The Complex Dialectics of Virtuality and Reality), and "Réminiscence du Discours Maternel" (Reminiscence of Maternal Discourse).

As the first monograph of major scope, this volume aims to trigger and stimulate the process of making an overall assessment of Orlan's work, following a retrospective hosted by the Fonds Régional d'Art Contemporain (FRAC) in the Loire region in collaboration with the Centre National de la Photographie in Paris.

Conceived as a diptych, this book adopts two successive but complementary approaches. The first part offers a "chronophotology" of her oeuvre, providing an overview that stresses its coherence; most of this section is devoted to images of varying types and overlapping dates. Although not a *catalogue raisonné*, it makes it possible to better understand (or to discover for the first time) various facets of the artist's work. Orlan herself helped us to gather the material for this book from forty years' worth of archives, a resource that testifies to her precocious decision to preserve a record of her artistic development, even though several works and documents have been lost over the decades and even though the artist herself blurs the picture by recycling earlier works. Rather than representing a "best of Orlan" collection, the material here—pictures, texts, and recollections placed side by side—is designed to present a broad panorama that repositions each work within its specific context.

In the second part of the book, the floor is given to the artist herself, to critics, and to art historians. This new anthology of texts includes not only useful tools such as a chronology and bibliography, but also essays on Orlan's work by Régis Durand, Eleanor Heartney, and Julian Zugazagoitia, a conversation between Christine Buci-Glucksmann and Bernard Blistène, and an interview with Orlan by Hans-Ulrich Obrist.

As a figure famous enough to be included in Taschen's *Women Artists in the 20th and 21st Century*, yet still an artist represented by only one work in France's Musée National d'Art Moderne, Orlan constitutes a true enigma. With her round, Corbusier-style glasses (designed by herself), her lively gaze, her impeccable appearance (including two sparkly bumps on her forehead and a dialectically black-and-white hairdo), her perfect manners, her inimitable voice, her extreme sensitivity, her tact, her shrewdness, her jolly yet serious demeanor, and her honorary title of Chevalier des Arts et des Lettres, Orlan is a living oxymoron. Yet behind the metamorphoses there is a being profoundly divided between modesty and freedom. She is a contemporary version of the mythical chimera.

Individual versus celebrity, artist versus star, modest versus immodest—it is a dialectic that this book is attempting to illustrate. But suppose this volume were just another fiction, another scene from her script of *Le Plan du film* (A Shot at a Movie)? If Orlan seems determined to scramble the boundaries between fiction and reality, between truth and legend, if she is determined to break new ground, that is probably her way of maintaining a certain irreducible measure of subversiveness in all artistic creativity.

Caroline Cros, *curator, Délégation aux Arts Plastiques*
Vivian Rehberg, *curator, ARC/Musée d'Art Moderne de la Ville de Paris*
Laurent Le Bon, *curator, Musée National d'Art Moderne*
Assisted by **Jeanne Brun**

1964–2003 | Chronophotology

Caroline Cros, Laurent Le Bon, Vivian Rehberg

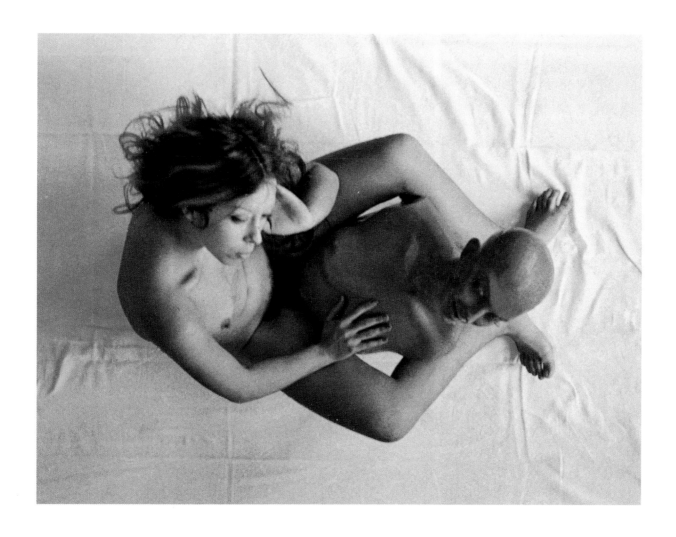

1964
Orlan accouche d'elle-m'aime (Orlan Gives Birth to Her Loved Self)
31 ¾ x 30 in. (81 x 76 cm) including frame, black and white photograph. Artist's collection.

Orlan is sitting on a table covered with a white sheet, prefiguring the subversive use of sheets from her trousseau. With her left hand raised to her head in a contemplative gesture, she gives birth to a figure that is not an alter ego in the style of Marcel Duchamp's Rrose Sélavy but rather an inert, androgynous body, neither male nor female. Both heads turn to look in the same direction. This work, which inaugurated the series of nude studio photos, symbolically constituted an attempt to give birth to oneself, to invent a new identity for oneself. This giving birth to herself—the first violation of natural laws that Orlan presented to the public— followed her adoption of a new name, a *nom de guerre:* Orlan. According to the artist, her choice of this name became imperative after a psychoanalytic session in which she became aware that her signature on checks underscored the letters M,O,R,T,E (D,E,A,D); once her analyst pointed to the anomaly, she decided that she would no longer accept this state of "slow death," and she took on a new identity. Like the lifeless body to which she gives birth, the name she chose is neither feminine nor masculine. It incorporates Orlan's determination to violate taboos and to remain on the cusp of sexual differentiation, returning to the "primal Eros" of earliest mythology, which knew neither male nor female, nor any sexual beings. "I am man and woman," claims Orlan.

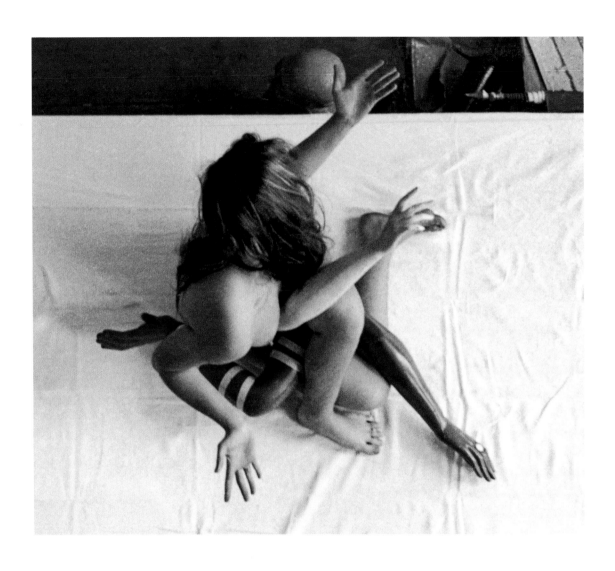

1964
Corps-sculpture No. 3 dit Shiva ou tentacules de bras multiples (Body-Sculpture No. 3 called "Shiva, or Many-Armed Tentacles")

3 ½ x 4 in., 31 ¾ x 30 in. including frame (9 x 10 cm, 81 x 76 cm), black and white photograph.

The resurrected Orlan, who had just invented a new identity for herself, violating social norms and constraints, exhibited her body in a series of studio nudes. Her mother, who normally gave her practical gifts such as sheets, slippers, and pajamas, finally realized that her daughter would make better use of a camera. Endowed with a delayed-action shutter, this camera recorded Orlan's early, solitary "eccentricities" as she stripped herself bare and sought to liberate the drives that were symptomatic of her "metamorphosis" by adopting rebellious, awkward postures that ran counter to traditional feminine poses. The lens recorded the impassioned,

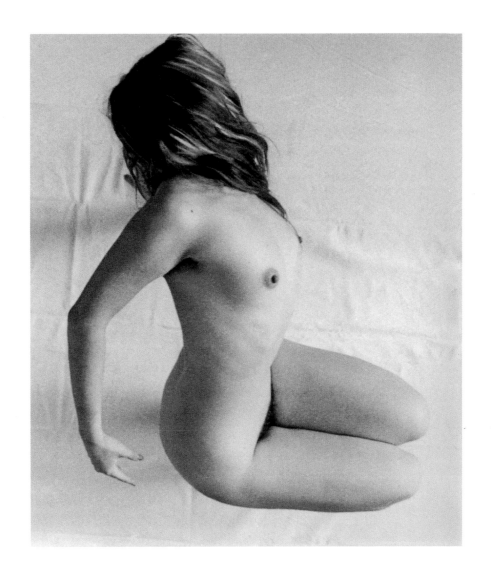

1965
Corps-Sculpture sans visage et au bras droit (Faceless Body-Sculpture with Right Arm)
31 ¾ x 30 in. (81 x 76 cm) including frame, black and white photograph.

defiant poses of a body handled like sculpture, with or without plinth. This body rejected the normal framework, folding and refolding itself into positions somewhere between those of yoga, judo, dance, and relaxation. Orlan alternately displayed and hid—with hair or hands—the erogenous zones of a frenzied body. Then the body rose from the sheet-covered bed/table, becoming the target of shadows cast on the walls of the studio. These shadows were perhaps the mark of traumatic ghosts that Orlan sought to overcome, as someone who had been "possessed" (in her poetic biography, Orlan pointed out that she was born the year the

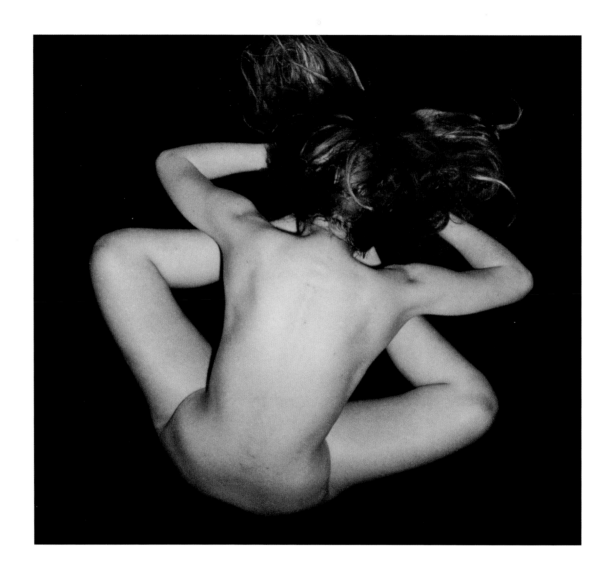

1965
Le corps-sculpture dit batracien sur fond noir (Body Sculpture called "Frog Against Black Ground")
31 ¾ x 30 in. (81 x 76 cm) including frame, black and white photograph.

film version of *Le diable au corps* was released) seeks to overcome. The upright body then played and posed with masks, both tribal and grotesque. The cathartic dance slowly became calmer, until Orlan, having managed to "escape the social and familial framework," headed for the stairs and into the street. The shoes she wore on one of these two nude poses (on the stairway) prefigured her public actions. The etymology of the French *batracien* and the English batrachian is the Greek *batrachos*, which means frog. The term designates a family of four-footed vertebrate animals that undergo a metamorphosis via highly active glands on the surface of the skin.

12

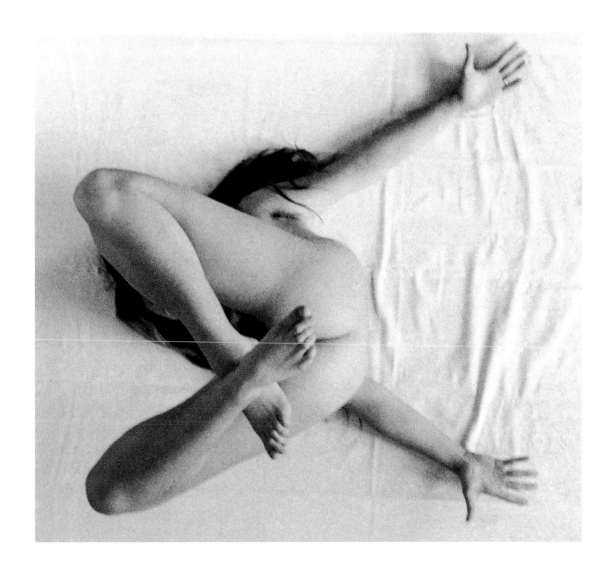

1965
Le corps-sculpture sans visage avec cul (Faceless Body-Sculpture with Ass)

31 ¾ x 30 in. (81 x 76 cm) including frame, black and white photograph.

Orlan underwent a metamorphosis starting in 1964, when she was only seventeen. From that moment onward, she began painting and writing poetic texts that she called *Prosésies écrites* (Written Proems) and published as a book in 1967. These texts, signed OR L'AN—some dating back to 1962—were conceived as scores, recorded on audio tape, recited in public (in the street or in cabarets), or even stamped on the hands of passers-by.

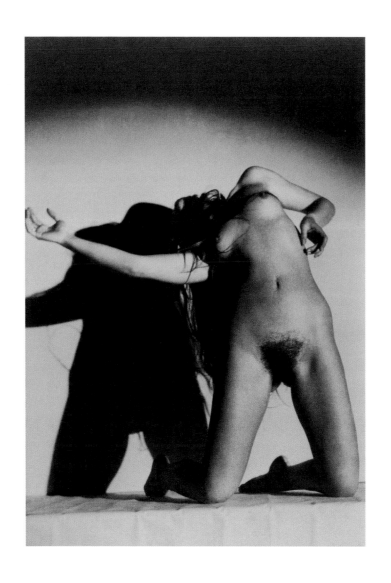

1967
Corps-Sculpture sans visage sexe à l'avant en mouvement dansant avec ombre No. 3
(Faceless Body-Sculpture with Up-Front Genitals in Dancing Movement with Shadow No. 3)
6 ½ x 4 ½ in., 31 ¾ x 30 in. including frame (16.5 x 11.5 cm, 81 x 76 cm), black and white photograph.

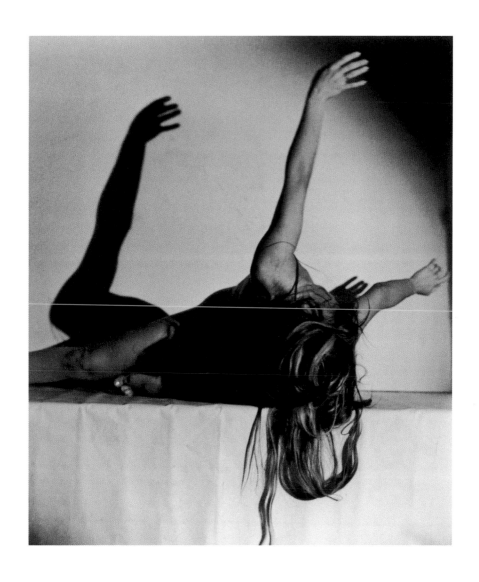

1967
Corps-Sculpture sans visage en mouvement dansant avec ombre No. 6
(Faceless Body-Sculpture in Dancing Movement with Shadow No. 6)
6 ½ x 4 ¾ in., 30 ¾ x 30 in. including frame (16.5 x 12 cm, 81 x 76 cm), black and white photograph.

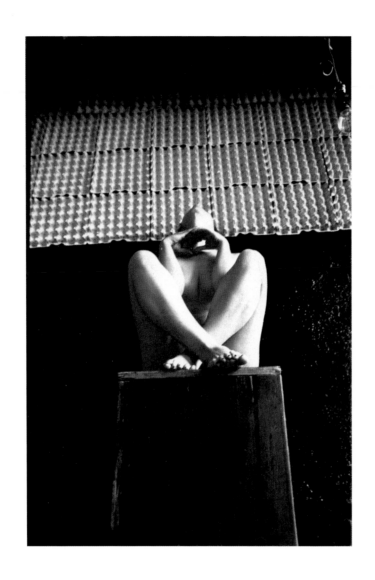

1965
Corps-Sculpture en perspective sur socle No. 8 (Body-Sculpture in Perspective on Plinth No. 8)
4 x 2 ¾ in., 31 ¾ x 30 in. including frame (10 x 7 cm, 81 x 76 cm), black and white photograph.
Collection J. N. F.

16

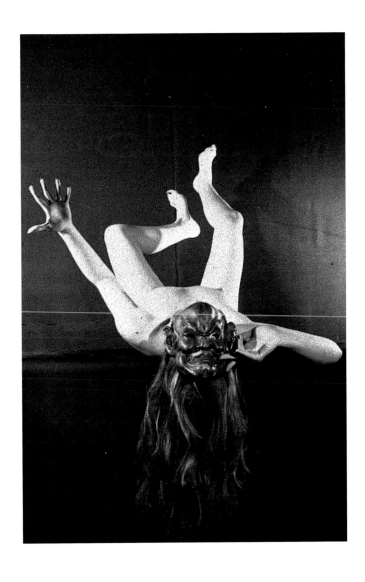

1965
Sens dessus-dessous ou jambes en l'air, masque et tête à l'envers (In a Muddle, or, Flat on Back with Upside-Down Head and Mask)
3 ¾ x 2 ⅓ in., 31 ¾ x 30 in. including frame (9,6 x 6 cm, 81 x 76 cm), black and white photograph.
Collection Fonds national d'art contemporain, Paris.

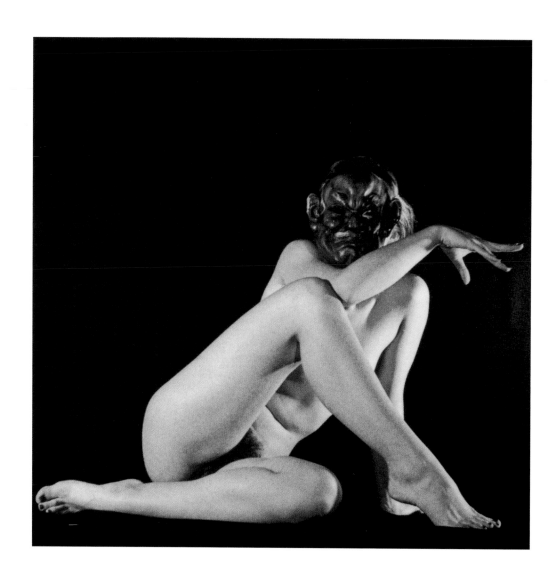

1965
Pose nue avec masque, entrejambe et main No. 2 (Masked Nude with Crotch and Hand No. 2)
3 x 3 ⅓ in., 31 ¾ x 30 in. including frame (8 x 8.5 cm, 81 x 76 cm), black and white photograph.
Collection Fonds national d'art contemporain, Paris.

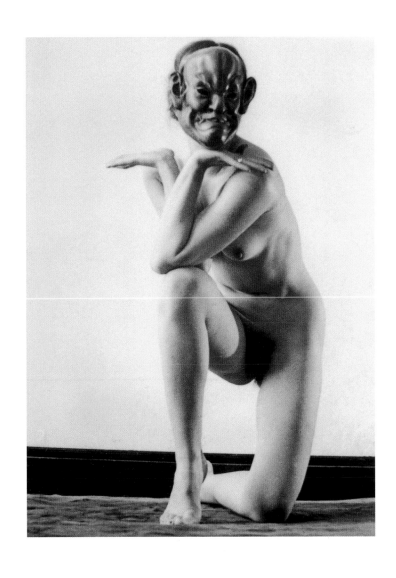

1965
Corps-Sculpture avec masque prenant pose à genoux avec bras repliés (Masked Body-Sculpture on Bended Knee with Folded Arms)
3 ¾ x 2 ¾ in., 30 ¾ x 30 in. including frame (10 x 7 cm, 81 x 76 cm), black and white photograph.

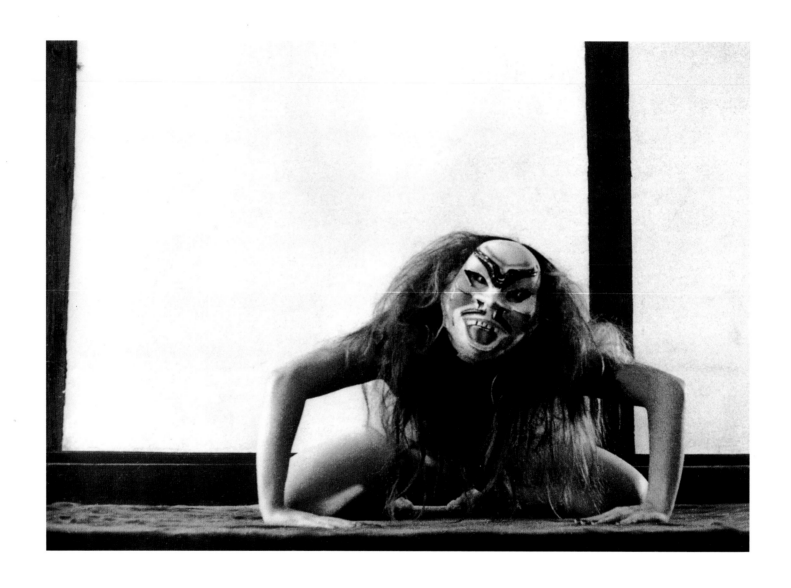

1966
Orlan masquée se moque du monde à quatre pattes (A Masked Orlan Shows Her Nerve on All Fours)

31 ¾ x 30 in. (81 x 76 cm) including frame, black and white photograph.

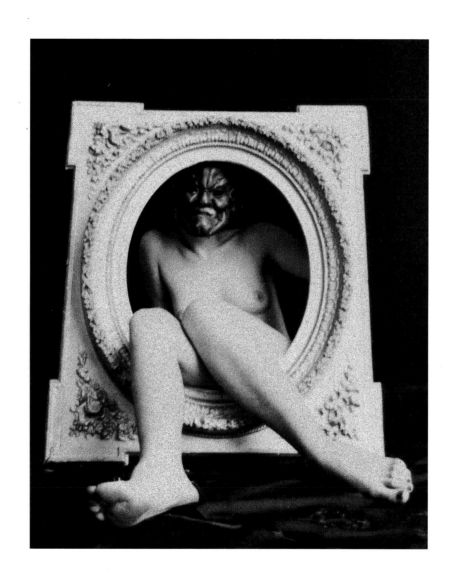

1965
Tentative pour sortir du cadre avec masque No. 1 (Attempting to Escape the Frame with Mask No. 1)
2 ½ x 4 in., 31 ¾ x 30 in. including frame (6.5 x 10.5 cm, 81 x 76 cm), black and white photograph.
Collection Fonds national d'art contemporain, Paris.

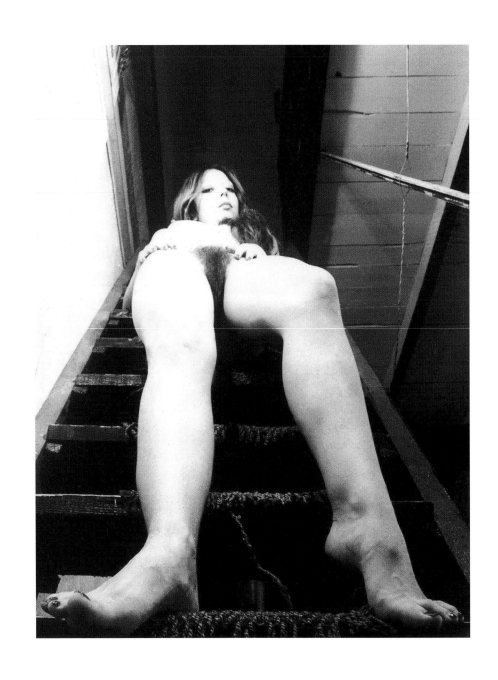

1967
Nu descendant l'escalier—contre-plongée avec tête (Nude Descending a Staircase—Low-Angle Shot with Head)
Black and white photograph.

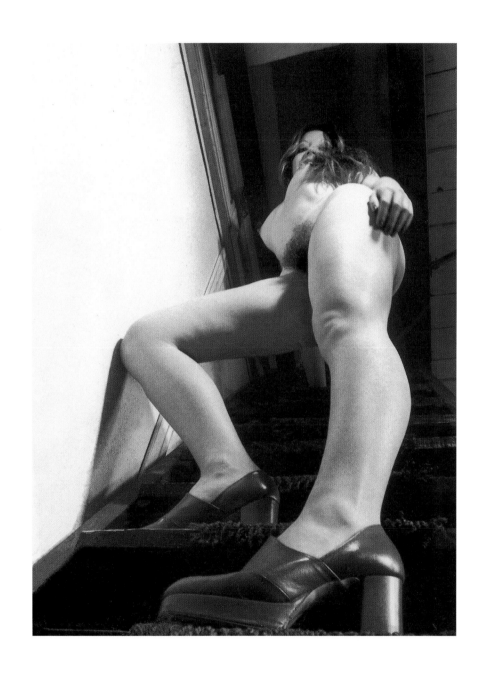

1967
Nu descendant l'escalier avec talons compensés (Nude Descending a Staircase with Platform Shoes)
Black and white photograph.

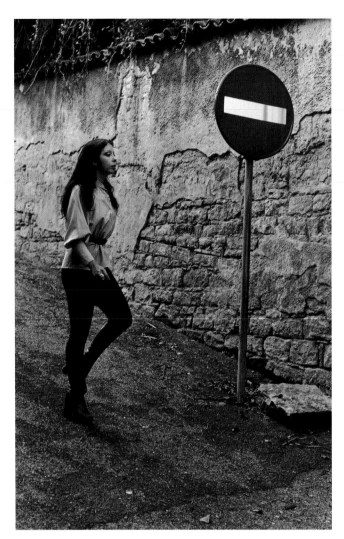 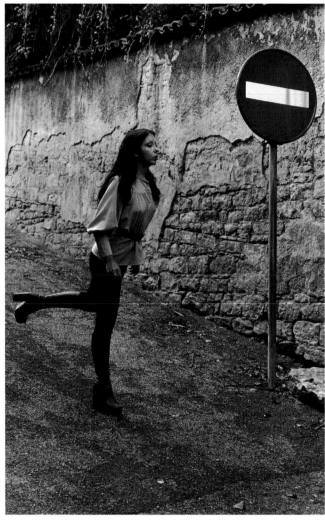

1964
Action Or-lent: les marches au ralenti dite au sens interdit (Orlan Body Action: Slow-Motion Walks Down "No Entry" Routes)
Four black and white photographs.

Orlan moved her sculpture-body into the streets, putting it to the test with a series of actions located in neutral spaces of the city and then in cultural and strategic institutions. The slow-motion walks she undertook around 1965 in the streets of Saint-Étienne and other French cities such as Toulon, Marseille, Nice, Avignon, and Firminy launched this cycle of events in the public sphere. These "body actions" involved walking very slowly in a city, following a route that was heavily traveled during rush hour. Her absurdly slow pace was observed by involuntary, indifferent witnesses. Photographs supply the sole surviving testimony of one of the first walks, executed in Saint-Étienne. It is no coincidence that what leaps to the eye in these pictures is an urban road sign indicating "no entry," underscoring the fact that Orlan has just embarked on a taboo-breaking path.

24

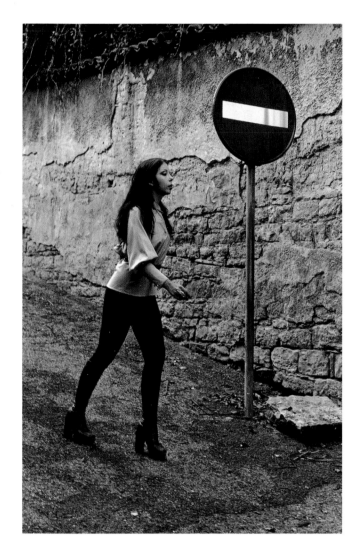
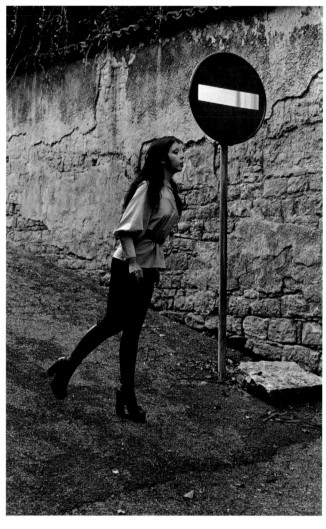

Public walks and marches are known to be tools of political, social, and economic demands. By appropriating this act of non-conformism, the silent, solitary Orlan was making a protest (as a pro-abortion campaigner) and was going against the grain of standard urban behavior (the residents of Saint-Étienne rush along this route every day, around noon, to catch a bus or tram). Orlan staunchly defended an "against-the-grain" time-frame that stressed the perception of space, revealing that no gesture, no decision, no choice is neutral, not even highly automatic and vital ones such as getting around. This work also represented the beginning of Orlan's use of her own body as a tool for fathoming space in relation to others: "I've never produced a work (drawing, photo, sculpture, video, performance) without conceiving it as a body in search of other bodies in order to exist."

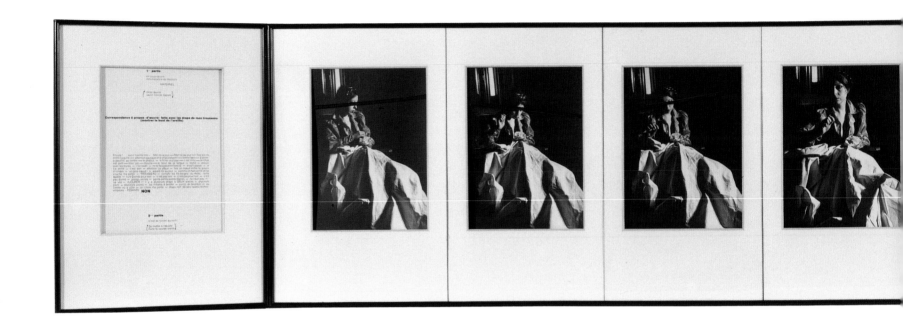

1968
Documentary Study No. 1: *Plaisirs brodés* (Embroidered Dissipations, or, Chiaroscuro Couture)

102 1/3 x 74 3/4 in. (260 x 190 cm), seven black and white photographs. Text: "Réminiscence du discours maternel." Sheets from the trousseau. Embroidery hoop. Sperm. Tint.
Collection Fonds national d'art contemporain, Paris.

Orlan took sheets from the trousseau given to her by her mother and asked friends and lovers to wet, stain, and soil this virgin linen—a phase that she has described as "very euphoric." Traces of sperm were carefully recorded by being initially marked with a tint, then with embroidery stitches using an embroidery hoop. The hairstyle and clothing adopted by Orlan parodied the conventional image of a housewife. She realized that her painting activities were not sufficient to attract the attention of dealers, to be accepted as a female artist. "As an artist, I have only one recourse: sell myself. I have to deal with this situation. So I'll go for it. I'll find

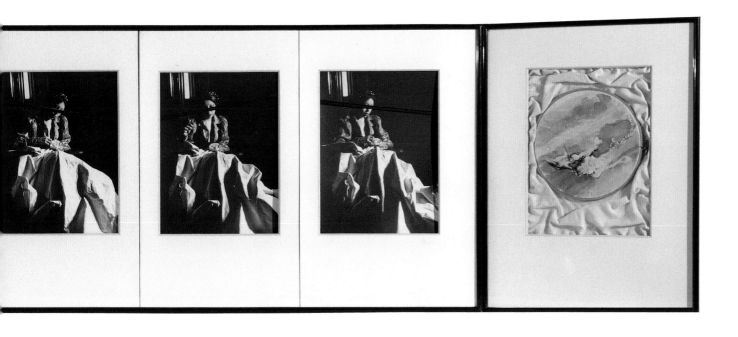

Mister So-and-So, offer him my body as I show him my work, soiling the sheets of my trousseau in order to exhibit them." She thus boldly addressed the following invitation to dealers: "Sir, I'll supply the canvas, supply me with the paint!" Some didn't bother to reply, in which case the action was labeled as "a report of deficiency." Then, in Ben's gallery in Nice, Orlan exhibited the correspondence with an easel on which was hung a sheet, either virgin or soiled.

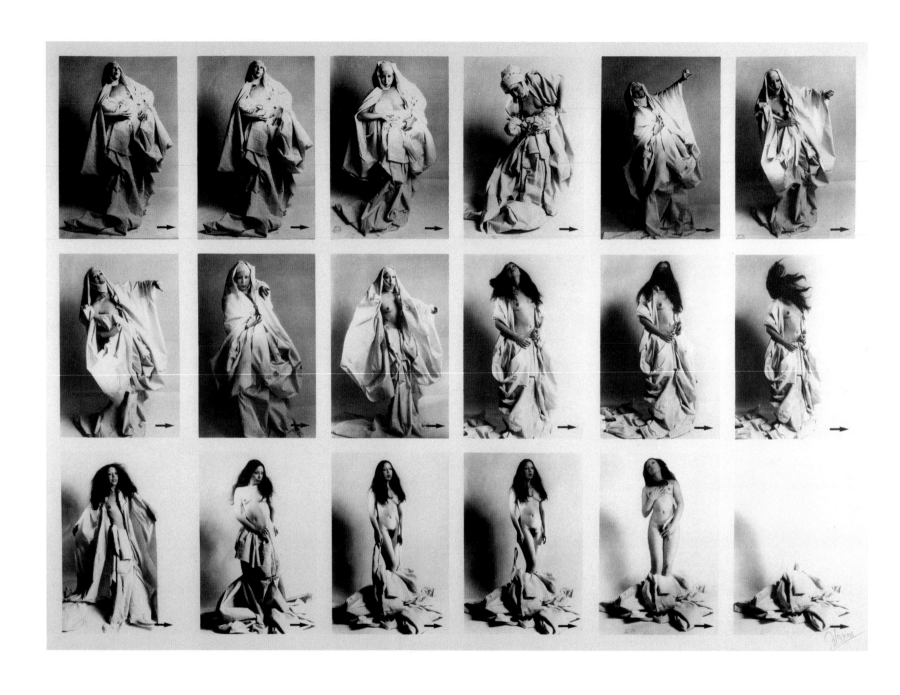

1974–1975
Strip-tease occasionnel à l'aide des draps du trousseau (Incidental Strip-Tease Using Sheets from the Trousseau)

Eighteen black and white photographs taken in 1974 and put together in one work of art in 1975.
Collection Fonds national d'art contemporain, Paris.

Following her subversive use of sheets from her trousseau, Orlan disguised herself as a Madonna, then slowly unveiled herself as though doing a strip-tease. All the while she adopted poses allowing her to play the role of various feminine myths that would resurface in later actions. "Pregnant with countless selves," Orlan was simultaneously glowing saint, mother, and Venus, until "everything came undone—the silk of the chrysalis was rent and the hair fell free, undone: there appeared

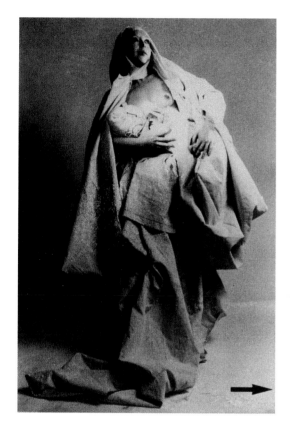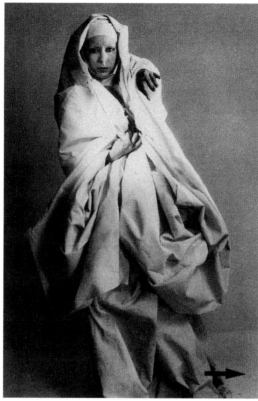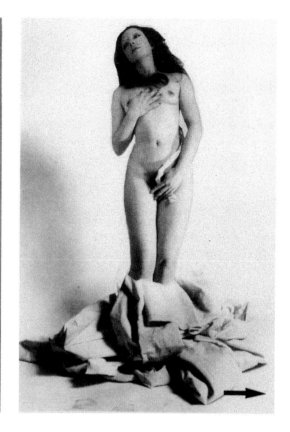

1974–1975
Strip-tease occasionnel à l'aide des draps du trousseau
Details

the body of the strip-teasing woman, trampling upon the tatters of future metamorphoses." The metamorphoses in question entailed the *Opérations chirurgicales* (Surgical Operations, 1990), during which Orlan surrounded herself with reproductions of some of her poses. The first of these eighteen baroque poses was re-used for the dummy in *Le Baiser de l'artiste* (Kiss the Artist, 1976–1977).

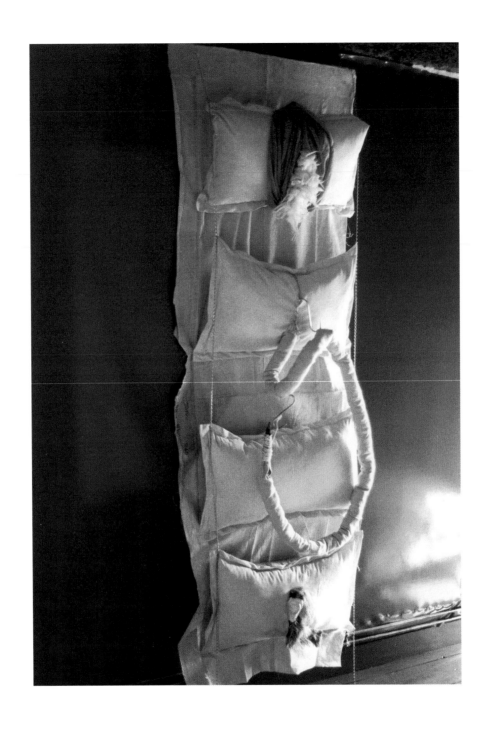

1974
Petite suite d'oreillers: multiples raisons pour ne pas dormir (Little Series of Pillows: Many Reasons for Not Sleeping)

86 ½ x 27 ½ in. (220 x 70 cm), stitched fabric, assemblage of various objects (frames, easels, swaddled dolls). Espace lyonnais d'art contemporain, Lyon. Photo: Jean-Paul Vacher.

This is a shot of one of her sculptural assemblages of pillows, butcher's hooks, and torn sheets (*Portrait tiré à quatre épingles*, Portrait Neat as a Pin, 1970; *Petite suite d'oreillers: multiples raisons pour ne pas dormir*, Little Series of Pillows: Many Reasons for Not Sleeping, 1974), which Orlan sometimes included in certain installations, notably in a show on contemporary trends that was held at the Espace lyonnais d'art contemporain in 1977.

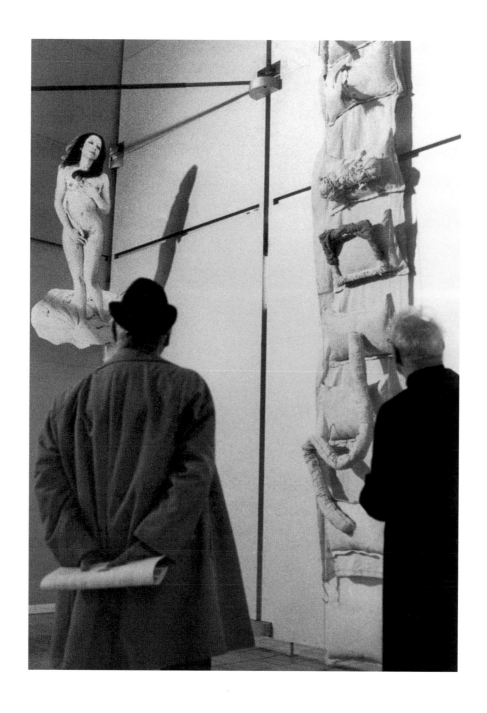

1974
Petite suite d'oreillers: multiples raisons pour ne pas dormir
86 ½ x 27 ½ in. (220 x 70 cm), stitched fabric, assemblage of various objects (frames, easels, swaddled dolls). Photo: Jean-Paul Vacher.
Espace lyonnais d'art contemporain. *Made in France* exhibition curated by Jean-Louis Maubant.

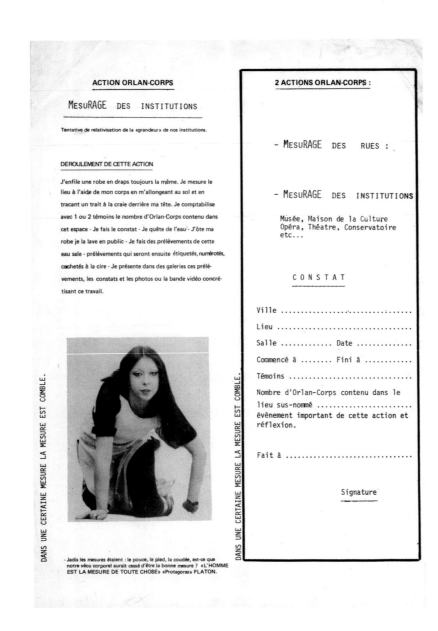

ACTION ORLAN-CORPS

MesuRAGE DES INSTITUTIONS

Tentative de relativisation de la «grandeur» de nos institutions.

DEROULEMENT DE CETTE ACTION

J'enfile une robe en draps toujours la même. Je mesure le lieu à l'aide de mon corps en m'allongeant au sol et en traçant un trait à la craie derrière ma tête. Je comptabilise avec 1 ou 2 témoins le nombre d'Orlan-Corps contenu dans cet espace - Je fais le constat - Je quête de l'eau'- J'ôte ma robe je la lave en public - Je fais des prélèvements de cette eau sale - prélèvements qui seront ensuite étiquetés, numérotés, cachetés à la cire - Je présente dans des galeries ces prélèvements, les constats et les photos ou la bande vidéo concrétisant ce travail.

DANS UNE CERTAINE MESURE LA MESURE EST COMBLE.

- Jadis les mesures étaient : le pouce, le pied, la coudée, est-ce que notre vécu corporel aurait cessé d'être la bonne mesure ? «L'HOMME EST LA MESURE DE TOUTE CHOSE» «Protagoras» PLATON.

2 ACTIONS ORLAN-CORPS :

- MesuRAGE DES RUES :

- MesuRAGE DES INSTITUTIONS

Musée, Maison de la Culture Opéra, Théatre, Conservatoire etc...

CONSTAT

Ville
Lieu
Salle Date
Commencé à Fini à
Témoins
Nombre d'Orlan-Corps contenu dans le lieu sus-nommé
évènement important de cette action et réflexion.

Fait à

Signature

DANS UNE CERTAINE MESURE LA MESURE EST COMBLE.

1974
Feuille de constat avec déroulement de l'action (Documentary Record of Performance of Action)
8 ¼ x 11 ⅔ in. (21 x 29.7 cm), facsimile, paper.

Orlan began her *MeasuRages* around 1974, notably during a trip to Rome to study the Baroque. The title of this series of events stresses the "rage" felt by an artist who refused to play the role expected of her. Using a new unit of measure, the "Orlan-body," she assessed the length and width of streets, leaving traces of chalk on the sidewalk. She thus adopted for herself the axiom of Protagoras that "man is the measure of all things" (which Le Corbusier also adopted when he developed the Modulor).

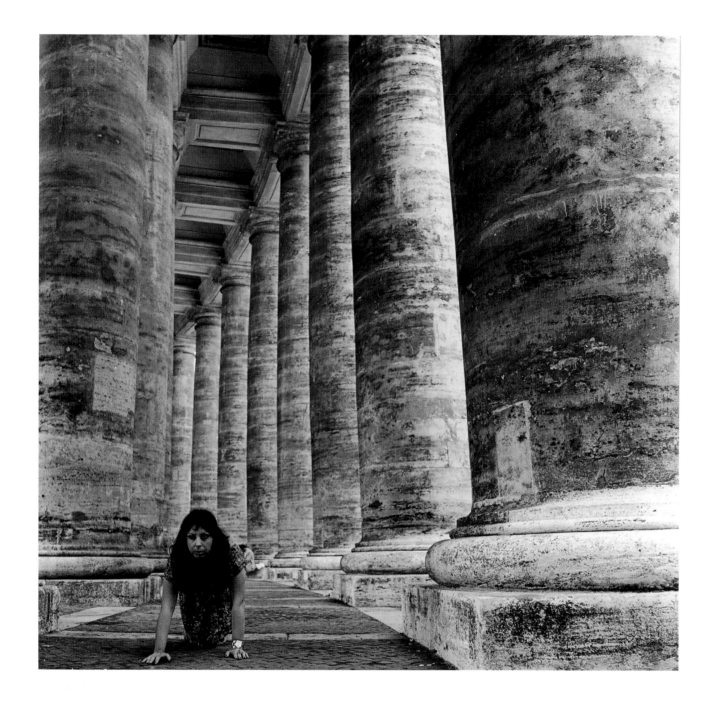

1974

Ceci n'est pas un voeu (This is Not a Vow), Saint Peter's Square, Rome, Italy, from the series *Action-corps, mesuRage d'institutions et de rues*

8 x 12 in. (20 x 30 cm), black and white photographs. Edition of three. Photo: Luc Wauman.

For her first *MesuRage*—an improvised, wildcat affair—Orlan did not yet wear the dress-like smock that she later donned over her clothing, nor did she make white marks on the ground. The event was halted by security guards, forcing Orlan to find a dodge to avoid further hassles with the Vatican. So she pretended to be fulfilling a vow by crawling on her knees, thus reassuring the security forces and temporarily interrupting the action, which over the next decade would be repeated in various forms.

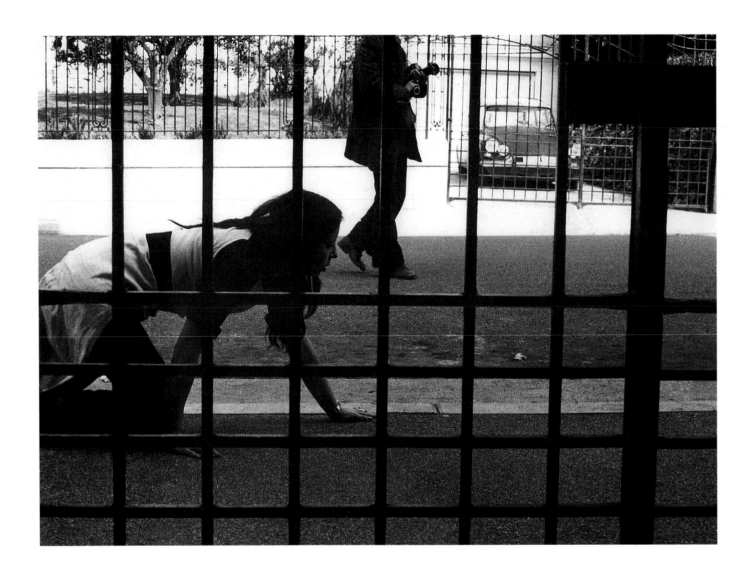

1976
MesuRage de la rue Chateaubriand à Nice, France (MeasuRage of rue Chateaubriand in Nice, France), from the series *Actions Orlan-corps, mesuRage d'institutions et de rues*

23 ²/₃ x 19 ¼ in. (60 x 49 cm), black and white photograph.

This *MesuRage* was done on a street in Nice, a city where Orlan had spent some vacation time and where, a few years later, she participated in a Fluxus festival at the municipal theater. It was filmed by Ben, who hosted Orlan's *Art et Prostitution* action in his Galerie La Différence. The *MesuRage* Orlan performed on this residential street was more elaborate than the earlier one in Rome. It transpired thus: Orlan went to the selected spot, set down her easel, put on the dress-like smock made of sheets from her trousseau, got down on all fours, then stretched out and drew a chalk line at the top of her head. Starting from that line on the ground, she repeated the sequence as many times as necessary to take complete possession of the designated place, like an animal marking its territory. She then counted the total number of Orlan-bodies and recorded it on a document. She took off the smock, washed it in public—immediately suggesting the expression "to wash your

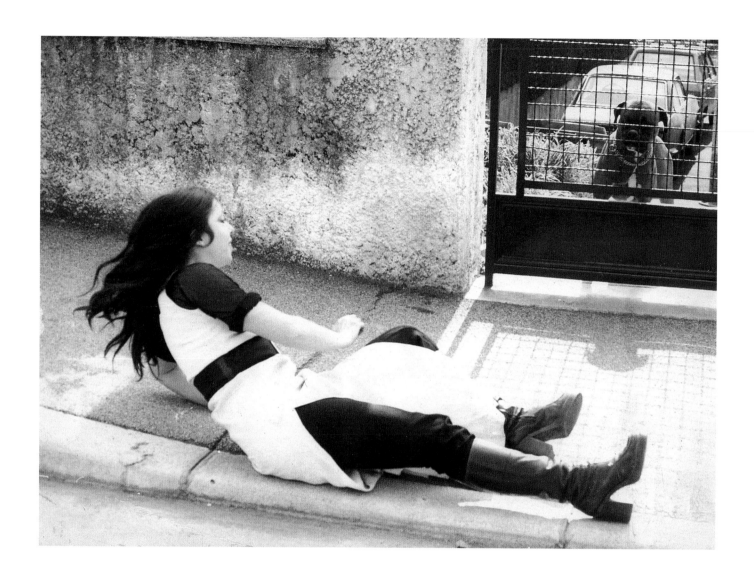

1976
MesuRage de la rue Chateaubriand à Nice, France (MeasuRage of rue Chateaubriand in Nice, France), from the series *Actions Orlan-corps, mesuRage d'institutions et de rues*

23 ⅔ x 19 ¼ in. (60 x 49 cm), black and white photograph.

dirty linen in public"—and saved the dirty water in a flask that was then labeled, numbered, and sealed with wax. She concluded the action by holding the flask aloft, in a pose similar to the Statue of Liberty. All these gestures were provocative ones in terms of our relationship to urban spaces and the place we occupy there: "Are modern cities made to our measure?" asks Orlan. "Are the streets tangibly, physically ours?" She's saying that the relationship between space and body is crucial, that the body can be an unmatched instrument of perception and knowledge (which is often overlooked). At the same time, as a female artist Orlan indirectly evokes responsibilities traditionally assigned to women (laundry, clothing, pluckiness), the better to trample on them.

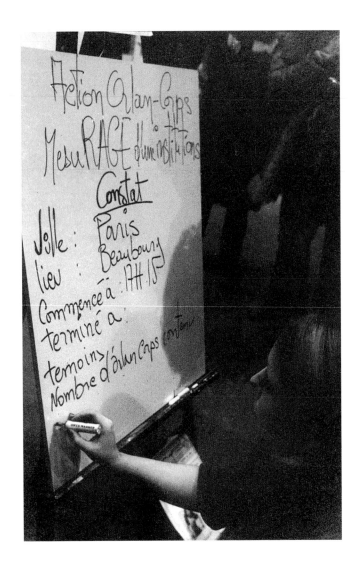 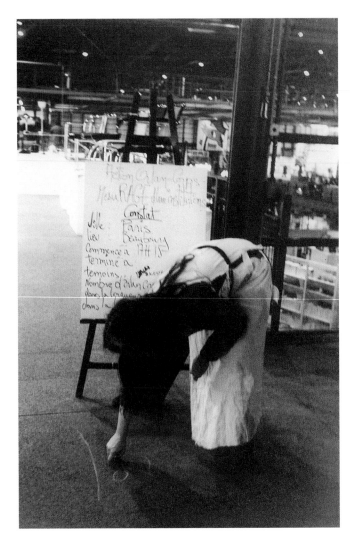

1977

Action-Orlan-Body-Action: mesuRage d'institutions (MeasuRage: Institutions). Centre Georges Pompidou, Paris, from the series
Orlan-corps: mesuRages d'institutions et de rues

Black and white photograph.

Like the street *MesuRages,* Orlan's organization of institutional *MesuRages* varied according to context, although all were documented in identical fashion. As a project likely to be reactivated at any moment, Orlan acknowledges the possibility of conducting future measurings, for example at the inauguration of a major new museum. This particular event took place at the Centre Pompidou in Paris in 1977, the year the Centre opened. As the documentation indicates, the action took place

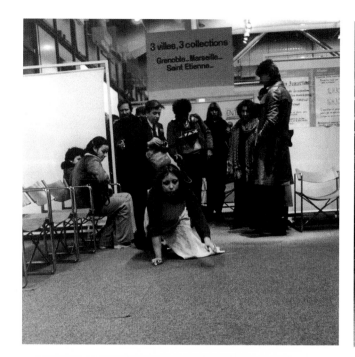
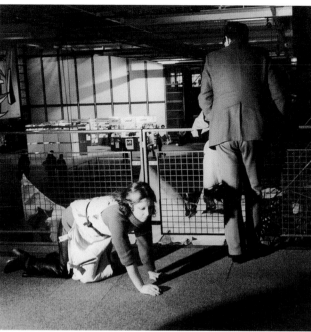
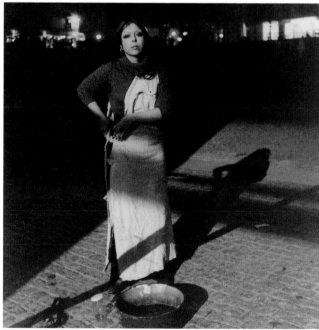
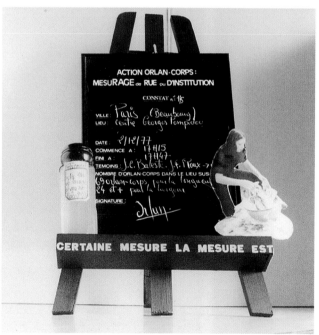

1977
Bottom right: *Dans une certaine mesure, la mesure est comble* (To a Certain Extent, the Extent's the Limit)

17 ¾ x 13 ¾ in. (45 x 35 cm), black and white photograph, easel, documentary report, flask of dirty water from washing the smock-like dress (with wax seal and label), lettering. Edition of three. Collection MNAM-CCI-Centre Georges Pompidou, Paris.

on December 2, beginning at 5:15 p.m. and ending around 6:00 p.m. Orlan set her easel on the mezzanine overlooking the forum and then headed to the upper floors to continue her action in the rooms of the Musée National d'Art Moderne, then featuring an exhibition on public collections of modern art in France, specifically devoted to three cities and three collections: Grenoble, Marseille, and Saint-Étienne. The place and date of this *MesuRage* were therefore doubly strategic.

1979
Triptych, *MesuRage d'institutions* (MeasuRage: Institutions)

Musée Saint-Pierre, Lyon.

Each panel 51 x 39 in. (130 x 100 cm), sepia architectural drawing with inclusion of text by Alain Charre and photographs. Edition of three.

Fonds régional d'art contemporain, Rhône-Alpes.

Two years later, as part of the Symposium International de Performance et de Vidéo in Lyon, Orlan organized a *MesuRage* in another French museum, one with the more austere architecture of a former Benedictine convent. It took place on April 25, following an itinerary that echoed the original design of the convent: the Orlan-body was employed only outside the museum, around the cloister. After having measured the site by crawling on the ground and marking white lines, Orlan repeated

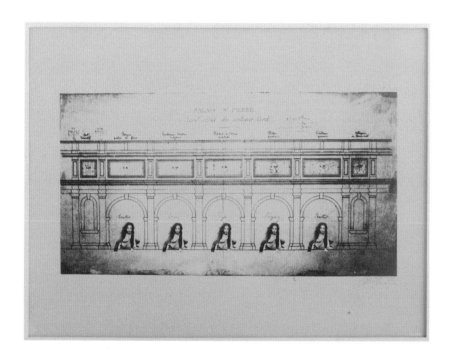

the itinerary again, this time with two witnesses. The action ended—in the presence of numerous witnesses—with the final ritual of washing the dress that had been dragged along the floor of the building.

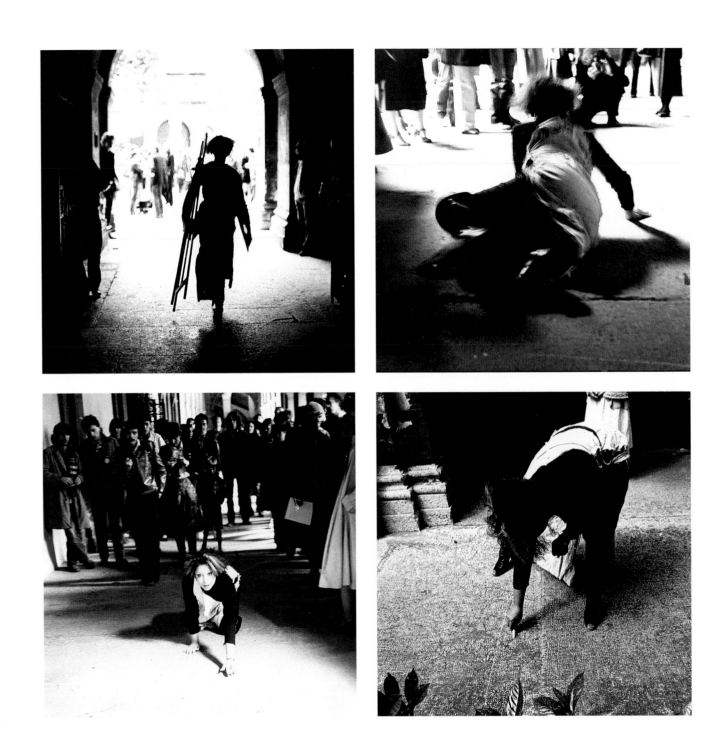

1979
MesuRage d'institutions, Musée Saint-Pierre, Lyon
Black and white photographs.

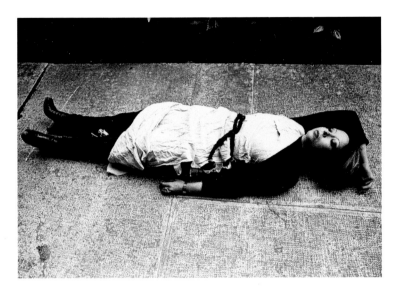

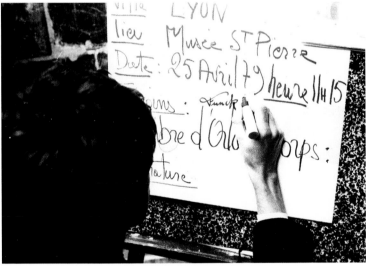

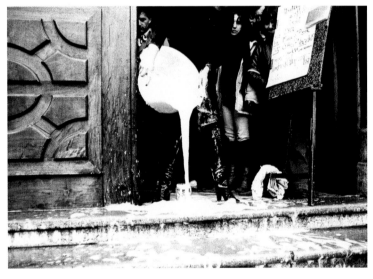

1979
MesuRage d'institutions, Musée Saint-Pierre, Lyon
Black and white photographs.

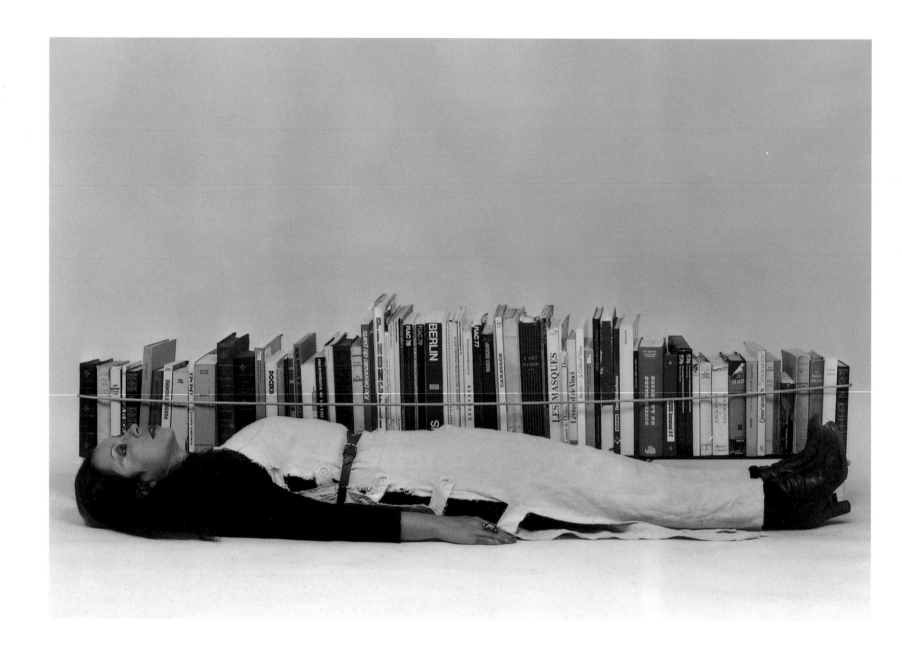

November 8, 1979
Un Orlan-corps-de-livres (One-Orlan-Body-of-Books)
Black and white photograph. *Performance Orlan-corps, MesuRage*, NRA Gallery, Paris.

Orlan invited artists and art-lovers to come read an *Orlan-corps-de-livres* (One-Orlan-Body-of-Books) in a gallery that exhibited artists' books. She asked her friends to bring the one book that most influenced their art or their life: "You are invited to bring your book between November 8th and November 16th at the latest. The book must bear a dedication or at least your name on the flyleaf and on an envelope which tells us, in long or in short, why this book was influential." By the end of the week, a number of books had accumulated in the gallery, and Orlan, dressed in her screen-smock, used her body to measure the books aligned on the ground as though on a shelf. This row of books formed the standard unit of one "Orlan-Body-of-Books." After this static *MesuRage* (Orlan lay down along the line), she stayed in the gallery day and night until she had read all the books. While reading out loud, she strove to stamp, annotate, and mark the pages of each book. Pages felt to be most significant were torn out and replaced by blank sheets. The selected pages would then form another corpus. At the conclusion of this action, Orlan offered participants a signed photograph of the performance.

 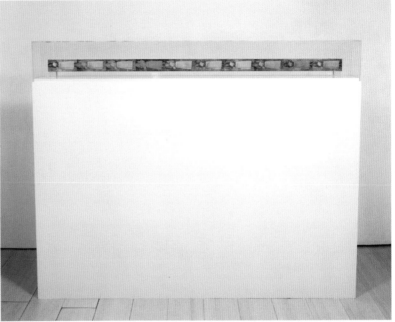

2002
Étalon Orlan-corps (recto et verso) (Standard: One-Orlan-Body, Front and Back)

71 x 47 ¼ x 78 ¾ in. (180 x 120 x 200 cm), wooden ruler, Plexiglas, white-lacquered wooden base. Work produced by the Fonds régional d'art contemporain, Pays de la Loire, for the *Éléments favoris* exhibition, 2002. Prints: Bruno Scotti.

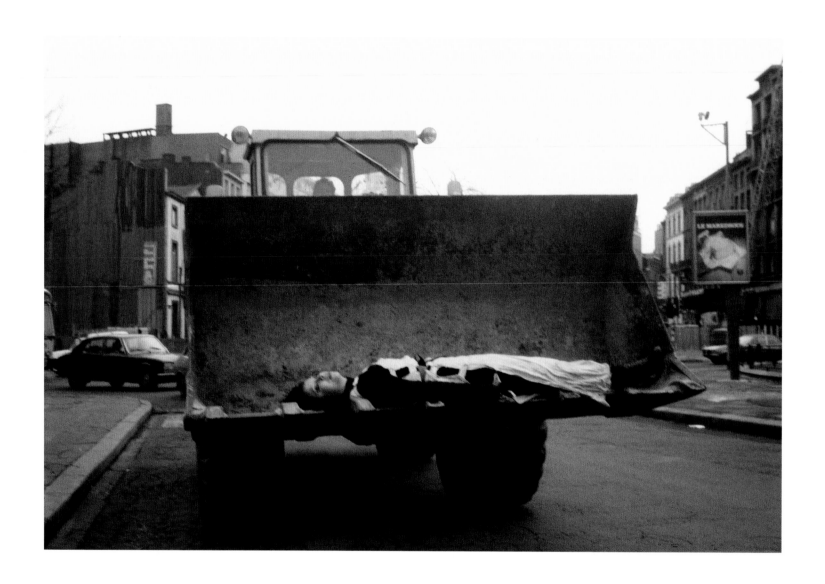

1980

MesuRage Saint Lambert Square, Liège, Belgium

Color photograph. Photo: Jean-Paul Lefret.

While this *MesuRage* in Liège was a logical progression from the two previously mentioned ones, it assumed a distinctly more political and publicized nature. Orlan's action was solicited by a neighborhood association that was campaigning to protect a square under threat due to lack of a development project. Over a four-day

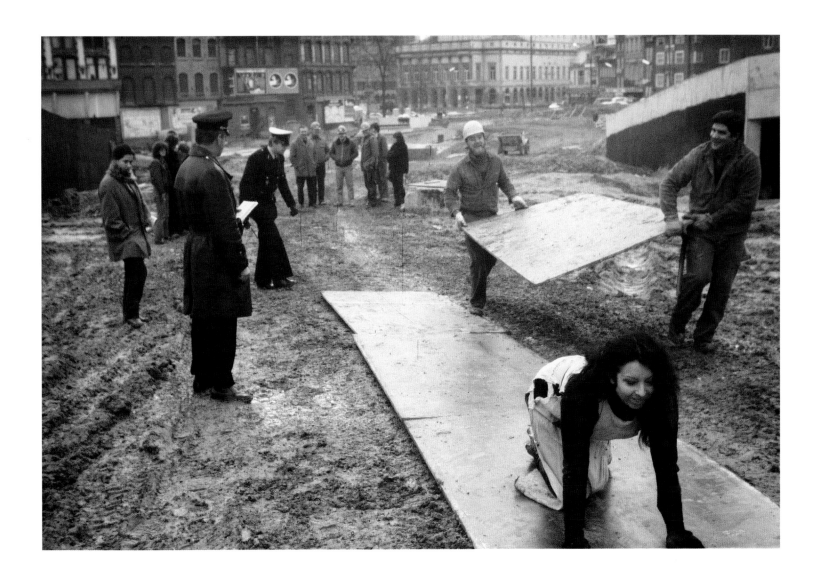

1980
MesuRage Saint Lambert Square, Liège, Belgium
Color photograph. Photo: Jean-Paul Lefret.

period, Orlan physically committed herself to this cause. She called on a bulldozer, the very machine used to demolish the square, to carry the Orlan-Body—like rubble—from one spot to another.

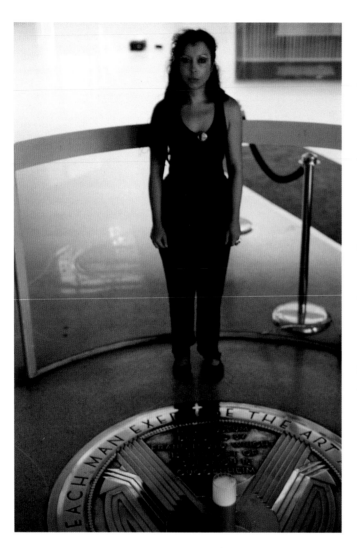 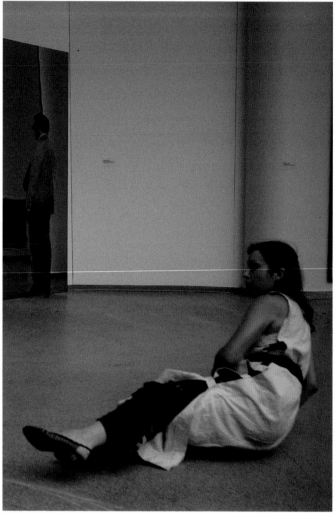

1983
MesuRage, **The Solomon R. Guggenheim Museum, New York**
Four color photographs.

The point of departure for one of the final institutional *MesuRages* was the inscription Frank Lloyd Wright placed over the entrance to the Guggenheim Museum in New York: "Let each man exercise the art he knows." In these pictures, we see Orlan crawling along the various levels of the spiral interior, whose walls featured an exhibition titled *Aspects of Postwar Painting in Europe, Acquisition Priorities*. Notably visible are "mirror paintings" by Michelangelo Pistoletto.

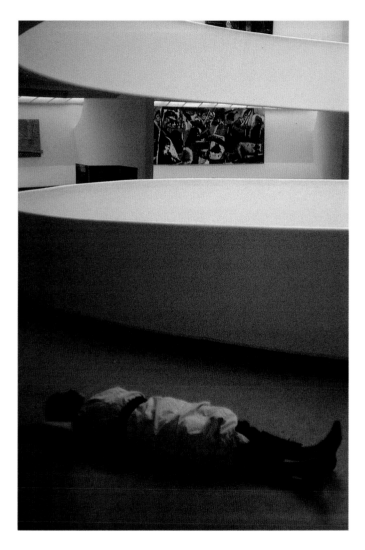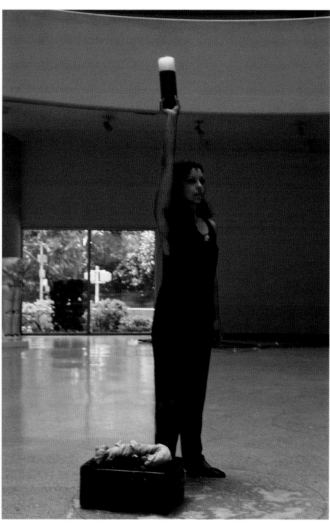

1976–1977
S'habiller de sa propre nudité (Dressed in Her Own Nudity)

Performance. Fourth International Contemporary Art Symposium (programmed by Egidio Alvaro), Museum Malhoa, Caldas da Rainha (Portugal)
Black and white photograph.

All Orlan's actions in urban spaces should be seen in the context of other city-based artistic events that were flourishing everywhere in Europe during the 1970s. Associated with Body Art, and even with Situationism in so far as that philosophy advocated experimenting with exceptional situations in the anonymous environment of a city, these ephemeral actions still exist through photographic records, accounts, and sometimes films. A major part of Orlan's contribution to this art-historical development began as early as 1965 in her home town of Saint-Étienne and in the Rhône-Alpes region; it then continued notably in Portugal in 1976 with a series of Body-Actions and with the first version of *Le Baiser de l'artiste* (Kiss the Artist), which preceded the version shown at the Foire Internationale d'Art Contemporain in Paris. Strangely, it was in this festival in Portugal, where censorship seemed to be stricter, rather than France, that Orlan first carried out some actions deemed highly disturbing at the time.

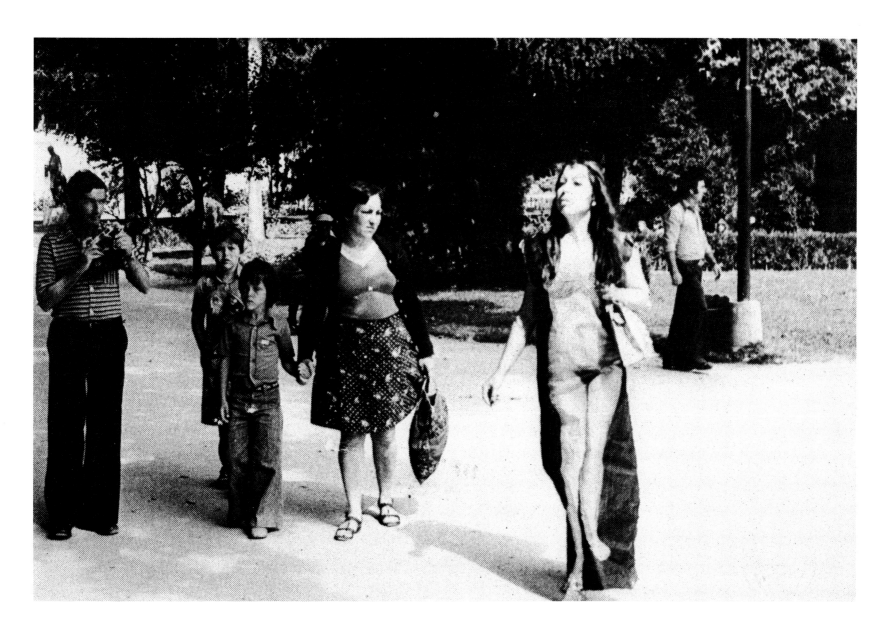

1976–1977
S'habiller de sa propre nudité
Black and white photograph.

Starting with the *MesuRages,* Orlan subverted the normal use of sheets from her trousseau by transforming them into a dress-like smock pulled over other garments, then washed in public in a concluding ritual. "I didn't want the measurements to be made with a naked body, but with a socialized body, which means a body that is dressed (even overdressed) in a smock that . . . [also] plays the role of a screen." Promenading through the public parks of the Portuguese city of Caldas da Rainha, Orlan again wore a screen–gown made from sheets, but this time not white and neutral. It bore a photographic reproduction of the artist nude, thus displaying precisely what a gown is supposed to hide. Dressed in her depicted nudity, Orlan strolled among the greenery and the passers-by as though nothing were amiss, as witnessed by two pictures preserved by the artist. The ruse enabled her to avoid arrest (which happened to her in Rome in 1974) even as she provoked the stupefaction of strollers who didn't seem to grasp the *parody* inherent in the situation. While Orlan employed this trick to avoid scandal (in fact, a traffic cop warned her, and Orlan had him touch the gown, replying that she had the right to wear "a print dress"!), it also triggered a dialectic between "real" and "phony." The doctored, reworked reality was later found in series such as *Portraits officiels* (Official Portraits), *La Femme qui rit* (The Laughing Woman, 1997), and certain *Self-Hybridations* (Self-Hybridizations) in which the make-up, the traces of scarring and lumps—whether real or simulated—sustain the same confusion as this photographic gown.

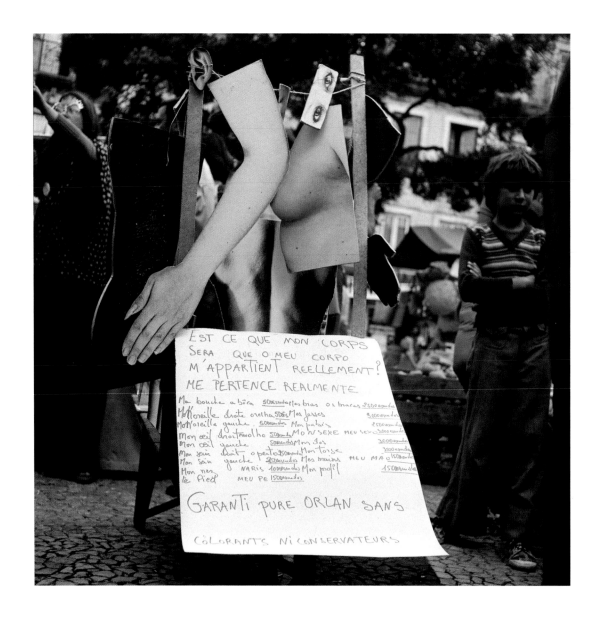

1976–1977
Se vendre sur les marchés en petits morceaux (Selling Herself on the Market, Piecemeal)
Performance at Caldas da Rainha, Portugal.

Black and white photographs.

Before producing *Le Baiser de l'artiste,* Orlan sold reproductions of small pieces of her body on the market, raising the following question: "Does my body really belong to me?" These photographs show the display of parts of her body and face—eyes, an ear—reproduced in black-and-white photographs stuck to wooden panels like advertising boards. These pieces of flesh, guaranteed to be "pure Orlan, with no added color or preservatives," hung among the market stalls. Orlan, present on the scene, loudly hawked the merchandise: "Who'll buy my left breast, my right breast, my genitals, my little finger," and so on. Thus, even prior to selling "flesh and blood" kisses, Orlan exhibited all the parts of her body as merchandise, selling herself "openly, if at first symbolically. Her body [was] photographed and chopped into pieces like meat in a butcher's shop." This quotation is drawn from a text titled *Action–Prostitution,* written in collaboration with Hubert Besacier, in which Orlan clearly raised the question of prostitution and its insidious nature within all social systems, even the loftiest. Although Orlan was unfamiliar with Pierre Guyotat's book *Prostitution,* published in 1975, it is hard not to make connections between their two analyses of the body.

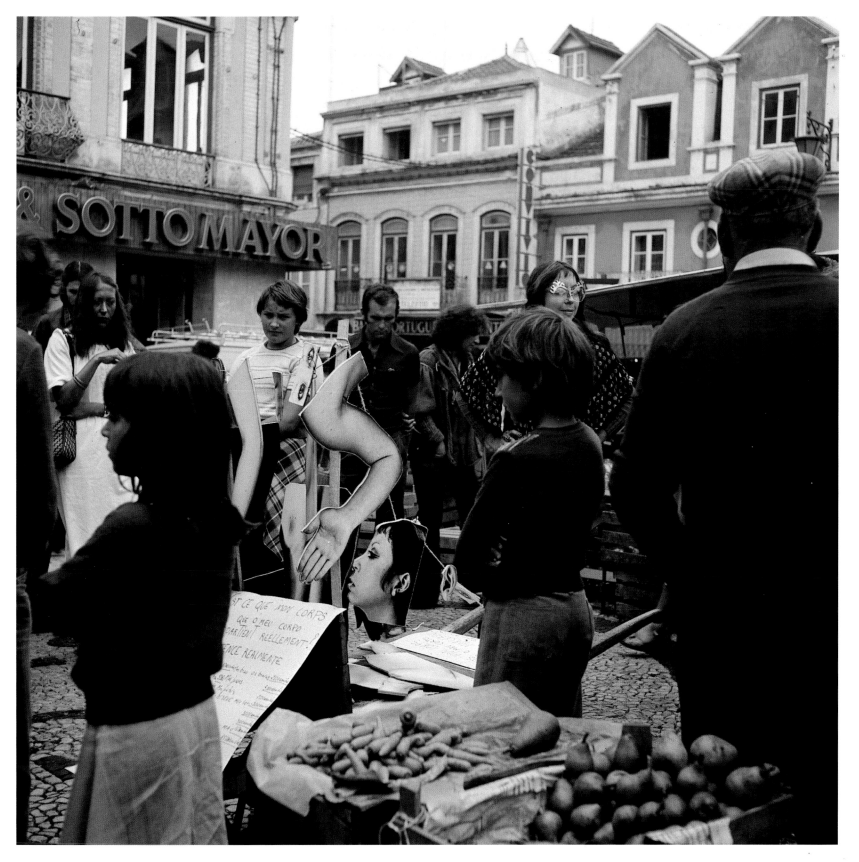

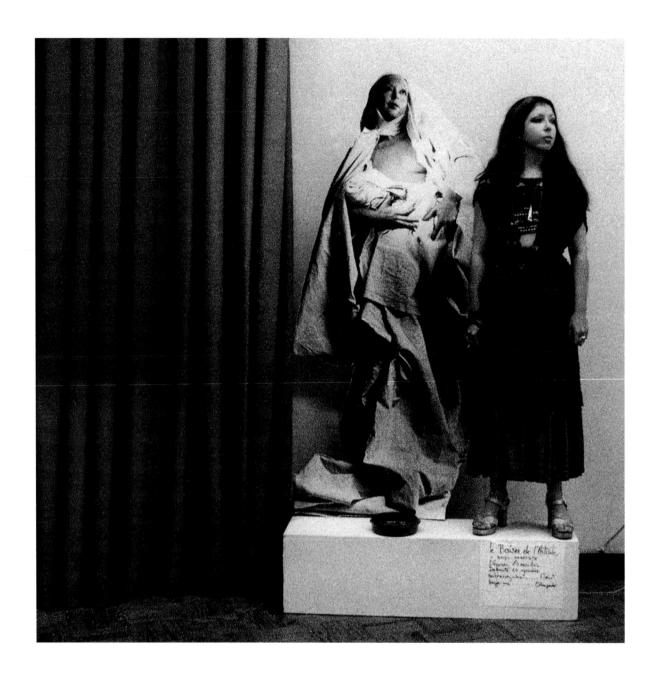

1976
First version of *Le Baiser de l'artiste à vingt escudos* (Kiss the Artist for Twenty Escudos)

Black and white photograph. Cultural Center, Caldas da Rainha, Portugal.

This first version of *Le Baiser de l'artiste* is different from the later one performed in Paris, because the earlier event took place in an institution that partly shielded Orlan from scandal and censure. Standing on a white platform, alongside an illusionistic dummy that shows her as a white-garbed Madonna holding a swaddled infant, Orlan awaited volunteers. At her feet was a bowl containing a few coins, attesting to kisses sold for twenty escudos. The rules of the game were hand-written by Orlan on a little sign; the action lasted roughly half an hour, during which seventeen participants agreed to buy a kiss.

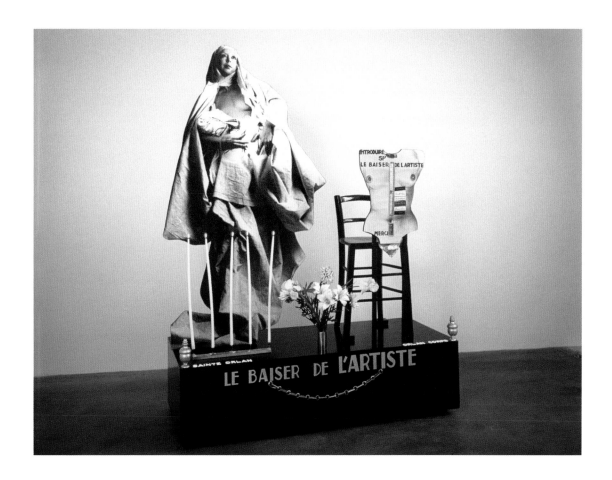

1977
Le Baiser de l'artiste (Kiss the Artist)
Black-and-white photographs, wooden plinth, flowers, plastic lettering, chair, soundtrack.
Photo: Stéphane Bellanger. Fonds régional d'art contemporain, Pays de la Loire.

Following the version in Portugal, Orlan performed *Le Baiser de l'artiste* uninvited at the Foire Internationale d'Art Contemporain (FIAC) held in the Grand Palais in Paris. In collaboration with Hubert Besacier, Orlan had just written *Face à une société de mères et de marchands* (Faced with a Society of Mothers and Dealers) and *Art–Prostitution*, two texts in which she not only claimed the right to dispose freely of her body but also denounced the mercantile art system, which explains her choice of the FIAC as the site for the French version of *Le Baiser de l'artiste*. The action took place at the foot of the grand staircase in the Grand Palais, near the stands allocated to art magazines. For several hours a day throughout the entire fair, Orlan hailed the crowds: "Come up, come up, come onto my pedestal, the pedestal of myths: mother, whore, artist." On the black platform, placed side by side, were a chair with a photograph of the artist's torso and pubis, transformed into an automatic dispenser, and a life-size photograph of Orlan as a Madonna (this picture was the first of the eighteen poses in the 1974 *Strip-tease occasionnel avec les draps du trousseau*). The *tableau vivant* took on a funereal air given the black platform, the candles, the bouquet of flowers, and the white, tombstone-like lettering. Orlan effectively "signed her own death warrant" with this action, for it created a scandal over which she was pilloried for several years. Her appearance on Philippe Bouvard's television show on November 6, 1977 turned media spotlights onto the event and led to the cancellation of her teaching position in Lyon; a strike by her students failed to reverse that arbitrary, unfair decision—Orlan was out of a job. Despite the criticism thrown at her, marking a veritable divide in her life, Orlan was invited the following year by a contemporary art center in Lyon to present *Le Baiser de l'artiste* in a show titled *Langages au féminin* (Languages in the Feminine). Then, on May 25, 1978, she was invited by Gérard Deschamps and the Lara Vincy Gallery in Paris to present *Le Baiser de l'artiste* as part of an exhibition called *Orlan/Deschamps, Bigeard/Bise-Art*. Reflecting the absurdity of the situation, the exhibition presented Orlan's automatic dispenser alongside a work by Deschamps, *Barrette de croix de guerre, dite Bigeard–Bise Art* (War Cross Medal, Called Biz-Art/Kiss Art). For this Parisian version of *Le Baiser,* Orlan devised a triptych composed of panels covered with a shattered stretcher. At its base was a sheet. The panel represented three stages: "soliciting and kissing; swallowing and going for the money; plastic pubis filling with change."

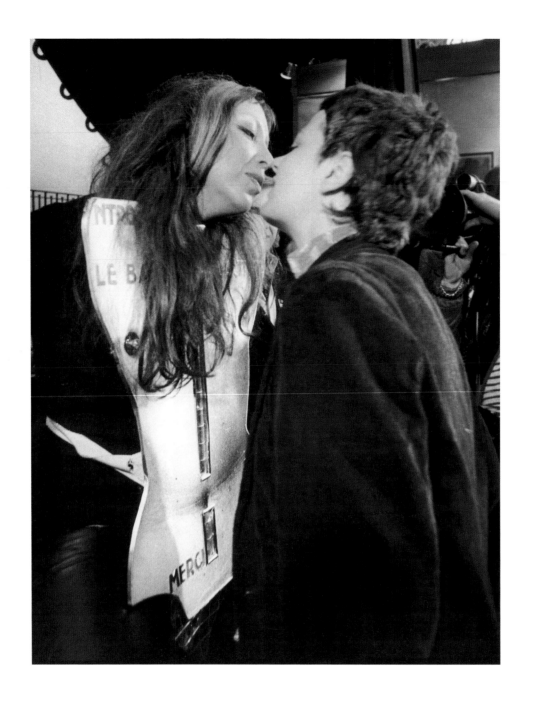

1977
Orlan kissing one of her clients.
Black and white photograph. Grand Palais, Paris.

People who found themselves confronted with this *tableau vivant* were offered the choice of buying a kiss for five francs or offering a candle to Saint Orlan disguised as a Madonna. In the roles of whore and saint, Orlan was selling both dissipation (a kiss) and devotion (a candle). As explained in the *Mode d'emploi* (User's Manual), Orlan turned on a tape recorder that played a few tunes from the *Toccata,* then a siren would sound to mark the end of the kiss. "Once the Orlan-Body kiss is over, the music stops Please leave, or else the alarm will go off. Thank you and good-bye." As Catherine Millet pertinently pointed out in an essay titled "L'espace du corps" (published in *L'art du corps*), referring to actions by Michel Journiac and Gina Pane that were contemporaneous with Orlan's *Baiser,* any Body Art that tackled the social environment would inevitably come up against another system of measure—namely, that of money.

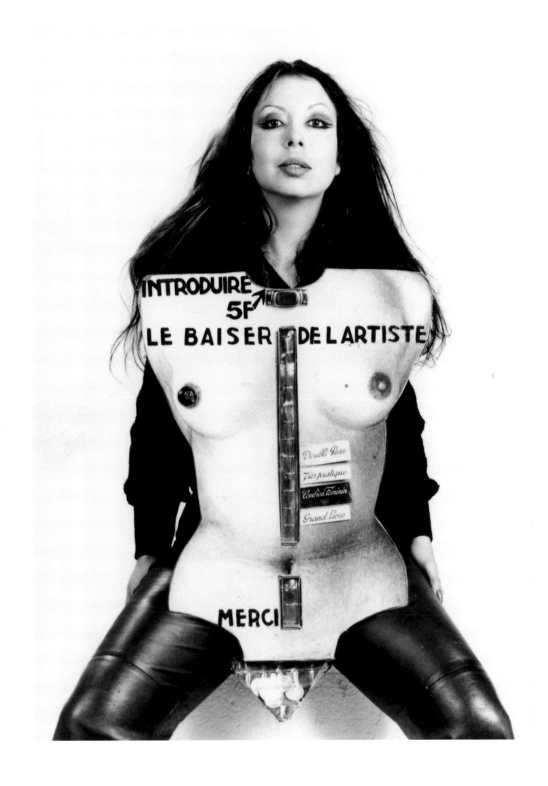

1977
Le baiser de l'artiste. Le distributeur automatique ou presque! (Kiss the Artist: Automatic—Well, Almost—Dispenser)

Black and white photograph. Maison européenne de la photographie, Paris.

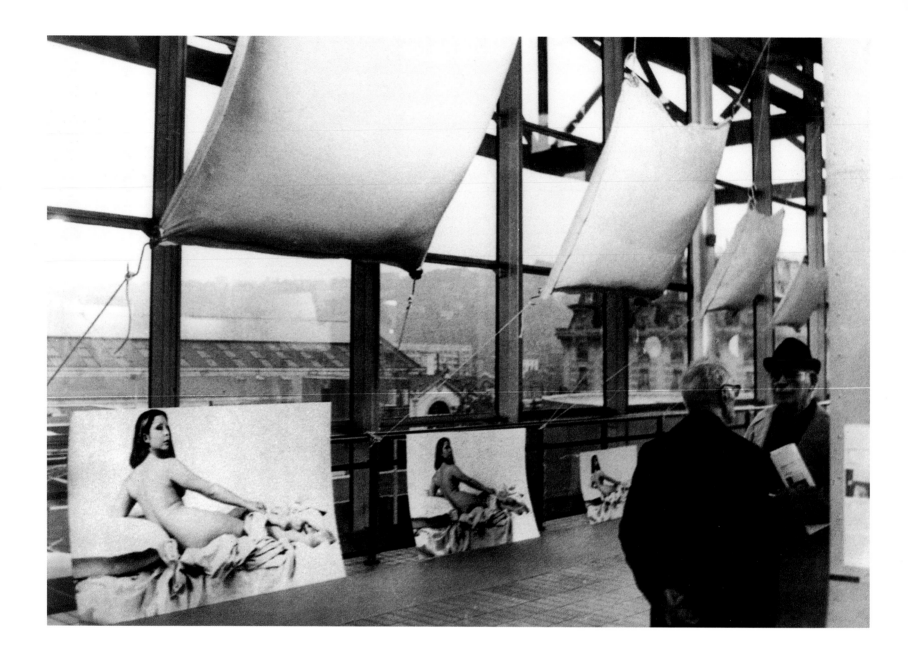

1977
Orlan en Grande Odalisque d'Ingres (Orlan as Ingres's *Grande Odalisque*)
Views of exhibition, Espace lyonnais d'art contemporain, Lyon. Curated by Jean-Louis Maubant.

After using her body as a unit of measure and as a marketable pleasure-machine, Orlan turned to the history of art—and, later, to the rites of non-Western civilizations—in an effort to "retrace the path of art history, going through all the historic stages and, to a certain extent, re-experiencing it all through her own flesh and thus imbuing herself with a past view of things. . . ." This series of *tableaux vivants* shows Orlan in "Situation-Quotation": Venus as painted by Botticelli, the large odalisque depicted by Ingres, and the nude Maya by Velasquez. The appropriation of these female poses—from muse to virgin via mother and whore—enabled Orlan to bring to life, even as she challenged them, depictions "forged and frozen by the imagery of male historical power." Quoting them meant situating herself: "I situate myself by temporarily freezing my own reality and my own life-filled body, inflicting upon it the coldness of marble and the density of objects. For a moment, totally alienated from my own substance, I can experience all the solemnity and stiffness." Orlan's *tableau vivant* of the *Grande Odalisque* by Ingres was presented

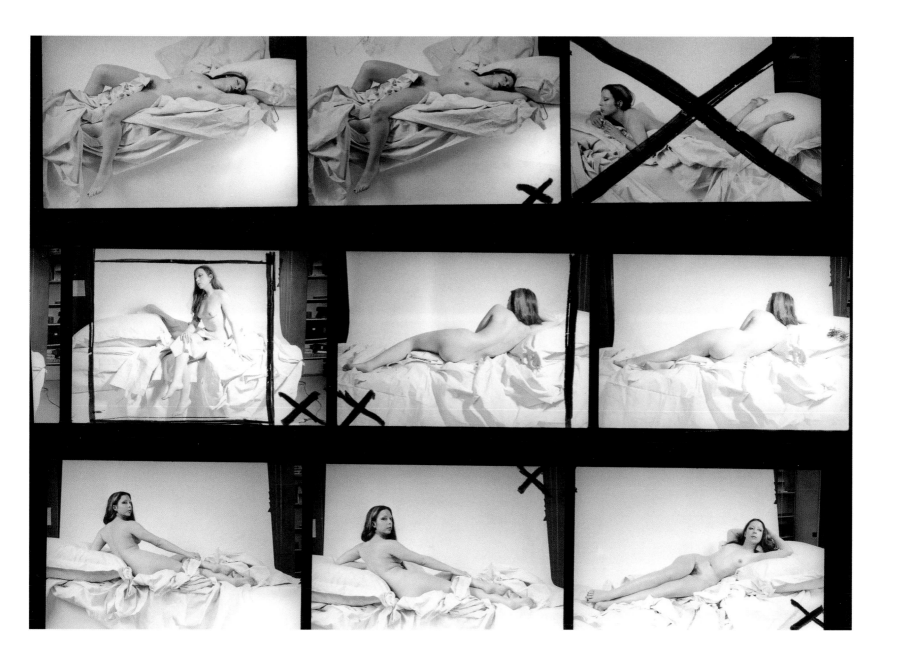

1977
Planche-contact (Contact Sheet)
Black and white photograph.
Espace lyonnais d'art contemporain, Lyon. Photo: Jean Paul Vacher.

at a show on contemporary trends held at the Espace lyonnais d'art contemporain in 1977. Orlan devised a progressive series of reproductions of the odalisque: from contact sheet, to the scale of her own body, to a full-size reproduction of Ingres's painting, concluding with an even larger image, thereby suggesting a dialectic between *mesure* and *démesure* ("measured" versus "outsized"). Orlan, slipping fully into the myth, accompanied each print with a white pillow—of increasingly large size—that hung in the exhibition space. Orlan claims that she has always considered these *tableaux vivants*—which are so many portraits of the woman artist—as "words in a unique vocabulary, to be organized in sentences throughout [her] oeuvre and across [her] various procedures." In the 1990s, some *Situation-Citations*, such as *La naissance d'Orlan sans coquille* (The Birth of Orlan without Seashell), would resurface in the form of stage props for some of the surgical performances.

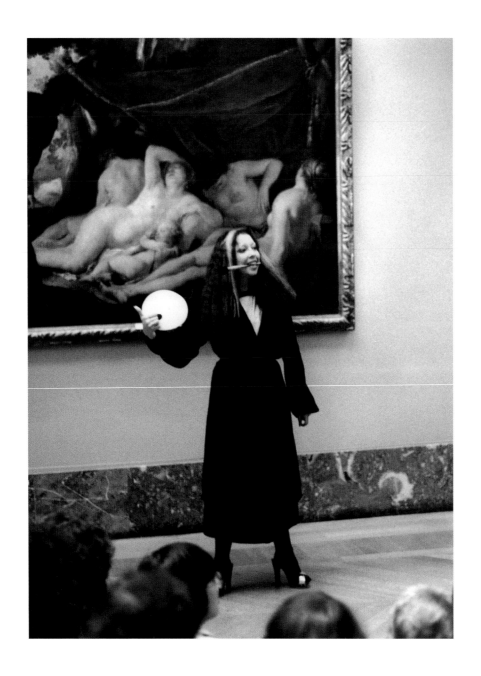

1978
A poil / sans poil (Bare No Hair) performance
Black and white photographs. Musée du Louvre, Paris.

In October 1978, Jean Dupuy invited Orlan to present a performance in the "one minute, one work" show at the Louvre. She chose a painting by Jacques Blanchard, *Venus and the Graces Discovered by a Mortal* (1631–33). The action was performed in front of the painting and had to remain very discreet: a few visitors gathered around Orlan who, dressed in a black cloak, paced back and forth before the painting, then undid the belt of her cloak to reveal the photographic dress she was wearing. She undid the part of the dress showing her genitals, roughly yanked out her pubic hair (previously shaven), then put the hairs on a palette. With a brush held between her teeth, she repainted her shaven pubis, closed her cloak, and slipped away before the guards could seize her. Once again Orlan played on confusion between a real act and its depiction—Blanchard's painting shows the women of yore naked but with no pubic hair.

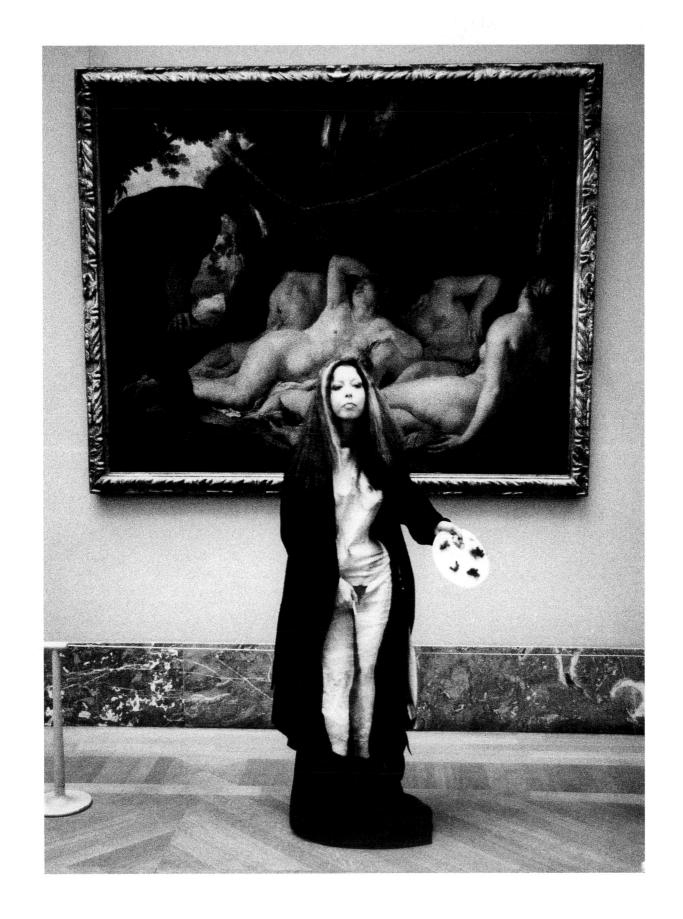

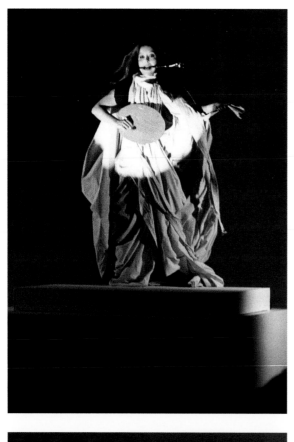
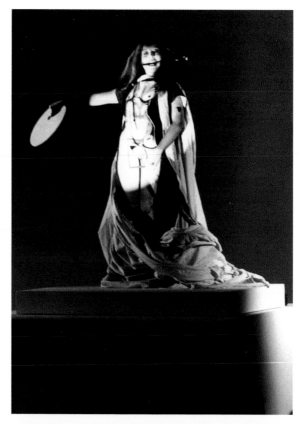
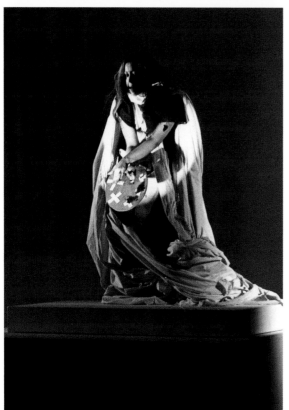
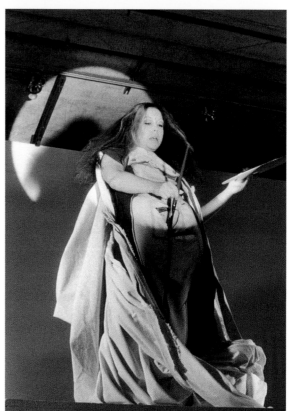

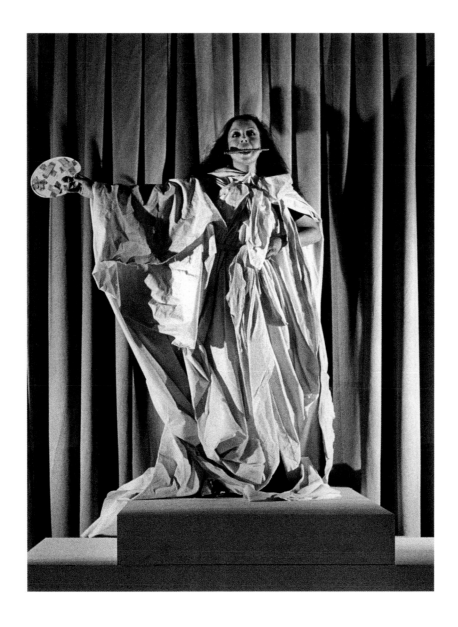

December 1978
Performance à poil / sans poil
Black and white photographs. Sammlung Ludwig Museum, Aachen, Germany.

Two months later, Orlan carried out a similar action at Sammlung Ludwig in Aachen, Germany, during a symposium on performance art. For the German version, Orlan donned the baroque drapery of her trousseau linen. Wearing this Madonna's gown, which she slowly opened while she held a palette against her belly, she offered a glimpse of the photographic gown of her own nudity. Then she repeated the same gestures she had performed at the Louvre, concluding with a triumphant pose: Orlan brandished the palette covered with pubic hair and surgical tape, whereas at the Louvre she had adopted a pose of feminine modesty by placing the palette against her pubis.

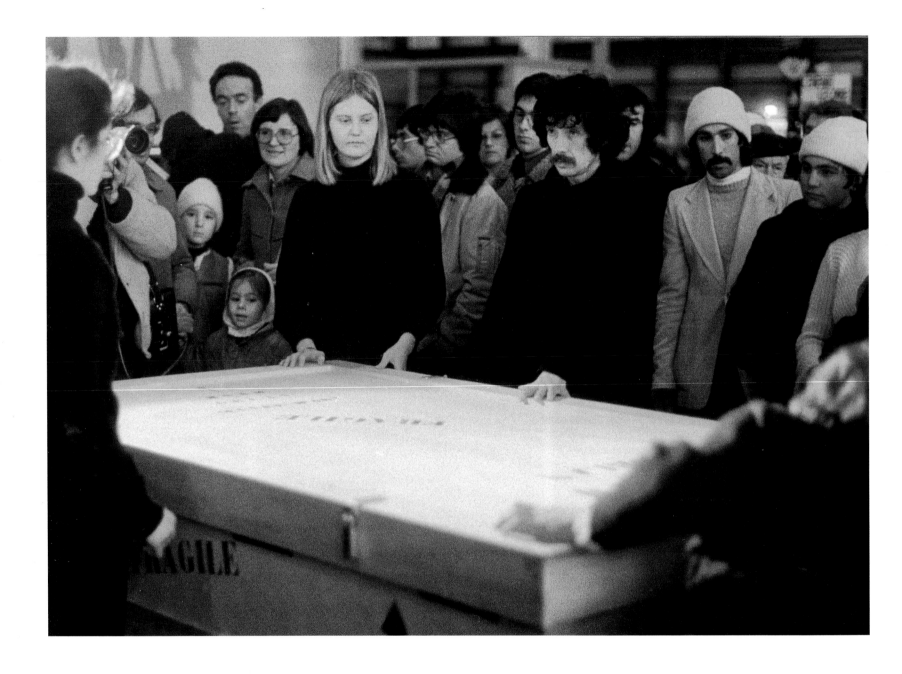

1979
Documentary Study: *Le drapé-le Baroque* (Drapery-The Baroque)

Black and white photographs. Performance for *Rencontres internationales d'art corporel et vidéo,* curated by Jorge Glusberg. Centre Georges Pompidou, Paris.

Like *MesuRages, Le Baiser de l'artiste,* and the public walks, Orlan's *Processions* assume various forms depending on context and location. In general, Orlan is wrapped in trousseau sheets and appears in a Plexiglas reliquary chest like a saint or untouchable icon (at the Pompidou Center, however, she arrived in a shipping crate used for artworks). "From these linen tatters an infant is pulled up, a rag doll frozen in the folds of a Burgundian Madonna, that noble image with radiant face." The folds of Orlan's baroque gown are held by nylon threads attached to the transparent box, which assistants can pull in order to make the drapery roll and flow around the artist's mystic body. The slight ruffle of drapery is sometimes rebroadcast on television screens. Orlan's face and breasts are painted white. Once her assistants cut

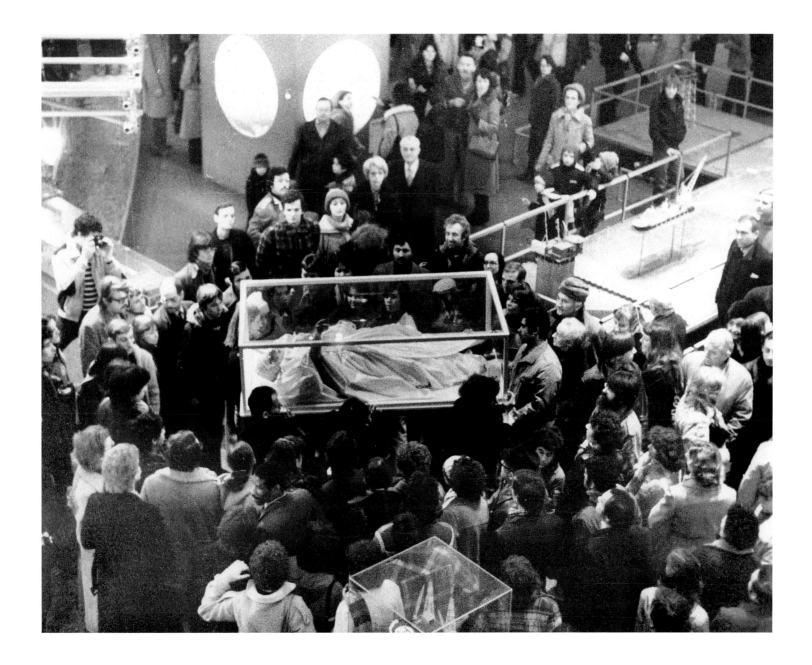

1979
Documentary Study: *Le Drapé-le Baroque*
Black and white photograph. Performance for *Rencontres internationales d'art corporel et vidéo*, curated by Jorge Glusberg. Centre Georges Pompidou, Paris.

the threads, the body of the saint is transferred to a plank carried like a coffin, which then moves through space according to an itinerary that reflects the specific site. The procession advances very slowly. Then Orlan rises and begins to spin, unrolling the drapery around her face and unswaddling the linen around her arms. The inside of the rag doll sometimes contains a crusty loaf colored red (blood) and blue (the colors of the draped gowns of saints and virgins in classical paintings). Orlan will then break it in two and eat it, sometimes making her choke and vomit. The unraveled fabric is transformed into a long train (or rope), pulled taut. The saint's hair is unveiled. The Madonna bares herself. The mystic body becomes living and secular once again. It begins to crawl and walk on a carpet in which it

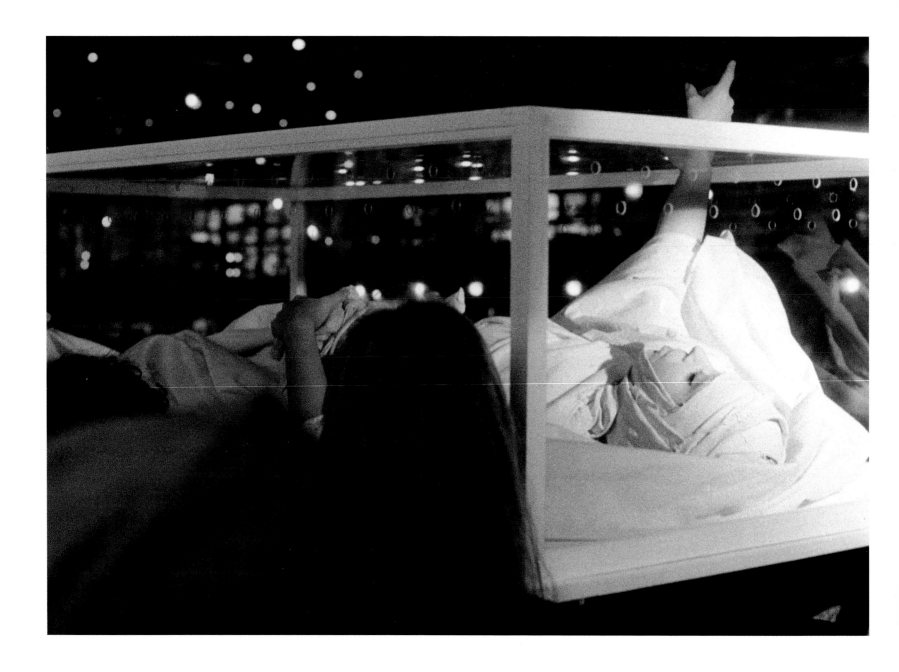

1979
Documentary Study: *Le Drapé-le Baroque*

Black and white photograph taken at the end of the procession. Multimedia performance, *XIᵉ biennale d'art contemporain de Paris*, Musée d'Art Moderne de la Ville de Paris. Photo: Georges Poncet.

wraps itself up, becoming a red ball. The audience watches, live, the demystification of this saint, who arrived in magnificent drapery reminiscent of Bernini's ecstatic statues only to turn everything into rags. Appropriating the image of this "integrated woman" is a way of measuring the power of this icon and seeing how it might be conveyed through a travesty of itself. The baring of the sacred figure is a way of *denaturing* the myth. For Orlan, this means refusing to be a mother, means insisting on being her own mother, what Eugénie Lemoine-Luccioni called "the corporeal womb of the world." Becoming her own mother means the permanent, total death of the maternal heritage along with everything stifling and asphyxiating about it.

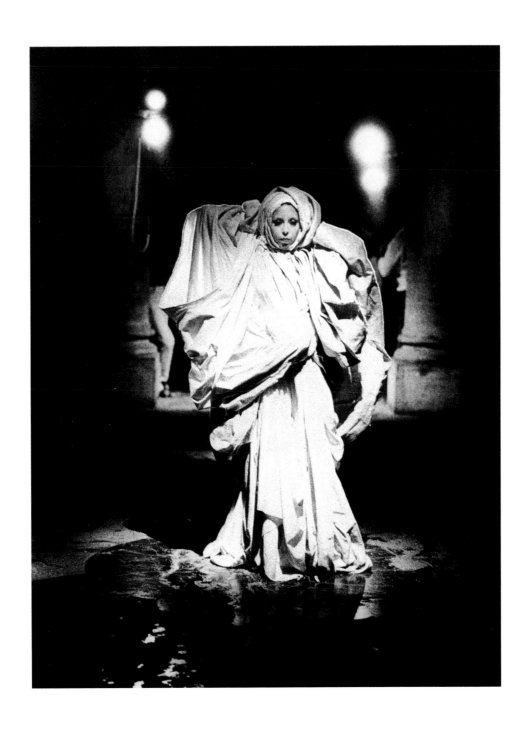

1979
Documentary Study: *Le Drapé-le Baroque*
Black and white photograph. Performance for *Rencontres internationales d'art corporel et vidéo,* Palazzo Grassi. Venice, Italy.

1979
Documentary Study: *Le Drapé-le Baroque*

Black and white photograph. Performance for *Rencontres internationales d'art corporel et vidéo*, Palazzo Grassi. Venice, Italy.

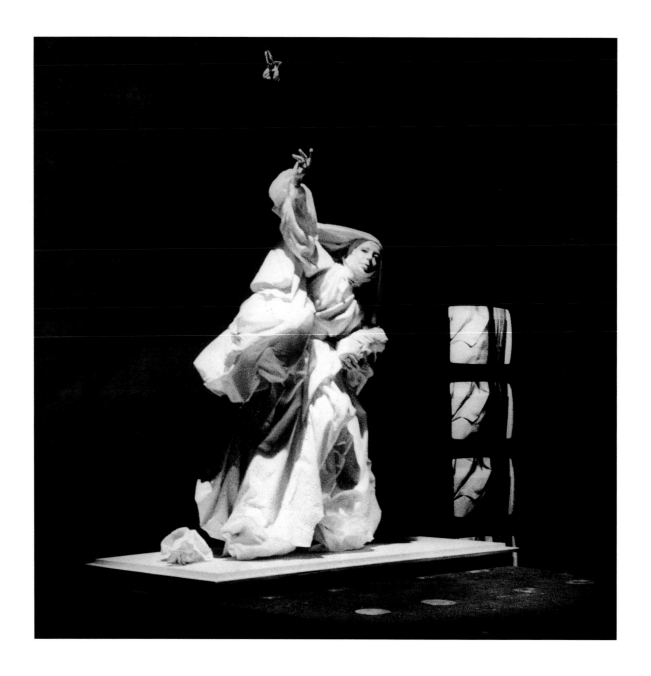

1980

Documentary Study: *Le Drapé-le Baroque*

Black and white photograph taken at the end of the procession. Multimedia performance, *XIᵉ biennale d'art contemporain de Paris*, Musée d'Art Moderne de la Ville de Paris.
Photo: Georges Poncet.

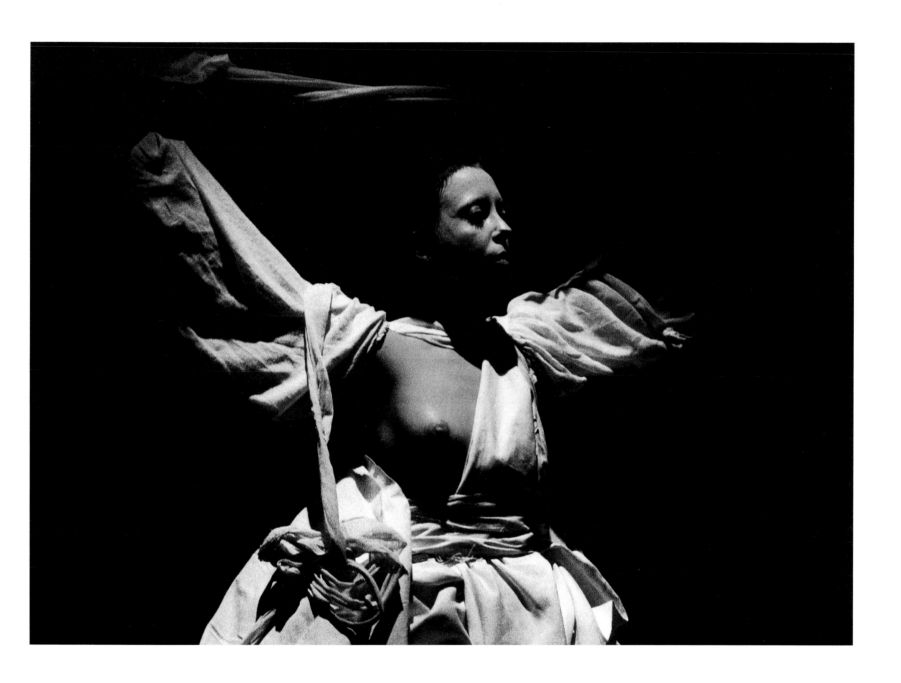

1980
Documentary Study: *Le Drapé-le Baroque*
Black and white photograph taken at the end of the procession. Multimedia performance, *XIᵉ biennale d'art contemporain de Paris*, Musée d'Art Moderne de la Ville de Paris.
Photo: Georges Poncet.

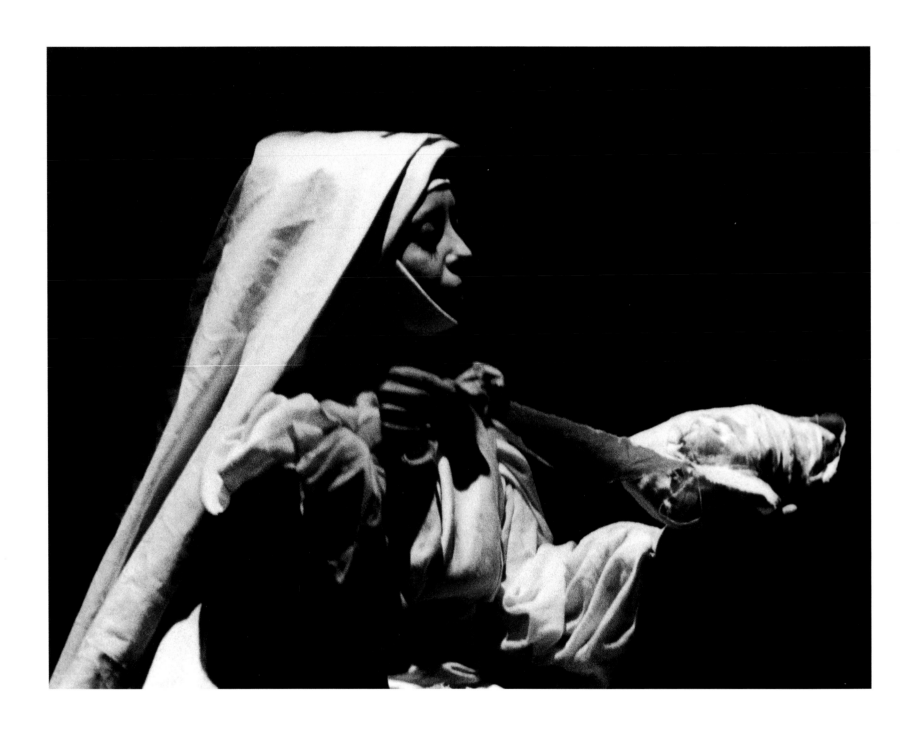

1980
Documentary Study: *Le Drapé-le Baroque*
Black and white photograph taken at the end of the procession. Multimedia performance, *XIe biennale d'art contemporain de Paris*, Musée d'Art Moderne de la Ville de Paris.
Photo: Georges Poncet.

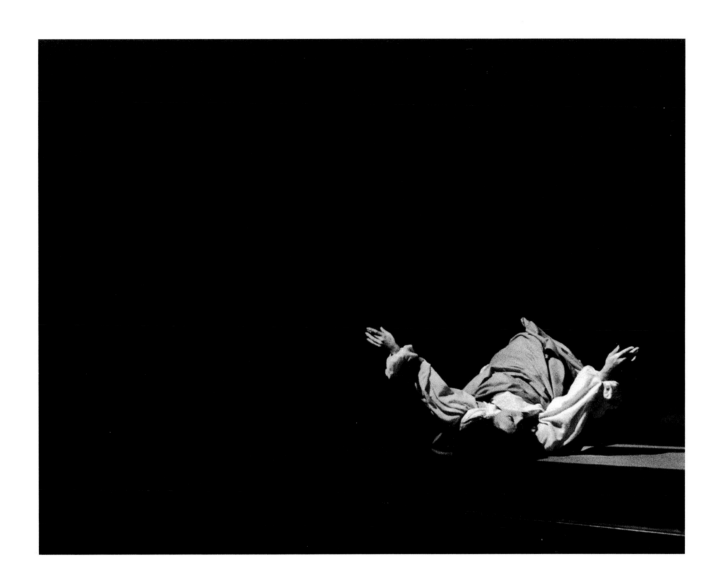

1980
Documentary Study: *Le Drapé-le Baroque*
Black and white photograph taken at the end of the procession. Multimedia performance, *XI^e biennale d'art contemporain de Paris*, Musée d'Art Moderne de la Ville de Paris.
Photo: Georges Poncet.

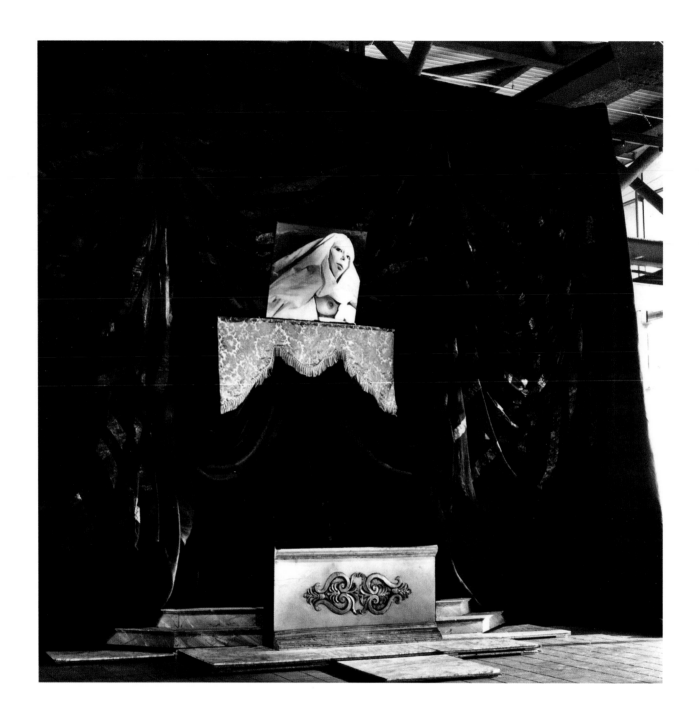

1980
Documentary Study: *Le Drapé-le Baroque. Chapelle à moi-même* (Chapel to Myself)
Black and white photograph. Installation of a chapel dedicated to Saint Orlan. Espace lyonnais d'art contemporain, Lyon.

1983
Documentary Study: *Le Drapé-le Baroque*: Single Breast, Phallic Monstrance
8 x 11 ¾ in. (20 x 30 cm) aluminum-backed black and white photography. Edition of five. Photo: Luc Wauman.

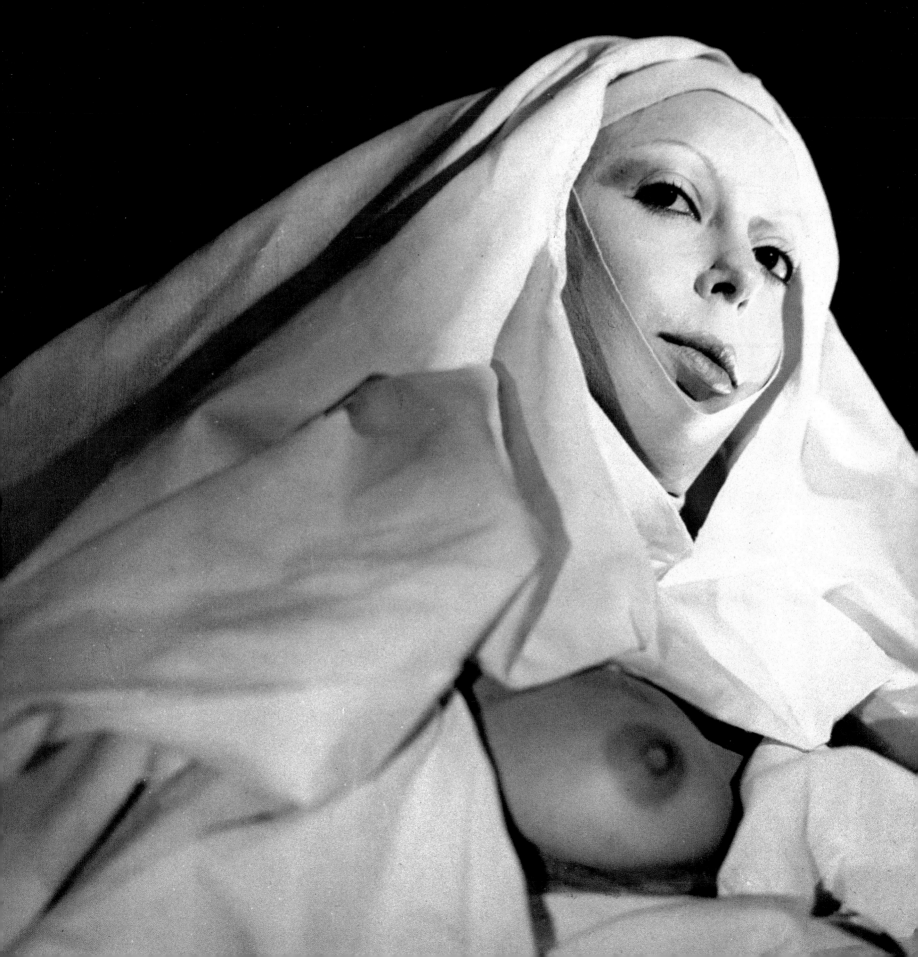

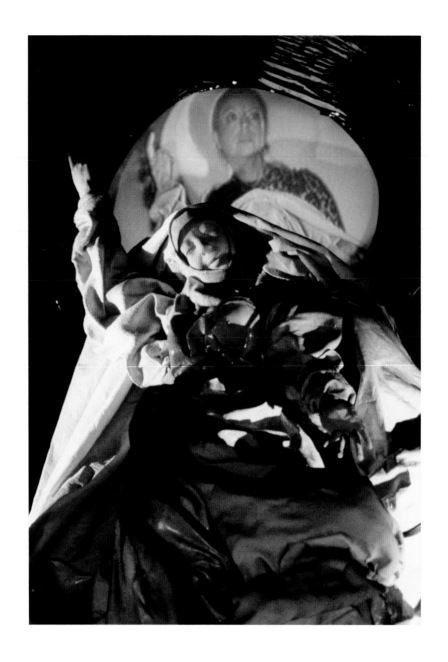

1980
Documentary Study: *Le Drapé-le Baroque. Chapelle à moi-même*

Color photograph. Multimedia installation. View of marble-like resin sculpture with video halo of Orlan's face. Espace Lyonnais d'Art Contemporain, Lyon.

La Chapelle à moi-même (mise en scène pour une sainte) is a key multimedia piece in Orlan's "Drapery and the Baroque" series. It condenses different aspects of her reflection on the Baroque into a lavish sensorial extravaganza. Mounted for the exhibition "Made in France" at the *Espace lyonnais d'art contemporain*, where Orlan showed her work on several occasions, the 105-square-foot (10-square-meter) Chapel defies easy classification. Both an installation and a site for performance, the Chapel was meant to function as an artwork in the artist's absence as well as a decor for her action. Although it was dismantled at the end of the exhibition, film,

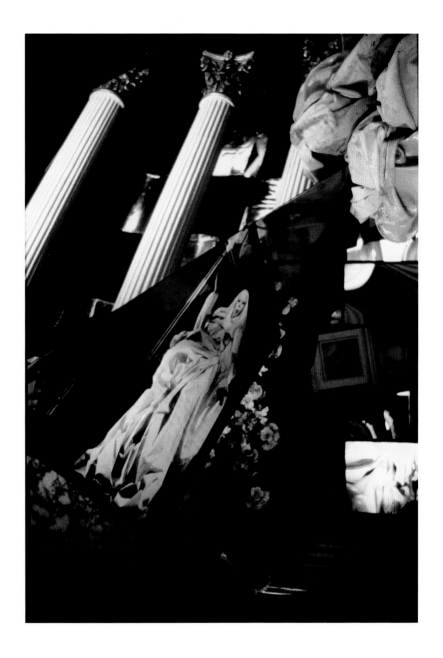

1980
Documentary Study: *Le Drapé-le Baroque. Chapelle à moi-même*
Color photograph. Multimedia installation. View of white virgin with two columns and doves, and view of space with columns.
Espace Lyonnais d'Art Contemporain, Lyon.

television, and photographic records of the space and Orlan's performances in it testify to the Chapel's visual and spatial complexity. The Chapel entrance was decorated with elaborate draped curtains and topped with the black and white photograph *Sein unique, monstration phallique* (Single Breast, Phallic Monstrance, 1979). Once inside, the visitor was confronted with a theater of the self constructed out of real, artificial, and virtual elements in two and three dimensions: a resin sculpture of Saint Orlan, a single breast revealed and her finger pointing skyward, plastic flowers mixed with lilies, a hologram representing an angel, live doves. Real and

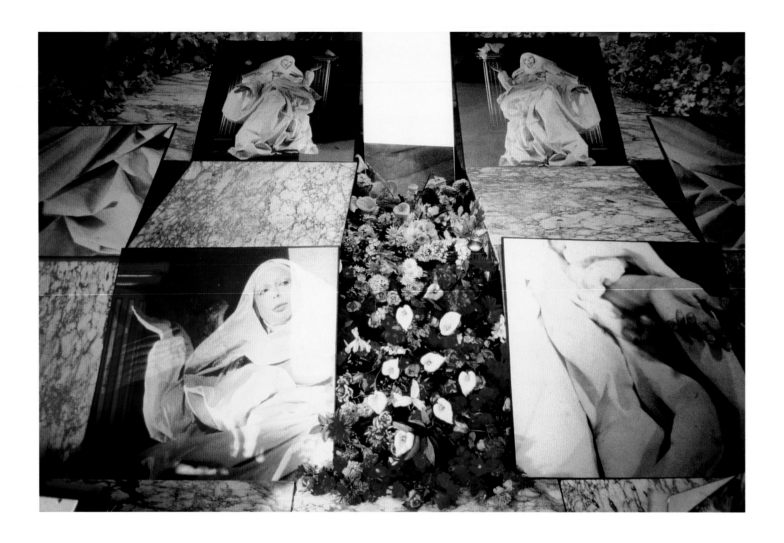

1980
Documentary Study: *Le Drapé-le Baroque*. A view of the entrance to the chapel dedicated to Saint Orlan
Color photograph. Multimedia installation. Slab of real marble, real and artificial flowers. Curated by Marie-Claude Jeune. Espace Lyonnais d'Art Contemporain, Lyon.

faux marble plaques and photographs of the artist as a Madonna were placed on the floor in front of the sculpture and a set of columns from the Lyon opera house surrounded it in a half-circle. Behind the sculpture she placed a large mirrored halo and video monitor, which showed the space and part of her sculpted face, intensifying the perspectival effect created by the combination of architectural components.

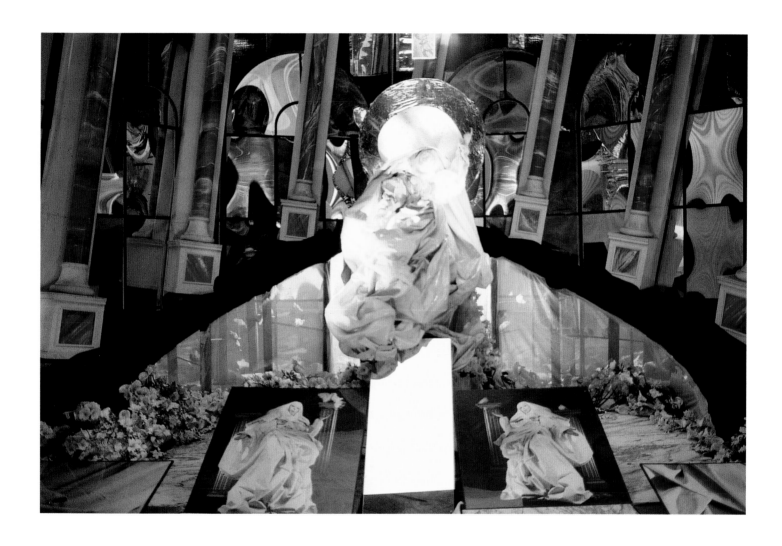

1980
Documentary Study: *Le Drapé-le Baroque*. A view of the entrance to the chapel dedicated to Saint Orlan

Color photograph. Multimedia installation. Real and imitation marble, photograph, white plastic flowers, hologram, video, resin sculpture, mirror, effect of perspective, columns, large birdcage with doves, etc. Curated by Marie-Claude Jeune. Espace Lyonnais d'Art Contemporain, Lyon.

As is frequently the case with Orlan's work, the title is enigmatic. It signifies her self-canonization, her adoption of the role of the saint, and her designation of a place for her own edification. However, the *mise en scène* implies the temporary, illusory character of this space—and of her sainthood. Many of the elements found in *La Chapelle à moi-même* will be reworked or recycled in later performances and images, most notably in the *Réincarnation de Sainte Orlan*.

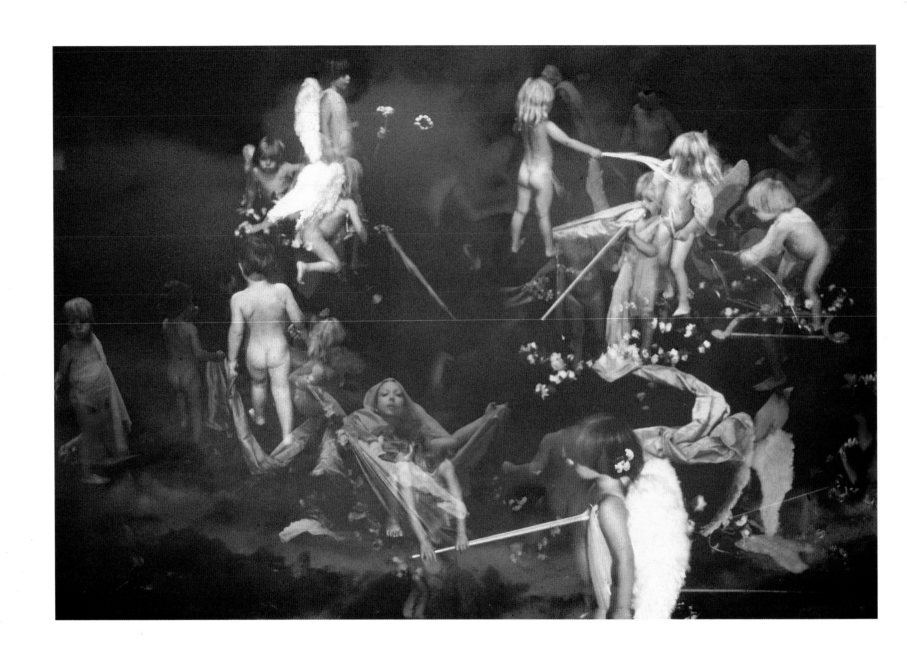

1981
Documentary Study: *Le Drapé-le Baroque*: Multiprojections for a Baroque Ceiling
Color photograph. Multimedia installation, Espace lyonnais d'art contemporain, Lyon.

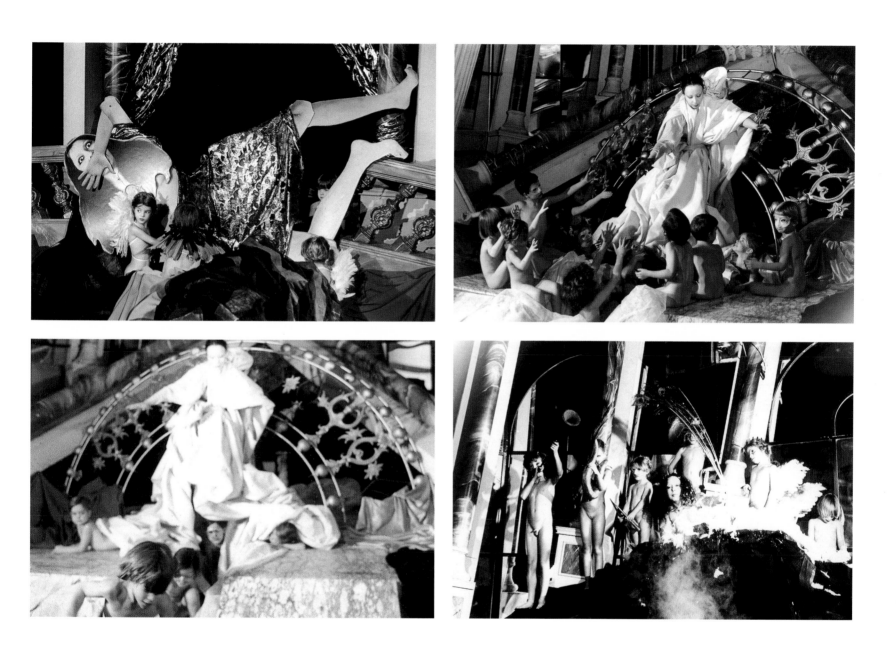

1981
Documentary Study: *Le Drapé-le Baroque*
Black and white photographs. Performance with thirty children as putti. Espace lyonnais d'art contemporain, Lyon.

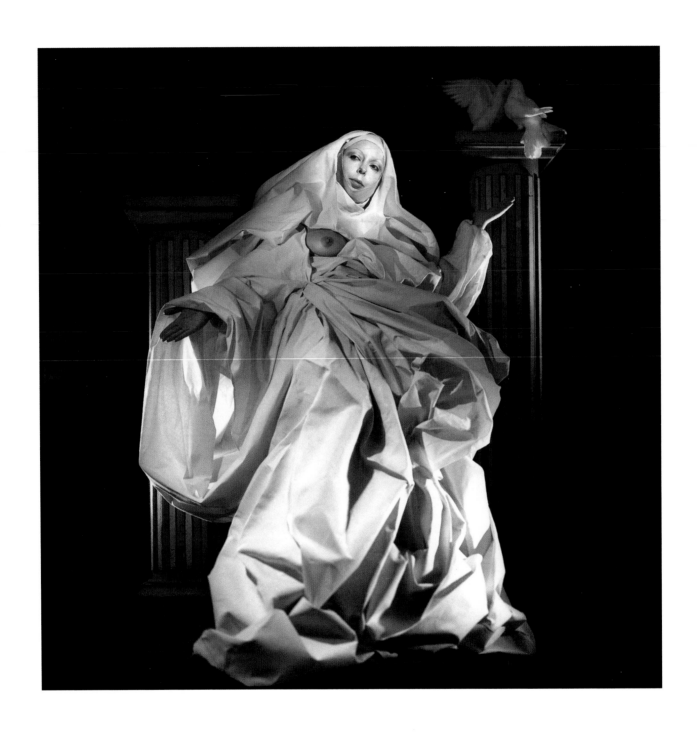

1979–1980
Documentary Study: *Le Drapé-le Baroque No. 32*, or White Virgin with Two Columns and Two Doves

39 ⅓ x 39 ⅓ in. (100 x 100 cm) aluminum-backed black and white photograph. Edition of seven. Photo: Luc Wauman.

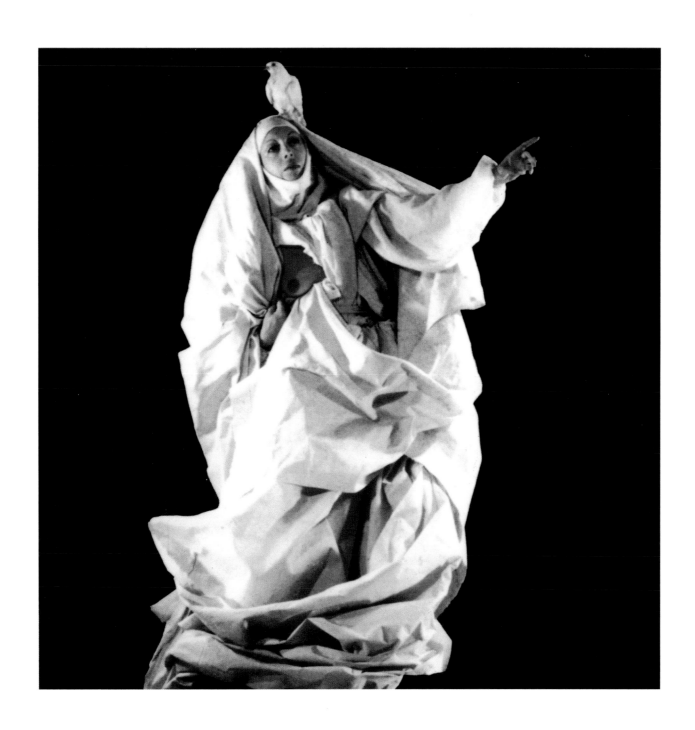

1979–1980
Documentary Study: *Le Drapé-le Baroque No. 36*, **or Sculpture of the Virgin with Dove on Head**
39 ⅓ x 39 ⅓ in. (100 x 100 cm) aluminum-backed black and white photograph. Edition of seven. Photo: Luc Wauman.

1984
Documentary Study: *Le Drapé-le Baroque*

Color photograph. Installation, church of Saint-Vorles, Châtillon-sur-Seine, France.

In contrast with the profusion of images and objects in the *Chapelle à moi-même*, Orlan's intervention in the exhibition "Ubi à Saint-Vorles" at the Romanesque church of Saint Vorles in the Burgundy region is restrained and discreet. Here, she placed images and objects in different locations in the church and on its grounds. Outside, a china plate printed with her portrait as Saint Orlan was tucked into a niche in a weathered stone fragment of the edifice. Inside, she placed a golden easel with four candelabra on an altar, and in the crypt she deposited two photographs of herself in the guise of the Black Virgin. Placed strategically on the floor in front of a sixteenth-century sculpted Entombment of Christ, the glossy surface of the photographs reflected the image of the tomb and the mourners. In the chapel to her, Orlan designed the architecture and prescribed the liturgy. In Saint Vorles, she marked out her territory by leaving traces in an already circumscribed sacred site. Orlan placed the easel, a recurring stand-in for the origins of her artistic practice in painting, on the altar as a critical commentary on the history of art's reverence for the high priests of the visual arts: painting and drawing. Her use of the Black Virgin photographs from the *Sky et Skaï* series is particularly appropriate here, as the twelfth-century Cistercian monk Saint Bernard of Clairvaux, who had much to say about the enigmas of contemplation, was schooled at Châtillon and, according to some accounts, he claimed to have been fed from the breast of a Black Virgin there.

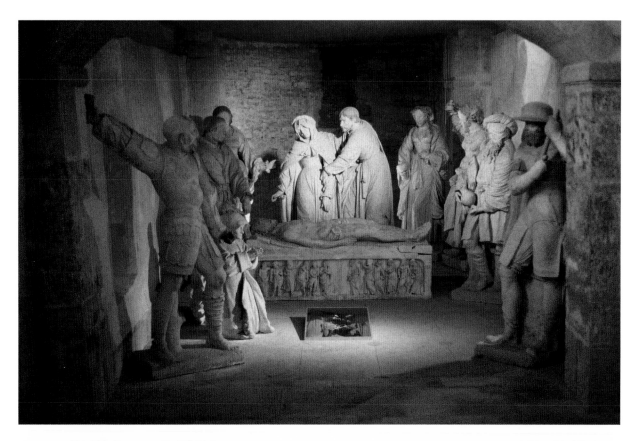

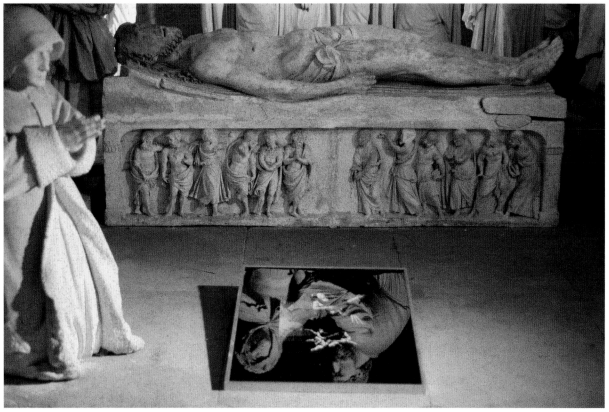

83

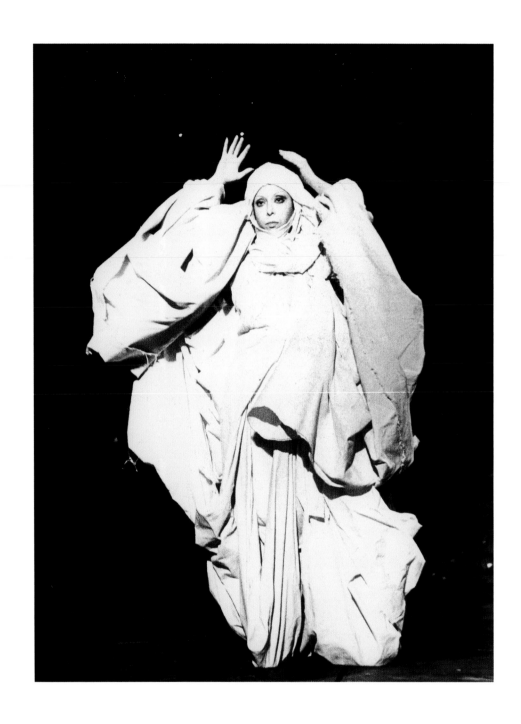

1978
Documentary Study: *Le Drapé-le Baroque No. 20*
Black and white photograph. Michel Enrici collection.

Between the mid-1970s and the mid-1980s, Orlan developed a spiritually suggestive and complex iconography with her personae Saint Orlan, the White Virgin or Madonna, and the Black Virgin, who figure as alter egos in her performances, installations, and photographs. Prolonging her investigation of feminine identity and her critique of the social and cultural pressures endured by women, Orlan's work during this period demonstrates a shift in register from that of a sexually active woman embroidering sperm stains on sheets from her trousseau, or offering kisses for cash, to that of a chaste Christian icon—a shift from the realm of profane,

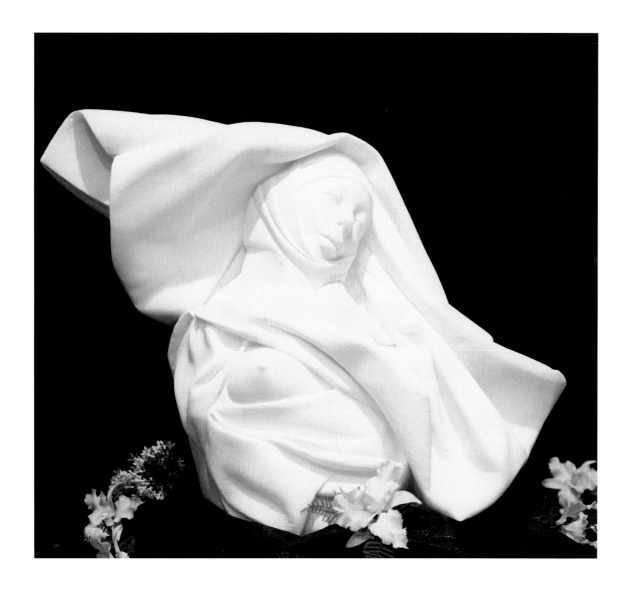

1978
Documentary Study: *Le Drapé-le Baroque*
27 ½ x 31 ½ x 17 ¾ in. (70 x 80 x 45 cm). marble bust of Orlan as Saint Orlan.

corporeal desire to a holier, disembodied love. In short, and not without irony, Orlan played the binary roles of whore and virgin (both of which are negations of the maternal) in order to deconstruct them. Raised without religious instruction, Orlan nevertheless notes the power of sacred images. And although she is aware that others might find her appropriation of religious icons a transgressive act, her interest in the Baroque aesthetic was not motivated by provocation. Rather, the Baroque offered a context for exploring how art uses imitation and artifice to solicit the senses, and provided a means for testing art's capacity to suggest what lies beneath

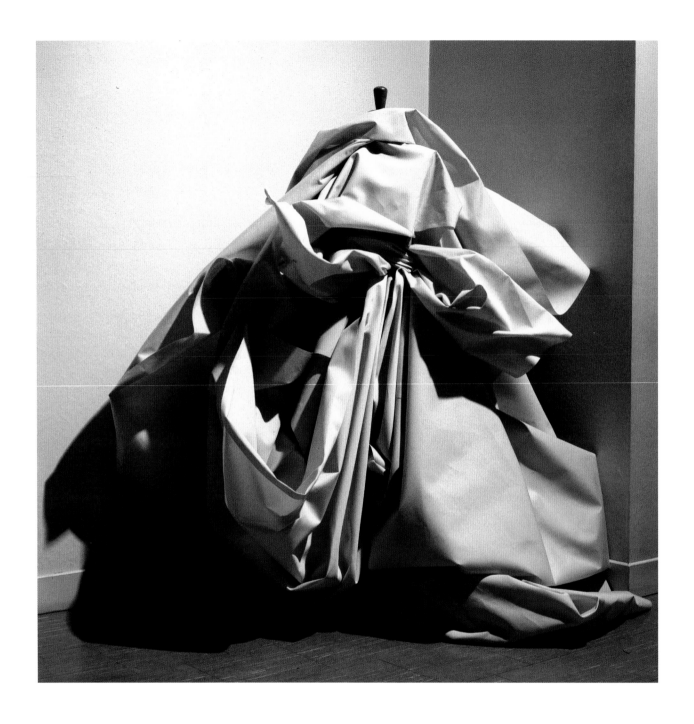

1983
Robe sans corps: Sculpture de plis No. 10 (Bodiless Garment: Fold Sculpture No. 10)

67 x 47 x 59 in. (170 x 120 x 150 cm) starched trousseau sheets. Peccolo Gallery, Livorno, Italy.

the surface of things. Declaring her admiration for Bernini's rendering of Saint Teresa of Avila's blessed ecstasy, Orlan consecrated an entire body of work to the intricate folds, textures, and forms of drapery, as they are depicted in Baroque sculpture and painting. In these studio photographs of the White Virgin, Orlan theatrically enveloped herself in robes made partially out of her starched trousseau sheets. Working the fabric and her body as one might work artistic media, she is at once a *tableau vivant* and a living sculpture. Her bare breast, hands and face are powdered pale and almost blend into the fabric. She alternately imitates the posture of a Virgin

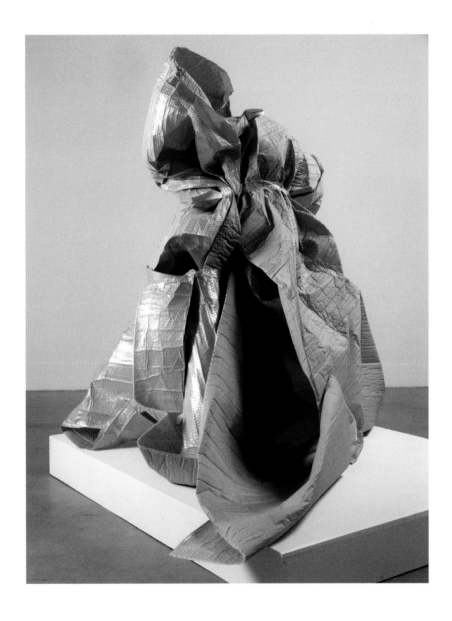

2002
Documentary Study No. 1: *Sculpture de plis* (Fold Sculpture)

67 x 67 x 67 in. (170 x 170 x 170 cm) padded Kraft paper on dummy. Produced for the *Éléments favoris* exhibition, FRAC, Pays de la Loire, Carquefou, France.

swept up in ascension against a painted blue sky or, in the exterior shots, a bride being photographed on her wedding day. The tightness of the composition and the stillness of the photographic image are counteracted by the crisp waves and folds of her skirts, which intensify the impression that her body is in motion.

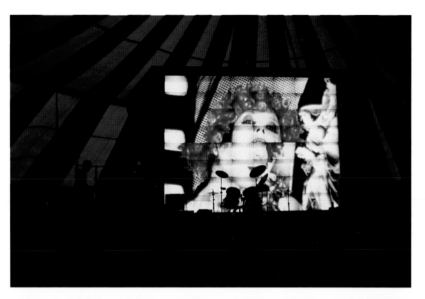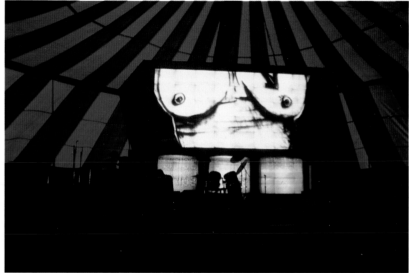

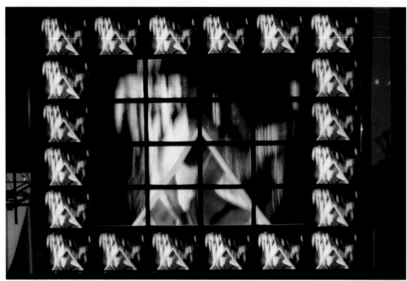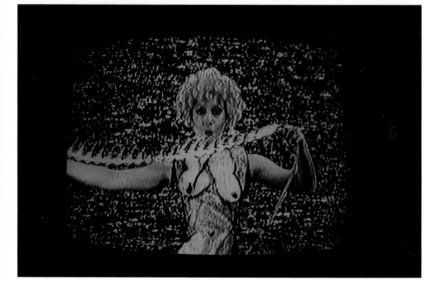

1982
Mise en scène pour un grand Fiat (Staging Her Great Fiat)
Photographs of multi-screen installation with live video-image sampling by Orlan. Circus tent, Festival d'Art Electronique, Toulouse.

Orlan mounted this large-scale video installation in a circus tent at the Albi Festival (Téchnologie du futur/futur de la culture), where along with other artists, she was invited to conceive of a multi-screen piece. According to Orlan, it was one of the first experiments of its kind in Europe. Working with the on-site technicians, artists chose samples from their pre-recorded videotapes in order to create a new "live" piece with the system. Rather than attempt to create a coherent visual structure or narrative continuity, Orlan used the opportunity to experiment with the deconstruction of her performance images and their potential meaning by enlarging certain details and minimizing others.

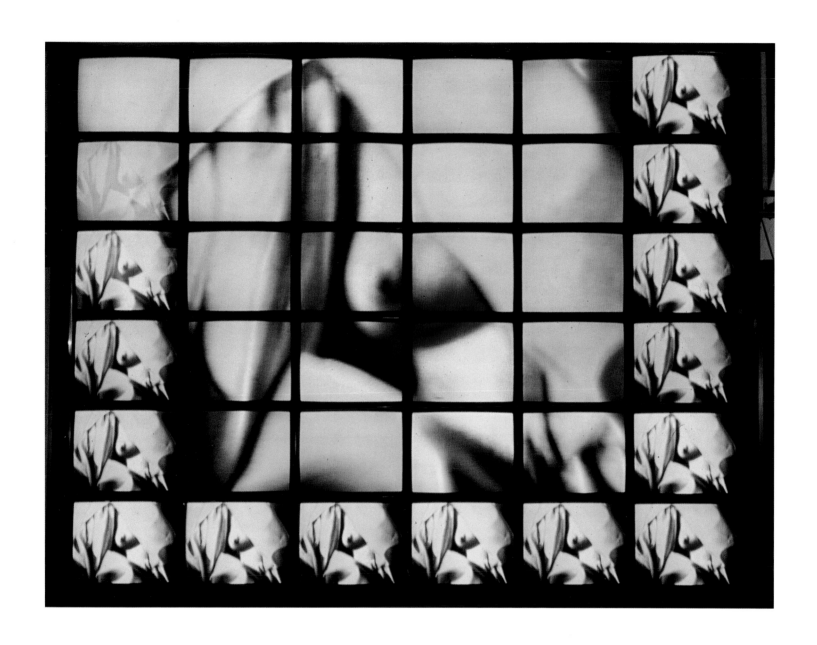

1982
Sainte Orlan et les vieillards (Saint Orlan and the Elders)
Color photograph. Video installation, multi-screen version.
Le Magasin, Grenoble.

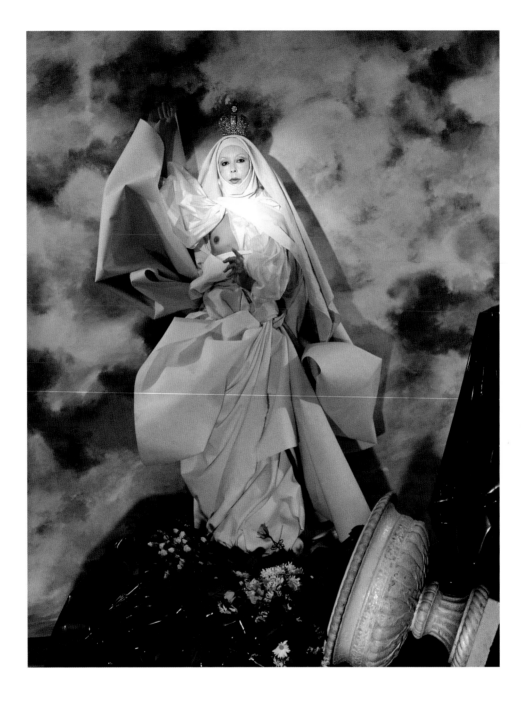

1983
Documentary Study No. 6: *Le Drapé-le Baroque* or *Sainte Orlan couronnée et travestie à l'aide des draps de son trousseau, avec fleurs et nuages* **(Saint Orlan Crowned and Costumed in Trousseau Sheets with Flowers and Clouds)**

47¼ x 63 in. (120 cm x 160 cm). Photo: Anne Garde.

Christine Buci-Glucksmann, and others, have analyzed Orlan's Baroque imagery and her work on drapery from the perspective of a "scopic impulse," present in all of the artist's work. Indeed, Orlan has qualified her production as being "situated between the madness of seeing and the impossibility of seeing," which, Buci-Glucksmann has argued, is proper to the dual nature of the Baroque. Orlan's work is organized according to a dialectical principle, which holds the pairs negative/positive, masculine/feminine, absence/presence, thesis/antithesis, haptic/optic, black/white, form/meaning, past/future, etc. in constant tension. The division between these

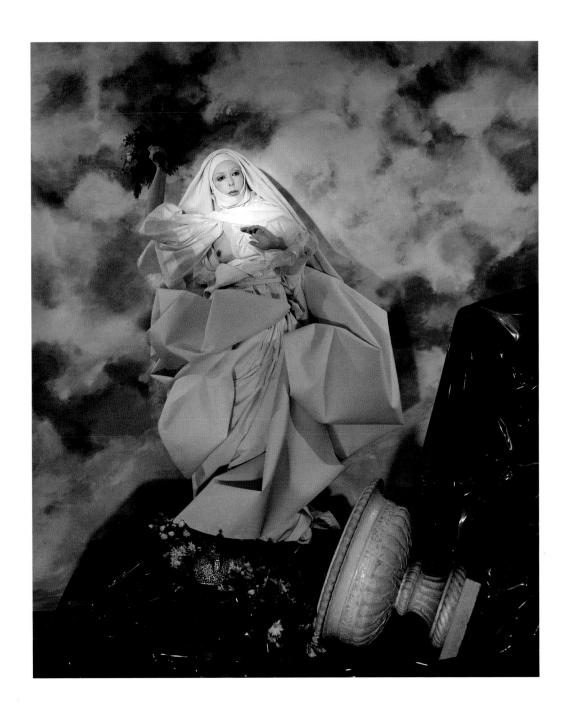

1983
Documentary Study No. 1: *Le Drapé-le Baroque,* **or** *Sainte Orlan avec fleurs sur fond de nuages* **(Saint Orlan with Flowers, Against Clouds)**
47 ¼ x 63 in. (120 cm x 160 cm) aluminum-backed Cibachrome. Photo: Anne Garde.
Fonds national d'art contemporain, Paris.

terms is not conceived of as an opposition, but as a "fold," as theorized by Gilles Deleuze in his book on Leibniz and the Baroque. For Deleuze, the fold that unfolds infinitely (in matter and in the soul) is proper to the Baroque. Knowledge resides in the fold, which is multiplicity in unity, difference within itself. In its unfolding and refolding, the fold engenders form, space, and time; it is the very image of complexity that Orlan develops throughout her work.

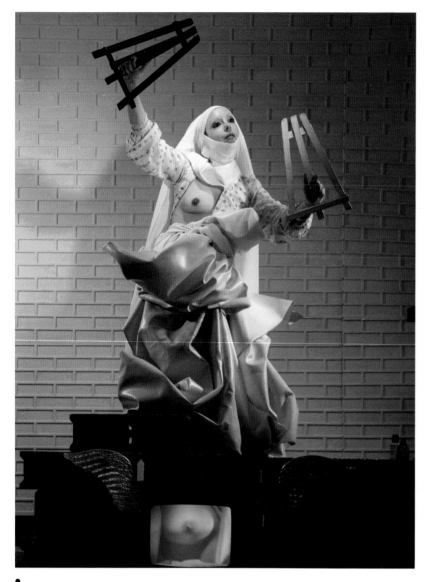 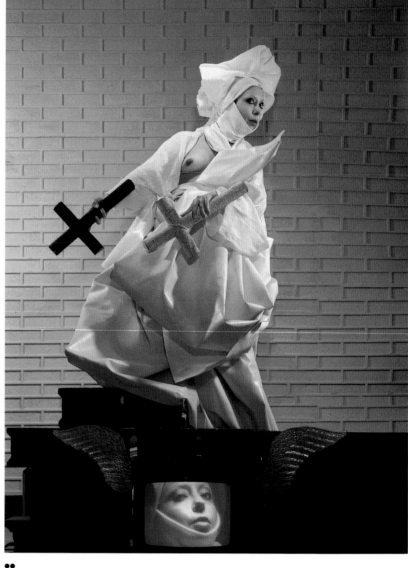

1983
Skaï and Sky et vidéo (Leather in the Sky with Video)
• White Virgin Playing with Two Easels and Projecting a Second Breast.
•• White Virgin Playing with Two Crosses and Projecting a Second Face.
••• White Virgin Against Yellow Bricks, or The Assumption of Saint Orlan on Video Monitor No. 2
•••• White Virgin Against Yellow Bricks, or The Assumption of Saint Orlan on Video Monitor No. 1
47¼ x 63 in. (120 x 160 cm) aluminum-backed cibachrome prints. Photo: Jean-Paul Lefret, Ace3P School of Photography.

Orlan produced her *Skaï and Sky et Video* series in the framework of a workshop given at the Photography School in Ivry-sur-Seine. Dressed in robes made out of white and black fabric and leatherette, which she chose for its malleability and its visual approximation to marble when photographed, Orlan mounts a pedestal of cinder

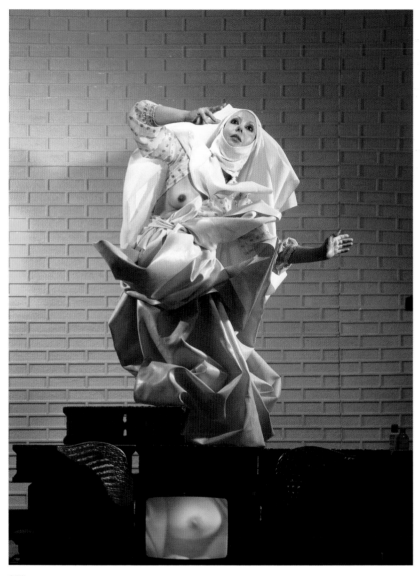

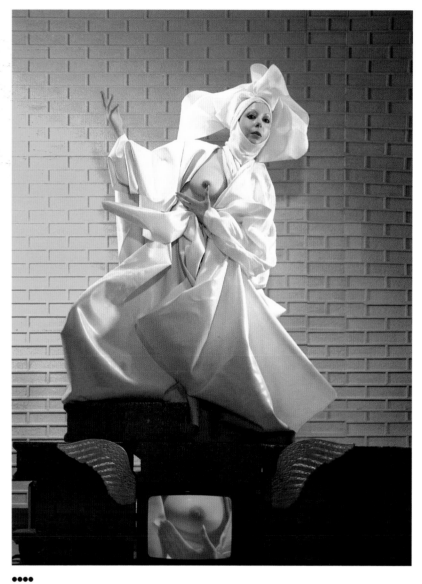

••• ••••

blocks and a video monitor to which she has attached a pair of golden wings. The video screen reproduces fragments of her body: her face, her foot, and the breast revealed by her costume. The inclusion of this "second", but same, breast eroticizes the image and counters what Orlan refers to as the *Sein unique, monstration*

93

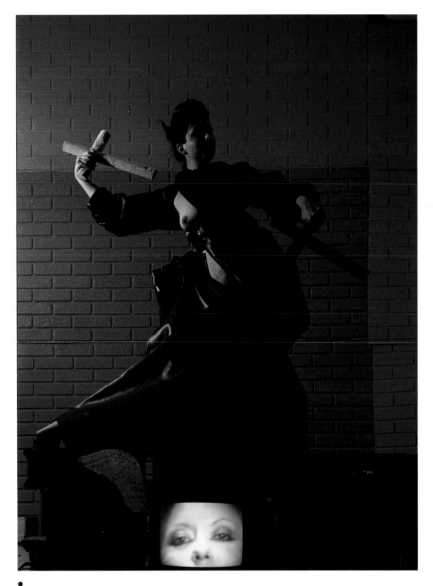

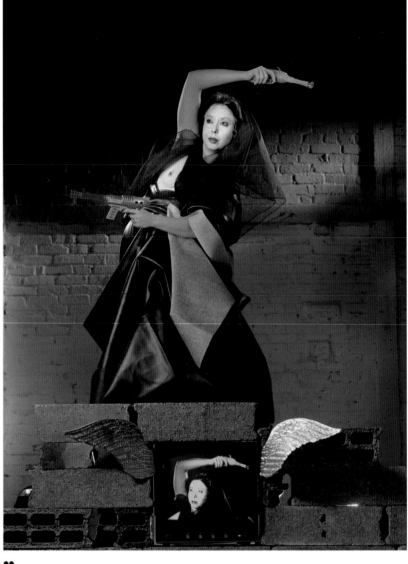

1983
Skaï and Sky et vidéo
• Black Virgin Wielding White Cross and Black Cross No. 15.
•• Assumption of Black Virgin on Video Monitor Playing with Toy Guns.
47 ¼ x 63 in. (120 x 160 cm) aluminum-backed Cibachrome prints. Photo: Jean-Paul Lefret, Ace3P School of Photography.
Fonds municipal d'art contemporain de Marseille.

phallique of the single represented breast (as in Jean Fouquet's *Virgin and Child surrounded by Angels*/Portrait of Agnès Sorel, mistress of Charles VII). In these photographs, especially in those of the Black Virgin, Orlan experiments with a new scenography, gestural syntax, and props, activating the figure and amplifying or diminishing the force of the Christian symbolism. In several, she brandishes black and white crosses—polar opposites—one held upright as if to ward off spirits and

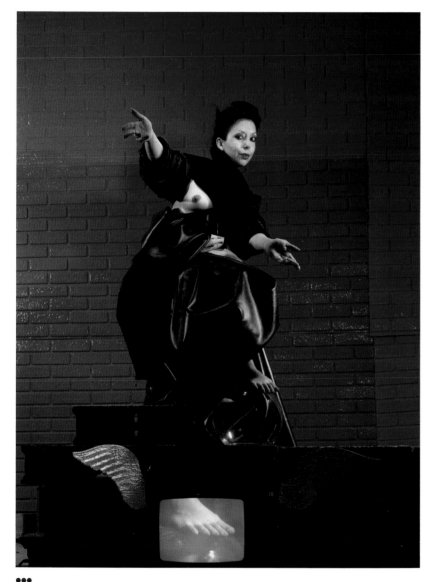

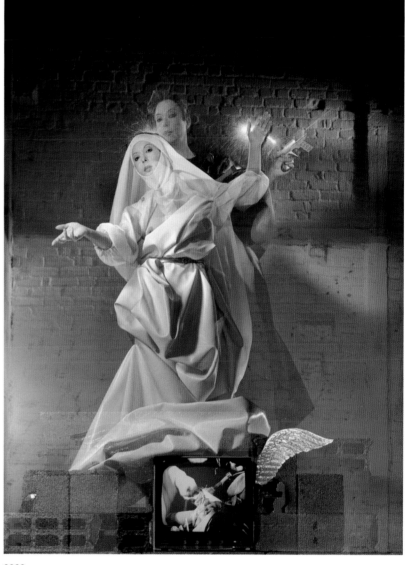

1983
Skaï and Sky et vidéo
••• Assumption of Wing-Footed Black Virgin on Video Monitor No. 9.
•••• Assumption of Black and White Virgin on Video Monitor Playing with Toy Guns.
47 ¼ x 63 in. (120 x 160 cm) aluminum-backed Cibachrome prints. Photo: Jean-Paul Lefret, Ace3P School of Photography.
Collection fonds municipal d'art contemporain; Marseille.

the other inverted, as a satanic symbol. In others, she is a spark-shooting, gun-toting, female warrior or an allegory of the arts, whether bearing easels, pretending to "read" a video-cassette, or looking at a drawing pad.

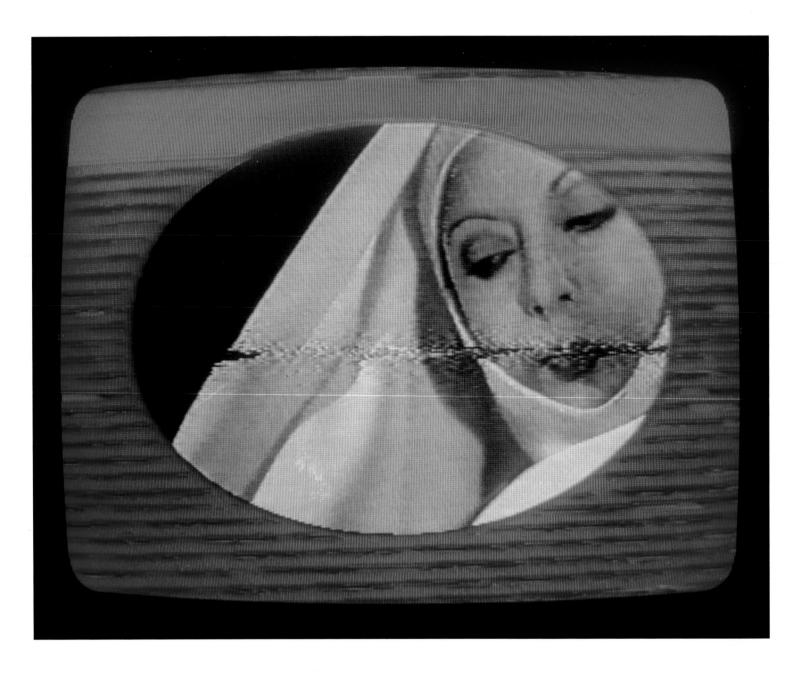

1984
Visage en sainte avec scratch (Face of Saint with Scratch)

23 ⅓ x 31 ½ in. (60 x 80 cm) photograph of the television monitor of *Sainte Orlan et les vieillards*.
Le Magasin, Grenoble.

Parallel to her investigation of the Baroque through still photography and performance, Orlan continued to experiment with video. She was invited to conduct formal research by technologically transforming iconography from the past with the GRAPH 9, the height of computer/video technology at the time. Non-narrative in structure, *Sainte Orlan et les Vieillards* nevertheless makes reference to the biblical tale of Susannah and the Elders, if only through its title. The video opens with a reproduction of an oval Assumption of the Virgin by Tiepolo, surrounded by a computer-enhanced frame. This image cedes, leaving the oval frame behind, to a continuously rolling screen on which color-synthesized bands, animated cherubs, and images of Orlan as saint and Black Virgin alternate. Cut to a full-screen image in which the "Elders" (gentlemen Orlan hired from an elder care home) strike the surprised poses of witnesses to the Assumption. As the top edge of the screen/frame descends in an inverted triangular shape—the female sex, as in *A poil sans poil* (Bare No Hair, 1978)—images of Orlan as White and Black Virgin and the detail of her

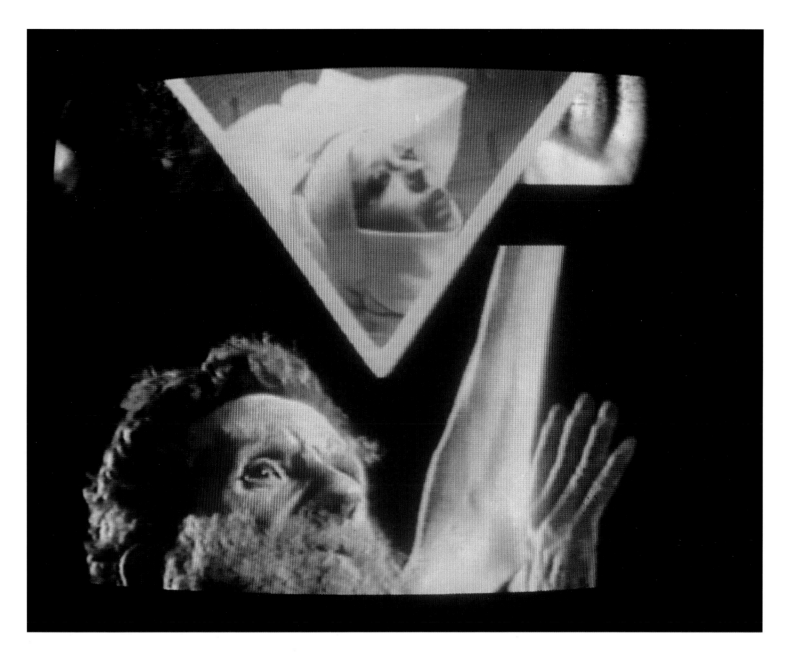

1984
Sainte Orlan et les vieillards (Face of Elder with Face of Sexual Saint Orlan)
23 ⅓ x 31 ½ in. (60 x 80 cm) color photograph of the television monitor of *Sainte Orlan et les vieillards*.

single breast spool upward while the Elders look on and gesticulate. The video ends with individual television sets lining up and taking over the screen, creating the illusion of a multiple-screen monitor (a reference to the *Video Screens* piece shown in Albi in 1982) before going black. Sacred music from a badly scratched record album by an unknown singer and static sound interference play throughout. In fact, it was the music, which Orlan purchased at a flea market, that inspired *Sainte Orlan et les vieillards*. The progressive loss of the voice on the record was equivalent to the inevitable, progressive loss of the images taped on to video. For Orlan, the Elders became the embodiment of this artistic loss.

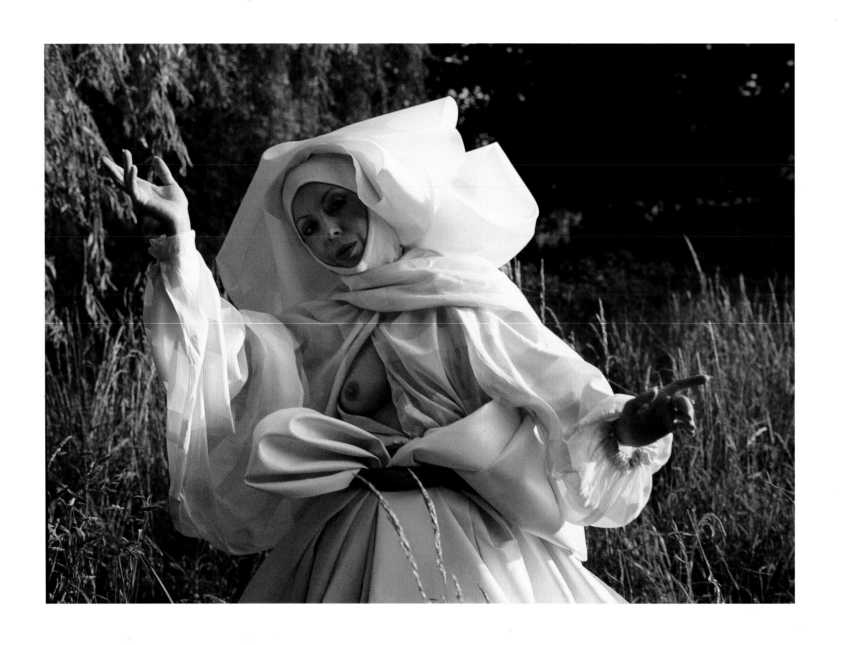

1986
Documentary Study No. 30: *Le Drapé-le Baroque* (*A Licentious Saint Orlan Playing at Liaisons Dangereuses*)
43 ⅓ x 65 in. (110 x 165 cm) cibachrome. Edition of three.

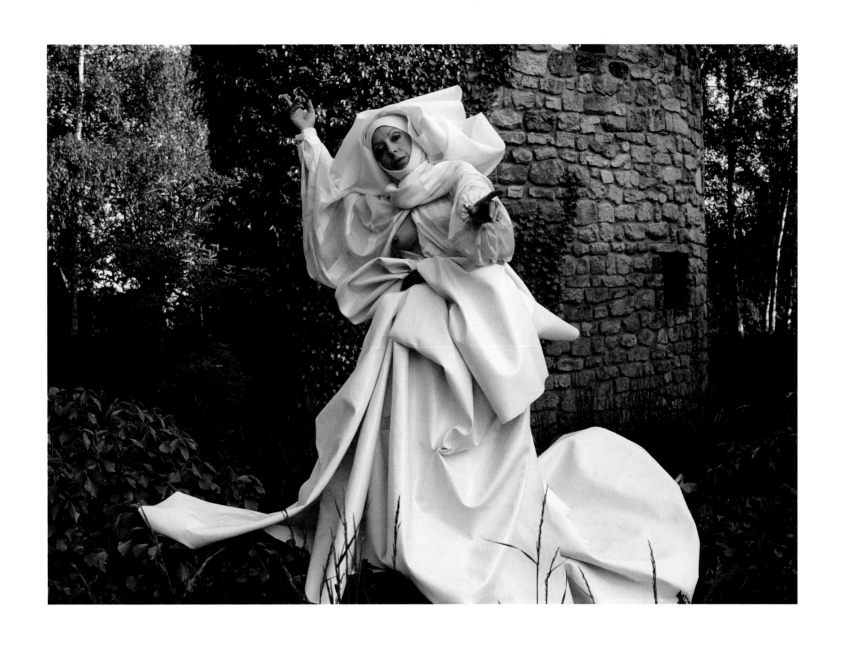

1986
Documentary Study No. 28: *Le Drapé-le Baroque* (A Licentious Saint Orlan Playing at Wedding Pictures)
43 ⅓ x 65 in. (110 x 165 cm) cibachrome. Edition of three.

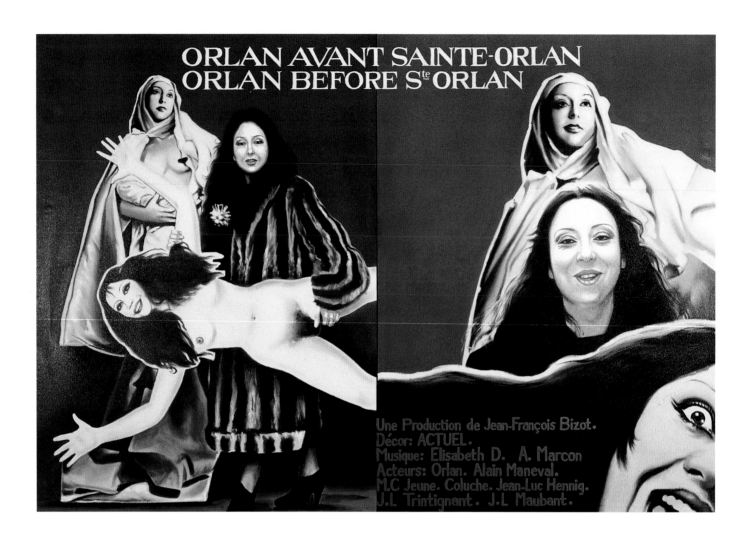

1988
Les affiches peintes (Painted Posters): Imaginary credits for *Orlan before Saint Orlan*

118 x 78 ¾ in. (300 x 200 cm) acrylic on stretched canvas. Painted by Publidécor.

These works represent an important watershed in Orlan's artistic career, a new type of recapitulation. The large—six feet by nine—advertising posters for imaginary movies, executed in acrylic on canvas, put an original "twist" on the Orlan story, one that she described as "a screen on which [her] truth came to light" (Bernard Ceysson, "ORLAN, l'Ultime Chef-d'Oeuvre," *Les Vingt Ans de pub et de ciné de Sainte Orlan*, Hérouville-Saint-Clair 1990, p. 8). In Orlan's case, however, the screen itself serves as a support for the development of an obvious fiction. But is it painted or not? Painted, yes, but not by the artist's hand. Inspired by posters for Bollywood movies, Orlan called on the services of an ad agency, Publidécor, to portray her artistic career on film "posters" based on photographs from her archives. Each poster

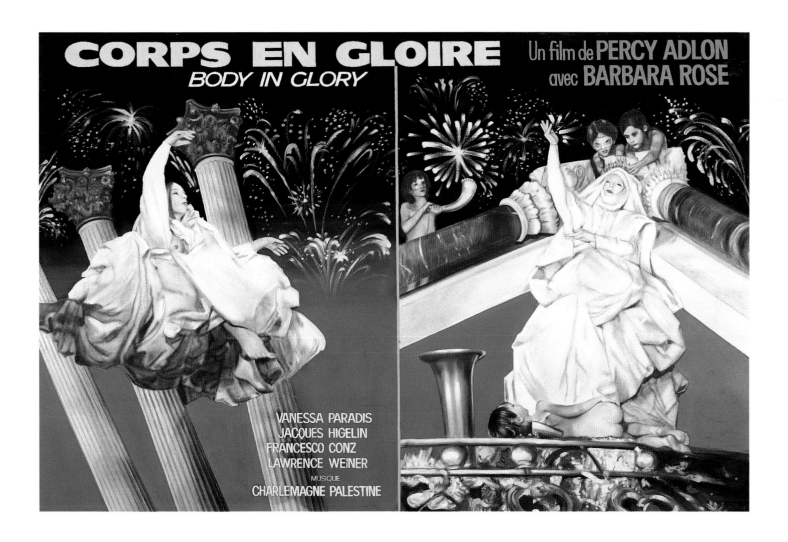

1988
Les affiches peintes : Corps en Gloire (Painted Posters: Body in Glory)
118 x 78 ¾ in. (300 x 200 cm) acrylic on stretched canvas. Painted by Publidécor.

bears a title—*Orlan Before Saint Orlan, Art Makes Your Mouth Water, Saint Orlan Blesses Cult Objects* (Episodes 1 and 2), *Body in Glory*, etc.—with credits made up from the names of her friends and well-known figures from the world of art and movies, notably Jean-Christophe Bouvet who allegedly plays Satan (a role he really played in Maurice Pialat's *Sous le Soleil de Satan*) and who actually served as Orlan's model for *Origine de la guerre* (Origin of War). Orlan herself also features in her imaginary films. The series unfolded in a more or less chronological order, and the images were reproduced with great clarity, yet the whole undertaking was completely based on artifice: the posters for Orlan's film exist, the images they employ exist, but the films that allegedly recount the story of Orlan's life remain pure invention.

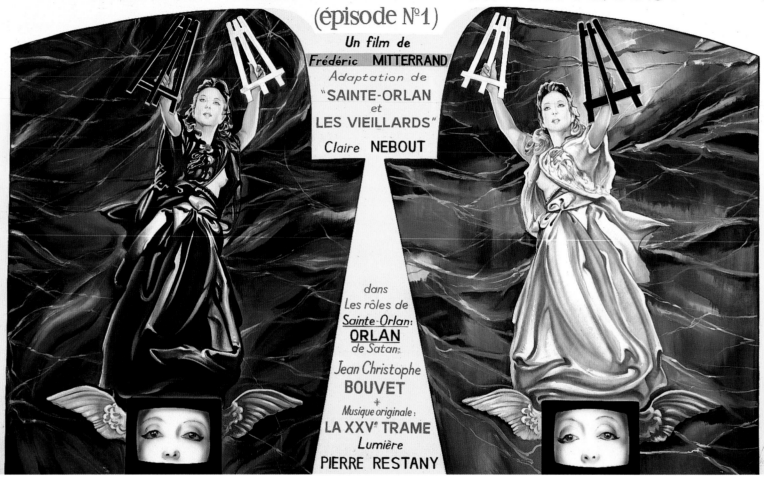

1988

Les affiches peintes: Imaginary credits for *Saint Orlan and Cult Objects No. 1*

118 x 78 ¾ in. (300 x 200 cm) acrylic on stretched canvas. Painted by Publimode.

The works collectively labeled *Vingt ans de pub et de ciné de Sainte Orlan* (Twenty Years of Advertising and Movies by Saint Orlan) represent a formal break with her performances and photography, yet she never abandoned those fields even while producing her "posters." Nor would she abandon the posters—they can be seen in the operating theater of *La réincarnation de Sainte Orlan* (The Reincarnation of Saint Orlan), and they form the very basis of a later,

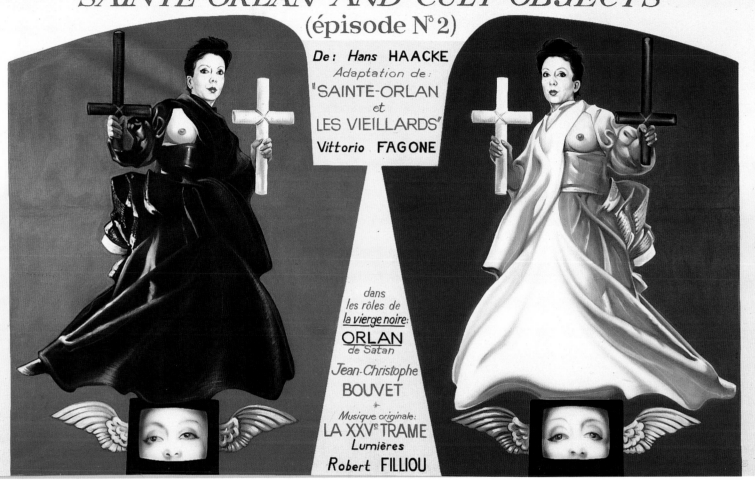

1988

Les affiches peintes: Imaginary credits for *Saint Orlan Blesses Cult Objects No. 2*

118 x 78 ¾ in. (300 x 200 cm) acrylic on stretched canvas. Painted by Publimode.

ongoing series, *Le Plan du film* (A Shot at a Movie). As representations of representations, these works constitute a sophisticated type of self-reflexiveness, based on Orlan's propensity for quoting herself, for concocting her characters, and for blurring the boundaries between original and copy.

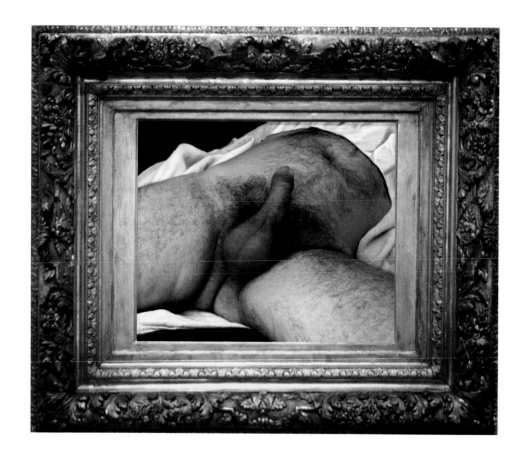

1989
Origine de la guerre (Origin of War)

34 ²/₃ x 41 ¹/₃ in. (88 x 105 cm) aluminum-backed Cibachrome. Edition of eight plus two artist's proofs. Photo: Georges Merguerditchian.
Vincent Grégoire collection.

Orlan's concern with the mechanics of desire and sexuality is evident in works like the *Baiser de l'artiste* (Kiss the Artist) or the *Draps du trousseau* (Sheets from the Trousseau). Given her criticism of standards that perpetuate women as reproductive vessels in *Face à une société de mères et de marchands* (Faced with a Society of Mothers and Dealers, 1976), and her performance *Étude documentaire: La tête de méduse* (Documentary Study: Medusa's Head, 1978), in which she confronted the spectator with a magnified image of her vulva, it seems almost inevitable that Gustave Courbet's *Origin of the World* (1886) would eventually figure in her work. The story behind Courbet's explicit depiction of female genitalia is now well known. Purchased by the Turkish collector Khalil Bey, who apparently kept this object of male pleasure hidden behind a curtain in his bathroom, the *Origin of the World* eventually found its way into the hands of Sylvia Bataille and Jacques Lacan. The couple kept the painting at their country house in Guitrancourt, displaying it behind a set of wooden doors (which hinted at the contents) painted by Lacan's brother-in-law André Masson. In 1995, the painting was given to the Musée d'Orsay where it hangs unobstructed in a sumptuous gold frame. Orlan's reproduction is faithful in format, color, and tone; the drapery is accurately copied and the work appears to be framed like the original (the frame is a photographic illusion). However, she has replaced the truncated female body with the photo-montaged fragment of a man (actor Jean Christophe Bouvet) with his erect penis exposed. Just as Orlan was commenting on Freud's notorious equation of the vagina with the Medusa head in her earlier performance, it is difficult to divorce her *Origine de la Guerre* from Lacan's analytical concept of the phallus as a signifier of desire. However, here, the erect penis/phallus is meant to evoke sovereign power and virility. For Orlan, as the title indicates, the male organ is not only at the origin of the war between the sexes, but is a progenitor of a more generalized violence.

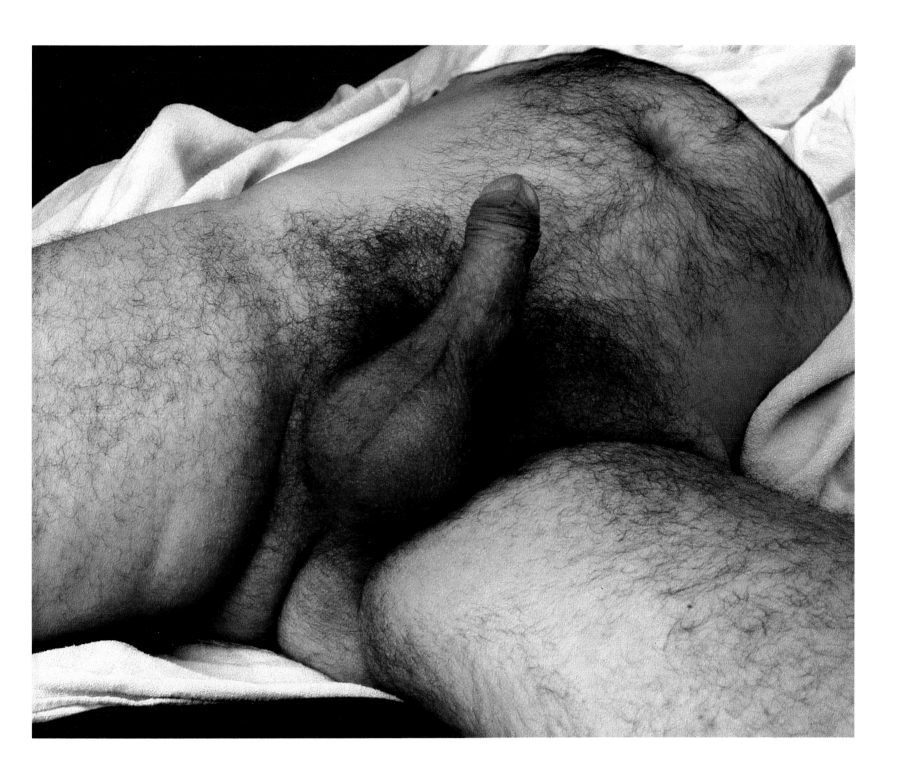

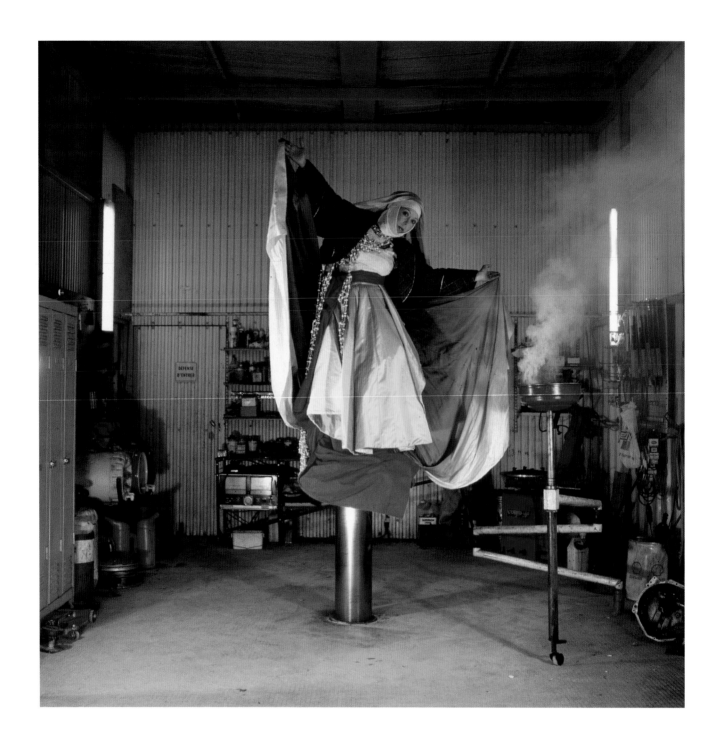

1990
Madone au garage en assomption sur vérin pneumatique (Assumption of Madonna of the Garage on Pneumatic Jack)

47 ¼ x 47 ¼ in. (120 x 120 cm) cibachrome. Edition of three. Photo: Pascal Victor. Musée Départemental d'Art Ancien et Contemporain, Épinal, France.

Orlan frequently uses humor to mark a shift in register in her work; it allows her to take a step back before making her next move. In the final images of the *Sainte Orlan* series, the *Madonna of the Garage,* she abandoned the photo studio for the mechanic's workshop, thus transgressing the spaces of representation that she had so carefully orchestrated and framed in her *Le Drapé et le Baroque* and *Skaï and Sky* photographs. Familiar gestures and poses are playfully diverted in this

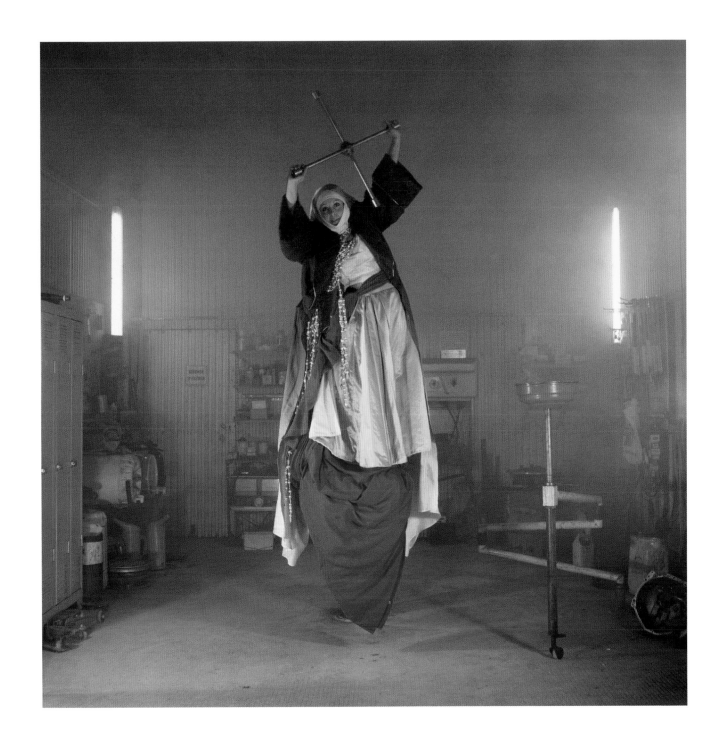

1990

Madone au démonte-pneu, en assomption sur vérin pneumatique (Assumption of Madonna with Tire Iron on Pneumatic Jack)

47 ¼ x 47 ¼ in. (120 x 120 cm) cibachrome. Edition of three. Photo: Pascal Victor.

"profane" working-class context. Adopting a new, carnivalesque persona, costumed in cheap, colorful robes, Orlan self-mockingly feigns her own Assumption by mounting the pneumatic lift. "Repaired" by her curator, she brandishes the cross-shaped tire iron, and eventually disappears behind the smokescreen of the Holy Spirit.

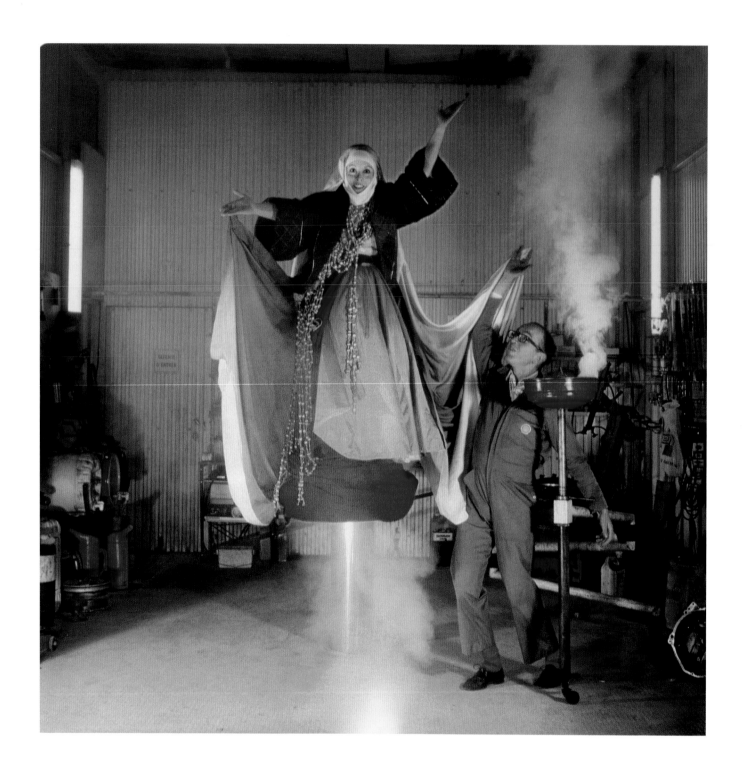

1990
Madone au garage réparée par son commissaire même avec clé de 12 (Madonna of the Garage Repaired by Her Own Curator with 12 mm Wrench)

47 ¼ x 47 ¼ in. (120 x 120 cm) cibachrome. Edition of three. Joël Savary in the role of curator. Photo: Pascal Victor.

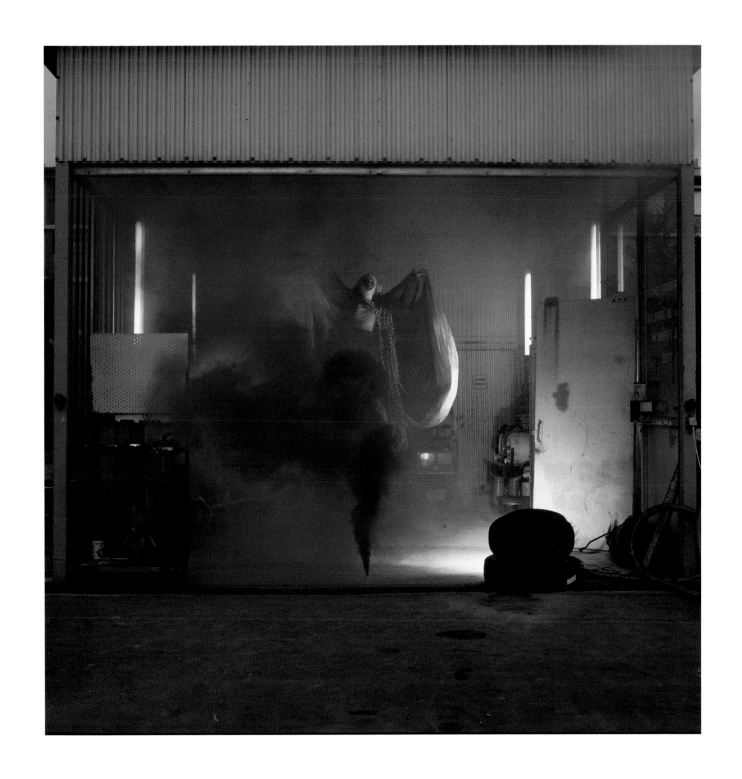

1990
Sainte Orlan au garage disparaît au final dans un vent paraclet (Saint Orlan of the Garage Finally Wafted Away by the Paraclete)
47 ¼ x 47 ¼ in. (120 x 120 cm) cibachrome. Edition of three. Photo: Pascal Victor.

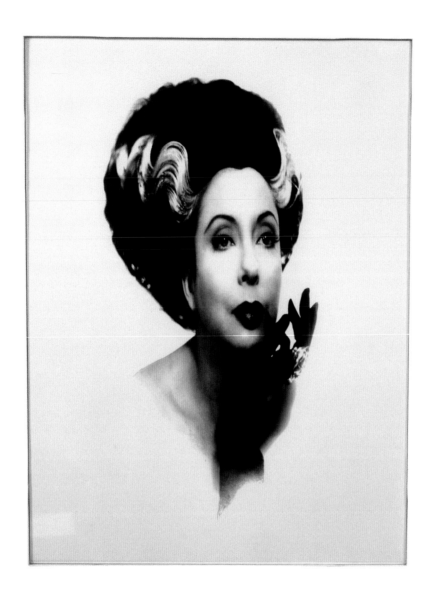

1990
La Fiancée numérique de Frankenstein (The Digital Bride of Frankenstein): Official Portrait with Bride of Frankenstein Wig and Rectifying Insert No. 5

23 ²/₃ x 35 ½ in. (60 x 90 cm), insert 2 x 2 ¾ in. (5 x 7 cm). Photo: Fabrice Lévêque. Print: Bruno Scotti.

This "official" portrait of Orlan was taken between her third and fourth plastic surgery performance. She vamps for the camera: her tastefully made-up face is exquisitely poised on her elegant gloved and jeweled hand as she artfully gazes into the distance. Her bride of Frankenstein wig, immortalized by Elsa Lanchester in James Whale's 1935 film, is a comic touch, poking fun at her critics' outrage over her "monstrous" use of her own body for art's sake. Whale's sequel to *Frankenstein*

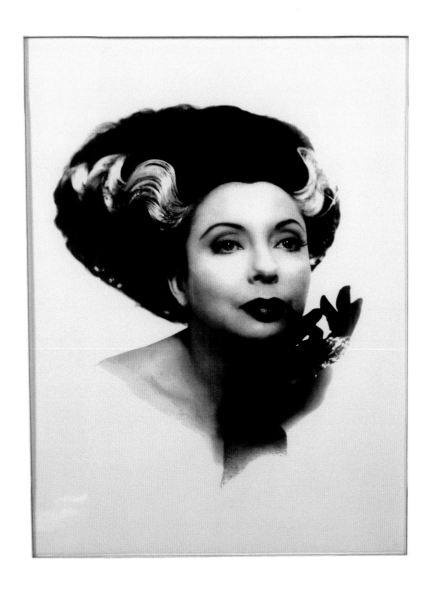

1990
La Fiancée numérique de Frankenstein: **Official Portrait with Bride of Frankenstein Wig and Rectifying Insert No. 8**

23 ²/₃ x 35 ½ in. (60 x 90 cm), insert 2 x 2 ¾ in. (5 x 7 cm). Photo: Fabrice Lévêque. Print: Bruno Scotti.

(subtitled *The Monster Demands a Mate!*) has been interpreted as a moral lesson to those who seek to play God, but also as an attack on standard sex roles and family values, which are themes Orlan has treated throughout her artistic career.

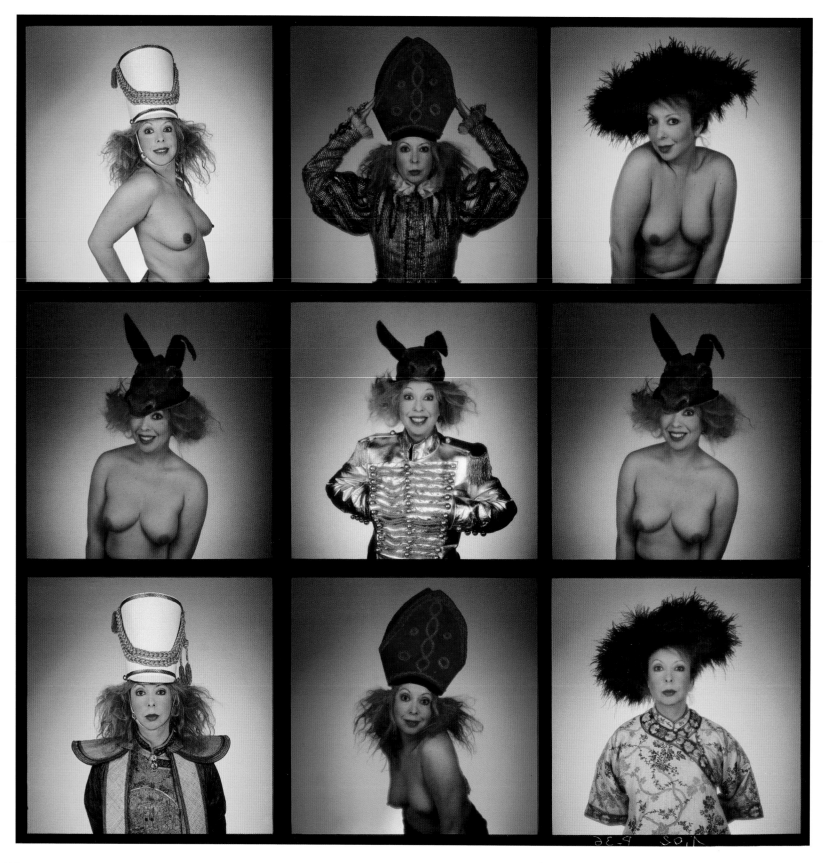

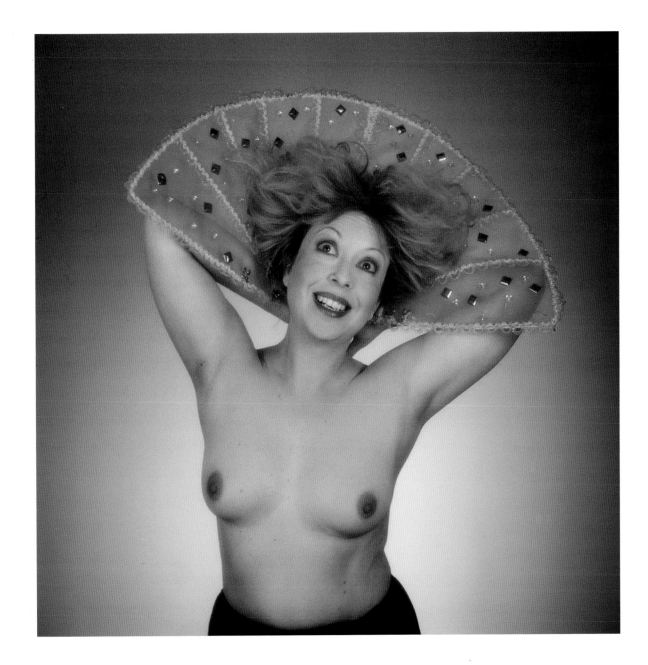

1990
Peau d'âne (Donkey Skin)

Facing page: *Pour échapper au territoire du père, il faut changer de peau* (You Have to Change Skins to Escape Your Father's Domain)
Above: *Peau d'âne aux anges No. 16* (Donkey Skin in Seventh Heaven)
Color photographs.

In the *Peau d'âne* photographs, which were taken prior to her plastic surgery works (*La Réincarnation de Sainte Orlan*), Orlan dons hats and costumes and preens for the camera with a touch of self-parody. However, the title alludes to a deeper meaning behind the comic masquerade. In Charles Perrault's fairy tale *Peau d'âne* (made into a film in 1971, directed by Jacques Demy and with Catherine Deneuve in the heroine's role), the princess eventually finds her prince, but only after escaping her father's incestuous lust by disguising herself in the putrid skin of his slaughtered prized donkey. The donkey, so valued because he excreted gold, was sacrificed by the King as proof of his (unlawful) love for his daughter. The princess *Peau d'âne*'s virtue and lack of vanity—emblematized by her willingness to take on another skin—enable her to flee from the desirous gaze of the father, thus freeing her from the oedipal bond that ties them. In 1990, Orlan had long abandoned her father's name, and she would soon undertake the surgical transformation of her own body.

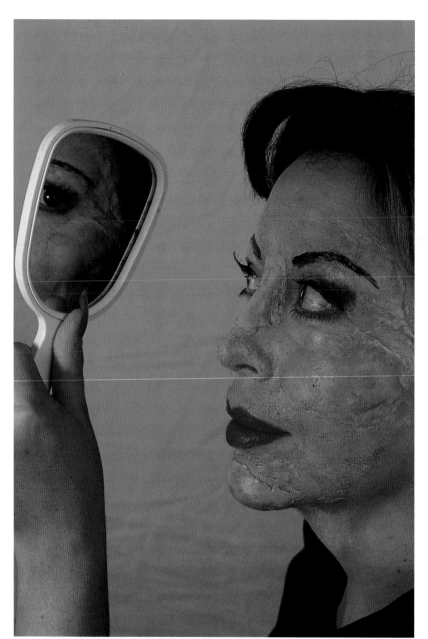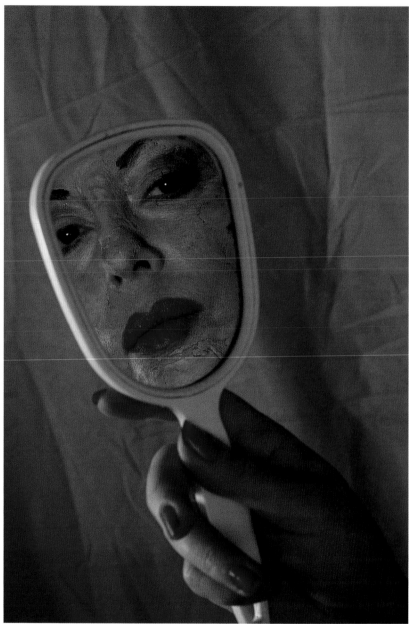

1993
Question de miroir (A Question of Mirrors): Sight of an Eye / Solo Reflection in Hand / A Question of Skin / Swinging Reflection
23 ²/₃ x 31 ½ in. (60 x 80 cm) light box.
Fiorella Lattuada collection.

Orlan plays with notions of vanity and narcissism in the "Woman before a Mirror" series, a theme commonly treated in the history of art. Taken prior to her surgery performance *Omnipresence*, in which kidney-shaped silicone implants, normally destined for cheek-bones, were inserted under the skin of her temples, these photographs show the result of one of Orlan's make-up sessions. Instead of using cosmetics in order to beautify herself, she covered her face with a flesh-colored putty-like substance, simultaneously disfiguring and remolding it. These photographs are considered preludes to her digitally produced *Self-Hybridizations*.

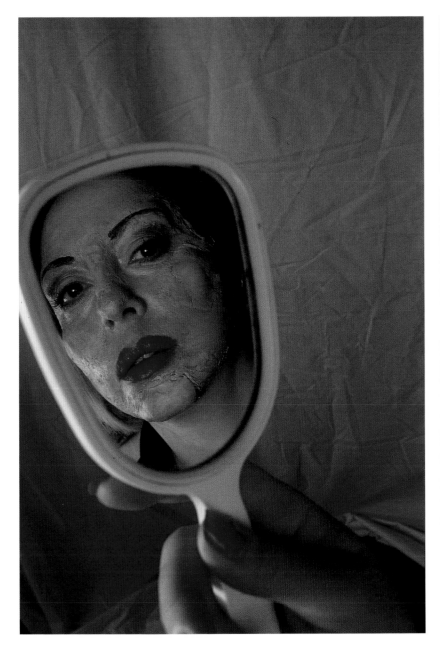
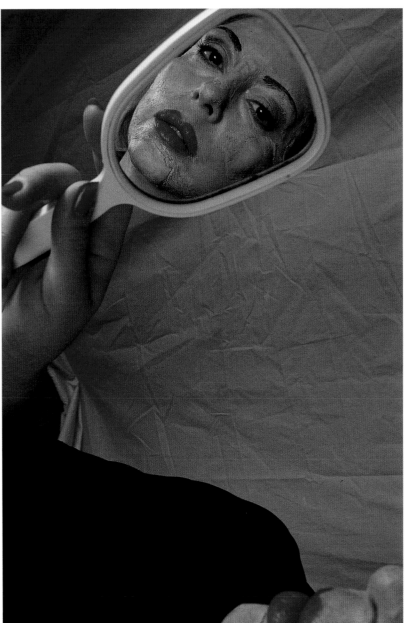

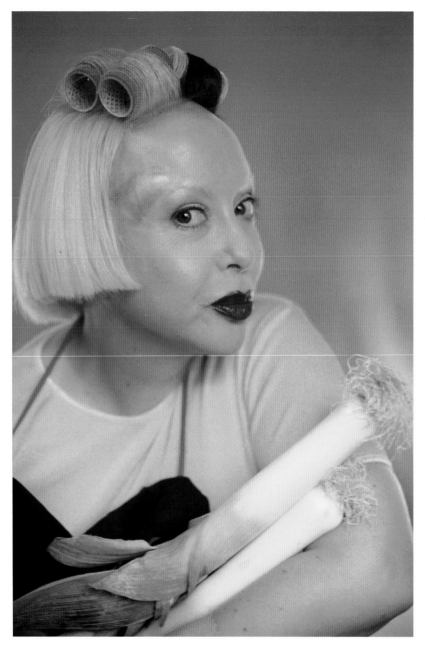 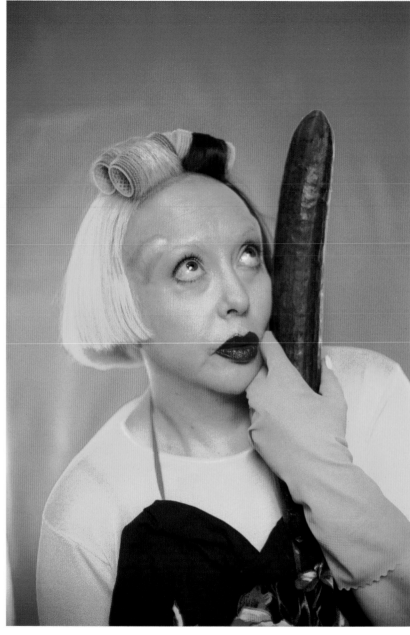

• ••

1998
La femme qui rit (The Laughing Woman)
• Oh, the Cute Little Leek! How Pretty!
• God How I Like Big Vegetables!

39 ⅓ x 41 ⅓ in. (100 x 105 cm) cibachrome. Edition of three. Photo: Fabrice Lévêque.

Orlan's detractors are frequently surprised to discover that she has an acute sense of humor, which she most often directs at herself. Inspired by Lars Von Trier's film *The Idiots* and its critique of conformist behavior, she dressed up and posed for the camera as a housewife in hair-rollers and rubber gloves, alternately caressing phallic vegetables or serving tea. The installation of the latter work, which was partially inspired by Thomas McEvilly's *Art and Discontent: Theory at the Millennium* (1991),

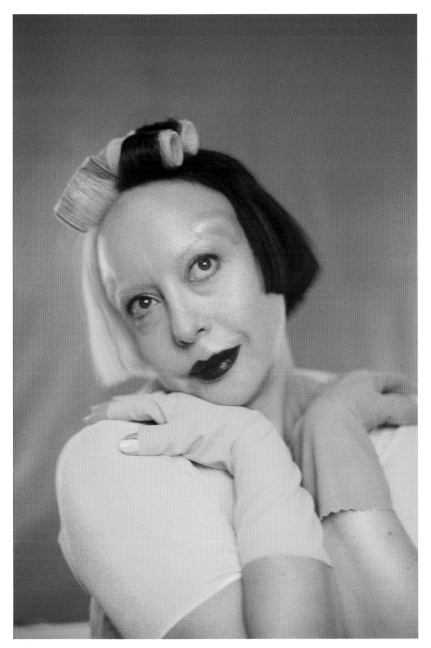 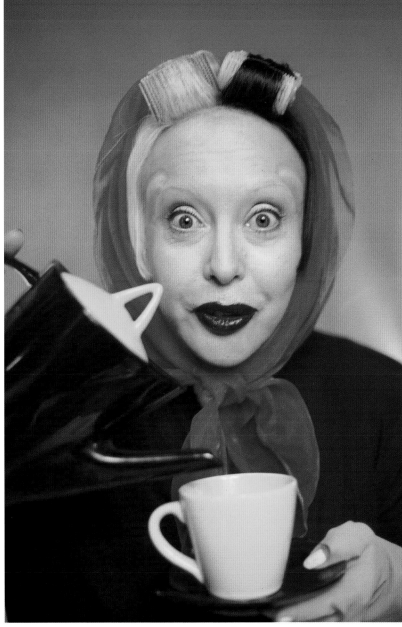

• ••

1998
La femme qui rit (The Laughing Woman)
• Lady with Gloves
• Will You Have a Little. . . *Content,* Mr. Greenberg?
39 ⅓ x 41 ⅓ in. (100 x 105 cm) cibachrome. Edition of three. Photo: Fabrice Lévêque.

includes a motion detector that sets off a recording of Orlan asking: "Will you have a little . . . Content, Mr. Greenberg?" In these portraits, as well as in others in the *Femme qui rit* (The Laughing Woman) series, Orlan demonstrates the inimitable flair for gesture and expression that she developed, for example, in her *Drapery and the Baroque* studio photographs.

1979
Urgence G.E.U. (**Ectopic Emergency) Camera view prior to anesthesia / Daubed with orange disinfectant / Opening the anaesthetized body.

11 ¾ x 15 ¾ in. (30 x 40 cm) three color photographs.

Although Orlan's *La Réincarnation de Sainte Orlan* project was initiated in May 1990 at "Art and Life in the 1990s" in Newcastle, England, where she publicly announced her desire to use plastic surgery as an artistic tool, it was not the first time surgery figured in her work. During a performance symposium she organized in Lyon in 1979, Orlan was rushed to the hospital for emergency surgery, due to complications linked to an ectopic pregnancy. Under general anesthesia, she had the operation

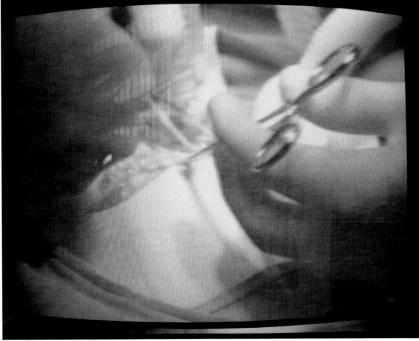

filmed and transported the resulting video to the symposium by ambulance in order to include it as her performance. It was simply another attempt, she says, to "use life as a recoverable aesthetic phenomenon."

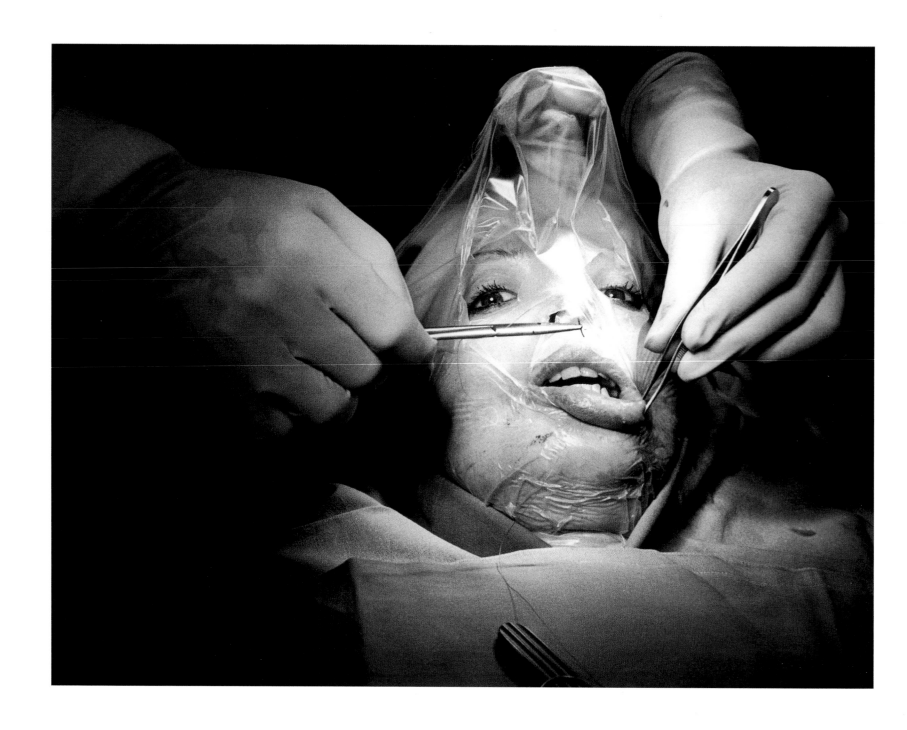

September 1990
La Réincarnation de sainte Orlan ou Images nouvelles images (The Reincarnation of Saint Orlan, or Pic New[s] Pics)

The "unicorn" operation with transparent plastic sheets and grimacing lips.

23 ²/₃ x 31 ½ in. (60 x 80 cm) black and white photograph.

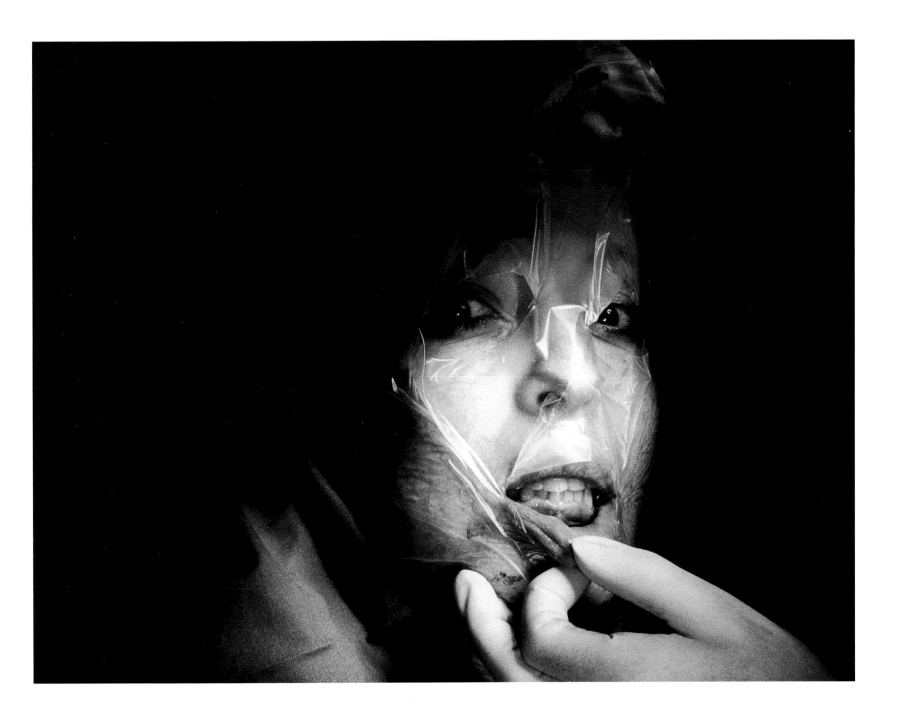

September 1990
La Réincarnation de sainte Orlan ou Images nouvelles images

The "unicorn" operation with transparent plastic sheets and Orlan showing her teeth.
23 ²/₃ x 31 ½ in. (60 x 80 cm) black and white photograph.

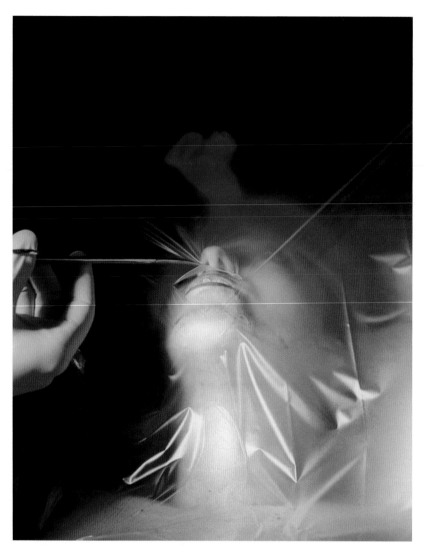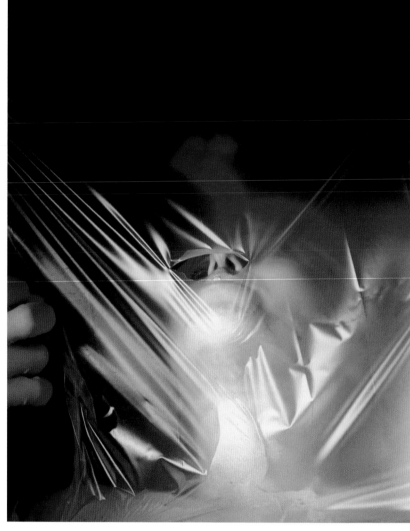

1990
La Réincarnation de sainte Orlan ou Images nouvelles images
The "unicorn" operation, cutting the transparent plastic sheets.
Left: Cutting the opening for the mouth.
Right: Opening for the nostrils.
23 ²/₃ x 31 ½ in. (60 x 80 cm) color photographs.

Orlan underwent nine plastic surgery operations between 1990 and 1993. Her first operation/performance was instigated in part by *La Robe*, written by Lacanian psychoanalyst Eugénie Lemoine-Luccioni, excerpts of which she read aloud during the surgery. Citing Lemoine-Luccioni, Orlan has proposed that her operations have enabled her to make "what she has" correspond to "what she is," in other words, bring her object (body) and her subject into closer proximity. Literary texts, by Michel Serres, Julia Kristeva, Antonin Artaud, and others also figure in her performances. Speaking or reading during these performances reinforces the impression that everything taking place in the operating room is a conscious act, orchestrated and designed by the artist, who manages to retain her capacity for elocution even when

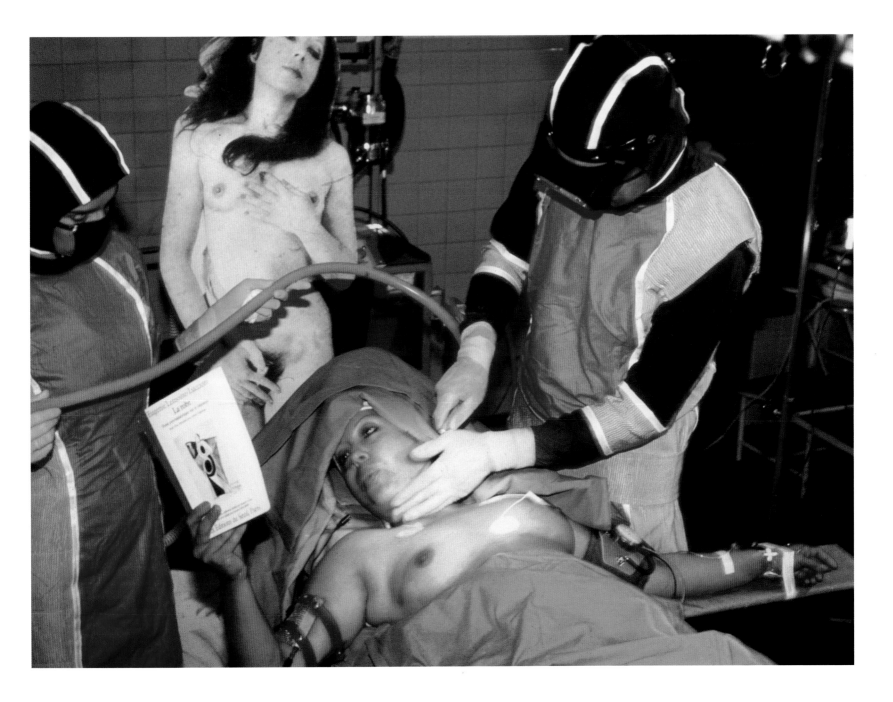

July 1990
First Surgery–Performance
Orlan reading *La Robe* by Eugénie Lemoine-Luccioni.
43 ⅓ x 65 in. (110 x 165 cm) cibachrome. Costumes by Charlotte Calberg.

the skin of her body or her face is being removed from her flesh. Orlan plays precisely on the viewer's inability to dissociate the visual images, sounds, and spaces of the operation from the sentient experience of pain, which generally renders articulate language impossible. The surgery performances are staged in the theater of the operating room. Her first plastic surgeries involved modeling the body—through liposuction, silicone, collagen injections, etc.—and maintain a certain ideal of physical beauty in the result. Costumed in designer robes (by Paco Rabanne, Franck Sorbier, Issy Miyake, and others), Orlan treated the operating room like a studio, surrounding herself with her artworks, which inscribed the work in progress in her artistic history.

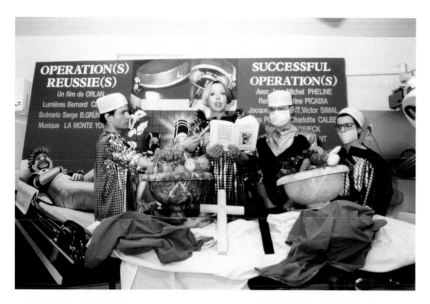

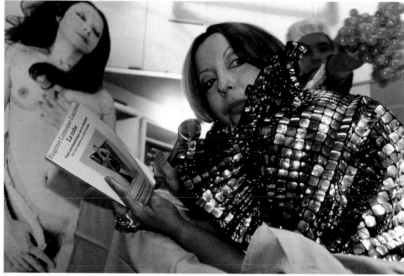

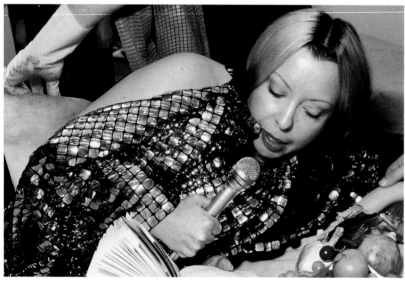

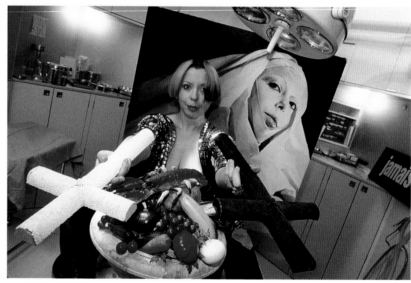

July 6, 1991
Surgery-Performance
Four color photographs. Dress by Paco Rabane. Photo: Alain Dohmé for Sipa-Press.

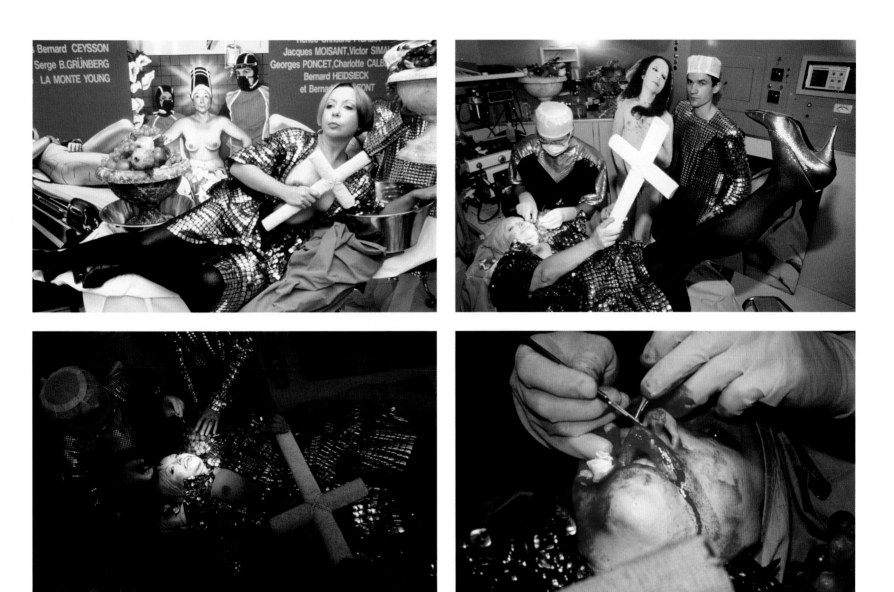

July 6, 1991
Surgery-Performance
Four color photographs. Dress by Paco Rabane. Photo: Alain Dohmé for Sipa-Press.

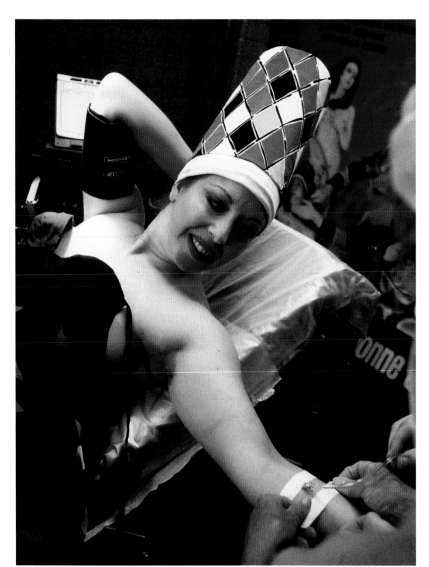
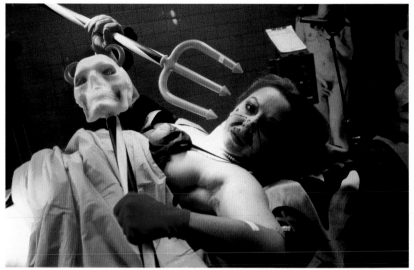
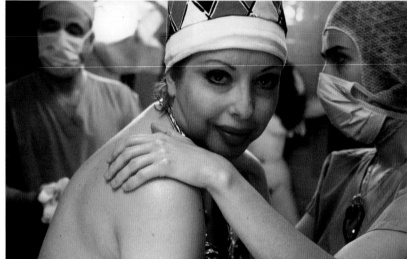

July 6, 1991
Fifth Surgery–Performance, or, the Opera Operation
Nine color photographs. Operation conducted by Dr. Chérif Kamel Zaar in Paris; set and props by Orlan, costumes by Franck Sorbier.

Each operation/performance is carefully planned and executed, directed and edited by Orlan. In the video and photographs from her fourth operation, the surgeon enters and kisses her hand while she nibbles and offers fruit from a round platter. Portraits of Orlan—*Monstration unique, monstration phallique, Strip-Tease occasionnel*, the poster *Opération(s) réussie(s)*—are placed around the operating table. We see her reading, or handling the black and white crosses she had used in her *Skaï and Sky et Video* photographs, while a surgeon (also costumed by Paco Rabanne), slices into her face. In the fifth operation/performance, Orlan dressed up in a harlequin's hat and robe, and invited dancer Jimmy Blanche to perform a strip-tease while she undertook surgery, thus creating a carnivalesque atmosphere. Orlan has spoken of her different performances in terms of their "styles," as "rites of passage," and as an attempt to come to terms with the fact that the body is "obsolete."

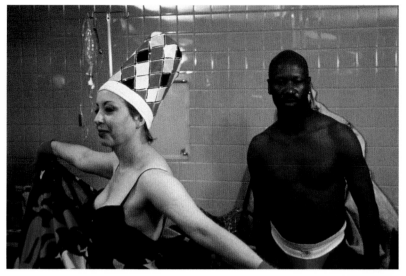

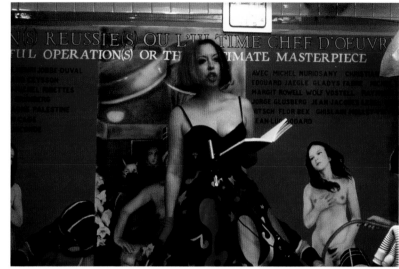

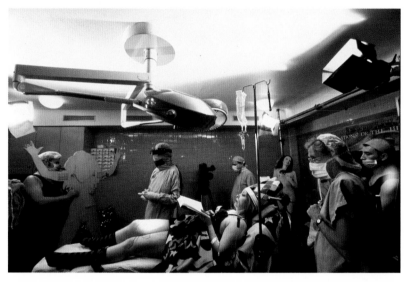

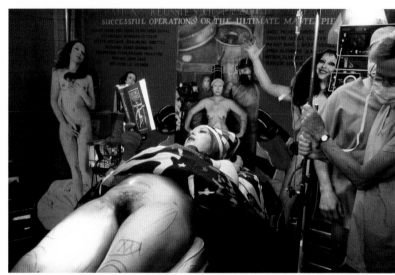

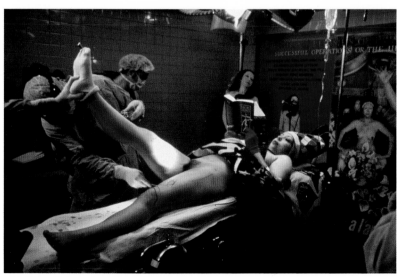

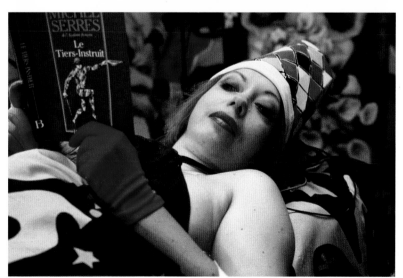

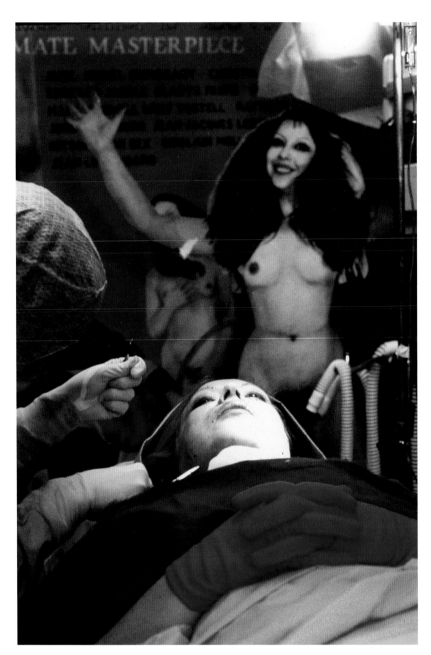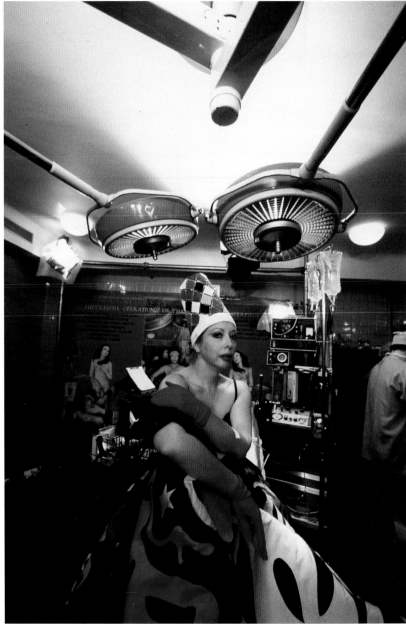

July 6, 1993
La Réincarnation de sainte Orlan ou Images nouvelles images
Left: Movie poster and image of nude Orlan while surgeon stitches.
Right: Orlan with parti-colored Harlequin cap, dress by Franck Sorbier, and red gloves, under the operating lamp of the operating theater.
43 ⅓ x 65 in. (110 x 165 cm) cibachrome. Fifth surgery-performance, with Dr. Chérif Kamel Zaar in Paris.

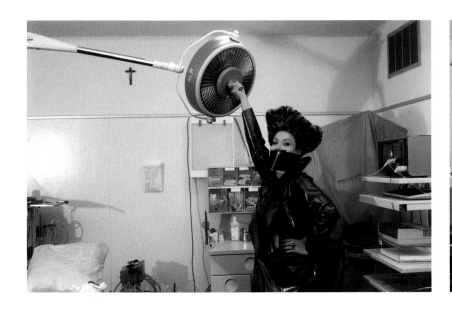
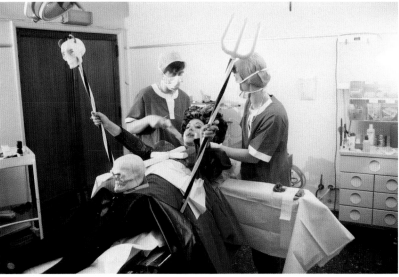
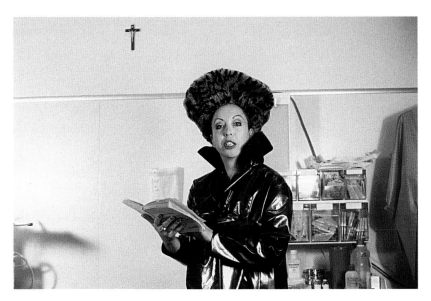
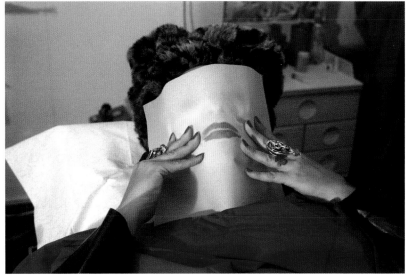

1993
Sixth Surgery-Performance
Posing with the operating lamp / Posing with skulls and trident / Posing with text beneath cross / Printing lips on paper.
Color photographs. Performance at the Cirque Divers, Liège, Belgium.

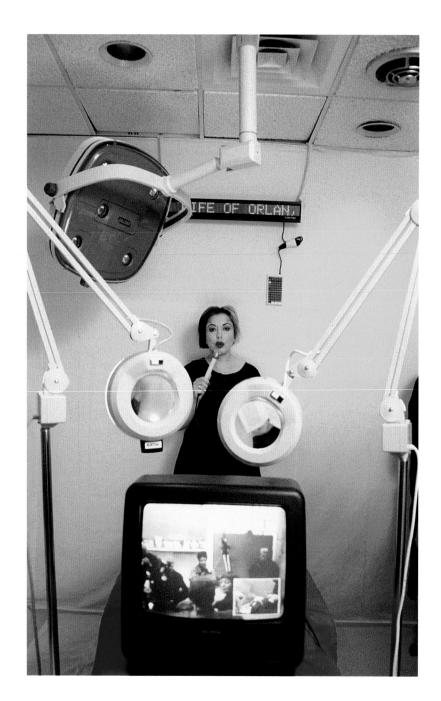

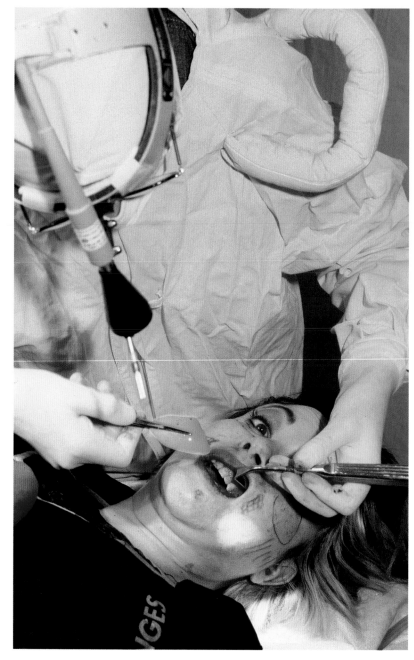

December 21, 1993
Ninth Surgery-Performance, New York

Micro-lecture, LED display, enlarging magnifiers, and video link. Blue-on-yellow implants.

43 ⅓ x 65 in. (110 x 165 cm) cibachrome in Diasec mount. Edition of five. Photo: Robert Puglisi and Vladimir Sichov for Sipa-Press.

Orlan's operation, *Omnipresence*, which took place in New York in November 1993, was the most ambitious in scope. She located a plastic surgeon, Dr. Marjorie Cramer, who fully subscribed to the artistic and feminist aims of her project: the radical transformation of her face through implants on her cheeks and temples. In essence, Orlan was asking the doctor to divert plastic surgery from its usual goals and to help her undermine the standards of beauty perpetuated by it.

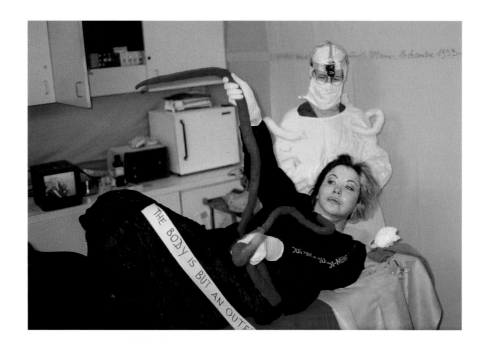

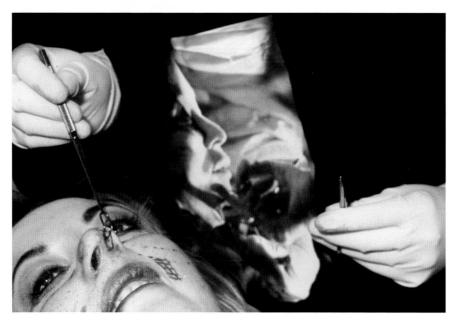

December 21, 1993
Ninth Surgery-Performance, New York

Top: Orlan performing with her costume during the ninth surgery-performance.
Bottom: The double face during the operation in New York.
43 ⅓ x 65 in. (110 x 165 cm) cibachrome in Diasec mount. Edition of five. Photo: Robert Puglisi and Vladimir Sichov for Sipa-Press.

The operation/performance was transmitted live via satellite to her New York gallery (Sandra Gering), to the Centre Georges Pompidou in Paris, the Multimedia Center in Banff, and the MacLuhan Center in Toronto, Canada, as well as other sites. Spectators could interact with Orlan during the performance; she received faxes, spoke to her audience in Paris through a live-feed, received encouragement from friends. Lan Vu provided the costumes, clocks on the wall behind her gave the time in Paris,

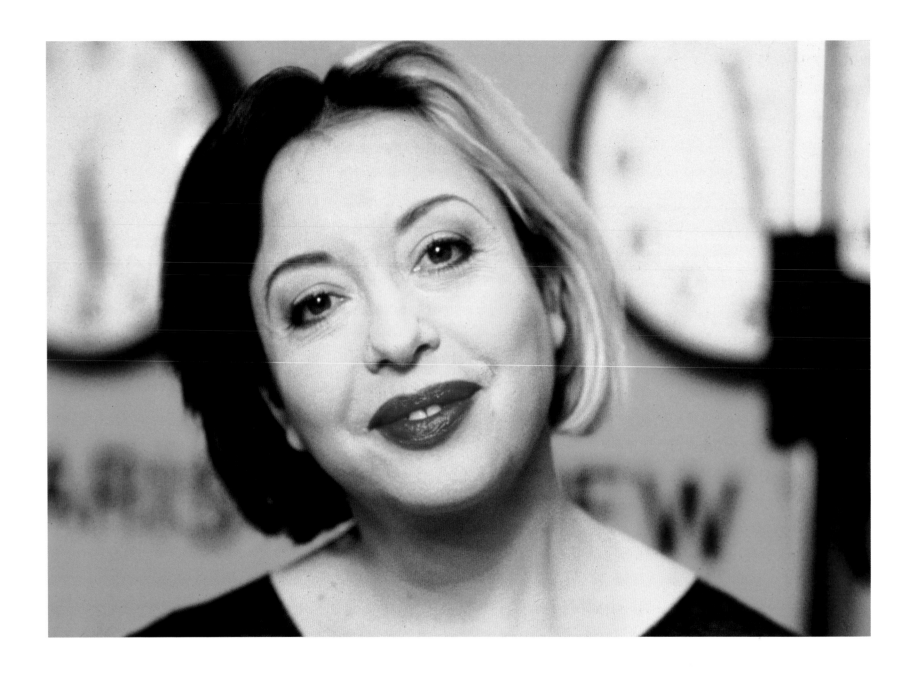

November 21, 1993
Seventh Surgery-Performance, titled *Omniprésence*, New York
Portrait of Orlan in the operating theater prior to the operation.
43 ⅓ x 35 in. (110 x 165 cm) cibachrome in Diasec mount. Edition of five. Photo: Vladimir Sichov for Sipa-Press.

New York, Tokyo, and Toronto, and two simultaneous translators (English-French and sign language) worked throughout the operation. Orlan is an artist who pushes herself and her audience to the very limit. The *Omniprésence* video and photographs document the entire surgical process, from the moment the doctor draws on her skin to the moment it is stitched up, and can be unbearable for the spectator. However, Orlan has stated that her "Carnal Art" must be considered in opposition to

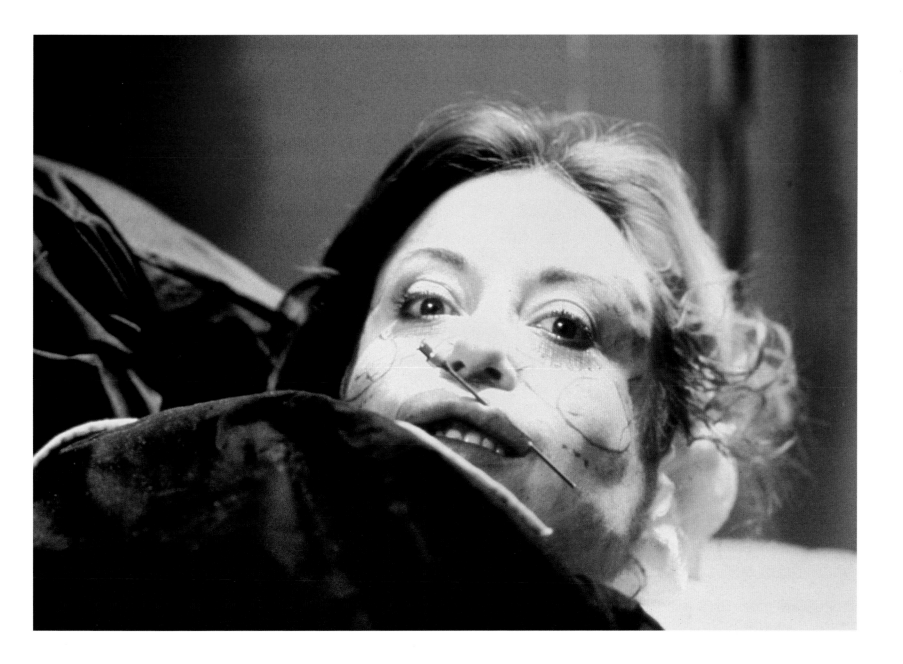

November 21, 1993
Seventh Surgery-Performance, titled *Omniprésence*, New York
Needle of anesthetizing syringe in upper lip.

43 ⅓ x 65 in. (110 x 165 cm) cibachrome in Diasec mount. Edition of five. Photo: Vladimir Sichov for Sipa-Press.

Private collection.

body art that celebrates pain. *Omniprésence* testifies to this. Thanks to local anesthesia, Orlan smiles and speaks throughout the operation. However, when she realized that continuing with the cheek implants, which were to be inserted through holes made inside her mouth, would mean enduring considerable pain, she decided on the spot to postpone the rest of the procedure.

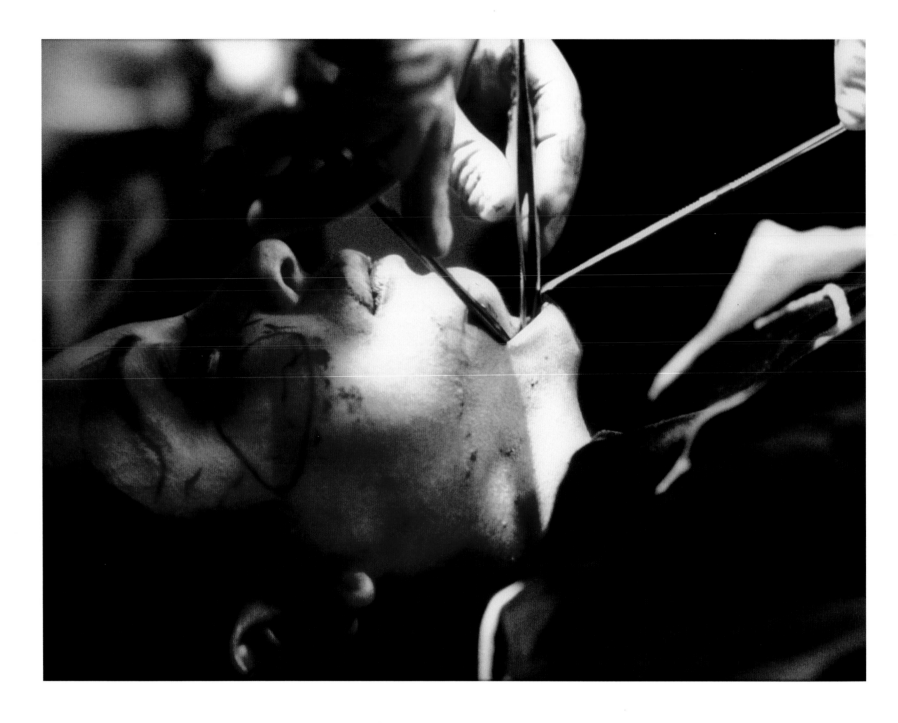

November 21, 1993
Seventh Surgery-Performance, titled *Omniprésence*, New York: The Second Mouth

47 ½ x 69 in. (120 x 175 cm) cibachrome in Diasec mount. Edition of seven. Photo: Vladimir Sichov for Sipa-Press. Print: Bernard Renoux.
Fonds régional d'art contemporain, Pays de la Loire, France.

In addition to the *Omniprésence* photographs, hung in the Sandra Gering gallery, Orlan created an entire series of portraits, as well as a number of works out of the materials used in the operation (surgical robes, gauze, and blankets). In the portrait photographs entitled *Ceci est mon corps ... ceci est mon logiciel* (This is My Body,

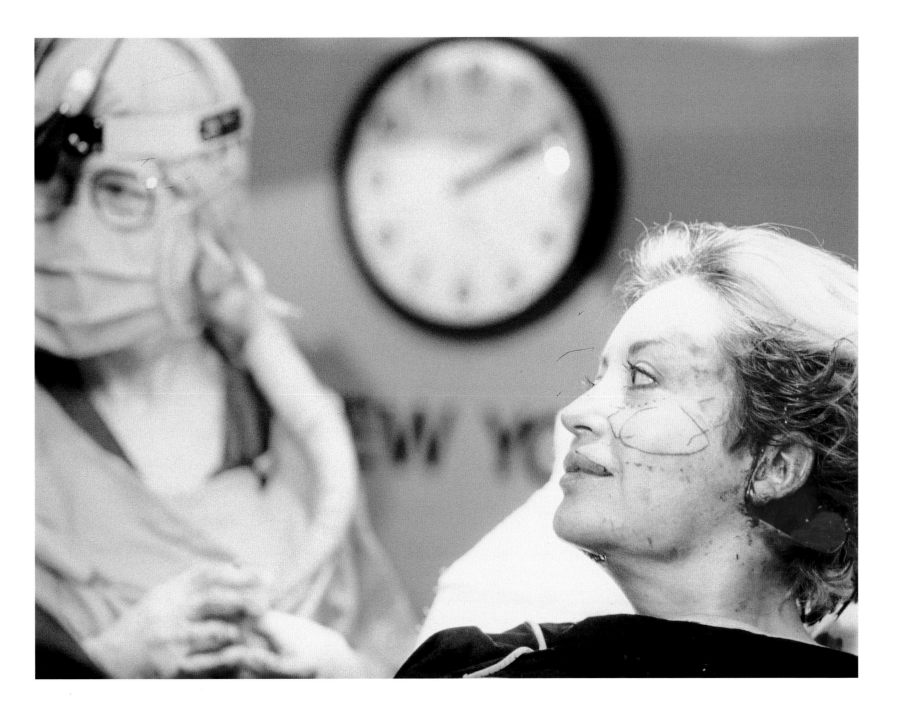

November 21, 1993
Sourire de plaisir (Smile of Delight)

47 ½ x 69 in. (120 x 175 cm) cibachrome in Diasec mount. Edition of seven. Photo: Vladimir Sichov for Sipa-Press. Print: Bernard Renoux.
Fonds régional d'art contemporain, Pays de la Loire, France.

This is My Software) a bandaged and bruised Orlan poses coquettishly. Her self-portrait with narcissi in front of the New York skyline demonstrates Orlan's critical distance from her own narcissism, even in the most extreme of circumstances.

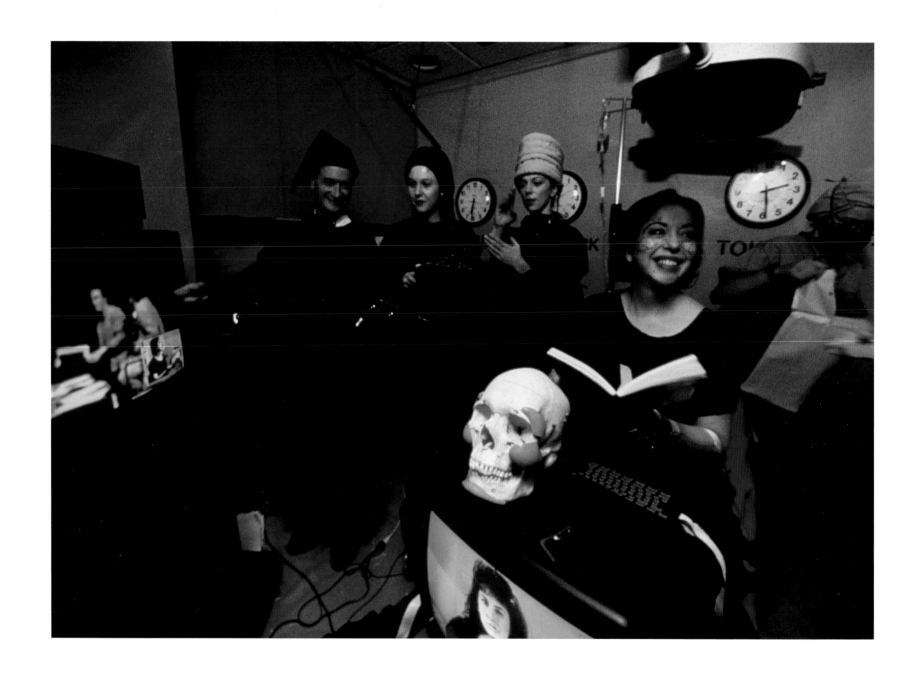

November 21, 1993
Seventh Surgery-Performance, titled *Omniprésence*, New York

Operating theater during the reading of a text by Eugénie Lemoine-Luccioni, with translation into English and sign language.

43 ⅓ x 65 in. (110 x 165 cm) cibachrome in Diasec mount. Edition of seven. Photo: Vladimir Sichov for Sipa-Press.

Private collection.

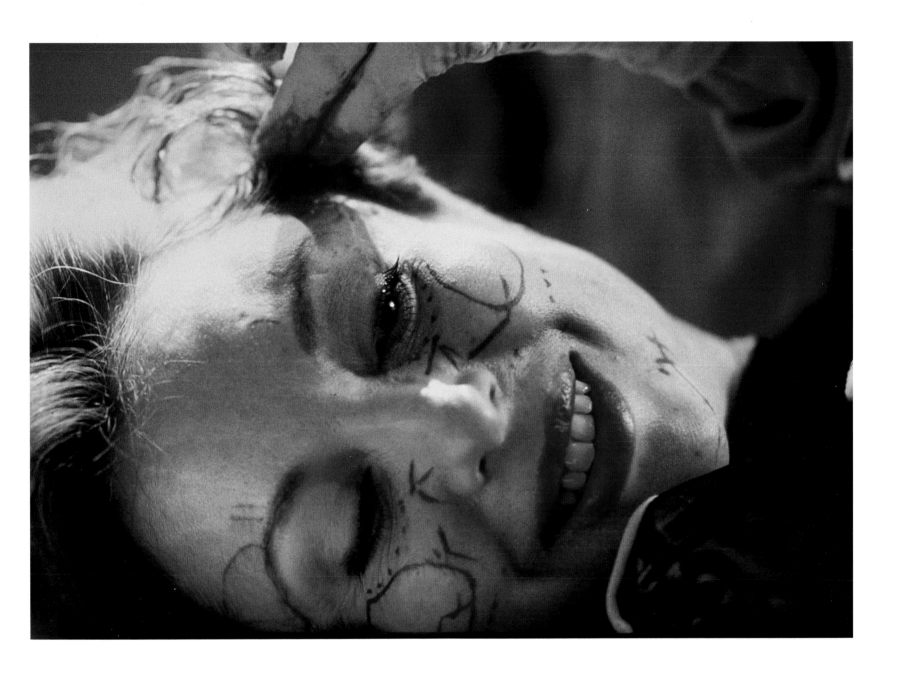

November 21, 1993
Seventh Surgery-Performance, titled *Omniprésence*, New York: Close-up of Laughter during the Operation

43 ⅓ x 65 in. (110 x 165 cm) cibachrome in Diasec mount. Edition of seven. Photo: Vladimir Sichov for Sipa-Press.

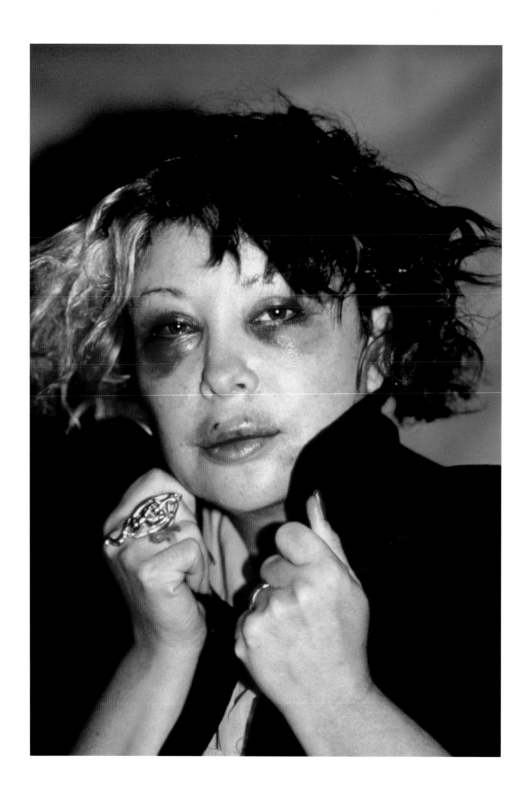

November 25, 1993
Portrait Produced by the Body-Machine Four Days after the Surgery-Performance

86 ⅔ x 65 in. (220 x 165 cm) in two sections of 43 ½ x 65 in. (110 x 165 cm) each cibachrome in Diasec mount. Edition of seven. Photo: Vladimir Sichov for Sipa-Press.

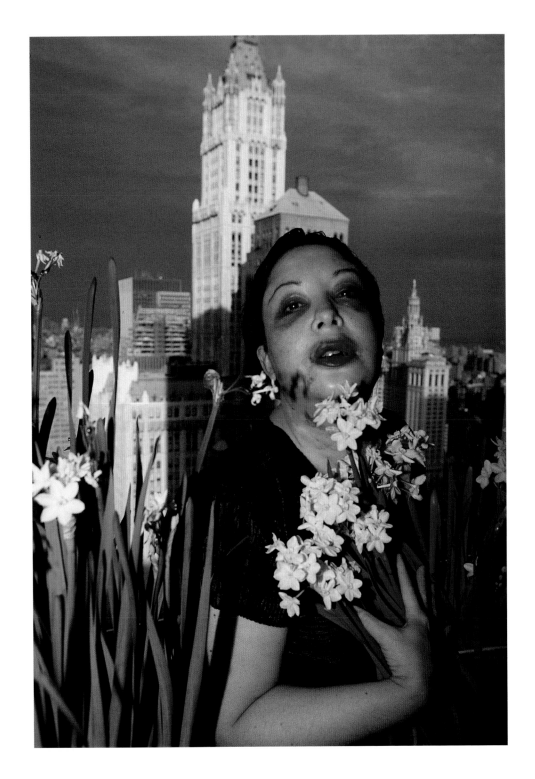

November 27, 1993
Les femmes ressemblent à la lune, mes yeux à des fleurs ou autoportrait aux narcisses fait par la machine-corps six jours
(Women Resemble the Moon, My Eyes Resemble Flowers, or Self-Portrait with Narcissus Produced by the Body-Machine Six Days after the Seventh Surgery-Performance)

86 ⅔ x 65 in. (220 x 165 cm) in two sections of 43 ½ x 65 in. (110 x 165 cm) each, cibachrome in Diasec mount. Edition of seven. Photo: Vladimir Sichov for Sipa-Press.

1993
Pièce à conviction (Courtroom Exhibit): Costume for the Seventh Surgery-Performance
Fashion designer: Lan Vu and team. Translator Sophy Thompson's costume: Sophy Thompson. Print: Bruno Scotti.

1993
Pièce à conviction
Blue high-heels and protective overshoe of unwoven cloth, label.
Exhibit of the surgery-performance with Dr. Bernard Cornette de Saint-Cyr. Print: Bruno Scotti.

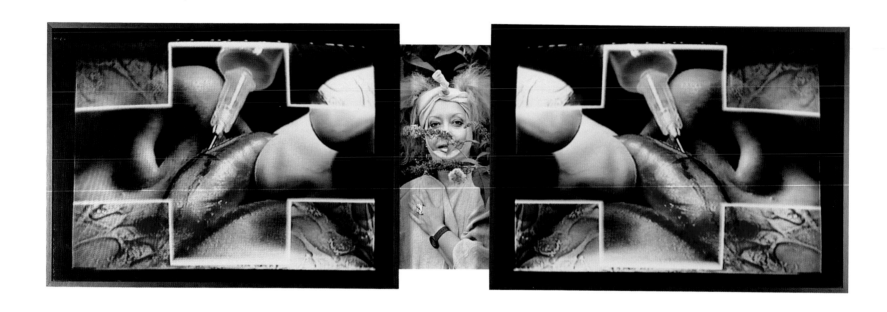

1993
Séduction contre séduction (Appeal vs. Appeal)

Photographic triptych of Opera Operation No. 10. Injecting anesthetic into the lips.

35 x 107 x 2 in. (89 x 272 x 5 cm), two Cibachrome prints, black wood frames, with a black and white photograph on matte paper in the middle.

Photo: Olivia Frysowsky and Georges Merguerditchian.

Work produced for Les Rencontres Photographiques, Arles, France.

In *Séduction contre séduction*, Orlan plays two mirror images—stills reworked from video shot during her surgeries—off each other, inserting a third element between them in order to destabilize and call into question the active/passive dynamics of seduction. Seduction is connoted through the glossy Cibachrome prints, the internal cross-shaped framing device as well as the exterior frame, and the mirroring effect. The triptychs are completed with the "counter" seductive images: smaller,

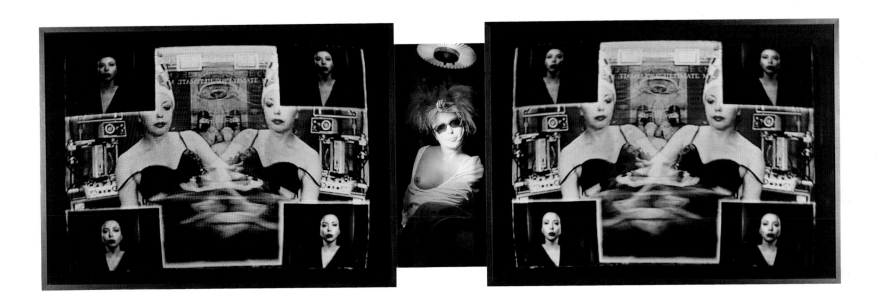

1993
Séduction contre séduction: "I is Someone Else," at the Height of Confrontation, No. 7
35 x 107 x 2 in. (89 x 272 x 5 cm), two Cibachrome prints, black wood frames, with a black-and-white photograph on matte paper in the middle.
Photo: Olivia Frysowsky and Georges Merguerditchian.
Work produced for Les Rencontres Photographiques, Arles, France.

unframed, matte finish, black and white photos of Orlan striking typically seductive poses in her pre- or post-surgery garb, which act as a vertical hinge for the larger horizontal color photographs.

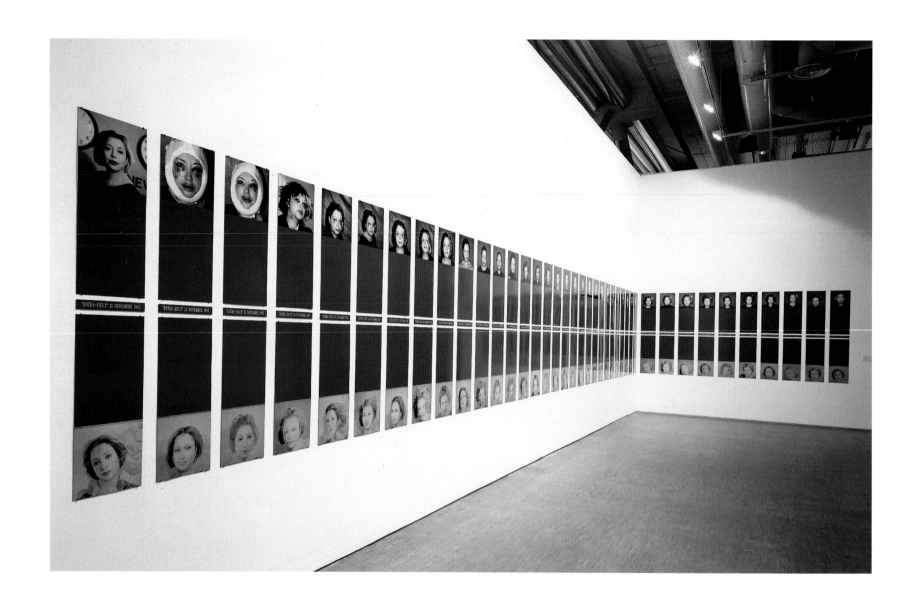

1994
Omniprésence No. 2 (Omnipresence No. 2)

Variable dimensions approximately 63 x 669 in. (160 x 1700 cm), forty diptychs of metal and eighty color photographs. Pictured during the *Hors limites* show at the Centre Georges Pompidou, Paris, November 1994–February 1995. Photo: Raphaël Cuir (Orlan's face) and Alfons Alf (on screen).

The five-foot (sixteen meters) long photography installation *Omniprésence* was created in conjunction with Orlan's seventh plastic surgery performance of the same title and first shown at the Sandra Gering gallery in New York in November and December 1993. There, the installation functioned as a work in progress. It was made out of two horizontal rows of images. On the bottom row, Orlan presented forty-one self-portraits in which her features were digitally morphed with those of

144

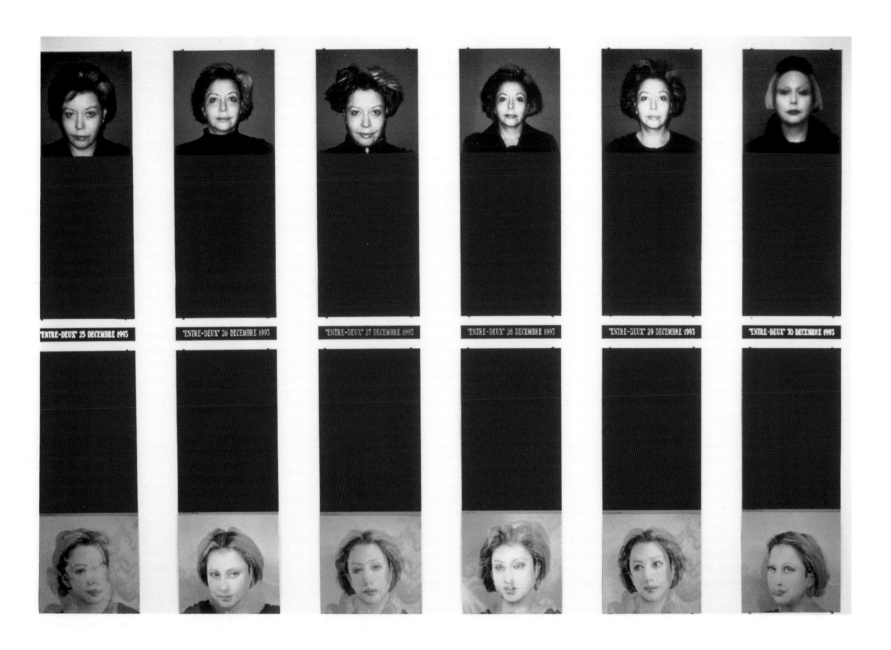

"ENTRE-DEUX" 25 DECEMBRE 1993 · "ENTRE-DEUX" 26 DECEMBRE 1993 · "ENTRE-DEUX" 27 DECEMBRE 1993 · "ENTRE-DEUX" 28 DECEMBRE 1993 · "ENTRE-DEUX" 29 DECEMBRE 1993 · "ENTRE-DEUX" 30 DECEMBRE 1993

November–December 1994
Omniprésence, detail

Forty-one diptychs of metal and eighty-two color photographs.
Version for a show at the Sandra Gering Gallery, New York. Photos: Raphaël Cuir (Orlan's face) and Alfons Alf (screens).

classic beauties from the art-historical canon. The images obtained were precisely calibrated to correspond to a median stage of morphing between her face and that of her chosen icon—thus forming a dual visual identity. On a daily basis, starting on November 21, 1993, Orlan added a top row of photographs of her face as it progressively healed after the operation. The last image in the series, the *Portrait officiel après la sortie de la quarantaine*, represents the "finished" Orlan, with her

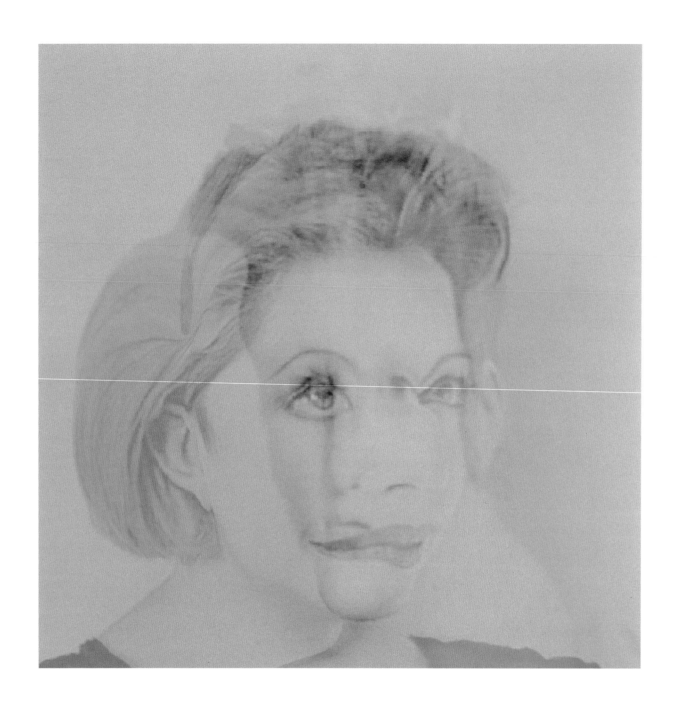

1994
Entre-deux No. 8 **(Between the Two No. 8)**

47 ¼ x 63 in. (120 x 160 cm), color photograph in light box.

hair done and in full make-up, as well as the end of the exhibition. A text panel printed with the date the upper portrait was taken and the words "entre-deux" (between the two) separated the two rows. *Omniprésence* measures out in space and time two sets of facial mutations—one produced by the "machine-body" and the other by the "machine-computer." It questions our historical and contemporary notions of physical beauty, ultimately confronting the spectator with the proximity or

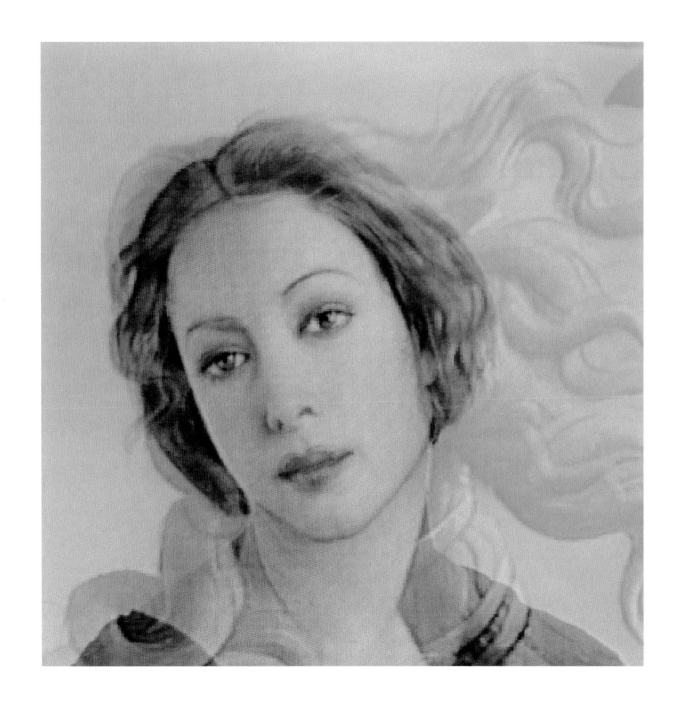

1994
Entre-deux No. 15
47 ¼ x 63 in. (120 x 160 cm), color photograph in light box, .

distance between the real and the virtual. The reproduction here shows *Omniprésence* as it was modified for and installed in the exhibition *Hors Limites: L'art et la vie*, at the Centre Georges Pompidou in Paris in 1994.

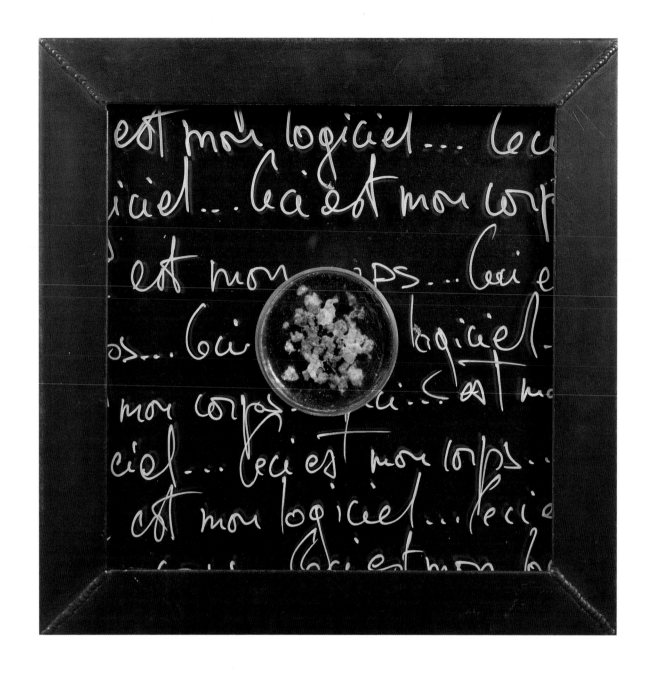

1992
Les petits reliquaires (Small Reliquaries): "Ceci est mon corps... Ceci est mon logiciel" ("This is My Body, This is My Software")

11 ¾ x 11 ¾ x 2 in. (30 x 30 x 5 cm), soldered metal, burglar-proof glass, ten grams of Orlan's flesh preserved in resin. Edition of one. Photo: Georges Merguerditchian. Jacques Ranc collection.

Orlan's critique of the (Christian) sanctification of the body is foregrounded in her reliquaries, a series of multiples in which the corporeal residue of her performances becomes an artistic commodity. In the "small" reliquaries, ten grams of her fat, blood, skin, and flesh—removed during her surgical operations—are suspended in preserving fluid or resin disks resembling Petri dishes. These are then mounted on panels inscribed with well-known statements by Orlan ("this is my body, this is my software," "the body is but a costume") in order to show the "relationship between the flesh and the word." The relic and its support are secured in a soldered

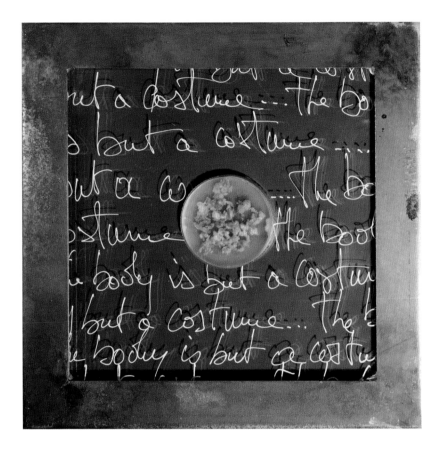
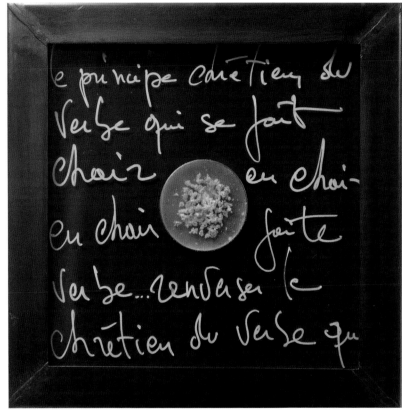

1992
Les petits reliquaires
Left: "The body... is but a costume."
Right: "Renverser le principe chrétien du Verbe qui se fait chair" ("Overthrow the Christian Principle of the Word Become Flesh").
11 ¾ x 11 ¾ x 2 in. (30 x 30 x 5 cm), soldered metal, burglar-proof glass, ten grams of Orlan's flesh preserved in resin. Edition of one. Photo: Georges Merguerditchian.
Serge François collection.

metal frame, thus open to admiration, or worship, but not to touch. The "large" reliquaries function similarly, but they are centered in a text by Michel Serres, which is translated from the French into as many languages as it takes to do away with the remaining morsels of Orlan's body. Serres's citation opens: "What can the common monster, tattooed, ambidextrous, hermaphrodite and cross-bred, show to us right now under his skin? Yes, blood and flesh."

... "WHAT CAN THE COMMON MONSTER, TATTOOED, AMBIDEXTROUS, HERMAPHRODITE AND CROSS-BRED, SHOW TO US RIGHT NOW UNDER HIS SKIN? YES, BLOOD AND FLESH. SCIENCE TALKS OF ORGANS, FUNCTIONS, CELLS AND MOLECULES TO ACKNOWLEDGE THAT IT IS HIGH TIME THAT ONE STOPPED TALKING OF LIFE IN THE LABORATORIES BUT SCIENCE NEVER UTTERS THE WORD FLESH WHICH, QUITE PRECISELY, POINTS OUT THE MIXTURES IN GIVEN PLACE OF THE BODY, HERE AND NOW, OF MUSCLES AND BLOOD, OF SKIN AND HAIR, OF BONES, NERVES AND OF THE VARIOUS FUNCTIONS AND WHICH HENCE MIXES UP THAT WHICH IS ANALIZED BY THE DISCERNING KNOWLEDGE" ...

"מה יכולה המפלצת המצויה, המקועקעת במומחיות, הדו־מינית, בת־הכלאים, להראות לנו ברגע זה ממש מתחת לעורה? כן, דם ובשר. המדע מדבר על איברים, על תפקודים, על תאים ועל מולקולות, כדי להגיד שהגיע הזמן להפסיק לדבר במעבדות על החיים. אבל המדע מעולם לא הגה את המילה בשר, שהוראתה המדויקת היא המזיגה המסוימת של הגוף, כאן ועכשיו של השרירים ושל הדם של העור ושל השיער של העצמות, של העצבים של התפקודים השונים ושל מה שממזג את כל מה שהידע המבחין מנתח"...

1993

Grands reliquaires (Large Reliquaries)

• "My Flesh, the Text, and Languages" No. 10. English
•• "My Flesh, the Text, and Languages" No. 12. Hebrew
••• "My Flesh, the Text, and Languages" No. 11. Arabic
•••• "My Flesh, the Text, and Languages" No. 1. French.

اذا يستطيع الوحش - الخنثى المهجنة الموشومة بمهارة - أن يرى نا في هذه اللحظة بالذات مما يخف يه تحت جلده؟ نعم، لحم ودم. العلم يتحدث عن اعضاء الجسم وعن وظائ فها وعن الخلايا والانسجة، بغرض أن يقول بان الوقت قد حان لان يتوقف الحديث عن الحياة ● داخل المختبر ات، ولكن العلم لم ينطق ابدًا بكل مة لحم بدلالتها المحددة على أنها مزيج معين للجسم مكون من ال عضلات والدم والجلد والشعر والعظم والاعصاب، وسائر المركبات الوظا فية الاخرى، وكل مزيج آخر يمكن أن يفرزه تحليل الوعي للدرك ...

●●●

..."LE MONSTRE COURANT, TATOUE, AM BIDEXTRE, HERMAPHRODITE ET METIS, QUE POURRAIT-IL NOUS FAIRE VOIR, A PRESENT, SOUS SA PEAU? OUI, LE SA NG ET LA CHAIR. LA SCIENCE PARLE D ES ORGANES, DE FONCTIONS, DE CELL ULES ET DE MOLECULES, POUR AVOUE R ENFIN QU'IL Y A BEAU TEMPS QUE L'O N NE PARLE PLUS ● DE VIE DANS LES LABORATOIRES, MAIS ELLE NE DIT JA MAIS LA CHAIR, QUI, TOUT JUSTEMEN T, DESIGNE LE MELANGE, EN UN LIEU DONNE DU CORPS, ICI ET MAINTENAN T, DE MUSCLES ET DE SANG, DE PEAU ET DE POILS, D'OS, DE NERFS ET DE FO NCTIONS DIVERSES, QUI MELE DONC CE QUE LE SAVOIR PERTINENT ANALYSE"...

●●●●

Soldered metal, burglar-proof glass, ten grams of Orlan's flesh preserved in resin, 34 ½ x 39 ⅓ x 4 ¼ in. (90 x 100 x 12 cm), weighing from 132 to 220 pounds (60 to 100 kg) depending on thickness of glass. Edition of one. Photo: Georges Merguerditchian.
Jacques Ranc collection. Produced by the Israel Museum in Jerusalem and the Jona Fischer Foundation.

December 8, 1993
Drawing done in blood during the surgery-performance of 8 December

19 ²/₃ x 23 ²/₃ in. (50 x 60 cm), light box. Edition of eight.

The Blood Drawings may first appear as crudely executed finger-paint portraits, but they go to the heart of the problematics of self-representation and the gaze in Orlan's work. They are another example (a most literal one) of the dialectic between disfiguration and figuration in her "Carnal Art." Undeniably faces, and undeniably

December 8, 1993
Drawing done in blood

39 ⅓ x 27 ½ in. (100 x 70 cm), blood on paper, enlarged onto oilcloth through the Scanachrome process. Edition of nine.

her own, she drew them with her blood during her eighth surgical operation performance in New York City. Strong images, despite their rudimentary composition, they function, like the *Saint Suaires* and the *Réliquaires,* as indisputably material evidence that her body is her artistic tool and the operating block her studio.

1993
Saint Suaire No. 9 (Holy Shroud No. 9)

11 ¾ x 15 ¾ in. (30 x 40 cm), photographic transfer onto blood-soaked gauze, Plexiglas box.
Photo: Georges Merguerditchian.

Using a photographic transfer process, Orlan imprinted her portrait on scraps of gauze that had soaked in her blood and body fluids during her operations, creating works that are both of her and that resemble her. Here again, with her poignant sense of irony, she makes reference to religious iconography: the miraculous impression of Christ's face on the shroud of Turin and its trace on Veronica's veil: images produced solely by contact with the skin. In Orlan's case, the material substance of her body remains on the fabric, but she must resort to technological means to make her face appear.

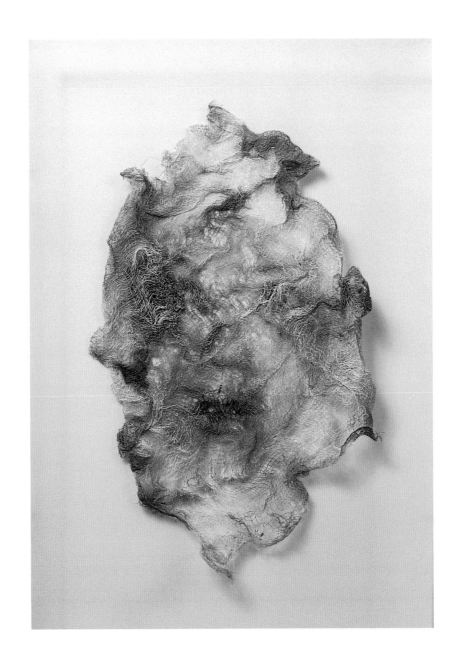

1993
Saint Suaire No. 21

11 ¾ x 15 ¾ in. (30 x 40 cm), photographic transfer onto blood-soaked gauze, Plexiglas box.

Photo: Georges Merguerditchian

Whereas the surgical operations may be considered radical exercises in ostentatious self-exposure, the imprints of Orlan's face on the *Saints Suaires* function as barely visible vestiges of her presence, mere apparitions, fragile mementos of the grueling performance, which enable us to put distance between the images of her bruised countenance and our gaze. Orlan photographed the *Saints Suaires*; they are more frequently exhibited as photographs than displayed on their own as objects.

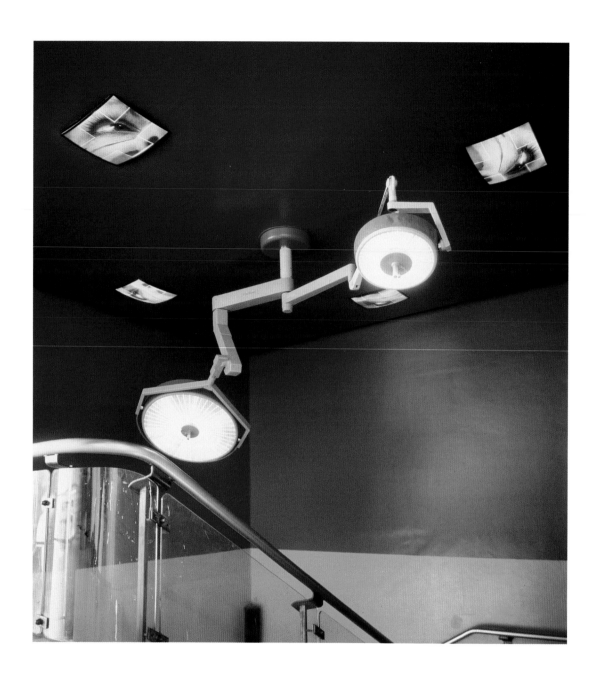

1995
"Un peu de temps . . . et vous ne me verrez plus . . . un peu de temps . . . et vous me verrez"
("A Little While . . . and You Won't See Me . . . A Little While . . . and You'll See Me")

Installation with video and operating lamps. Biennale d'Art Contemporain de Lyon, Musée d'Art Contemporain, Lyon.

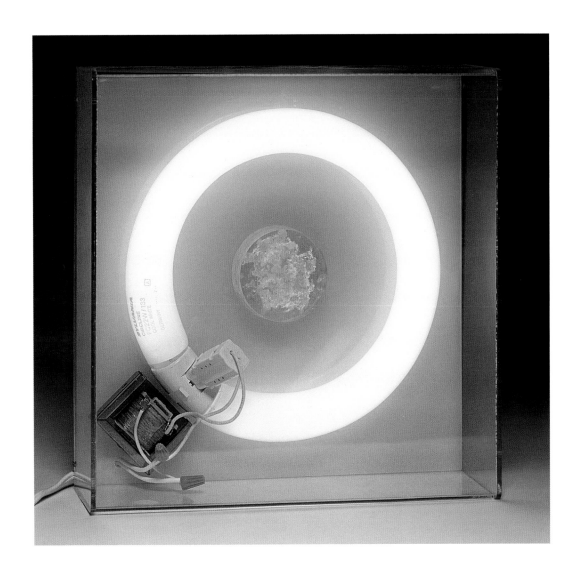

1993
Reliquaire de ma chair avec néon No. 5 (Reliquary of My Flesh with Neon)

15 ¾ x 15 ¾ x 2 ⅓ in. (40 x 40 x 6 cm), Orlan's flesh preserved in resin, neon, Plexiglas box, transformer.

Photo: Georges Merguerditchian.

Private collection.

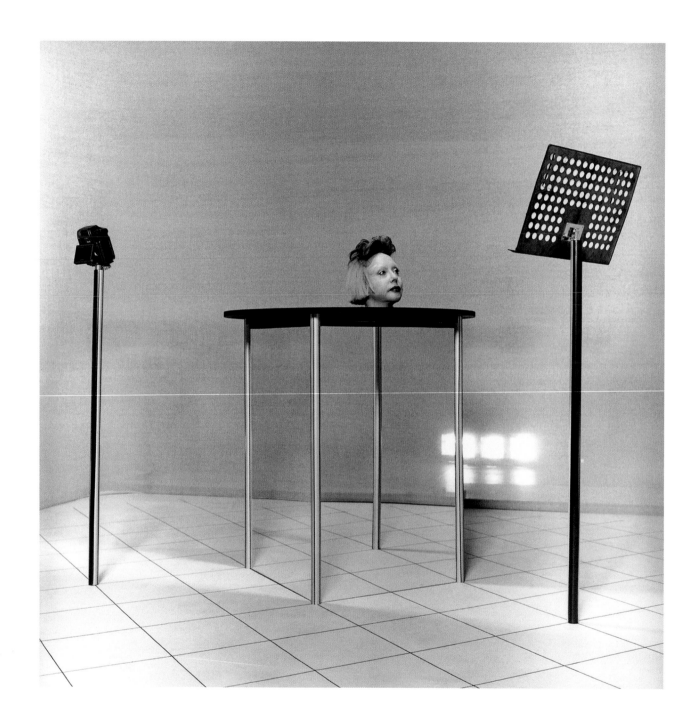

1996

Femme avec tête No. 5 (Woman with Head): Overall view with face in three-quarter profile

19 ²/₃ x 23 ²/₃ in. (50 x 60 cm), black and white photograph. Edition of three. Photo: Peter Sinclair.

Performance given during the _Totally Wired_ show at the ICA, London. With Paul Kieve (magician), Dean Bramnagann (video-maker), Robin Rambau (musician).

There are certain physical transformations that even Orlan cannot accomplish without the help of a little magic. In "Woman with Head," a radical reversal of images that objectify women by reducing them to their sexual attributes (like Courbet's _Origin of the World_), she approaches the mind-body problem with characteristic humor. In this live performance at the Institute for Contemporary Art in London, Orlan faced her critics head on. She responded to questions posed by her

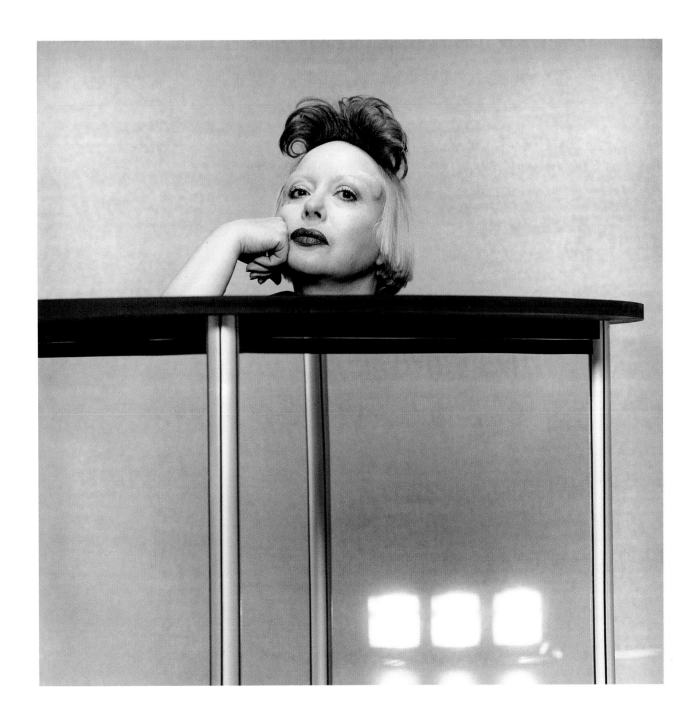

1996
Femme avec tête No. 8: Close-up of hand on cheek

19 ²/₃ x 23 ²/₃ in. (50 x 60 cm) , black and white photograph. Edition of three. Photo: Peter Sinclair.
Performance given during the *Totally Wired* show, curated by Lois Keidan, at the ICA, London. With Paul Kieve (magician), Dean Bramnagann (video-maker), Robin Rambau (musician).

video-projected image, such as: "Orlan, are you a copy or the original? Do you believe in God? Are you mad?" by simply reading out excerpts from the texts by Antonin Artaud, Julia Kristeva, and Michel Serres that inspired her decision to make her body a "site for public debate."

2001
Le plan du film (A Shot at a Movie): Credits No. 27: *Catharsis*; Credits No. 28: *Body*
47 ¼ x 63 in. (120 x 160 cm) each, two Duratrans photographs in light boxes.

Georges
Verney-Carron

Orlan

MESAS

un film de richard dembo
avec André Marcon

Eric
Roux-Fontaine

SCÉNARIO **RAPHAËL CUIR** PRODUCTION **MARIE RAFLIN** COPRODUCTION **ALICE MORGAINE** DIALOGUES **BERNARD MARCADÉ** DIRECTEUR DE LA PHOTOGRAPHIE **ALAIN-JULIEN LAFERRIÈRE** DIRECTEUR ARTISTIQUE **ADRIEN SINA** MUSIQUE **PHILIPPE PIGEARD** ET **CHRISTOPHE VAN HUFFEL** COSTUME **AGATHA RUIS DE LA PRADA**

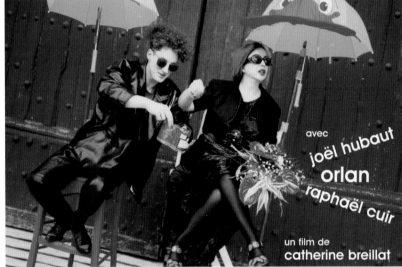

ENTRE

avec
joël hubaut
orlan
raphaël cuir

un film de
catherine breillat

DEUX

SCENARIO **JULIEN BLAINE** PRODUCTION **STEPHAN ORIACH** COPRODUCTION **NICOLAS HÉLION** DIALOGUES **NORBERT HILLAIRE** DIRECTEUR DE LA PHOTOGRAPHIE **KIMICO YOSHIDA** DIRECTEUR ARTISTIQUE **JEAN-LOUIS MAUBANT** MUSIQUE **JOELLE LEANDRE** DÉCORS **RAYMOND HAINS**

2001
Le plan du film. Credits No. 30; *Mesas.* Credits No. 24: *Entre-deux*
47 ¼ x 63 in. (120 x 160 cm) each, two Duratrans photographs in light boxes.

November 24, 2001–January 7, 2002
Le Plan du film

View of the display of posters in l'Espace Créateur, Forum des Halles, Paris. Photo: Georges Merguerditchian.

Taking off from the "Twenty Years of Advertising and Movies by Saint Orlan," Orlan launched the project of *Le plan du film*, or, citing Jean-Luc Godard, the production of a *un film à l'envers* (a movie backwards). Starting from the creation of photographic movie posters (the images of which serve as a foundation for the film's narrative), and moving on to the casting, the script, a promotional soirée at the Fondation Cartier, a soundtrack composed by the group Tanger, the trailer, and, of course, the producer, Orlan determined a set of criteria for the final product. These include featuring Orlan and the players mentioned on the posters, if only symbolically, maintaining the Godard citation, and keeping traces of the original images of her works and posters in the finished films.

6 December 2001
Le Plan du film

Clockwise, from top left: General shot of assembled participants; projection of presentation by Jean-Claude Dreyfus, Nadine Richard; improvised presentation by Raymond Hains; talk by Orlan flanked by Richard Dembo, Serge Grumberg, Paul Ardenne, Jean-Jacques Bernard and Jean-Christophe Bouvet.

Television broadcast shot in public under live conditions, hosted by Alain Maneval at the Cartier Foundation, Paris, as one of the foundation's "Soirées Nomades."

This ambitious collaborative effort was launched with the exhibition of Orlan's posters at the Forum des Halles, a shopping mall and cinema complex in central Paris. The posters, with their montage of images, eclectic lists of participants, and evocative titles *(Corporis Fabrica, Narcis, Le Baiser)* attracted considerable attention, inciting potential viewers to seek out the movies in the theaters. For this occasion, Orlan produced a collector's edition "DVD," in fact, an audio CD of the soundtrack, snippets of dialogue written by Serge Quadrupani and performed by Orlan, Manuel Joseph, and Philippe Pigeard, as well as an explanatory booklet with a text by Jean-Pierre Rhem. "A Shot at a Movie" is still in progress.

2001
Trailer for *Le Plan du film*, based on the poster for *Oscillations*.

Cast: Jean-Michel Ribettes, Izou, Frédéric Mollard, Orlan, Frédéric Comtet, Philippe Ramette, Vincent Wapler, and others.

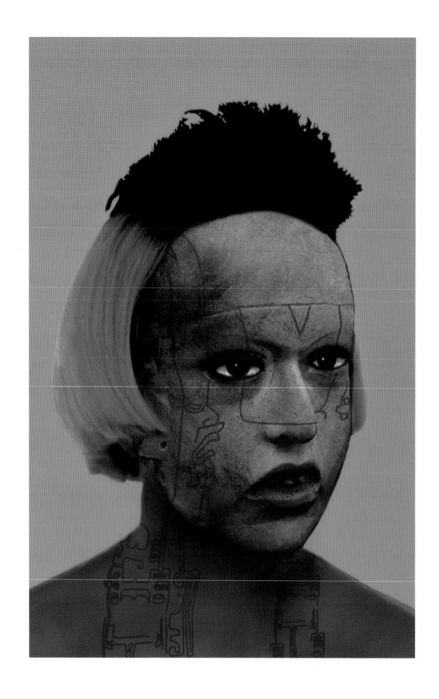

1999
Défiguration-refiguration: Self-hybridation précolombienne No. 1 (Disfiguring–Refiguring: Pre-Columbian Hybridization No. 1)
39 ⅓ x 59 in. (100 x 150 cm), aluminum-backed Cibachrome.
Jacques Kerchache collection.

Orlan's long-standing fascination for the dialectic between disfiguration and refiguration, the mingling of the real and the virtual, led to the *Self-Hybridizations* series. In her operations/performances, and the videos and photographs that result from them, Orlan tackled ideal standards of beauty as they are promoted in Western cultures and art history. For the *Self-Hybridizations*, she worked with a digital imaging specialist to produce hybrid photographic portraits in which her facial features (transformed by plastic surgery) were combined with the features found on artifacts from pre-Columbian (Olmec, Aztec, and Mayan) civilizations and masks from a number of black African civilizations.

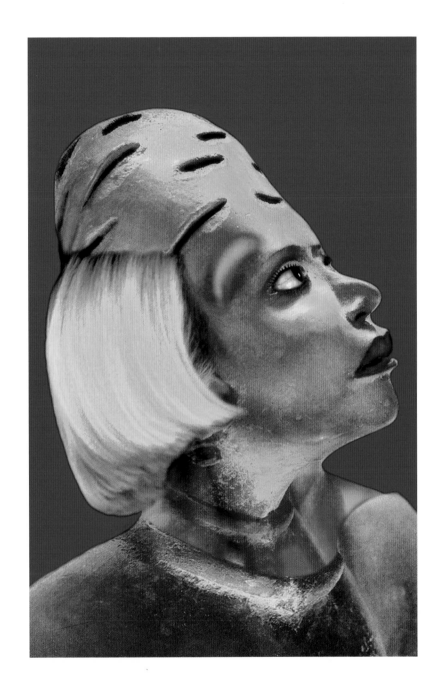

1999
Défiguration-refiguration. Self-hybridation précolombienne No. 2
39 ⅓ x 59 in. (100 x 150 cm), aluminum-backed Cibachrome.
Musée National d'Art Moderne-CCI, Centre Georges Pompidou, Paris.

Orlan has traveled extensively throughout Mexico and Africa. She has studied pre-Columbian and African histories and ethnologies, their specific notions of beauty, their rituals and rites, specifically those related to death, their particular understanding and use of the body, their clothing and costumes. Here, the hybrid is not simply two images brought together to make a third, but a composite of non-Western and Western cultures, of the past and present, of sculpture, masks, and photography, of Orlan's skin and stone, wood, flesh, wounds, and scars. Defining herself as the "Cybernaut of my own faces, representations, nomadic, moving, without frenzy, *without discrimination,*" Orlan has written or cited from texts in a set of "computer files" that reflect on virtuality and reality and illuminate her intentions:

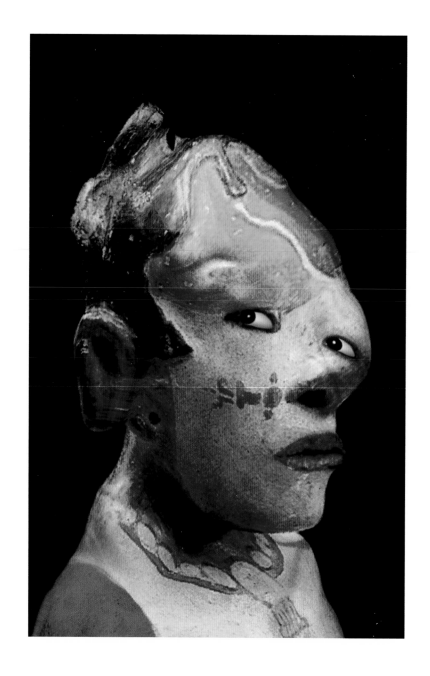

1999
Défiguration-refiguration. Self-hybridation précolombienne No. 4
39 ⅓ x 59 in. (100 x 150 cm), aluminum-backed Cibachrome.
Fonds national d'art contemporain, Paris.

"Refiguration, reduction, recomposition: construction. Call into question resemblance"; "Hard Drive/Boot up again: blunt obsidian, tear out the heart/scalpel, gives color: the fingers will paint themselves without pain Dr. Norton." Orlan deliberately worked with color for the pre-Columbian prints; each head appears on a solid color background, as in her *Femme qui rit*, *Les idiotes*, and *Peau d'âne* pictures. In contrast, she turns to black and white for the African images, in reference to original photographs taken during early ethnological missions. In each series, Orlan's features (which she named Euro-Parisienne, or Euro-Stéphanoise, "from Saint-Étienne") are more or less recognizable; one can spot her signature two-toned hair, her implants, her eyes, or her lips. Certain of the hybrids are monstrous in appearance, with deformed skulls, crossed eyes and long, oversized noses, and their "type" is difficult to ascertain. Others recall images by modern or contemporary artists who

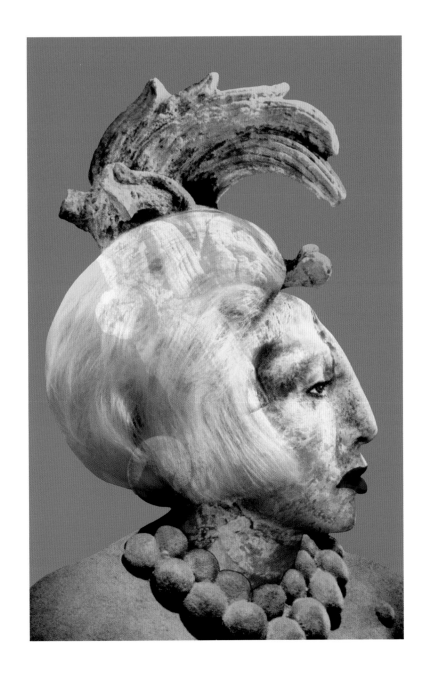

1999
Défiguration-refiguration. Self-hybridation précolombienne No. 17
39 ⅓ x 59 in. (100 x 150 cm), aluminum-backed Cibachrome.
Private collection.

questioned resemblance and dissemblance in their work, such as Pablo Picasso, Georges Braque, or Francis Bacon, or who were interested in the "primitive." Finally, working on the same principle of corporeal and cultural hybridization, Orlan has created several life-size resin sculptures, such as *Nuna Burkino Faso Sculpture with Scarification and the Body of a Euro-Saint-Étienner with Facio-Temporal Lumps* (2000), which was first exhibited at the 1999 Lyon Biennial, organized by Jean-Hubert Martin.

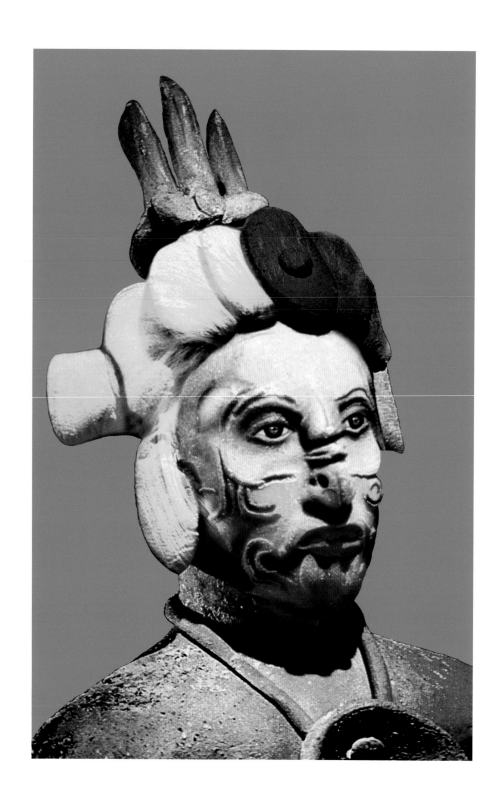

1999
Défiguration-refiguration. Self-hybridation précolombienne No. 18
39 ⅓ x 59 in. (100 x 150 cm), aluminum-backed Cibachrome.
Jean-Michel Ribettes collection.

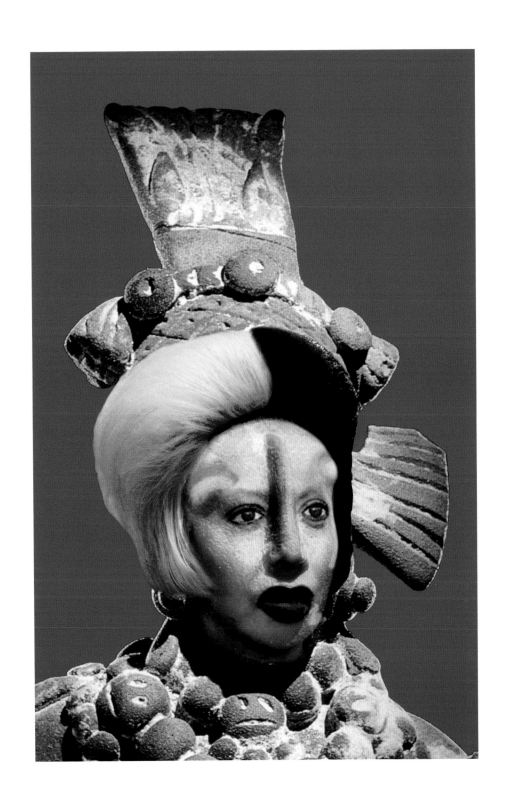

1999
Défiguration-refiguration. Self-hybridation précolombienne No. 27
39 ⅓ x 59 in. (100 x 150 cm), aluminum-backed Cibachrome.
Jean-Marc Michali collection.

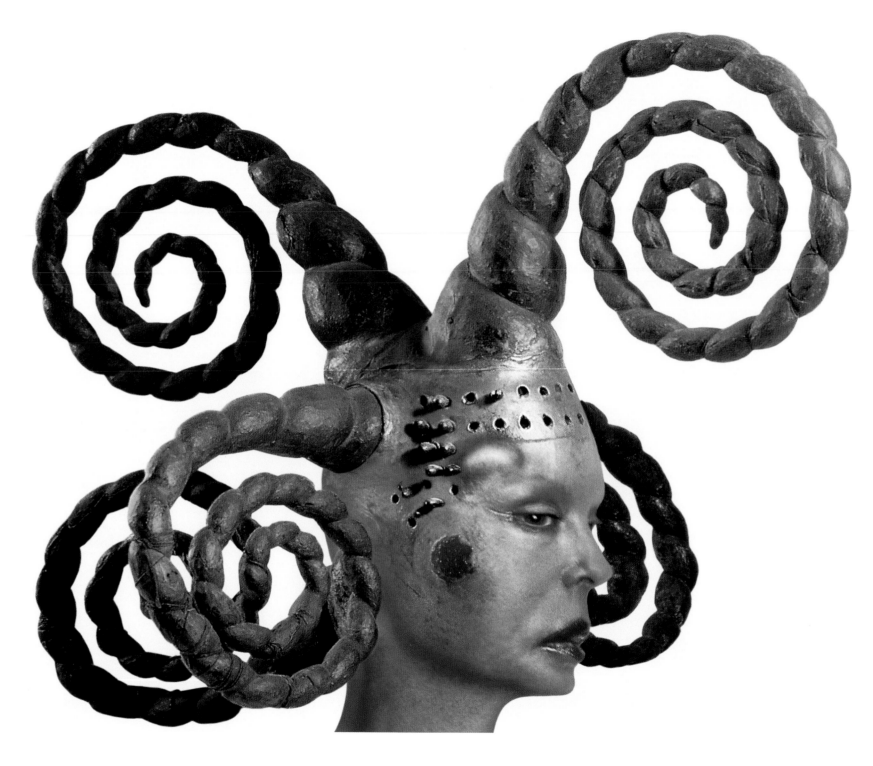

2000
Self-hybridation africaine: Cimier ancien de danse Ejagham Nigéria et visage de femme euro-stéphanoise
(African Self-Hybridization: Old Ejagham Dance Crest, Nigeria, with Face of Euro-Saint-Étienne Woman)
49 ¼ x 61 ½ in. (125 x 156 cm), digital photograph on color photographic paper. Edition of seven.
Nadia and Cyrille Candet collection, courtesy Michel Rein Gallery, Paris.

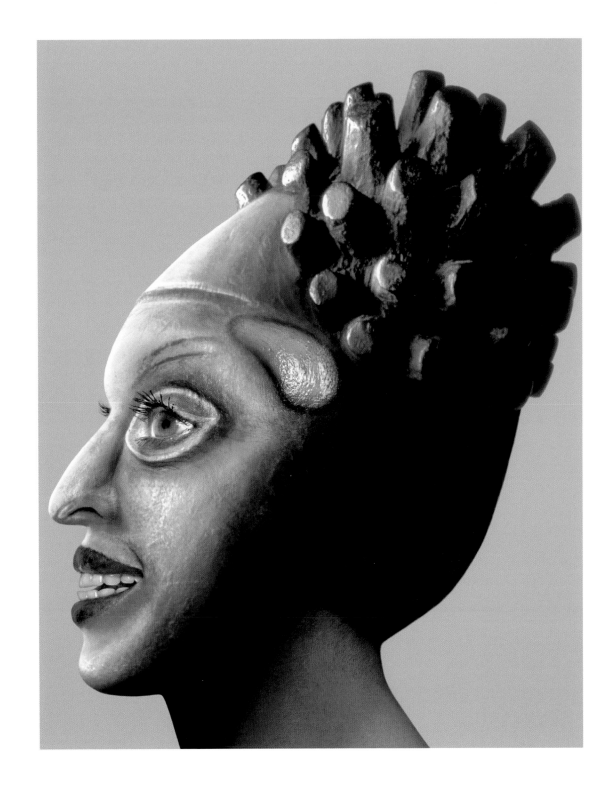

2002
Self-hybridation africaine: Masque de notable Kom du Cameroun et visage d'artiste euro-mondiale
(African Self-Hybridization: Mask of Kom Notable, Cameroon, with Face of Euro-Global Artist)
49 ¼ x 61 ½ in. (125 x 156 cm), digital photograph on color photographic paper. Edition of seven.
Courtesy Michel Rein Gallery, Paris.

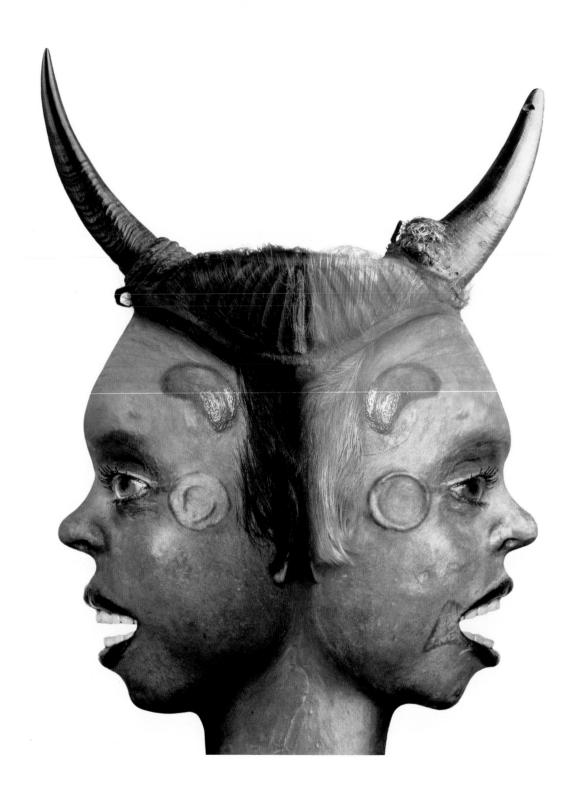

2003
Self-hybridation africaine: Masque Janus Ekoi Nigeria et visage de femme euro-forézienne
(African Self-Hybridization: Ekoi Janus Mask, Nigeria, with Face of Euro-Forezian Woman)
49 ¼ x 61 ½ in. (125 x 156 cm), digital photograph on color photographic paper. Edition of seven.
Courtesy Michel Rein Gallery, Paris.

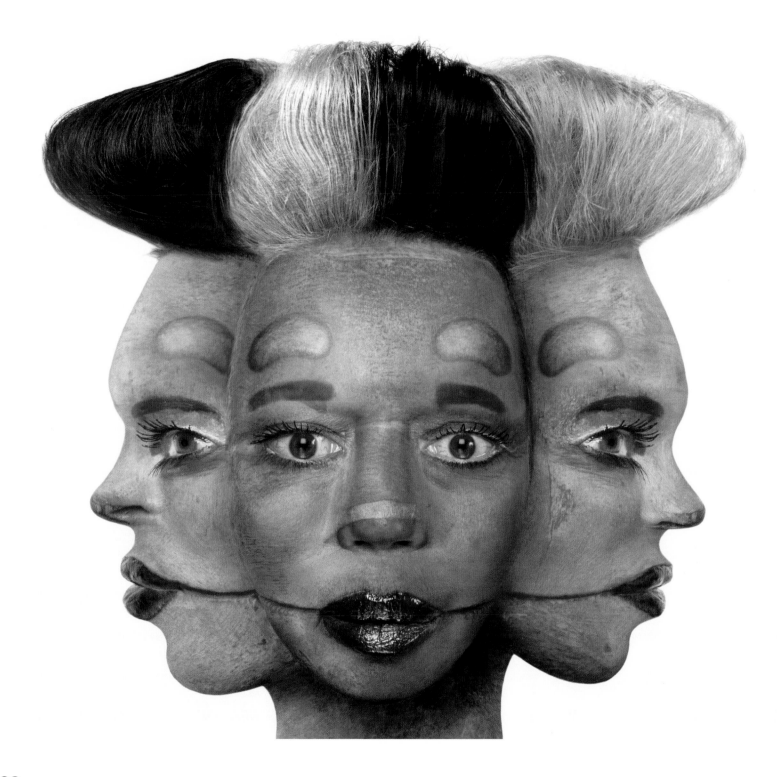

2002
Self-hybridation africaine: Masque tricéphale Ogoni du Nigeria et visage mutant de femme franco-européenne
(African Self-Hybridization: Three-Headed Ogoni Mask, Nigeria, with Mutant Face of Franco-European Woman)
49 ¼ x 61 ½ in. (125 x 156 cm), digital photograph on color photographic paper. Edition of seven.
Courtesy Michel Rein Gallery, Paris.

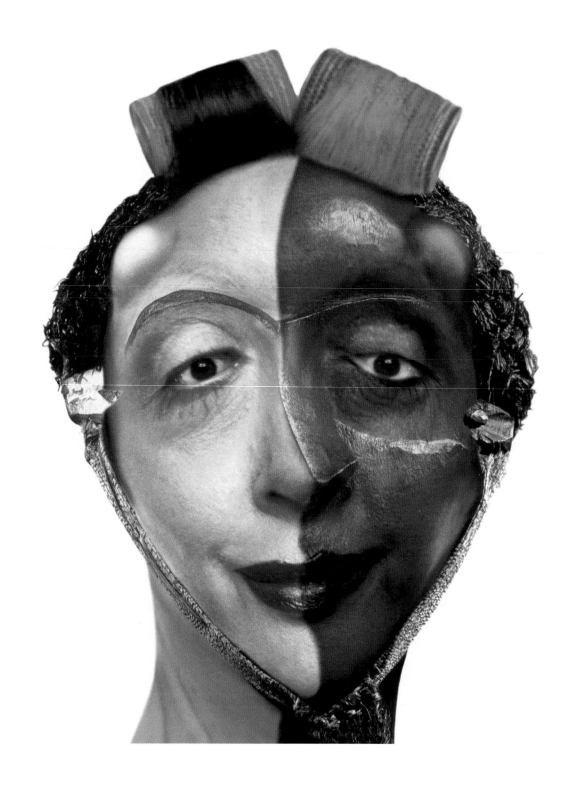

2002
Self-hybridation africaine: Masque Mbangu moitié noir moitié blanc et visage de femme euro-stéphanoise avec bigoudis
(African Self-Hybridization: Half-White Half-Black Mbangu Mask with Face of Euro-Saint-Étienne Woman in Rollers)
49 ¼ x 61 ½ in. (125 x 156 cm), digital photograph on color photographic paper. Edition of seven.
Jean-Michel and Pastri Beurdeley collection, courtesy Michel Rein Gallery, Paris.

176

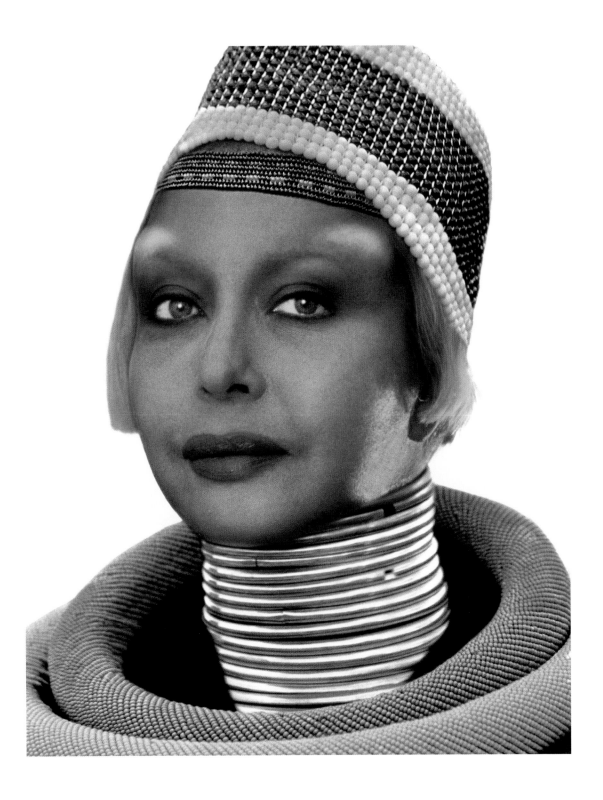

2002
Self-hybridation africaine: Femme girafe Ndebelé souche Ngumi Zimbabwe et visage de femme euro-parisienne
(Ndebele Giraffe Woman of Ngumi Stock, Zimbabwe, with Euro-Parisian Woman)
49 ¼ x 61 ½ in. (125 x 156 cm), digital photograph on color photographic paper. Edition of seven.
Fonds régional d'art contemporain, Île-de-France, France.

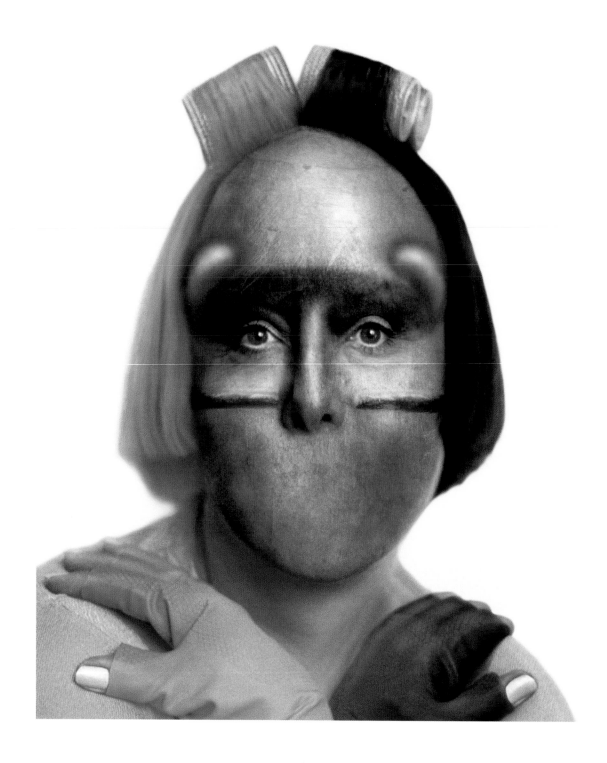

2002

Self-hybridation africaine: Masque Songye "de secret" et femme aux gants euro-forézienne avec bigoudis
(African Hybridization: Songye "Secrecy" Mask and Gloved Euro-Forezian Woman with Rollers)

49 ¼ x 61 ½ in. (125 x 156 cm), digital photograph on color photographic paper. Edition of seven.

Jean-Michel Cambilhou collection, courtesy Michel Rein Gallery, Paris.

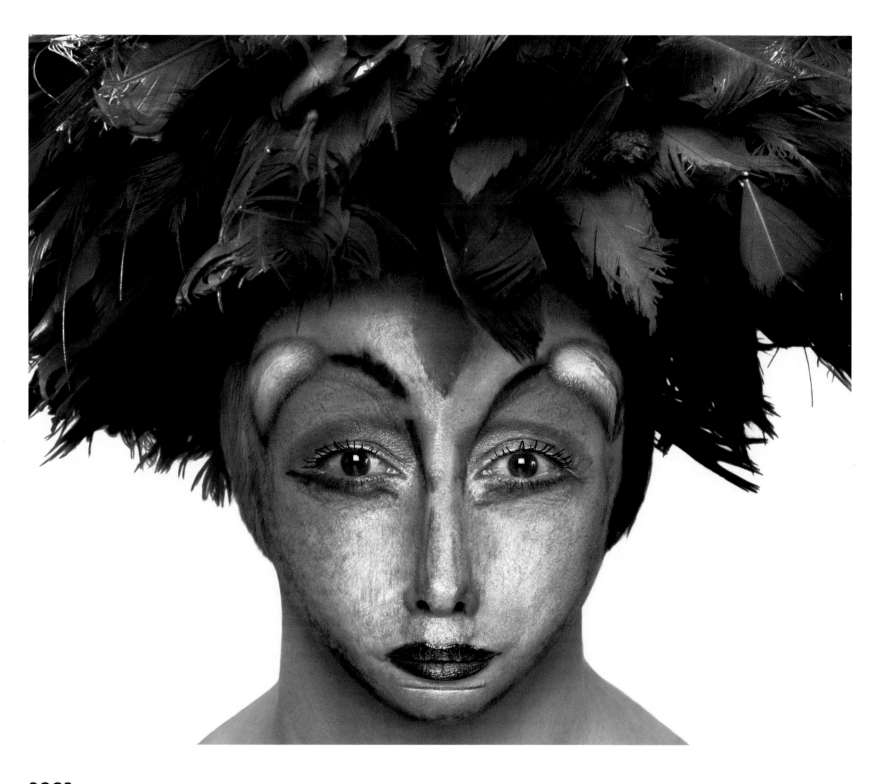

2003
Self-hybridation africaine: Masque de société d'initiation Fang Gabon et visage de femme euro-stéphanoise
(African Self-Hybridization: Fang Initiation Group Mask, Gabon, with Face of Euro-Saint-Étienne Woman)
49 ¼ x 61 ½ in. (125 x 156 cm), digital photograph on color photographic paper. Edition of seven.
Courtesy Michel Rein Gallery, Paris.

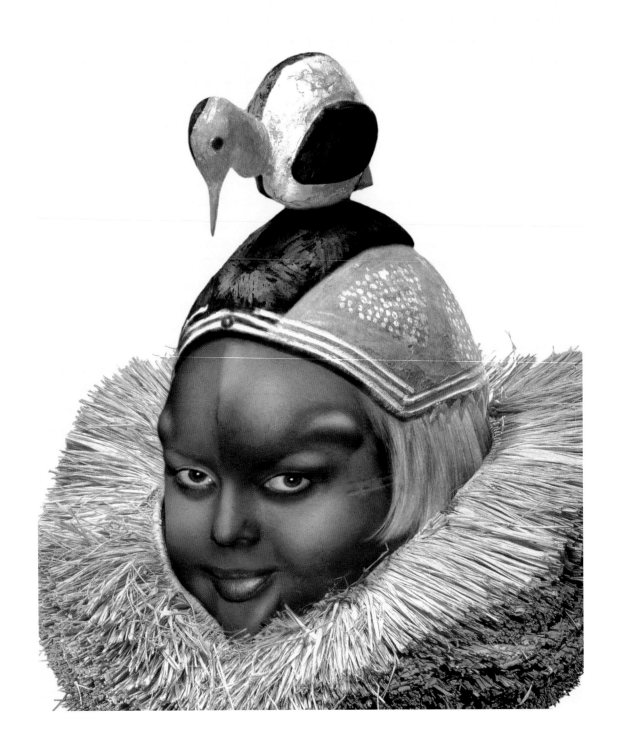

2002
Self-hybridation africaine: Masque heaume Suku avec oiseau et visage de femme euro-stéphanoise
(African Self-Hybridization: Suku Bird Helmet-Mask with Face of Euro-Saint-Étienne Woman)
49 ¼ x 61 ½ in. (125 x 156 cm), digital photograph on color photographic paper. Edition of seven.
Courtesy Michel Rein Gallery, Paris.

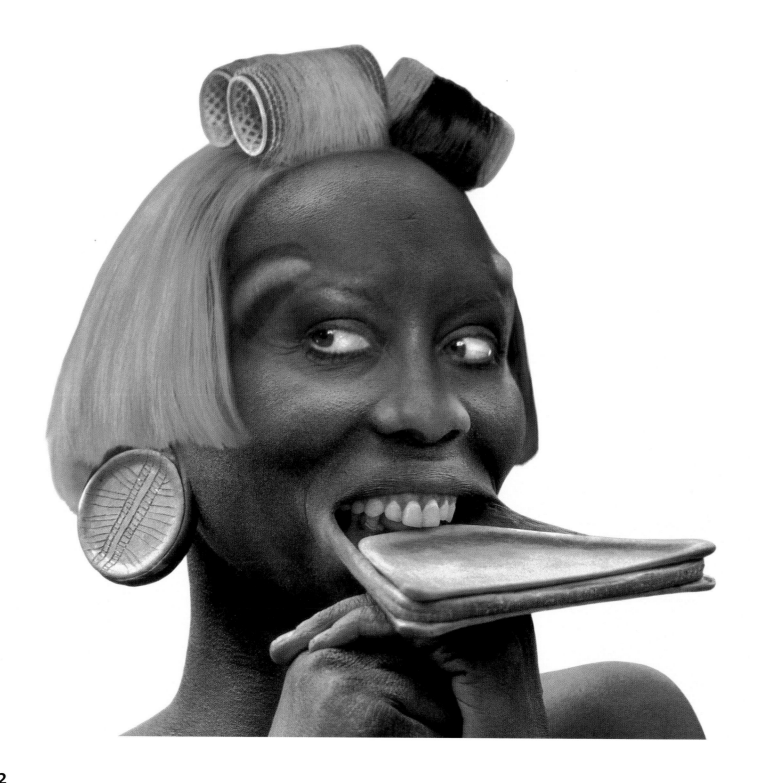

2002

Self-hybridation africaine: Femme Surmas avec labrets et visage de femme euro-stéphanoise avec bigoudis
(African Self-Hybridization: Surmas Woman with Lip Plug and Face of Euro-Saint-Étienne Woman with Rollers)

49 ¼ x 61 ½ in. (125 x 156 cm), digital photograph on color photographic paper. Edition of seven.
Michèle Barrière collection, courtesy Michel Rein Gallery, Paris.

2003
Bien que . . . oui mais (Although . . . Yes, But)

Photographs from the video piece Mementori épicurien. DVD. Edition of seven. Original musical score by Frédéric Souchez. Editing assistance by Lucien Loustou.
Courtesy Michel Rein Gallery, Paris.

 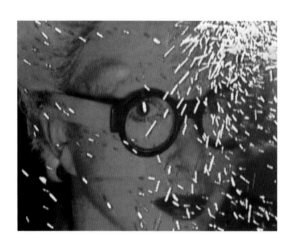

Anthology

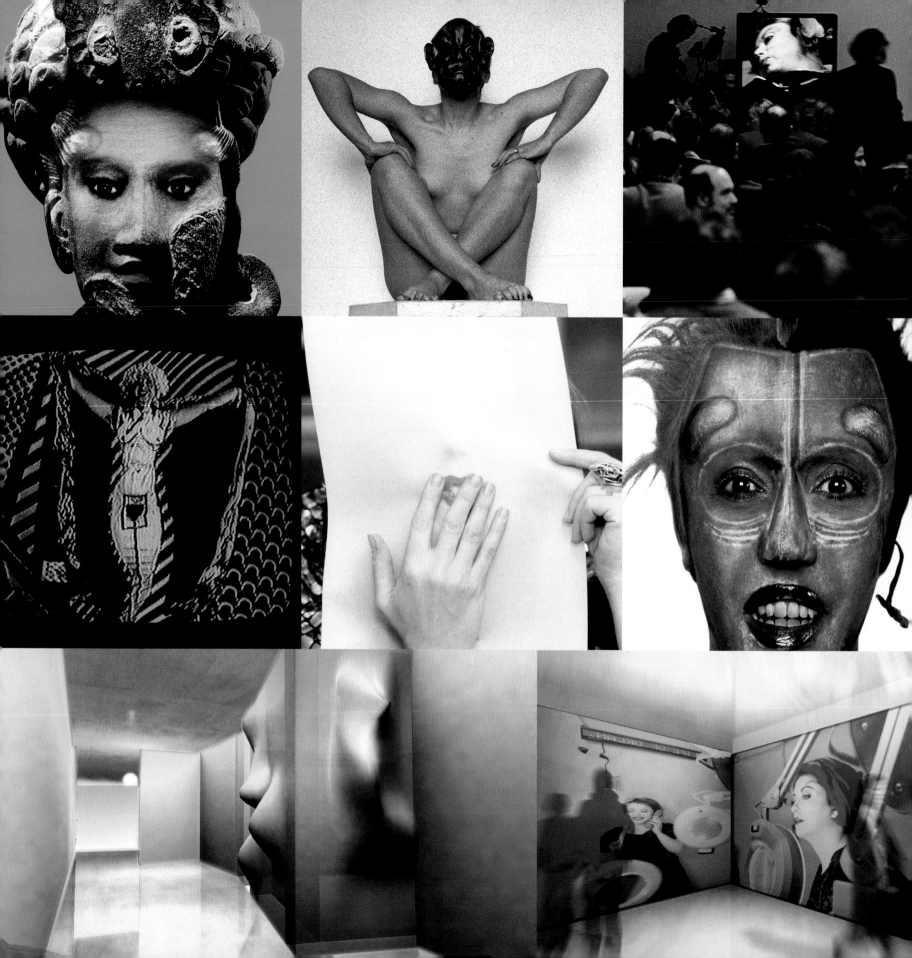

Orlan Interviewed
by Hans Ulrich Obrist

Hans Ulrich Obrist: To begin the interview, I'd like you to tell me about the place we're in right now, your studio. Would you describe it as a laboratory? Or a site of research? A place of production? An archive? How does it function?

Orlan: It's a little bit of all those, all at once. It's also a living space. On this table where you've put your recording equipment, there are currently lots of photos of my work for a book I'm doing, but sometimes there's food, too! Everything happens pell-mell. At the same time, my studio's a place of production, a storeroom, and a packing space, because works are constantly moving in and out. And it's also where my assistants work, so there's an office with computers, and people work here day and night on all kinds of things—simultaneously filing the archives, trying to answer all the requests that come from everywhere via the web, or from students doing theses on my work, or from art critics, television stations, and exhibition and conference organizers. So it's all mixed up, but that's what I like. I like work and ideas to be part of ordinary, everyday life.

Hans Ulrich Obrist: So even on the level of your workplace, there's no distinction between art and life—it's all one place.

Orlan: My mental space and private life resume their normal roles when I'm no longer on show, when visitors and my assistants have left. I must also say that, despite appearances, my work is much more independent of my life than it may initially appear.

Top to bottom, left to right: *Self-hybridation précolombienne, No. 35* (Pre-Columbian Self-Hybridization No. 35, detail), 1998, cibachrome / *Corps-sculpture au carré, jouant des coudes, avec masque* (Elbowing Sculpture-Body, Squared, with Mask), 1965, black-and-white photograph / *Mise en scène pour un grand Fiat* (Staging her Great Fiat), 1982, video / Sixth Surgery–Performance , 1993, color photograph /*Self-hybridations africaines* (*African Self-Hybridizations), 2000, digital photograph /Proposals for the CCC exhibition in Tours, March 2004.

Hans Ulrich Obrist: So how are your archives organized? I can see there's an entire archive department here, there are catalogs, films, and so on. How do you file the vast collection of existing imagery?

Orlan: With difficulty. Let's just say there's a disorder that constitutes my personal type of order. So many things in an artist's life pile up, constantly growing higher! There are works dating back to 1964, 1965, 1966, many things that have vanished during successive moves, disasters, thefts, and losses. And what remains is constantly being disorganized. Since there are almost always requests for material from the press, and from forthcoming publications and exhibitions, there are items that are lent out; and since we're "a business undergoing a growth crisis"—that is to say, there aren't enough of us here to do all the work to be done—the archiving suffers. For example, I'd just about managed to file all the slides, negatives, etcetera, but because of the constant coming and going these archives are currently open, being rifled apart; it'll take me several months to get everything back, at which point several key pieces will probably have disappeared, even supposing that I manage it, because meanwhile there will be lots of other requests. Added to that is the fact that I teach in an art school and give lots of lectures and travel; I'm not a full-time secretary and archivist, and there is a great deal of filing that I can't delegate because there are too many things that only I know.

Hans Ulrich Obrist: The question of archives occurred to me on seeing your show in Nantes, and also, incidentally, on taking a closer look at the posters for the films, because they reveal that you use existing pictures, that you recompose old images and give them a new life. So it seems like the archives must have a direct impact on the way you work.

Orlan: In fact, as my work evolved, I'd intended to pursue each series until I'd completely assembled thirty or forty works. In other words I would have liked each series to reach a cataloguing stage, a complete and exhaustive documentation. But given lack of time and resources, I rarely managed it. So most of the time my works have taken the form of a prototype of a series I hope to continue some day. For example, there were a huge number of photos that were supposed to be published in editions of five or even seven copies; almost all the negatives for a given series were supposed to be printed, but it just never happened, and since then certain negatives have been damaged or lost—not all of them, of course—but there have been losses. What's more, as you know, people always want to exhibit either the most recent or best-known works, which is okay when you're a young artist who's just getting started, but when you have twenty or thirty or forty years of work behind you, it creates this strange situation: you completely forget certain pieces you did, simply because they weren't sought after or didn't come to light at just the right moment. So on reopening the archives, as I've just done for this book, some works leap out at me, which is very moving. I myself come across images I thought were completely lost, or pictures that had stirred my imagination at a given moment but that I hadn't pursued or exploited for various reasons. You just mentioned the Nantes show, called *Eléments Favoris* (Favorite Items), organized by the Fonds Régional d'Art Contemporain (FRAC), which is very

typical of what I've just been saying. Jean François Taddéi, who understood all this, offered me the possibility of redoing pieces that no longer existed, such as *Etalon: Un-Orlan-Corps* (Standard: One-Orlan-Body). I'd kept some photos that showed me during the ICC show in Antwerp with this *Etalon: Corps*, but the object itself no longer existed! I felt all the sadder at having lost it since it could have been shown in relation to *Un-Orlan-Corps-de-Livres* (One-Orlan-Body-of-Books). Sometimes there are projects that never even existed concretely, that exist only in my memory, but which I'd like to concretize. So some pictures trigger my memory, enabling me to put the puzzle back together. Such photos allow me to stress the continuity in my work. When you look at one of my works, you'll see there are lots of photos and items that I've already used in other contexts and in other ways. These objects don't play a decorative or illustrative role; they play a role—an extremely precise role—in the staging of my installations or photographs. They work on the thread spun by a given piece, and also on all the other intersecting threads, on the rhizomes. I've always intended to generate the terms of a vocabulary that, in the totally unconventional context in which I use it, produces phrases that don't necessarily have anything to do with the starting point of the work. For example, I've taken a lot of photographs, "photo-photos," by which I mean photos that were not pictures of performances but photos posed in a studio, where you see me holding easels—a little white easel and a little black easel. Easels recur often in my work because, like most artists, I began with drawing, painting, and sculpture, and so an easel is simultaneously a symbolic landmark and something to struggle against.

Hans Ulrich Obrist: Was that before your early work of the years 1964 and 1965?

Orlan: No, not those photos. On the other hand, the masks used in the early photos, and the idea of the plinth and the body-sculptures, have often recurred. I got my start in painting when I was just a teenager, and the same goes for poetry, as documented in the 1967 book *Prosésies écrites* (Written Proems).

Hans Ulrich Obrist: On seeing the Nantes show I said to myself, if we look at Viennese Actionism, for instance, and much of the 1960s art related to action and performance—seen most clearly in Otto Mühl—there is almost always a line that runs from painting and opens into other spaces before winding up at action-based art practices.

Orlan: True, but Mühl also returned to painting!

Hans Ulrich Obrist: Yes, that's true. In your case, is there such a line or are these various activities pursued in a parallel fashion?

Orlan: Well, I've found some early works painted in 1961, 1962, and up to 1964 that of course I wouldn't want to acknowledge today—we've all gone through a thumb-sucking stage!—but for which I have photos. While I was doing photography, I continued to paint. And you might say I retraced the history of art for my own purposes, beginning

with figurative painting then moving on to abstraction—lyrical and geometric abstraction—then incorporating objects into paintings. I also did collages and all kinds of large tapestries of stitched or glued fabrics. But little by little, I broke free of painting; I began thinking that, as a female artist, the main material and recording surface I had to hand was my body, which I had to reappropriate because I had been dispossessed of it, in a way, by dominant ideology. Because I was a woman, dominant ideology prevented me from living my personal life and my artistic life the way I wanted to live them. I thought working directly on the representation of my body—including its public representation—was much more interesting, much more problematic, and much more efficient politically—especially in those days—than hiding myself behind canvas and paint. I should also mention that the first canvases I painted were done on sheets from my trousseau, stretched over doorframes because they were cheap—it was all salvage. So my first paintings were done that way. Then I took some of those sheets to my lovers—fine quality linen sheets from my wedding trousseau—asking them to leave some sperm in certain places, and then I marked the stains of sperm by embroidering them with a huge needle and a kind of embroidery thread. I did the embroidery with my eyes shut, or while looking at the audience, or blindfolded. These items have an actual existence; one even belongs to the Fonds National d'Art Contemporain (FNAC), which you must have seen at the FRAC show in Nantes. I also used those same sheets for free, unstretched canvases, and I did sculpture. So to answer your question, the practices were parallel, as demonstrated by this story of the trousseau sheets. But the same applies generally—I always work on parallel projects. Right now there are numerous projects I'm continuing to develop even as I explore other imaginative spheres and mental constructions, and as soon as I find the right context and place I'll redevelop a series that has remained at the planning stage.

Hans Ulrich Obrist: So your practice is not at all linear.

Orlan: Absolutely not. In that respect, I haven't developed an oeuvre that makes it easier for art historians and people who want to write about my work or publish my photos in a monograph like this one. [Laughter.] It's pretty hard to establish a chronology because several series exist in parallel, they overlap, they may stop at one point and begin again at another. I was just talking about easels—I've also used them in their actual dimensions, for measuring streets and institutions, when I'd arrive at an institution with an easel that I'd use to make my observations. And I retained the idea—which maybe comes from my "classical" training as a painter—that all performances are stages in a broader process rather than autonomous entities, just as the work of a painter is a type of research, a work of exploring new paths, from initial sketches to final corrections. So the famous easels constantly accompany me, each time for something new and different but always to produce a work, to make an observation that could be preserved and displayed. Just to conclude this story of the easels, alongside the photos of black and white easels I took photos with white crosses and black crosses that I also used in my surgery–performances, my installations, and so on. For me they were religious objects—not only objects of a kind of religion but also objects of the worship of a certain kind of art: painting. These are the very traditions I'm challenging, of course, that I'm overturning, and this attack

has been placed in perspective in various works that deliberately employ different materials and forms. I've always felt there was as much pressure on the human body as on the body of artworks, and I've also tried to make sure that my work is absolutely not formalist, that it always finds alternative appearances, styles, and ways of expressing itself. A question of shattering your own framework.

Hans Ulrich Obrist: What are your current projects? This book discusses your work of the 1960s and 1970s a good deal, but what are you doing today, November 2, 2003? There's a film, for example, but you probably have lots of other projects.

Orlan: First let's talk about where I'm at with the film. I made movie posters based on a comment by Godard, who basically said, "A masterful film is one made back to front, so that in a way it becomes the flip side of cinema." For this project, titled *Le Plan du film* (A Shot at a Movie), my idea was to take him at his word. Using my own personal imagery, often based on recycled pics—that is to say, photos that couldn't be used on a poster unless painted or rephotographed and manipulated by computer—I designed posters in the form of back-lit boxes like the ones you see above movie theaters. So these posters contained some of my own imagery, with credits based on the names of friends who have supported my work. The credits also featured one or two names of real movie stars to make people think that the film really existed. I placed these posters in the windows of the "artist's corner" of the underground shopping mall in Paris known as Le Forum des Halles. Passersby then starting looking everywhere for the new film by Cronenberg, or the latest film starring Jean-Claude Dreyfus, which they hadn't seen yet but knew must be playing in one of the movie theaters in the mall because they'd seen the poster! I was told that everyone was looking for these films. Parallel to that I did a performance at the Cartier Foundation in Paris, which involved making a large audience think there was a new TV program that would be shot right there that night. The work tried to establish links between contemporary art and the movies. So we set up a fake TV studio, with the group Tanger playing music (that was the group who did the sound track for the fake DVD published by Al Dante). And there was also a real TV emcee and artists like Patrick Corillon and Raymond Hains. . . .

Hans Ulrich Obrist: Sorry to interrupt, but what was the name of the group who did the sound track?

Orlan: Tanger (Tangiers). You probably know one of the members, Christophe Von Huffel, who worked with Dominique Gonzalez-Foerster. Now, where was I? Ah yes, I was saying that we found a real emcee. There were also well-known art critics, visual artists, and even actors and directors. I projected the images from the light boxes and everybody pretended that the film existed. The critics said, "I've just come from the premiere and I'll tell you about the film." And then they'd critique it. Everyone in the audience believed them. Then Jean-Claude Dreyfus recounted not only the plot of the film but also stuff that supposedly took place on the set during shooting, his relationship with the director, and why the film represented a turning point in his career. We thus produced a fifty-two-minute tape of an

authentically fake TV program that everyone thought was real! Meanwhile, I have another fake DVD in the works—when I manage to find a way to finance it—which this time will have images as well as sound, and which will include the synopses written ex post facto, or "back to front." We also made a trailer for a non-existent film, directed by Frédéric Comtet, starring myself along with Philippe Ramette, Vincent Wapler, Jean-Michel Ribettes, and Yzhou, which we screened at the last Cannes festival, where we also displayed the posters. And, finally, we've found a producer to back one of the films. So somebody is actually making it. And in addition to all that, I've met a producer who said he'd back a film if I directed it myself. So right now I'm writing a screenplay based on one of the synopses, and I think shooting will begin at the end of 2004.

Hans Ulrich Obrist: On seeing the posters in Nantes, I noticed the names of various artists, writers, and institutional figures, but I wondered specifically about the choice of David Cronenberg. Was that because you particularly like the director? Could you talk about your relationship with Cronenberg?

Orlan: I know I like Cronenberg's work a lot, and I think it's a shared feeling. We met because he read my "Manifeste de l'art charnel" ("Manifesto of Carnal Art") in an American book called *Bad Girls and Sick Boys*. After reading the essay, he wrote a script called *Painkillers* and asked me to play myself. I think it will be his next film, he's now redoing the screenplay, which will obviously take some time.

Hans Ulrich Obrist: You acted in Cronenberg's upcoming film?

Orlan: No, no, he wrote a script in which I'm given a part, I'm not the star, obviously.

Hans Ulrich Obrist: But you're really in discussion with him.

Orlan: That's right, it's a real discussion. I told him about the movie-based work I was doing, and asked his permission to put his name on one of the posters. He agreed. It was one of the posters I showed at Cannes the same year he screened *Spider*.

Hans Ulrich Obrist: You also credited Charlemagne Palestine with the music.

Orlan: Ah, yes. Charlemagne's a very old friend, we've known each other for the past ten thousand years, and I really love his music. I've seen him do absolutely amazing vocal and musical performances at the International Performance and Video Festival that I founded and ran for four years in Lyon. I hope someday he'll really do a soundtrack for one of these films.

Hans Ulrich Obrist: So is that your current main project?

Orlan: That's right. A feature-length movie for the general public, with a theatrical release. It won't be just a festival product like some experimental film, but there'll be two levels of interpretation.

Hans Ulrich Obrist: One last question about the film: your name will obviously be on the poster, and I'd like you to tell me about your name. When did you begin to use it? When did it start to become your signature?

Orlan: Orlan is a nom de guerre. When I was very young I underwent psychoanalysis, and at the end of one of the first sessions the analyst said to me—and it was the only thing he said to me during the whole session—"This time you can pay me with a check again, but next time I'd like you to pay me in cash." But as I was signing the check, he said, "No, now that I think about it, next time you can write another check." So I left with this contradictory message on my mind. All week long I wondered what he meant and why he said it, without really understanding. But before going to the next session, I went to buy myself something—just the way most patients, in fact, buy themselves something before or after, as compensation. I went to buy myself some shoes, probably as a way of "getting the shoe to fit," which is a French expression for "feeling good about yourself." But when signing the check to pay for the shoes, I saw what the analyst saw; he saw something that my friends hadn't seen, that my mother hadn't seen, and that I myself had never seen, namely that the signature I'd adopted (after having spent hours of practice and numerous sheets of paper testing a whole series of wonderful flourishes to get it right)—he saw that my signature spoke volumes, because the letters of my name that stood out were *M, O, R, T, E* (D, E, A, D). That's what the calligraphic signature I'd adopted actually spelled out! So on my way to the session I said to myself that I would no longer play "dead"; but I wanted to reuse the syllables to produce a positive connotation, by altering the signature. That is to say, I wanted to retain the word *OR* (gold). I don't know why I then added *LAN* (slow). Obviously, instead of "slow gold" I might have opted for *vif* (quick) or *rapide* (swift), but that's just the way it turned out—from that moment onward I called myself Orlan and now it's on my passport.

Hans Ulrich Obrist: What other projects are currently underway?

Orlan: It always depends on contexts, resources, and people who invite me to do something and make things possible. Currently I'm working on sculptures in resin, which might be called "mutant bodies," and which are a direct extension of my *Hybridations africaines* (African Hybridizations). I'm also working on an old project, a series of reliquaries, with an excerpt from a text by Michel Serres that served as the point of departure for one of my surgery–performances (just like the other operation–performances, which were all based on texts by people like Julia Kristeva, Michel Serres, Eugénie Lemoine-Luccioni, etc.). So this reliquary, which is very heavy, being made of metal and burglar-proof glass, holds a text by Serres and a little flesh in the middle, preserved in resin. The text is really wonderful.

My idea is to explore the relationship between the flesh and the word, the intention being that it's not the word that becomes flesh but the flesh that becomes word. The principle behind the series is to make as many reliquaries as possible until the body no longer exists, until there is no more flesh to place in reliquaries, each time with the same text but translated into a different language. For example, the most recent ones I've done, which you saw in Nantes, were produced by the Israel Museum in Jerusalem and contain a text in Hebrew, a text in English, and also a text in Arabic. In fact, the project is ongoing, and there will be a show, which is one part of the whole retrospective exhibition at the Centre National de Photographie (CNP) and simultaneously in the CCC in Tours and the Museum of Photography in Moscow (where I hope to be able to do a reliquary in Russian). I should point out that I'm actually selling my body in these reliquaries, which is not really legal.

Hans Ulrich Obrist: That brings up a general feature of your work, when you say it's an old but ongoing project—because there are many others. In fact, you never work to the time frame of a specific exhibition; you always inscribe your projects in a much broader time frame. I find it very interesting that artists are drawing us into their own temporality, their own time-scales. I've read that your first project to stretch over years and years was *MesuRages* (MeasuRages).

Orlan: Yes, that's true. But *Le Drapé et le Baroque* (Drapery and the Baroque) also lasted a very long time, as did *Draps du trousseau* (Sheets from the Trousseau) and, in fact *MesuRages*. It was even a bet that I made with myself: I wagered that I'd be doing *MesuRages* all my life. But I don't know if I'll win the bet. For instance, if a museum were being built now, and invited me to the opening to do its measurements, then I'd happily do it. Because I always work from architectural plans, and I try to retrace lines that were part of the architect's conception but are invisible in space. I've measured many spaces that way, from the Guggenheim Museum to Le Corbusier's Housing Unit in Firminy. In the latter case I was establishing a parallel between Corbusier's Modulor system and the *Orlan-corps* system. I've measured different kinds of spaces, and even streets. One day someone suggested something that might well be proposed again: in Liège a neighborhood association was campaigning for the protection of a site in the city that had been completely demolished and for which there were absolutely no redevelopment plans. The association invited me to come, and over four days I measured everything, using the very machines that had demolished the place—bulldozers picked me up in their jaws every morning and took me to the site for that day. I took advantage of this to state that every time I've performed an action, a performance of the *Orlan-corps*, I have always done them as a function of the context in which they occurred—not only the intellectual, social, and political context, but also as a function of the specific space in which I had to work. This means that every time these actions have taken on totally different forms and appearances, even though there has been a constant thread, a leitmotif that never changed: I would enter the space with my easel, and would begin my calculations wearing a smock-like dress made from a sheet from my trousseau—I didn't want the measurements to be made with a naked body, but with a socialized body, which means a body that is dressed (even overdressed) in a gown made of trousseau linen, one that goes over other garments and is meaningful in my artistic work since it plays the role of a screen.

Hans Ulrich Obrist: So there are rules to the game, then.

Orlan: That's it, it's a game with rules. The movements are the same, and it always ends with the recovery of dirty water from the public washing of my dress, water that I keep in a jar. This water is then decanted into smaller vials that are labeled, sealed with wax, and exhibited in galleries with a commemorative plaque about the event, etc.—sorry if we're getting too far away from the original question.

Hans Ulrich Obrist: That's okay, it's interesting. I was asking if the measurements were the first long-term project you'd launched, and you were saying that in a sense they even continue today.

Orlan: At least, they could carry on if the circumstances and the location were right. How can I put it? These measurements are exactly like the surgery–performances. I'm not trying to get into the *Guinness Book of Records*, I don't want to do the greatest possible number of measurements during my lifetime, and I don't want to push this idea at any cost, but if there were a place or a request that seemed right, or if I myself projected the idea on the place and assembled the technical, intellectual, and artistic resources, and had the necessary guarantees that it could be done correctly, then I'd do it. For example, when it comes to the surgery–performances, I have no internal drive that absolutely pushes me to undergo these surgical operations, and I'm not really interested in the end result on a day-to-day level. But if, for example, there were currently a certain context that allowed me to express something very powerfully, that might be the apotheosis of my work at all levels, then maybe I'd do it. For example, one that I've never done but that I've thought about is a purely poetic operation the goal of which would be to show that these days it's possible to open the body absolutely painlessly. There would be photographs and videotapes, just like all the other operations, and they'd show me laughing, smiling, reading, and talking to people. In short, people would see me living my life with my body cut open—and then they'd close me up again. Obviously, everything would be staged in such a way as to produce a certain type of imagery in photos, video, and film.

Hans Ulrich Obrist: So that's a project that hasn't been carried out yet.

Orlan: That's right. And maybe never will be. But it's not impossible, provided that I find a pertinent—and impertinent—context. I first thought of including it in the project with Cronenberg, but in fact what would be much more subtle in the Cronenberg film would be to do a fake operation that allows me to let my visual imagination do just what I want. Fiction allows you to take greater liberties on the strictly visual level—yet I'm sure that everyone who knows my work would think it's a real operation! People are always convinced that the surgery–performances they see on video are naturalistic, that absolutely nothing has been reworked, that the videotape is a kind of "snuff movie" even though that's not the case! Because sometimes during the operation I might say to the surgeon, "Careful, do that move again, the camera didn't catch it," or "Move aside, you're blocking me from the camera,"

and so on. So we start over, we build the image within the operation itself. We have a specific idea of the images we're looking for.

Hans Ulrich Obrist: You began the surgery–performances in 1979. I'd like to talk about the beginning, in Lyon, during a performance festival.

Orlan: A festival I ran for five years.

Hans Ulrich Obrist: True, you were the organizer, but in this instance there was an emergency, right? So you weren't able to "construct" the image...

Orlan: It was an emergency. My body was unwell, my body needed an operation. If we'd waited forty minutes longer, I would have died. I had an ectopic pregnancy. I'd put a lot of preparation into the festival, I wanted to see what the artists I'd invited would do, and then suddenly everything collapsed, from one minute to the next. Still, I had the presence of mind to ask for there to be a video camera in the operating theater. Every time a video was shot at the festival, the tape was shown as though it had been a planned performance. So the idea was to recuperate the real experience as an esthetic phenomenon. It was a question of turning the situation inside out. But I'm glad you've brought up the context of that first operation–performance because people often think I just woke up one morning with a strange mania for having operations done on me, when in fact there were many preliminaries, there were intellectual and physical preconditions and even, at first, vital imperatives that led me to the operating table. Still, I'd always been very interested in the things that occur in that situation: when suddenly you find yourself in an operating theater, with all that overhead light, with that terrific moment of concentration, with colossal efficiency and silence—there's an incredible density completely unrelated to everyday frivolity, a palpable intensity that's fascinating. I'd always said to myself that someday or other I'd work with surgery again, in one way or another.

Hans Ulrich Obrist: Since there was a whole series of surgery–performances, starting in 1979, people might wonder whether there was a master plan behind it. Was that the case with this series, or did it come together little by little?

Orlan: How did things come together? Well, English curators had seen one of my performances. It was a very light performance on the movies that I'd done for a public seminar at the Pompidou Center in Paris. The curators came up to me afterward to say they were organizing a show called *Art and Life in the 90s,* and they invited me to participate. I agreed and began looking for a project. I wanted to do something relevant to the 1990s. I was then reading a book which had two chapters devoted to my work, a book by Eugénie Lemoine-Luccioni called *La Robe*[1], and I came across a chapter that had nothing to do with me but that made me think I could maybe start doing surgical operations.

Hans Ulrich Obrist: So that text served as a trigger.

Orlan: Reading it led me back to the operations again. The written word led to an acting out—which shows just how dangerous reading can be. [Laughter.] The text, written by a Lacanian psychoanalyst, made me realize that psychoanalysis and religion had a lot of points in common; in particular, both turn the body into a shrine. And I felt all those ideas were anachronistic. I thought, these days a lot of people have had to violate the sanctity of their bodies, but the sky doesn't fall on their heads. There are people who are obliged to alter their bodies after a car accident, people who have their nose changed, or a kneecap or hip replaced, or who knows what—and they're none the worse for it! Neither physically nor mentally. In short, the actual alteration of the body has become almost commonplace, in contrast to the intellectual attitude adopted by some people. My first surgery–performance was supposed to take place in Newcastle, England, but no surgeon agreed to do it, at least they couldn't find one who would. So I did a piece in a church called All Saints, during which I made a public declaration, a gesture, where my friends and everyone there came to sign a book witnessing the fact that I was going to do this thing. Then I went in search of surgeons, who were hard to find, as I said. Finally I found someone who was very good but very, very cautious, and very wise, because he took things very slowly. That allowed me to see how things might work in an operating theater, to see how far I could stretch the limits of this environment. I often feel close to Christo and Jeanne-Claude because my surgery–performances call for a similar sense of undertaking, a similar need to convince an entire milieu that is often unfamiliar with art. It's a tricky thing to pull off in terms of attitudes, as well as on the practical level. So the first operations were very cautious, and little by little the staging and the scope of the operations became much greater. My approach became more confident. I only did the surgery–performances between 1990 and 1993. But I wanted to add something concerning the latest works now underway: I'm finishing a series of *Self-Hybridations africaines* (African Self-Hybridizations) which is not yet complete, but several of the latest pieces were shown at Michel Rein's gallery.

Hans Ulrich Obrist: And there's also a new film that I saw at the Michel Rein show in Paris.

Orlan: Right, that's a video installation. That was a single-tape version; another version, which might be described as the optimum one, includes three simultaneous projections of the same imagery, though not edited in the same way. It's a kind of Epicurean *memento mori,* showing superimposed images of the fireworks I shot on the island of Gozo, which are now illegal because they're so dangerous. The fireworks are set on poles, and during celebrations people move among the sparks and smell and noise and blinding flashes. It's amazing. I also shot some paving stones at a church not far from the site of the fireworks. They had skulls on them because they were tomb slabs. I combined the images of fireworks with the skulls, which viewers sometimes don't notice because they're subtle. I didn't want to frighten people, I just wanted to suggest the *joie de vivre* of all those blinding flashes, the delight in seeing and being dazzled. But the fireworks are still a metaphor for how fleeting life is. Then there's my own face among all

these images. So when you're caught between all three projections you're really bathed in light, especially since the tapes often white-out. The original sound track by Frédéric Sanchez is there to emphasize the importance of living life to the hilt.

Hans Ulrich Obrist: It's like being immersed.

Orlan: Yes, it's an immersion. I wanted to do a show where there were no barriers between photography, digital imagery, and video, nor between past and present, that is to say maintaining the continuity of my work. Earlier, you brought up the question of time. It's very important to me. I'm not a fashion designer; I don't need to change my look every season, doing little flowers one day, then something else the next. It's important for me to hold a steady course, to follow a method, to maintain a certain progression in my ideas and to return to certain aspects, which are also concepts, that can be reworked and sometimes even corrected. It's an acceptance of time. Which I think can be seen in my work—I love everything historical, I love to show old works, but I also take the present into account and I try to guess what the future holds. There's no schiz between the old and the up-to-date.

Hans Ulrich Obrist: There's another question I'd like to ask. We often come across the famous line "Life is a killer" by John Giorno, which is very present in your studio, and there is also your motto, "Remember the future," which is often cited. But there are other phrases and texts, and I wanted to ask you about the role played by words, which are almost like slogans, in your work.

Orlan: Words are triggers, they're part of the concept and working method. I've just mentioned that the surgery–performances began with texts, that the reliquaries include texts, and so on. I love to read, and certain texts stay with me. There's also the fact that I began my artistic career by writing poetic texts—some have been published—and I've continued to do so. Even now I write short texts almost every day, though I've no desire to show them to anybody. They're for me, aimed at me, and don't have the same status as my visual work; they just spring forth, emanate, whereas my visual work is much more considered.

Hans Ulrich Obrist: So not much of your writing has been published.

Orlan: Some has been published, for instance in the context of the embroidered work I spoke of earlier, shown at the FRAC in Nantes. One published text, called *Réminiscence du Discours Maternal*[2] (Reminiscence of Maternal Discourse),was a play on language and a play on eroticism, too—it was a version of motherly "dos and don'ts," transposed into an erotic-type text. It went with the trousseau sheets with the sperm stains, etc. So a few pieces have been published—"Le Manifeste de l'art charnel" ("Manifesto of Carnal Art") is another example, as are "Moteur de recherche/images nouvelles images/visages" ("Search Engine/Pics/New Pics, and Faces") and "Virtuel et réel:

dialectique et complexité" ("The Complex Dialectics of Virtuality and Reality") both published by Al Dante in the catalog on my pre-Columbian self-hybridizations. I've also given a lot of lectures that were written and occasionally published. It's true, however, that writing has become mainly an affair between me, myself, and I—a reunion with myself. The titles of my artworks, though, are often long and, I feel, very important. They're a play on language.

Hans Ulrich Obrist: Could you tell me a little about the "self-sculptural principle"?

Orlan: Okay. I can't exactly remember when I used that term. All of a sudden Victor Hugo's *Laughing Man* comes to mind. The flesh sculptures are also texts that have greatly fascinated and rewarded me. Things as violent as children being put into vases that were only broken after several years so their bodies were completely misshapen, etc. I wanted to do flesh sculptures the way I did sculptures of lines and folds, with the idea of increasing possibilities and faculties, never reducing them or developing a fascination with self-mutilation. I feel very, very removed from certain artists who work on piercing, blood, tattoos, bodily modifications and cutting into the body, even though I've been called the instigator of all that. In short, I don't at all share the culture of masochistic public sport. For me, pain is of no interest in itself, it's just an alarm signal, or maybe orgasmic, but has nothing to do with art or constructing anything. Pain just isn't a working hypothesis—on the contrary, I think our bodies have suffered enough over the ages, and we're now in a position to curb pain. So it's really very important to demonstrate the opposite—I think pain is anachronistic, we can now alter the body without provoking pain. I'm a campaigner for the use of epidural anesthesia and relief medication by medical teams often reluctant to use them.

To return to the self-sculptural principle, I confess I can't remember the context in which I used that exact term, or why. In my opinion, it probably concerned one of my first works, *Orlan accouche d'elle-m'aime* (Orlan Gives Birth to Her Loved Self), which involved the idea of giving birth to oneself but at the same time that birth was a split, a cloning, a play on identity and otherness. Hence the idea of creating oneself or "self-sculpting." In that respect, the surgery–performances are an extension of these ideas, a way of refiguring yourself, of vacillating between disfiguring and refiguring, the idea of not accepting what is automatically inherited through genes—what's imposed, inevitable—but of trying to pry open the bars of the cage. It's just an attempt, obviously. Bernard Ceysson authored a catalog on one of my first surgical operations, *Orlan ultime chef d'oeuvre* (Orlan: Ultimate Masterpiece)—art historians called me a living sculpture. It was also present in the idea of retransforming my body in a way that violated dominant esthetic criteria. If I'm verbally described as a woman with two big lumps on her forehead I'll probably be taken for an unscrewable freak; but if people actually see me, it's possible they'll look at me differently, or at any rate they'll realize that the lumps are esthetic possibilities—assuming, of course, that people manage to free themselves from the models conditioning their judgment. When people say, "I want, I love, I desire," it's always in terms of the models we've been presented with. The changes I made to my face were an attempt to sidestep the norms by which we—and I—are constrained. And also an attempt to make my body a site of public debate. And from that angle, I've sure succeeded!

Hans Ulrich Obrist: I'm very interested in the notion of interdisciplinarity, the idea of bridging various fields. Early in the twentieth century, Alexander Dorner said that we couldn't understand visual culture if we didn't understand what was going on in other fields; Duchamp, for instance, was interested in the mathematics of Henri Poincaré. In your case, how would you describe your interest in, or your relationship to, medicine and science?

Orlan: Right—I think medicine has made extraordinary strides. It has become a high-tech field, its methods are totally changing. I'd even say that the avant-garde is no longer to be found in the field of art but rather in the sciences, in biotechnology. I think artists should seek elsewhere. We have to put everything we represent—our awareness and insight as artists—into perspective with what the brains in those and other fields are doing, but in our own way.

Hans Ulrich Obrist: Have you had regular exchanges with doctors and researchers?

Orlan: For the moment, I'm greatly interested in biotechnologies, for example in growing skin. I've discussed it with scientists in the context of broader conversations on recent advances in the field. But you have to understand that my artistic interest inevitably involves deliberate *détournement* (misappropriation or subversion). I'll briefly explain what I intend to do: another open project, which I was supposed to launch with *Lieu Unique* (Unique Site), when Jens Hauser organized that exhibition on biotechnology. The idea is to take cells from my skin and dermis and hybridize them with skin and dermis cells from black people. The hybridized cells will then be grown in the lab. At the moment I'm in touch with a group that includes artists who feel that I've contributed a lot to their work, a group called Symbiotica. These people have generously opened the doors to their lab in Australia. But the problem is that they've mainly done skin cultures, while I also want to grow the dermis, which is much more difficult to do.

Hans Ulrich Obrist: So there's a veritable pool...

Orlan: That's it—the idea is to obtain pieces of epidermis and dermis, first from someone with black skin, since I'm working on the series of *Self-Hybridations africaines* and that's what interests me most. But I also aim to do it with people with skins of different color, in order to create a patchwork effect. This is yet another example of a crossover between fields, because the theme comes from a text by Michel Serres. In his book *Tiers-Instruit* there's an absolutely fantastic philosophical tale, twelve pages long, which inspired one of my operations. In it, a Harlequin figure is taken as a metaphor for a melting-pot culture because his parti-colored costume is composed of different fabrics of different origins and different hues. The story concerns this Harlequin figure, who is named king of the earth and the moon. One day the king says to an audience: "Look, wait here and I'll go visit my lunar lands and tell you what's happening." So everyone waits for him; he's gone a long time, and everyone gets more and more excited. Then he returns and tells them the truth: "Nothing's happening on the moon. Things are normal, which isn't very interesting."

He realizes that the whole show was a flop. So he begins wondering what he has to do get the audience's attention back. But what the public wants is to see him undress—they want to see the king naked. So he undresses. But like an onion—he peels off a whole series of cloaks, one after another. All the cloaks are of different color and different material, and after he finally takes off the last cloak the audience sees that his skin is made of different colors and his body is tattooed all over. That's where I decided to take up the text, which reads, "what could the common freak, that ambidextrous, mestizo hermaphrodite, now show us beneath his skin? Of course: his flesh and blood. Science refers to organs, functions, cells, and molecules, ultimately admitting that, in the end, lab people never talk about 'life' any more; indeed, science never even refers to 'flesh,' which precisely entails a mixture in a specific site of the body, a here and now of muscle and blood, of skin and hair, of bones and nerves, and various functions. 'Flesh' recombines what specialized science dissects." So scientific knowledge chops what is called flesh into little pieces. Harlequin's cloak is that flesh.

Hans Ulrich Obrist: The last question I'd like to ask—even if, in a way, you've already partly answered it—concerns projects that have never been executed. You referred to one project just now, but are there others? Do some projects remain that way because they're completely impossible to execute, or have they been censored, maybe even self-censored?

Orlan: Lots of projects have never been executed. Right now I recall one in particular: I was invited to do a show in the United States, and I wanted to install operating theaters in the rooms of a museum. The theaters would be completely redesigned from the architectural standpoint and in terms of the objects they contained. But it never happened, for lack of funds. There was also—once again involving operations—a contemporary art center in Copenhagen, in the Nikolaj Church, which suggested that I do a surgery–performance in the center itself. Rather than check into a clinic, I would organize the operation, live, in the gallery space itself. I worked for a long time with architects on designing the operating theater—we arrived at something that was halfway between an egg and a spaceship, with walls made of half-silvered mirrors. The idea was that the operation would take place within this egg-bubble, and when I didn't want the public to see I could reverse the lighting so that the inside was no longer visible. I was very interested in this space because it was simultaneously "cat-house and cathedral"— all my work, for that matter, whether it's *Le Baiser de l'artiste* (Kiss the Artist) or something else, falls somewhere between "cat-house and cathedral." It was a question of seeing and not seeing, the obsession with seeing and the impossibility of seeing. I wanted to play on that frustration at certain moments, to make the image appear and disappear in front of people, at the same time giving them the impression of flicking channels from one picture to another. It would have been possible to play on certain effects, notably to carry out a certain kind of editing. It reminds me of what Matthew Barney does—he organizes his films by conceiving all the props, costumes, lighting, and extras for the images he wants to obtain.

Hans Ulrich Obrist: In the *Cremaster* series, for example.

Orlan: For example, yes. Through these preliminary decisions and editing, he completely molds what he shows. Whereas my surgery–performances, for example, were transmitted live by satellite, so the public saw everything that was happening, including maybe what was not on show or at least should not have been seen. The [Copenhagen] project was interesting because I could suddenly control all those parameters by controlling the lighting, and I could also control what was filmed and what wasn't. But I didn't manage to pull it off.

Hans Ulrich Obrist: But it's very important to discuss it. We talk a lot about architects' never-executed plans, but almost never talk about those by artists.

Orlan: Absolutely. Moreover, I'm currently in touch with an architect about something else, not an operating theater, although...

Hans Ulrich Obrist: Who's the architect?

Orlan: Philippe Chiambaretta. At the moment he's re-doing—refurbishing—the façade of the CCC in Tours. And before my show a kind of brightly-lit room will be built. The CCC show is one part of the CNP exhibition, which will focus solely on "1993," thus on the surgery–performances and the works that relate to them or not.

Hans Ulrich Obrist: Is it supposed to be a chronicle of that period?

Orlan: No, I don't think you can say that. Although I imagine we'd agree that artists could be considered chroniclers of their times—let's just hope they're enlightened chroniclers. It's a question of elaborating part of my oeuvre that couldn't be included in the CNP for lack of space, because the pieces from those years are extremely important. For example, there's *Omniprésence* (Omnipresence), a piece exhibited at the Pompidou show called *Hors limite* (Off Limits). It is a way of focusing on some of my work that hasn't been seen much in France due to gut reactions provoked by the surgery–performances. Some of these works would never have existed without the operative act. So there'll also be this new piece developed with the architect—the idea is to make the public enter via a small, closed room that alludes to the operating theater. It will be made of Barissol, a flexible, translucent skin-like material: sensitive, malleable, sensual. This room will set the tone for the whole show, and will have an organic appearance. Both interior and exterior will be drenched in light—the public will enter via a kind of luminous air-lock.

But to wrap up the discussion of unexecuted projects, I also plan to have myself renamed by an advertising agency, a project that conforms to my concept of itinerant, shifting, changing identities. Dropping one name for another goes with the idea of modifying my image, one I liked a lot and with which I worked until 1990. "This is not my name," which makes it my name all the more; "this is not my image," which makes it my image all the more. That's the gap into which I'm trying to boot myself. Because this has become my body and my software.

1. Eugénie Lemoine-Luccioni, *La Robe: Essai psychanalytique sur le vêtement* (Paris: Le Seuil, 1983).

2. Orlan, *Réminiscence du discours maternel,* exhibition catalog (Espace Lyonnais d'Art Contemporain, 1977).

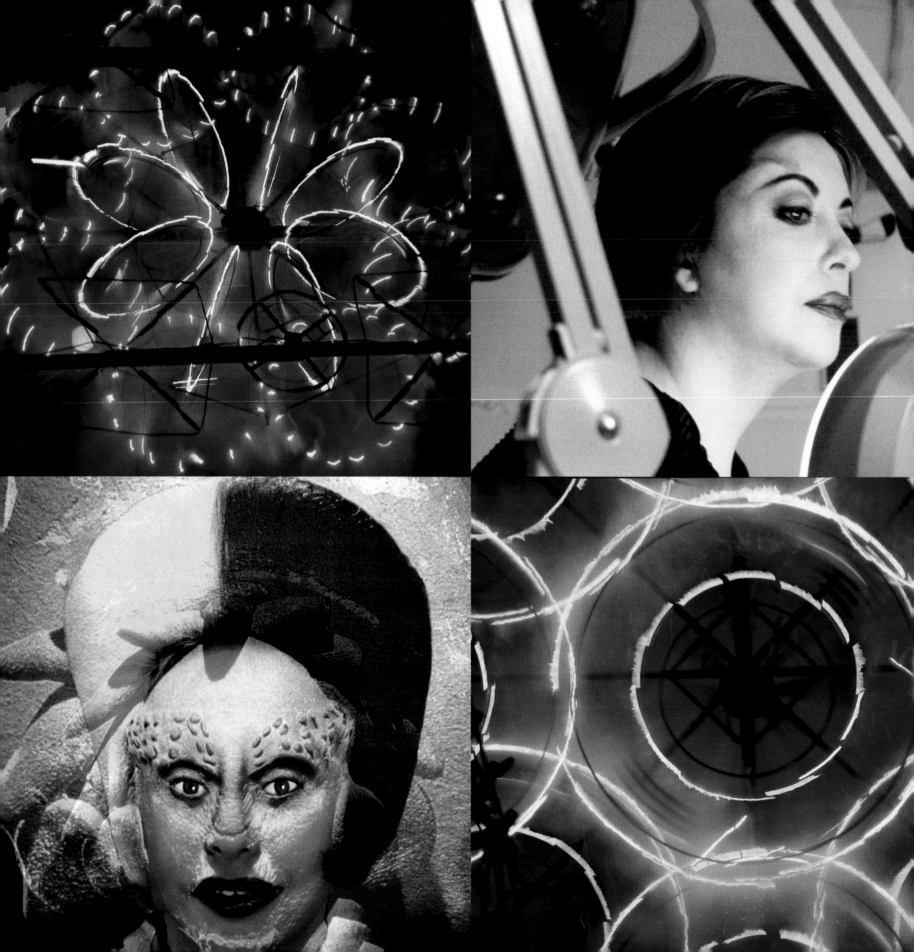

Texts for Orlan
Régis Durand

On several occasions Orlan has decided to incorporate a theoretical text into a performance or operation, when she felt the content of that text could shed light on—or simply resonate with—her own project. Thus she notably adopted texts by Eugénie Lemoine-Luccioni (1990), Michel Serres (1991), and Antonin Artaud (1993). These texts clearly assumed various functions ranging from theoretical justification to glamorous endorsement, yet also served, in a way, as the vocal part of her surgical "operas" (which have their own specific stage and setting, actors, and musical accompaniment).

The following notes attempt to pursue the links between text and artwork by eliciting an open inter-textuality. Here it is not necessarily a question of explicit affinities or influences, but rather of intersections through which a text—sometimes masked, consigned to the background—generates a dialogue, on a critical or imaginative level, with a given aspect of Orlan's work.

1 – Naming (Theories of)

In the early 1990s, one artist published long lists of other artists' names next to their real names, which appeared in the form of ads placed in major French art magazines of the day. They read, for instance:

BUREN's name was Daniel MEYER

MAN RAY's name was Emmanuel RUDNITZKY

. . . and so on.

I don't think I really understood the meaning of these ads at the time, but I do remember feeling that there was something deeply unpleasant about them. It seemed

Top left and bottom right: *Bien que... oui mais* (Although . . . Yes, But), 2003. Color photographs from the video piece *Mementori épicurien*.

Top right: Ninth Surgery–Performance, New York, 1993. Color photograph.

Bottom left: *Self-hybridation précolombienne No. 40* (Pre-Columbian Self-Hybridization No. 40), 1998, Cibachrome.

205

highly questionable for an artist to conduct a police-type investigation just to produce an artwork, as though revealing some kind of secret or some kind of fraud, thereby arousing the public's suspicion.

Indeed, people who change their name are immediately suspect in the eyes of your average petty bourgeois mentality: What does an alias hide? What need to mask a shameful family name, a "foreign" background, a shady past? True enough, the use of pseudonyms goes back a long way in the artistic sphere, but it still seems slightly suspicious, an impression that explains the dubious pleasure sparked by the revelations, themselves an assault on people who have decided to adopt new identities. The lists, it might be mentioned in passing, included a good number of Jewish names, which further added to the oppressive nature of the initiative.

I've just remembered the name of the artist in question, which has enabled me to track down one of the ads; it appeared on the back cover of *Art Press* 152 (November 1990), and bore a credit along the bottom of the page: "Space provided by Nina Ricci and the Langer Fain Gallery." At the end of the list, meanwhile, placed in the form of a signature, was:
ET N'EST-CE's name was Enes FEJZIC
Hollywood–Auschwitz

I seem to recall that this publication caused some sort of stir, which—as usual—quickly died. The artist, who thus identified himself, explained that all the published information had already been freely available. So did he intend the final line to indicate the fragility of our democratic peace, the thin line separating the most brilliant civilization from the most murderous abjection, separating

fame from persecution? In addition—or instead—was he decrying the fact that some people feel obliged to change their names due to residual distrust or to marketing requirements? Or, on the contrary, was he exposing the weakness (or courage) of those who feel obliged to do it in order to forge a new identity for themselves? The point seemed so confused that it left an unpleasant taste associated with grim memories. Beyond the reference to the war and the Holocaust, it also recalled a certain attitude typical of allegedly well-informed individuals who are "never fooled," who are always eager to tell you the "real" story behind this or that event, the "real" loyalties of this or that person. The purpose—whether deliberate or not—of such "revelations" is to make you complicitous, to draw you into the ideological swamp of sweeping suspicions, of fuzzy generalizations, of denunciations and, ultimately, of hatred of others.

2 – Place naming (Experience and appropriation of)

Orlan wasn't included in that list (the only woman included, apart from Hilla Becher—"Bernd and Hilla BECHER's names were Bernhard BECHER and Hilla WOBESER"—was, and I quote, "NEVELSON's name was Louise BERLIAWSKY"). On the other hand, Orlan often cites her home town of Saint-Étienne in the Forez region of France. In her series of self-hybridizations, she identifies the substance of her own image as belonging to a "Euro-Saint-Étienner," a "Euro-Forezian," or even a "Euro-Parisian" as witnessed, for instance by *Self-Hybridation africaine: profil de femme Mangbetu et profil de femme Euro-Parisienne* (African Self-Hybridization: Profile of Mangbetu Woman and Profile of Euro-Parisian Woman, 2000). Some part of her work therefore escapes the "methodical demolition of 'the indigenous,' of the

illusion of absolute origins."[1] Saint-Étienne is the place where Orlan's work began, in the form of slow-motion walks along certain itineraries. Why a slow-motion walk, why a slowing-down as an artistic act? It was not simply a commentary on the different "speeds" of time and experience, but a way of making her own time, a deliberately chosen and instituted time, a new unit of measure: the sovereign institution of a new system of measurement. Similarly, the length of a building—say, a museum—or the distance between two points, can now be measured in "Orlan-bodies," a unit of measure defined by the length of the artist's body, as already employed during public performances such as *Action Orlan-corps, MesuRage du Centre Georges-Pompidou,* (Orlan-Body Action—MeasuRage: Centre Georges Pompidou, 1977) and a similar one at the Musée Saint-Pierre in Lyon (1979).

As Orlan says, "it's round and about the name." So does *or* ("gold") plus *lan* ("slow") equal "slow gold"? Yes, and yet her name isn't really conducive to Proustian reverie, as the heading of this section might suggest. "To reach the end of a day, natures that are slightly nervous, as mine was, make use, like motor-cars, of different 'speeds.' There are mountainous, uncomfortable days, up which one takes an infinite time to pass, and days downward sloping, through which one can go at full tilt, singing as one goes."[2]

Instead, Orlan was concerned to find a new standard, one that literally "fit" her. She would no longer limit herself to subjective, variable "speeds" and "climates"—of which so-called personal identity is merely the more or less detailed sum—but would recast everything in the light of a new unit of measure and new procedures. Hers was a scientific approach in an effort to "harness the indigenous."

A new language was also called for; not the one that people speak locally, which is merely instrumental, but a language in which each "word" is one of the artist's productions, strung together in "sentences" that cohere as the oeuvre develops. In this respect, Orlan might be considered part of the grand family of inventors of secret or private languages, such as Schreber, Brisset, and many others (to say nothing of another Euro-Forezian, Pierre Guyotat, and his extraordinary way of working the French language with sounds, rhythms, and breathing that are alien to it). But this does not mean that Orlan is (really or artistically) crazy, but rather that she strives (perhaps in a similarly crazy way) to reinvent and recast everything based on the principle of oneself, oneself alone. Giving birth to oneself—exit mothers; but what about fathers?—to be born not from the ocean foam but from the painting (leaving the frame). Or from the (stained) sheets of a trousseau.

3 – Pure/impure (place your bets)
None of this, however, leads to some primal purity. There's no parthenogenesis (even if the male is lacking), no spontaneous generation (though we're not far removed), in any case no body without organs. The sheets of the trousseau are stained—with lovers' sperm, with paint, with dirt from the floor. Everything occurs as though the vanished scene of parturition (*inter faeces et urinam*) has been metonymically shifted in time (before and after) and space (the sheets), in a fantasy as powerful as it is banal. The scene may have vanished, but the linen will still remain (cf. the Holy Shroud, that sheet of sheets, used to wrap the Body; or Veronica's Veil, used to wipe the Face, hence forever imprinted with Its image). Orlan exhibits organic vestiges like trophies, but she

constantly flirts with religiosity in an hysterical, histrionic fashion, even as she appropriates the considerable energy that religion brings with its related imagery and social rituals. She constantly walks a narrow line, staking everything on the stroke that divides endlessly oscillating pairs such as pure/impure, incarnation/sublimation, and saint/whore, commonplaces charged with the energy of their actual elaborations and constant inversions.

Orlan's forty-year career can be interpreted as a long tale running from her self-birth to the invention of her own language and measuring systems, on to a kind of pseudo-mystical crisis with reincarnations in various forms, then to the controlled manufacture of her new faces, leading to total dissolution in the limitless euphoria of digital—and, soon, biotechnical—transformation. This tale is based, and demands to be considered, in its "narrative" dimension. Yet her oeuvre can also be seen as a limited number of variants that are constantly reworked and enriched through new techniques (performance, photography, video, surgery–performances, movies, computer technology, genetics, etc.). Synchrony, diachrony.

4 – Libidinal economy

So what are they about, the texts that Orlan reads during her surgery–performances? They usually refer to identity as something that is composite, hybrid—a patchwork or melting pot.

The amazing opening to *Économie libidinale,* a 1974 book by Jean-François Lyotard, could well have been part of that patchwork. It resonates directly and intensely with what was actually happening, something that Orlan probably—and wisely—decided to avoid. But the descriptive and theoretical energy running throughout Lyotard's text is well and truly consonant with the energy in Orlan's work:

"Cut into the purported body, open out all its surfaces: not only the skin with each of its folds, wrinkles, and scars, with its broad, velvety surface and, contiguous to it, the scalp and its fleece of hair, the soft pubic fur, the nipples, the nails, the transparent callus under the heel, the slight crinkle of the eyelids with their graft of lashes, but also open, spread, elucidate the labia majora and the labia minora with their blue, mucus-drenched web; dilate the diaphragm of the anal sphincter, cut lengthwise and lay flat the black channel of the rectum, of the colon, and of the caecum, henceforth just a band with a stripy, shit-smeared surface; go ahead, as though using your tailor's scissors to open the leg of an old pair of trousers, go ahead and bring to light the purported interior of the small intestine, the jejunum, the ileum, the duodenum; or take the other end, lancing the corners of the mouth, digging out the tongue from its deepest root, splitting it open, spreading the bat wings of the palate with its moist undersides, opening the trachea to turn it into the rib of a hull under construction."[3]

Here we have a patient unfolding of the "vast membrane of the libidinal 'body'" like an endless Moebius strip. This opening out, with all the intensity it releases, is a machine of theoretical war aimed at what Lyotard calls "theatricality" or "representation": a superimposed, authoritarian system, "a 'box' that, closed on itself, filters all drives, allowing on stage only those which, coming from what will henceforth be called the *outside,* satisfy conditions of interiority."[4]

This text makes it easier to define "the Orlan approach," which enters the field of representation as described here. Indeed, everything—from the choice of location and type of action to their visual handling—is filtered and constructed (which is precisely what makes it the work of an artist). Here, representation could be described as exaggerated, hyperbolic. At the same time, however, Orlan's art is carnal, it usually affects the body directly. The difference is that it concerns neither surface nor interior, nor seeks to reveal secret facets by exploring hidden depths and transforming everything into surface (that "extensive, ephemeral film"). Instead, her work is one of remodeling, of reconfiguring things according to a carefully developed program that cannot be reduced to straightforward incision. The field—the "theater"—is just part of the set; what's really at stake here is the "image." Like magicians who introduce props designed to deflect attention, yet whose presence is crucial to creating an effect, Orlan stages, recites, and films while the image is being forged. Obviously, this image is sometimes slow in coming. But the delayed effect is part of the process. The surgery–performances, for example, unfold in time, revealing different stages of "maturation" as the final image slowly emerges. When it comes to the *Saint Orlan* series, plus the *Self-Hybridizations* and *Reconfigurations,* the image appears immediately, but the elaboration of the series itself creates a similar time-delay effect. So when will the transformation be complete, when can we say that an image is "done"?

Unlike literary and theatrical works, the specificity of an artwork is perhaps that it doesn't fulfill this expectation. It is neither theater nor non-theater, neither story nor non-story. It's something different. A different economy.

5 – "Image done"

Carnal art, says Orlan, is an art in which "the body becomes a 'modified ready-made,' because it is no longer a perfect ready-made that merely needs to be signed." It is therefore an art of *alteration*. Georges Bataille claimed that the primary motivation of art wasn't form, but the deliberate alteration of displayed forms.[5] For Orlan, it is the subject herself who is transformed, is re-figured by subjecting herself to the various procedures mentioned above, thereby adopting "a kind of bodily itinerancy across the endless plains of identity."[6] Along the way, the subject evades any restrictive definition of identity, giving birth to what Christine Buci-Glucksmann called, alluding to Foucault, "new forms of subjectivization." Currents and objects remain external to the subject, which no longer appears as the stable pole of a single identity, but as a transformer. Such reconfigurations entail a type of "acting out," not in an impulsive and neurotic way, but in a highly considered way. In fact, this body-transformer has to be plugged into the outside—into "the other"—if the surgery–performances are to be more than vain rhetoric. The resulting image is just the opposite of a mere trick; it is obtained only when "plugged in," whatever the risk. *Alteration* does not mean a minor adjustment, but an implementation of form.[7] Furthermore, digital hybridizations are done from real works, not from simple representations. The images being cross-bred have already been altered, thus prefiguring the genetic hybrids that Orlan is currently working on. Concerning these genetic projects, Orlan hopes to obtain samples of skins whose assembly could someday result in a gown or finery that would give form to the multi-colored vision of the subject anticipated in seminal texts by Eugénie Lemoine-Luccioni and Michel Serres.

So what does this mean? We're not talking about "incarnating" a text chosen precisely because it resonates with the work being created, thereby becoming part of it. As the text itself states, there is no final outcome because "once mixed, the mixed flesh and blood of Harlequin still strikingly resembled Harlequin's parti-colored cloak."[8] Neither word nor flesh, nor flesh become word, but a composite and splendid patchwork that cloaked an infinity of others. Where will it end? In "a total white-out"? For Orlan, I think, it will end rather in a decision to halt, at some point, the process (depending on the case: Harlequin's strip-tease, the alterations, the reorganizations, the reminiscences). At what point? When the image seems "done." "Image done": Samuel Beckett, in a short text (dated "the 1950s"), described this operation as the outcome of a process simultaneously carnal, mental, and verbal. The body trapped and hindered in its shell, often reduced by Beckett to a few reptilian movements of extremities (hand, tongue); the slow emergence of a description of a scene (recollection? invention?), simultaneously sketchy and detailed; then the flow, the moving on, the moving off:

"… and here we are again we move off again across the field, hand in hand, arms swinging head lifted toward the increasingly tiny summits I can't see the dog anymore can't see you anymore the scene is empty a few animals sheep like granite that brush a horse I hadn't seen, standing motionless, back curved head low animals know blue and white of the April morning sky under the mud it's over it's done it's going out the scene remains empty a few animals then goes out no more blue I remain there, there on the right in the mud hand opening and closing it helps so let her go I realize I'm still smiling and it's no longer worth it for a long time it's no longer been worth

it the tongue comes out and goes into the mud I remain that way no longer thirsty the tongue back into the mouth which closes it must make a straight line now it's done the image I've done it."[9]

The crucial question is, indeed, how can an image be "done"? Every artist tries to answer this question. Far from being the literal production of certain images or forms, it is a process, a unique combination or tension between a frozen moment, the energy it holds, and the dissatisfaction it engenders.

6 – Orlac

I'm not trying to "literaturize" work that is visual and absolutely materiological, but simply to draw attention to the work's power to produce fictions. By fiction I don't mean tales and stories that could be recounted in other ways, but entire parts/sections of experience that the artist invents for herself as her oeuvre evolves, and which then become reality. What is so fascinating about Orlan is this "constant self-demiurgy," her horde of temporary personae that serve as brief vehicles to be tested, used, then abandoned, and whose very proliferation "challenges, in a heady fashion, the avowed function of body and face, namely to 'presentify' ourselves."[10] In each of these "fictions"—some of which occur over several years and are subject to all kinds of variations—Orlan conducts a kind of anamorphosis of her own story. It is indisputably her own; and the works, coming one after another, thus write the story of her life in art, a performing of life through art. But at the same time, certain series become autonomous and undergo a special coding, an encryption that makes a separate reading necessary. Take, for example, the series called *Le Plan du film* (A Shot at a Movie), itself part

of a work-in-progress launched back in 1985 on movie posters. A movie poster usually assumes that a film exists and can be seen—or can soon be seen—by audiences. Designed to promote that movie, the poster obeys certain rules: size, typography, imagery (neither a frame blow-up nor a production still, but a special composition, sometimes painted by specialized artists). A poster must convey information (title, names of main stars, director, etc.) and must also give an idea of the content of the film—genre and atmosphere—so as to arouse the viewer's desire.

Orlan has produced posters for films that don't exist (a reversal of procedure well described by Jean-Pierre Rehm[11]). A still, flat image that is not a photograph is thus supposed to give birth, in a way, to a moving image. The fictional protagonists listed on the posters (actors, producers, technicians) are drawn mostly from the "art scene," and thus find themselves drafted into assuming (at least in people's imaginations) a role for which they are purportedly suited. Orlan's work is thus populated with a rich series of inverted fictions, partially delegated and attributed to other people. There is splendor and poverty in this gesture, about which Rehm writes, in conclusion: "Claiming priority for the image within the order of existence puts it at the very heart of a principle of survival. Such survival is neither a pathetic lie dictated by the inevitability of misrepresentation, nor is it schizophrenic, nor a critique of the reign of pretence with its oppressive codes; nor obviously is it about life in the beyond, a higher life. Rather, being grasped first as image she signals a desire for a life on the edge of herself, freed from demands for authenticity, accepting the delightful awareness of a constitutive poverty. Orlan's Annunciation summons us to a bodily 'inversion,' to a rowdy staging of nativity scenes in which we all feature as flattened figurines."[12]

Malcolm Lowry's novel *Under the Volcano* features the obsessive presence of a movie poster advertising *Las Manos de Orlac, con Peter Lorre*. This poster of *The Hands of Orlac* is at the heart of a double fictional thread: one, retrospective, concerns the "framing" of the main story (Laruelle remembers his friend the Consul, killed a year earlier by the Mexican police); the other, projective, elaborates a system that lends symbolic weight to the events we are about to be told. In the first, Laruelle recalls having seen the film, a lousy Hollywood remake of a lousy German film from the days of the UFA studios; it was a "complicated, endless tale of tyranny and sanctuary"—that of Orlac, a performing artist "with a murderer's hands," which Laruelle interprets as a "hieroglyphic of the times," a sign of Germany's fate. In the second thread, it functions as a kind of primal scene of the tale of the fall of the Consul, following the obscure execution of U-boat officers being taken as prisoners on a ship he was commanding.

Exploring all the folds and reverberations triggered by this cinematic image would mean paraphrasing practically the entire novel. I probably recall it now due to the phonetic similarity to the name of Orlan, and maybe also due to the "carnal" theme running through it.[13] But it also testifies to the imaginative power of film posters, whether "straightforward" or "inverted." Orlan's "films" may not have this power, reinforced by richly layered writing, but in their own way they function in a similar fashion. Her posters become the active icon of a manufactured reality, acting like a magnet—a receptor—of fantasies and terrors. A fantastic Orlan? The project with David Cronenberg seems to suggest something of the sort is at work, as glimpsed earlier in the series of surgery–performances.

7 – Image done (2)

To conclude this brief anthology of "texts for Orlan," here is one of an historical and theoretical nature that may initially seem quite removed from Orlan's world. But that is not the case. Marie-José Mondzain's book *Le Commerce des regards* is closely related to the work of an artist sensitive to "the passionate nature of visibilities and . . . their political fate in a community" because the author attempts a veritable redefinition of the image.[14] Here it is no longer a question of seeing things from the standpoint of manufacturing images, but rather of using them—the "commerce" or trade in images. This is not the place to repeat the subtle and learned arguments of Mondzain's book, nor to suggest its specific "application" to Orlan's work. As with the previous texts, here I will merely isolate a fragment that may act as a reagent on contact with the artist's work—more specifically, in this case, on contact with the religious content of her work, whether conscious or unconscious.

Orlan approaches the religious element on the level of transgression, parody, and grotesque reversal. Which of course provides her with an opportunity, as Buci-Glucksmann has ably demonstrated, to appropriate and subvert religion's esthetic codes, notably those of baroque painting and sculpture.[15] No appropriation is fortuitous, however. Adopting the visual rhetoric of the Counter-Reformation, even on the level of grotesque parody, means affirming, for example, a faith in imagery that the Reformation challenged. Playing off the figures of saint, whore, and martyr means slipping into that highly coded discourse in order to hijack its energy (as Michel Journiac, for example, also did in his day). But there is more than these appropriations–inversions, which is perhaps where a close reading of Mondzain's book proves handy. The author meticulously describes what she feels is the very nature of the image, to which she opposes what she calls "visibilities." Forging an image can only be done from exchange, entailing a commerce between the one who shows and the one who sees. "In substance, [an image] exists nowhere," for it only assumes form in a particular economy. This concept of the image has undergone complex elaboration in Christianity, full of dialectical twists and turns. But it has an even earlier history, that of the Bible and the Talmud. It bears within it the "violence of blood, that is to say incest and desire. Such is the weighty heredity of the image, a living stain, a fertile hybrid. All these figures designate, and sketch, the face of the original threat. That is why the reign of 'the maternal' would call for a bleeding dry, a purification, a need for ceremonial cleansing, all of which are related to the construction of symbolic regimes at the very locus of what moves us: sex and death. Maternal cults—chthonic fertility cults—disseminated in entities as variegated as they are numerous, must be destroyed, their images broken. Making images means conducting—with one's own hands—a guilty trade with the world of stains and spots, a theme that Christianity would take up term for term although inverting the order and the meaning."[16] Hence an endless spiral of reversals and reprises. Rather than the rich folds and loftiness of the baroque "saint," we should hearken to Orlan's "guilty trade," to those stains so present in the early works and still detectable, in the series of surgery–performances. If the artist has been retracing, in a striking abridgment, the millennia-long development of the regime of images, then in recent years she seems to have abandoned the "archaic" phase of bodily humors, henceforth entering a different circulation of views and identities within her very own image: hybridizations (of face and skin) with other cultures, with other regimes of representation.

1 Arnaud Claass, "Orlan, la naissance mise à mort," *L'image décentrée—Un journal* (Crisnée, Belgium: Yellow Now, 2003), 189–195.

2 Marcel Proust, *Swann's Way* (translated by C. K. Scott-Moncrief), Project Gutenberg of Australia e-Book, n.p.

3 François Lyotard, *Économie libidinale* (Paris: Éditions de Minuit, 1974), 9.

4 Ibid., 11.

5 Georges Bataille, "L'art primitif," *Oeuvres complètes* (Paris: Gallimard, 1970), I: 248–254.

6 Claass, "Orlan, la naissance," 191.

7 In a note on page 251 of the article cited above, Bataille wrote that, "The term *alteration* has the twin interest of expressing a partial decomposition similar to that of cadavers, and at the same time the transition to a perfectly heterogeneous state corresponding to what Protestant theologian [Rudolf] Otto called the 'entirely other,' that is to say the holy, as manifested for instance by a ghost." (See Rudolf Otto, *Das Heilige,* 1917, trans. John W. Harvey, *The Idea of the Holy* [London: Oxford University Press, 1958]).

8 Michel Serres, *Le Tiers-instruit* (Paris: Éditions François Bourin, 1991), 16.

9 Samuel Beckett, *L'Image* (Paris: Éditions de Minuit, 1988), 17-18.

10 Claass, "Orlan, la naissance," 191.

11 Jean-Pierre Rehm, "Annonciation d'un corps à plat," in Orlan, *Le Plan du film*, CD and booklet, (Al Dante, 2001), n.p.

12 Ibid, n.p.

13 Laruelle refers to the version directed by Karl Freund in 1935, starring Peter Lorre, itself a remake of Robert Wiene's 1924 film starring Conrad Veidt. The film recounts the story of a pianist who, following an accident, receives a graft of the hands of a murderer. The hands turn out to have an evil life of their own, gaining power over their new owner (my thanks to Dominique Paini for supplying these details). Laruelle, who knows both versions but likes neither one, nevertheless draws a major distinction between them: Wiene's dated from the UFA days when a defeated Germany won the respect of cultured people through the films it made, while the Hollywood remake, a "hieroglyphic of its times," presented a picture of the degradation of Germany itself, like a pianist with a murderer's hands. The passage occurs at the start of Lowry's novel (pp. 30–31 of the Penguin edition) and plays a key role in the establishment of the main themes: guilt/degradation/redemption, violence/impotence, the obscurity of signs, the vague presence of evil, and so on.

14 Marie-José Mondzain, *Le Commerce des regards* (Paris: Le Seuil, 2003).

15 See, in particular, Christine Buci-Glucksmann interviewed by Michel Enrici and Jean-Noël Bret, in *Orlan—Triomphe du baroque* (Images en Manoeuvres Éditions, 2000).

16 Ibid., 40.

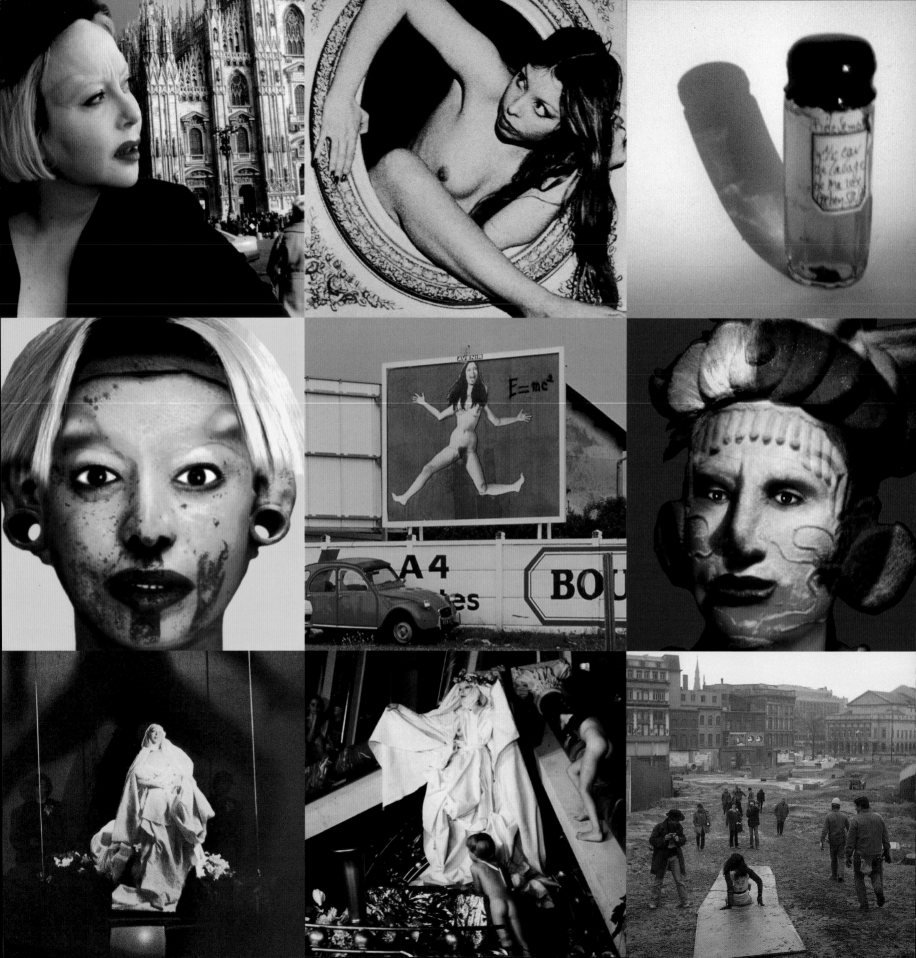

Orlan: The Embodiment of Totality?

Julian Zugazagoitia

Art that interests me has much in common with—belongs to—resistance. It must challenge our preconceptions, disrupt our thoughts; it is outside the norms, outside the law, against bourgeois order: it is not there to cradle us, to reinforce our comfort, to serve up again what we already know. It must take risks, at the risk of not being immediately accepted or acceptable. It is deviant, and in itself a social project. Art can, art must change the world, and it is its only justification. **Orlan Conference**

Orlan's work, which has developed with tremendous cohesion and intensity since the sixties, challenges our worldview and self-perception with what might be dubbed her own Copernican revolution.

This revolution grew from subtle beginnings with a simple walk in slow-motion in Saint-Etienne, the artist's hometown. This first act of walking through the streets does not suggest Orlan's subsequent development as an artist, and yet all of her questioning is implicit in this piece, performed at the age of seventeen. The elements that characterize her future works were all present in gestation in this piece, from the realization of movement as an artistic act to her critique of the cultural systems of which she is a part. Art, as conceived by her, or rather as lived by her, is a process whereby she passes through her personal stations of the cross, marking her journey by questioning the representational system, even through the use of her own skin.

At the heart of Orlan's project is her investigation of modern conceptions of identity and the self. One of the harbingers of modernity is inscribed in an image of Leonardo, where it is man—and no longer God—who is at the center of the world. Another is Kant's interpretation that all knowledge starts with experience but not all depends upon it. Orlan radically questions the understanding of these theoretical forms by enacting their principles, and substitutes them with her most immediate and unique experience, that of her individuality and her body. Consequently, her physical exterior is the measure of the world and her skin is the subtle mediation

Top to bottom, left to right: *Le Plan du film* (Plotting a Film): *Corporis fabrica* (detail), 2001 / *Tentative pour sortir du cadre* (Attempting to Escape the Framework), 1965, black and white photograph / Vial from *MesuRage* (MeasuRage), Musée Saint-Pierre, Lyon, 1979 / *Self-hybridation précolombienne Nº 30* (Pre-Columbian Self-Hybridization), 1999, cibachrome / *Self-hybridation précolombienne Nº 34* , 1998, cibachrome / Documentary Study: *Le Drapé-le Baroque* (Drapery–The Baroque), performance, Palazzo Grassi, Italy, 1979 / Documentary Study: *Le Drapé-le Baroque*, performance, Espace lyonnais d'art contemporain, 1981 / *MesuRage*, Liège, 1980.

215

between the Me and the other, the thin, sensitive border that becomes the medium for the recording of history.

Orlan made her debut—as one might say of an actress—in the sixties, a period of questioning where the onus was on experimentation, trying everything, and reinventing oneself. It was an era "without god or law," when longstanding conventions were destroyed, traditions derided, and certitudes ceased to be. It was an era marked by activism, demonstrations, and uprisings, all geared toward redefining oneself and the surrounding world. Against this background, the body was seen as both a receptacle for conventions and, simultaneously, as a vehicle for liberation (liberation from taboos, female liberation, sexual liberation). Orlan's work reveals the body in its true form, as a contested territory where political and social, esthetic and ethical, individual and collective issues are played out.

Orlan uses various media for her work including film, video, performances, photos, digital images, and sculptures, making her, before the term was devised, a multimedia artist. The crystallization of her activities around surgical operations is evidence of her profound commitment to create her work to the point of physically transforming herself to embody her ideas. Orlan experiments on her body and her image, and in this sense, her work is always a work in progress and will be so until her dying day. Her bodily changes are an integral part of the work, whether through the inexorable passage of time or through the alterations orchestrated at the artist's will, by hand, with a scalpel, or virtually with a computer. Using the body as an artwork generates works of art which are self-reflexive, as the subject is simultaneously the work's maker and model. In this way,

the distinction between life and the work are blurred to a creative totality, and the future is intrinsically anticipated. Taking her logic to its natural conclusion, Orlan plans, after her death, to bequeath her remains to a museum to be exhibited there *ad vitam aeternam*. The ultimate relic, this unsurpassable work will be the culmination of an investigation that has been striking at the heart of Western esthetics for forty years.

The violence that sometimes characterizes the reception of Orlan's work is undoubtedly the fruit of her questioning the basic notions of art, representation, and identity.

The history of Western art is marked by thousands of deaths as a result of iconoclastic wars. Minds are still haunted by these disputes, whether historical or current, the latter as evidenced in the most recent destruction of the giant Buddha images in Afghanistan. Biblical proscription of all representation still remains a reality in certain cultures, and the West remains equally and surreptitiously susceptible to it. The issue here is the right to produce a transcendent work of art and also the blasphemous threat of this very transcendence. The Iconophiles defended the possibility of representation using the thesis of incarnation as the cornerstone of their position. For them, God's figuration commandment in the tablets presented to Moses was superseded by her/his transformation into a historical figure in the form of Christ. Thus God's initial order banning representation was, by this act, in a way nullified. God chose to appear him/herself, refusing a part of his/her immanence in exchange for presence, and in doing so s/he reinforced the idea of the creation of humankind in his/her own image. Incarnation is therefore at the heart of the right of humankind to represent, and to produce

a work, and it guarantees the possibility of transcendence for the human form.

Orlan grapples with these values through her artistic approach. Instead of submitting to a God of creation or an a priori esthetics, she reverses accepted notions of representation by basing her art on her own incarnation, working on her image and posing as a model of herself. She discards canons of beauty from antiquity, the Renaissance or those peddled by the modern-day media, contesting these standards by substituting for them the value of the subject's individuality. She sets about deconstructing models of female beauty and subsequently posits a notion of identity in flux, never fixed, but on the contrary open and in mutation. For her, identity is not an immutable and inherent dimension but is something that has to be forged, educated, transformed, and enriched with every passing moment.

Work that deals intimately with portraiture necessarily troubles this genre's traditional claim of a correspondence between the model and the artist's vision. This questioning is even more poignant where self-portraiture is concerned, as the artist determines the distance between the interior self-image, her external image such as the mirror might reflect it, and finally her method of transforming this into an artwork.

Since Narcissus, the reflection in the mirror has disturbed Western art by calling into question the distinction between representation and identity. Appreciating the complexity of Orlan's work from the sixties right up to the present hinges on analyzing how the mirror, this surface upon which our appearance is projected, registers the skin. How does the transition from this exterior surface of representation intermingle with interiority and identity? Is it a question of a two-way mirror, a blind mirror, or a perceptive one?

This conundrum amounts to a modern view of the Narcissus myth where he feels compelled to visit his psychoanalyst to find out why the mirror won't reflect the image that he has of himself. Our appearance is not always as we would like, but inevitably, it is what we are, to paraphrase Eugenie Lemoine-Luccioni in a text that Orlan is fond of quoting. It is in the interstice between these three possible instances of the Me (interior Me, exterior Me, and its representation) that her work blooms.

The gap between these three possible visions of the Me drives Orlan to seek a resolution in the successive phases of her work. She has investigated historical identities, attempted to go beyond the opposite poles of the saint and the whore, of the white saint and black saint, explored *Je suis une homme et un femme* (translation note: "I am a man and a woman" would be the literal translation, but in the original Orlan introduces a gender confusion by coupling the masculine article with Femme and the feminine article with Homme), embarked on surgical operations to sculpt her appearance according to her own principles, and investigated virtual possibilities for self-hybridizations based on the esthetics of distant cultures. Despite these investigations, the image of the self remains elusive, like a constantly moving horizon heralding unforeseen perspectives which invest her work with new interpretations.

Her performances with trousseau linens engage multiple dialectics ranging from the most intimate to the most public: the transition from virgin to married

woman, the internal and external, and from sexually active to passive. By displaying her sperm-spattered sheets and embroidering around the stains, she is displaying that which is private, part of her personal history. The fabric becomes at once a camouflaging shroud, a cloth for exhibition, and a receptacle of the gaze: it is as much a private relic as a public trophy reminding one of the old rituals where a newlywed's virginity was proved by the presentation of bloodstained sheets.

Since this performance, the linens have become part of the artist's history. They are her double and act as a palimpsest that records the measurements Orlan takes with her body in the street or in artistic institutions. She thereby creates her own standard of measurement to quantify the world, a world that is becoming auto-referential, and one that acquires substance in relation to the artist. The fabric of the trousseau as an instrument of measurement and as a surface for recording private sexual activity announces the body as an artwork, and the sheet becomes a skin, a second skin that also takes account of history, of her history. It is this sheet that is used as a double for the skin during the Saint Orlan performances, this sheet which is folded to become a rich, baroque drapery.

When the sheet billows up around the body of the artist and transforms her, emulating Bemini's iconography, into Saint Teresa of Avila, it takes on the dual status of a veil that both hides and reveals. It becomes, in a way, an expressive skin where the eye is invited to lose itself in the meandering folds. Breasts, the hands, the face, are accentuated, revealed in their nakedness. The bared flesh is proof of femininity, of the traditional nourishing role of women, but also of sexuality and eroticism.

At the other end of this polarity is *Strip-tease occasionnel à l'aide des draps du trousseau* (Incidental Strip-Tease Using Sheets from the Trousseau, 1974) where one witnesses the metamorphosis of Orlan from a breastfeeding Madonna to the sexually evocative Venus emerging from the waters or an Eve tempting sin. This work explores the extremes which span the sacred and the profane, the asexual and the erotic, Bernini and Botticelli, all suggested by the evocative drapery that remains piled up at the end of her performances, like the discarded skin of a chameleon.

Orlan maintains a complex and ambiguous relationship with religion, its iconography and visual history. Her work assimilates the Counter-Reformation strategies, but replaces its discourse with her committed activism. She references religious imagery, simultaneously assimilating the baroque tradition while questioning the status of the modern woman's body. From the liturgy, finally, she borrows many symbols and totalizing forms for her surgical operations and performances.

Orlan's operation works emulate the liturgical ceremony, and the presentation of these pieces in the context of the operating room resembles great baroque and pagan feasts celebrated around religious events. Once again suggestive religious parallels and highly charged symbols abound.

With tremendous confidence and clarity, Orlan presents herself as a twenty-first-century Narcissus. She responds to the concern that the mirror does not reflect the desired self-image by resorting, without embarrassment, to plastic surgery (and later computer enhancement, and would even be prepared, under certain

conditions, to experiment with cutting-edge biotechnology). Thus she reduces the symptomatic distance between the "ideal" Me and its real-life embodiment. In the process, she unearths ancestral demons, challenges the accepted principles of Western beauty, and battles with Mother Nature.

Through this dialogue with the mirror, it is not only the glass's capacity to reflect which is questioned, but also the very act of looking which is challenged. In this sense, Orlan posits her work in the gap between "the madness of seeing and the impossibility of seeing."

Effectively, her work is located within this interstice; the madness of seeing refers to the baroque look, a spherical, total, and "omnipresent" vision, which according to Lacan, presents a tautological paradigm of Narcissus, one that results in the perpetual coming and going from self to self. Consequently, the impossibility of seeing results from approaching the mirror to the point when it merges with the self. At the moment when there is no more distance, no more separation between the self and the mirror, there is no longer any interior or exterior, and representation ceases to exist, supplanted instead by a hypersensitive presence. Thus the mirror becomes a skin, oneself, and a distanced understanding of the I is replaced by an overflowing and all-encompassing self-perception.

The surgical operations in Orlan's work amount to a complex personal liturgy. During the operation, when the body is opened up, Orlan is under local anaesthetic, thereby challenging the concept of suffering by remaining conscious and active. Busy reading texts selected to suit the ritual, she invites an interpreter to join her, who gives the words substance in the form of deaf sign language. In this way, the language is given body at the same time as the palimpsest of Orlan's skin is worked upon under her direction.

During the operations, Orlan is like the martyr saint: as both in her operations and with images of saints one witnesses a suffering body (Christian tradition abounds with severed breasts, flayed and burnt-alive martyrs). Yet, paradoxically, the expression of the saint and of Orlan is the exact opposite of pain, and it even hints at happiness with a slight dreamy smile. As spectators we feel for them, but they seem to sense none of the suffering which we see them undergo. The pain is transcended because a higher destiny is being served by the sacrifice. Despite this parallel, however, the power of Orlan's actions, in contrast to the saints or the esthetics of Frida Kahlo—with whom certain parallels can be drawn—is that she is not undergoing these ordeals against her will but is instead voluntarily enduring them as an act of total creative freedom. In this sense, Orlan is experimenting with the beauty of ecstasy as an expression of her free will during this full body engagement with her work.

This form of ecstasy collapses the distinctions between object and subject, and between interior and exterior; Orlan participates both as witness of the scene and within the scene itself. She blurs these two distinct perspectives by contemplating her own open interiority from the outside. By opening up a chasm deeper than that of the *Origine du Monde*, even Orlan's very entrails appear to be stripped bare in the hands of her surgeons.

During this ecstatic trance, her gaze, far from being distant, is settled, and engaged in the production of works that will result from the operation. One cannot help but wonder if she would go as far as to wield the scalpel herself, in an echo of the circular drawings of Escher, where two hands draw each other (the computer will indeed enable her to work on herself without the intervention of a surgeon). However, once the operation is over and the effect of the anaesthetic has subsided, Orlan recognizes that some of her works are unendurable, and are close to being unviewable. Thus she understands the natural and deep-rooted resistance to some of her images. When she returns to being a mere spectator of her work, outside the performance she has lived through, and views her images, she admits to experiencing pain similar to that invoked by the image of the saint undergoing his or her ordeal. It is more of a spiritual pain, which demonstrates our limits when faced with the contemplation of the unfathomable.

After the operations, Orlan collects all of the equipment and waste to reuse in subsequent works, which serve as relics. In this way, pieces of skin, her own flesh, her blood, and the bandages will be reused to produce drawings, reliquaries, and shrouds, in keeping with the totalizing spirit that pervades her work. Her work always poses the question of what is visible, and plays on our fascination with the remnants of history and the fetish. On the one hand, Orlan's body continues its constant transformation, and on the other, these relics provide us with an enduring reference to the real, tangible proof of the martyr and the memory of her ecstasy.

Orlan has broadened her investigation into esthetics by probing into non-Western conceptions of beauty where the relationship to the body is based on different conventions and our a priori forms of understanding are inapplicable. Orlan explores pre-Hispanic and African civilizations using the magic of computerized transformation. This approach unearths the incredible diversity of esthetic ideals across time and space. It also reveals the West's imposition of its canons of beauty onto other cultures, all the while claiming that these ideals are universal truths. The pages of history are replete with the struggle of one culture to establish hegemony of esthetic principles over another, from the ancient Greeks to the Romans, from the Crusades to the hype of the American cinema and television industry. These examples represent the same desire to impose a single standard of beauty on everyone, and it represents a proselytization of the image.

In the current climate of globalization, Orlan highlights a search for a plural aesthetics, based on the cultural specificity and the uniqueness of various peoples. In this sense, the *Self-Hybridization* series is an education in looking that embraces the richness of what is possible. It is an appeal for tolerance and for a respect of differences. Her art, which she formerly situated between the madness of seeing and the impossibility of seeing, is no longer in the order of the *fascinum tremens*, but instead criticizes ideological blindness. She suggests that the inability to recognize the other is an act of resistance and a subtle form of fanaticism.

In this series, the genre of self-portraiture is enhanced by this historical, ethnographic, and archeological mirror where the deformations and morphing stem from a sense of playfulness and from a search for hypothetical, time-space filiations. Whereas the body was a real-life sculpture to be shaped, it is now a space to explore the myriad of

possibilities inherent in the virtual realm. Whereas the palimpsest of her skin can only support a limited number of operations, the various permutations presented by the virtual are infinite. In this way, Orlan embraces a new totality in the greater time/space continuum.

These same issues are again raised in a similar vein of Orlan's work, that of *Le Plan du film* (A Shot at a Movie), which introduces fiction as a playful alternative to the existential questions which characterize her other work. Recently, the artist has focused more attention on this aspect of her oeuvre, and the pieces are film posters produced from reworked images drawn from her own archives. The films, which the posters purport to advertise, are consequently invented by and exist in the imagination of the passer-by who happens upon the images on display in the city. Thus, the poster is the basis of the film's existence, it is its proof. The question of incarnation is raised once again, now from the angle of procreation: is a poster image all that is required to generate a film in reverse? Is it necessary to make the movie, or is the poster's evocation of the film enough for it to exist? This desire to reverse the stages of creation, starting from the final visual ephemera which conjure up a film, demonstrates the predominate role of the visual, of the image, in Orlan's esthetics. As our civilization results from text, from the founding word, the reversal carried out here consists of invoking the text to come from the image.

These reconfigured images present the obsessions which continually haunt the artist. Orlan recycles her own imagery and constructs a fragment of fiction from her life and work. These images carry out a paradoxical reversal: the reality of Orlan's work is deconstructed by the very semantics of the cinema poster. The real operations end up appearing fictional, as if it was nothing more than a great illusion. After the disturbing fascination of the operations and the existential questioning of Saint Orlan's identity, could it be said, after all this, that it is only cinema? Orlan entertains these questions in a desire to play all parts and make herself the interpreter of her own role. With great critical irony, she places all of her work in perspective from the angle of illusion. Perhaps it is Orlan who has herself fallen under the spell of the spotlights and would be ready to interpret all: the Aztecs and the Mayans, the steatopygous Venuses and Botticellis, the saints and whores, the range of male/female nuances including the androgynous. In her desire to make her life a work of art at the extremes of what is possible, it seems that only fiction offers her the possibility of taking these experiments even further; isn't it quite rightly said that actors embody their characters? Would not the ultimate bid to embody totality be an exciting way of reminding us of Shakespeare's words: "all the world's a stage"?

Lights, Camera, Action.

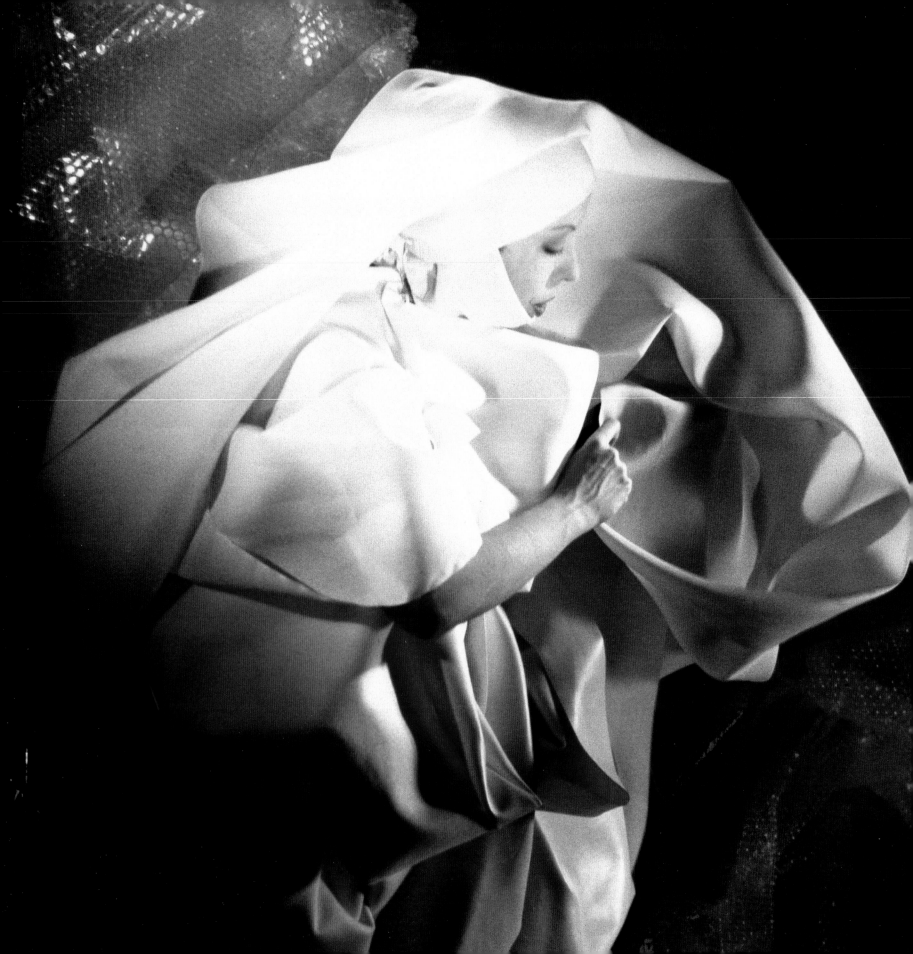

Orlan: Magnificent "And"
Eleanor Heartney

We now live, we are sometimes told, in a post-human world where the body is obsolete, nature is a construct, and representations are layers of illusions without a center, like those Russian nesting dolls that finally reveal an empty core. In such a world, identity is a fallacy, built up from the desperate myths we tell ourselves about who we are and where we come from.

Fashionably au courant as such ideas seem, they really go back to the longstanding Western tradition of mind–body split. They have their roots in Neoplatonic dualism, in the Cartesian definition of body as inanimate machine powered by immaterial soul, in modernist distinctions between form and content, and in the technology-inspired separation of software and hardware. Postmodern theory simply takes such ideas to their apparently illogical conclusions, requiring us to question all conventions that appear natural and normal.

In the case of the body, the electronic revolution seems to prove that digital networks are more relevant to modern life than the old-fashioned circulatory systems of flesh and blood. But has the virtual really triumphed over the real? Or are these apparently antithetical concepts actually interdependent, two sides of the same coin? Reflecting on the mix in her work, the artist Orlan remarks, "The aim is not to confront what is real with what is virtual—and vice versa—in a sort of endless Manichean and reductive opposition. On the contrary, virtuality mingles with reality as its imaginary part and the reality which I create is not devoid of virtuality."[1]

Left: *Skaï and Sky et vidéo* (Leather in the Sky with Video). White Virgin draped in leatherette and artificial marble, 1983, aluminum-backed cibachrome, 67 x 47 W in. (170 x 120 cm). Edition of three. Photo by Jean-Paul Lefret Ace3P School of Photography.

She offers examples of this from her own work. In a series of surgical operation performances she has sculpted her face to meld her features with specific details from famous Western paintings of female icons. In such works the real flesh serves as a canvas for the representational image. The virtual was further enlisted in the seventh of these performances, when the operation was broadcast live to various galleries, art centers, and individuals around the world. In a complementary body of work, Orlan creates digital transformations of her face by morphing its image with the (to Western eyes) distorted features of pre-Columbian and African sculptures. Here the real body becomes raw material for a virtual transformation into forms that long predate current technology.

Hence, in both sets of work, the real and virtual commingle. Orlan notes that people confronted with the digital images sometimes imagine that they are the result of extreme surgery, while a writer dealing with the surgical works was once challenged by her editor to prove that the photographic stills from the event had not been constructed or manipulated in the studio.

The idea of the inseparability of real and virtual helps us understand Orlan's complicated relationship to Western concepts of the body. For example, her "Manifesto of Carnal Art," still the best guide to her work, clearly proclaims that "Carnal Art does not inherit the Christian Tradition, it resists it!"[2] And yet, one cannot spend any time with Orlan's work without being struck by her obsession with elements of the Christian visual tradition. In the persona of Saint Orlan, she mimes the flowing robes and sacred eroticism of baroque representations of the Virgin Mary or the female virgin saints. These lushly realized representations echo the seductive beauty with which such images were endowed to draw the faithful to thoughts of God. However, in Orlan's case, the baroque style is presented in a spirit of irony and rebellion. Her virginal persona is swathed in white fake leather fabric and chastely exhibits a single breast in deference to the nursing Mother of God. However, this character has a black-garbed counterpart, clad in the same material, whose confrontational attitude is anything but demure and saintly. Often these two personas are presented in the same work. In one set of staged photographs, Orlan takes the transformation even further, going through a strip-tease which transforms the Holy Virgin into Botticelli's Venus. From Mother of God to goddess of love, from virgin to whore, from fantasy of purity to fantasy of seduction, Orlan critiques the Christian tradition from within, using its own devices to underscore the contradictory attitudes toward the body that form its understructure.

These contradictions of the Christian attitude toward the body underlie Western culture's sense of the physical. On the one hand there is the aspect of Christianity which is awash in misogyny, body hatred, and a Puritanical suspicion of pleasure. On the other is its unabashed sensuality, a quality that explains why artists continue to find this tradition so fruitful and fascinating. From both an esthetic and a theological perspective, the Christian tradition is immersed in corporeal experience. The pivotal moment in the Christian drama occurs when God is incarnated in the body of Jesus. Christian dogma tells us that, in order to expiate the sins of humanity and make fallen humans eligible for redemption, Jesus must assume a form at once wholly divine and wholly human. In this form, he must sacrifice himself for the sins of

mankind. The key point here is that for the sacrifice to be effective, the body must be real. In this focus on the reality of flesh and blood, we approach one of the most important themes in the work of Orlan.

Orlan offers us a critique of Western culture's vision of the body as it has been shaped by the Christian tradition. As one who herself has been molded by this tradition, and whose native culture is specifically Catholic, Orlan makes this critique from within, using that culture's most sacred images and concepts as her raw material.

Among the contradictions she exposes is the fact that Christianity assigns the body a double role. On the one hand, it is the source of temptation and the origin of man's fall from grace. Hence it is, at least since the Expulsion from Paradise, inherently sinful and represents a state to be transcended. But in Christianity the body is also the instrument of man's redemption. Christ's humanity and Mary's motherhood are at the heart of Christianity's corporeal consciousness. Hence, the body is something to be exalted as well as something to be disciplined or denied. Medieval devotional literature constantly resorted to erotic metaphors to explain God's love for man. Through art, music, incense, and ritual, medieval cathedrals appealed to all the senses in an effort to bring the faithful to a state of exalted belief.

The body-hating side of Christianity came to the fore during the Reformation, when reformers saw the sensuality of Catholic rituals and art as evidence of the religion's decadence. But the sensuality of Catholicism was restored in the defiant eroticism of Counter-Reformation artists like Bernini and Caravaggio, who deliberately mingled the sensual and the spiritual. The Enlightenment demoted the body again, seeing it as a mere container for the glory of the human mind. This separation of mind and body continues to this day in many cybernetic visions of the future.

Looked at from this perspective, Orlan's resistance to Christian tradition is less blasphemous than heretical. She is a heretic because she restores a long-neglected celebration of the physical body. In this she reveals that only one working from inside a Christian consciousness can really make us understand its weaknesses. She reminds us that the reason Bataille and de Sade were each able to so effectively lampoon the Catholicism of their times is that they had absorbed it so completely. The mix of pleasure and pain, sadism and masochism, sacred and profane, which permeate their works would be unimaginable in the works of writers from Protestant Europe.

The contradictions of Christianity underlie a series of performances from the 1970s in which Orlan deliberately muddied the distinctions between purity and sexual experience. Some of these works used the actual linens prepared by the artist for her trousseau in ways that challenged the valorization of virginity implied by the custom of preparing special sheets for the marriage bed. In one performance, Orlan presented these sheets stained with the semen of her lover, crudely embroidering these evidences of impurity to magnify their importance. In others, she draped these sheets around her body, transforming herself into the image of the Virgin. In others, she wore a dress cut from the sheets of the trousseau while using her body as a unit of measurement to take the dimensions of such urban spaces as

the Guggenheim Museum in New York The Centre Georges Pompidou in Paris and the Musée Saint-Pierre in Lyon. These performances culminated in the public washing of the dress and the preservation of the dirty washing water in a reliquary.

In such works, Orlan playfully criticized the culture's fixation on purity and virginity. Saint Orlan was the logical consequence of this critique. This persona was created by the artist out of images of Madonnas, holy virgins, and saints. In a series of performances and plastic works which spanned the years 1974 to 1990 under the title *Le Drapé et le Baroque* (Drapery and the Baroque) the artist made full use of the contradictions embodied by such Christian female role models as the Virgin Mary and Saint Teresa of Avila. The Virgin Mary, after all, offers the impossible spectacle of the Mother who has somehow managed to remain a Virgin. Saint Teresa is equally paradoxical. Her writings describe her mystical encounters with Christ in terms that are almost shockingly sexual.

In his famous sculpture of the virgin mystic, Bernini makes the most of this contradiction, choosing to depict the moment when Teresa feels the shaft of Christ's love physically penetrating her body. He draws on a passage from her journals which describe this moment. Teresa writes of being visited by a beautiful angel: "In his hands I saw a golden spear, at its tip, a point of fire. This he plunged into my heart several times so that it penetrated into my entrails. When he pulled it out I felt he took them with it and left me utterly consumed by the great love of God. The pain was so severe that it made me utter several moans . . . This is not a physical but a spiritual pain, though the body has some share in it—even a considerable share."[3]

In Bernini's sculpture, Teresa swoons under the influence of this penetration, the expression on her face is unmistakably that of a woman in the throes of sexual climax. In both photographic tableaux and live performances, Orlan exploits this slippage between physical and spiritual ecstasy. She envelopes her body in the voluminous garments favored in baroque representations of the saints, yet allows crucial parts of her body to be exposed—hands gesturing heavenward, a carefully made-up face, and often a single breast, which titillatingly blurs the line between nurturing mother and coy seductress. In some of the photographic tableaux, she appears to float over the heads of a gesticulating crowd composed of inmates from a mental institution made up to look like ecstatic worshipers of the Virgin. She has re-staged the Assumption—an article of Catholic faith, which holds that the Virgin Mary, thanks to her unblemished purity, was borne to heaven in her bodily form three days after her death. The Assumption of Saint Orlan is completed when she disappears behind a screen of smoke. Orlan has also staged a work in which she enters the performance space draped in fabric and carried by pole bearers. She holds a "baby," actually a tightly wrapped piece of bread which she slowly uncovers and then eats—a reference to the moment in the Mass when the faithful are enjoined to literally eat the body of Christ. After removing her makeup and exposing her breasts, she is taken away in a ball of red fabric. In this work, the transgressive merges with the orthodox, reminding us that underlying the founding stories of the Christian faith are intimations of human sacrifice, lust, and spiritual orgasm.

Since 1984 Orlan has been creating fictional film posters entitled *Le Plan du film* (A Shot at a Movie) which incorporate

the symbols and personas she has created over the years. Early works in this series counterpoint the virginal Saint Orlan with an alter ego swathed in black leather. Others borrow from aspects of both her personal and art life, creating the apparatus around a film which does not yet exist, thus once again confusing "real" and "virtual." Several posters make reference to a 1977 performance entitled *Le Baiser de l'artiste* (Kiss the Artist). In that work, Orlan seated herself behind a life-size photograph of her naked torso which had been outfitted with a slot leading to a coin collector in her crotch. For the same price, onlookers could purchase a kiss or place a candle before a representation of Orlan as the Virgin. The juxtaposition of the image of Virgin and Whore thus underlined the extent to which, in the gospel according to Saint Orlan, sacred and profane, spiritual and carnal, and body and soul cannot be separated. In all but erasing the distinction between spiritual and sexual pleasure and ecstasy, Saint Orlan playfully subverts the Christian emphasis on sensuous experience as a gateway to faith.

The works comprising *Le Drapé et le Baroque* led to the series of surgical operations/performances which Orlan titled *La Réincarnation de Sainte Orlan* (The Reincarnation of Saint Orlan). While earlier works had incorporated videos and involved various photographic processes, the new work brought Orlan's interest in the corporeal implications of developments in science and technology to the fore. These minutely documented (and in one case internationally televised) performances turned her own body into a medium for sculpture. Between 1990 and 1993 she undertook nine operations to alter her features, using as a template specific details chosen from famous Renaissance and post-Renaissance paintings of idealized females. While this project has

sometimes been erroneously described as an effort to recreate the ideal of Western beauty in her own body, in fact Orlan notes that she chose each model (among them Boucher's Europa, da Vinci's Mona Lisa, Botticelli's Venus, and Gérôme's Psyche) for their histories rather than their beauty. To emphasize this fact, she inserted silicon bumps on her forehead in the last operation, which, as she points out, lean more toward the model of the grotesque than the beautiful.

The operations were genuine performances. Orlan carefully orchestrated every detail, from the designer clothing she wore to the accessories, which included crucifixes, plastic fruit, and flowers. She was given a local anesthetic so that she could converse and read from significant literary texts during the course of the operation. These performances generated film stills, videotapes, and films that do not flinch from portraying the dripping blood, scars, and bits of fat removed during the course of the operation. The latter were not discarded, but sealed in vials to be sold as relics of the event. Playfully mocking the mystical reverence that surrounds the Shroud of Turin, that piece of ancient fabric said to contain an impression of the dead Christ's face and body, she also distributed "Sacred Shrouds" consisting of the blood-soaked bits of gauze used to soak up her blood during the operations. And she used the blood residue to "paint" a series of self-portraits.

This series of operations has been among the most controversial work in Orlan's controversial career, generating debate about whether the artist was insane or merely a sensation-hawking huckster. The sense of moral outrage that some critics have expressed returns us to Orlan's dialogue with the Christian tradition. She brings to the

fore an essential question about the relationship of body and identity.

If, as certain scientific and post-Reformation thinkers maintain, the body is simply an inert vessel for mind or soul, then it would seem to matter little how we alter or distort it. However, since the Middle Ages, there have been complicated ethical debates over the status of our corporeal forms. These have been traced by the medieval historian Caroline Walker Bynum in her ground-breaking studies of the meanings attached to the body, especially the female body, in the medieval period.[4]

Bynum shows how medieval consciousness was based on the belief in the inseparability of body and soul. As she points out, medieval theologians maintained that the elevation of saints into heaven was not considered complete until their souls were joined by their bodies, and until then, the bodies they left behind were imbued with special powers which reflected the exaltation of their souls. This is the belief system behind the cult of relics, those bits of blood and flesh of long-departed saints and martyrs, whose near-magical powers stemmed from a spiritual power that lingered in the flesh after the soul had joined its maker. Further, Bynum points to the importance attached to the Christian notion of the resurrection of the body. According to this dogma, the bodies of sinners and saved alike will rise from their graves at the second coming of Christ so that they can be reunited with their souls for an eternity in heaven or hell. In the Middle Ages, Bynum says, this belief led to widespread debate and anxiety over questions like: What will happen to the bodies of fetuses or to the remains of those ingested by cannibals? To what age and state of health will the bodies return? Will we be able to see, eat, engage in sexual intercourse, and defecate in heaven?

Arcane and even laughable as such questions may seem today, Bynum sees a direct link between these ideas and our own debates about the status of the body in a technological age. She argues that modern questions about the implications of cloning and of heart and brain transplants, fears that our humanity will be undermined by artificial intelligence, and the debate about whether those who are comatose or suffering from Alzheimer's have lost a portion of their personhood, suggest that we still see our identities as a mixture of body and soul. When we wonder whether the self can continue if the body is significantly altered, and whether mind and memory alone are enough to establish identity, we are confronting our conviction that the body is more than a neutral shell. Instead, we are accepting the belief that identity is a subtle and still mysterious blend of body and mind or body and soul.

Looked at this way, the moral outrage that some critics have expressed about Orlan's performance-operations makes more sense. Orlan challenges deep-seated convictions about the relationship of body and identity. She has elected to undergo a series of operations, not for the socially acceptable purpose of becoming more beautiful, but to pursue a radical definition of freedom. In doing so she confronts conventional ideas about the order of nature. She forces us to consider the idea that, if our bodies are an indispensable part of who we are, sufficiently radical changes to the body may turn us into someone new. In fact, Orlan has already metamorphosed more than once, starting with her decision at the age of seventeen to replace her given name with one that she

chose herself. In essence, she notes, she was thereby giving birth to herself. And she has suggested that she may change her identity again some time in the future.

Orlan's critics sense that she is playing God, choosing to adopt the role of creator rather than that of submissive creature. And indeed, she has declared, "My work is a struggle against the innate, the inexorable, the programmed, Nature, DNA (which is our direct rival as far as artists of representation are concerned), and God! My work is blasphemous. It is an endeavor to move the bars of the cage, a radical and uncomfortable endeavor!"5

However, despite her protestations against God and nature, Orlan has never abandoned the body as seat of identity. Like the medieval Christian, she believes that her flesh is fully implicated in her sense of selfhood. She feels it is necessary to undergo the messy procedures that lead to her transformations—inscribing the new images onto her flesh when she could just change her body virtually. For *La Réincarnation de Sainte Orlan* it was not enough to rearrange representations of her self— it was necessary to write the changes in the flesh. Orlan notes that she has reversed the Christian dictum—she represents, not the Word made Flesh, but the Flesh made Word, turned into a text whose form and syntax is created from blood and viscera rather than words.

The same subtle thread underlies Orlan's embrace of technology. Here again, Orlan can sound like a technological fundamentalist, positing an unfathomable divide between fallible body and rationalized machinery. She has remarked, "Like the Austrian artist Stelarc, I believe that the body is obsolete. It is no longer adequate for the current situation. We mutate at the speed of cockroaches, but we are cockroaches whose memories are in computers, who pilot airplanes and drive cars that we have conceived, although our bodies are not designed for these speeds. We are on the threshold of a world for which we are neither mentally nor physically ready." She goes on to propose a new mantra: "This is my body, this is my software."6

But again, her work demonstrates a desire not so much to transcend or reject bodily experience as to expand its possibilities. She could not be further from the extremist views expounded by some advocates of virtual reality for whom the body has become an unnecessary nuisance whose quirks and infirmities get in the way of the purely mental universe promised by technology. In a 1995 performance at the ICA in London she found a humorous way to mock this kind of thinking. Entitled *La Femme avec tête* (Woman with Head), she used the old magician's trick to make it appear that her body had disappeared and that her head, isolated on a table, could exist without it, as she conversed with the audience and read texts from authors such as Julia Kristeva, Antonin Artaud, and Michel Serres.

As Orlan continually points out, she is opposed to any kind of "either/or," the idea that we must choose between one vision of reality and the other. She notes, "In my work 'And' is an organizing principle that always recurs: 'past and present,' 'public and private,' 'that which is considered beautiful and that which is considered ugly,' 'the natural and the artificial,' 'satellite transmissions and the drawings I did with my fingers and blood in the course of my surgical performances,' 'the relics sculpted with my body and the works done by computer drawing and morphing . . .'"7

In this she echoes the critique of purely technological thinking explored by critic and artist Simon Penny. His own work in electronic media has led Penny to distinguish between the body knowledge upon which art has traditionally depended and what he calls the "engineering world view." The latter he sees as a perpetuation of Cartesian dualism in which the opposition of mind and body is reinscribed as the opposition between hardware and software. In this schema, the brain is described by recourse to mechanical metaphors based on computer science—it stores memory in files, uploads programs, processes information. The problem, Penny maintains, is that much of what we "know" is the result of embodied consciousness. He asks, "Why do we believe that consciousness is located exclusively in the brain, when, contrarily, we put so much faith in 'gut feelings'? Why do we describe some responses as 'visceral'? Why do the ancient Indian yogic and Chinese martial traditions locate the center of will in the belly? ... I want in all seriousness to argue that I 'know' with my arms and with my stomach."[8]

This sense of body knowledge is precisely what Orlan talks about when she refers to the mingling of real and virtual. She points out that all art works are traces of body processes, from the sweep of the hand, which lies behind the painted brush stroke, to the photographs documenting a performance. Her fascination with the baroque stems in large part from its appeal to the nonvisual senses—to touch and sound as much as sight. Even her *Self-Hybridations* (Self-Hybridizations) the series of works which followed the surgeries and consist of digital melds of her face with pre-Columbian or African sculptures, are not solely virtual. In the end, they depend on the virtual merging of two real physical bodies—one her own surgically altered face and the other a sculpted face from a culture in which such objects are infused with real spirits.

Because their origin is in something "real" (if the use of that word has not become too problematic), the self-hybridizations are compelling in the way that digitally invented characters of the sort that inhabit video games are not. These works are often discussed in relation to Orlan's redefinition of beauty. Just as the surgical performances satirically subvert Western standards of beauty, the self-hybridizations explore non-Western ideals of perfection. In their effort to meld technology and nature, they look back to her monumental photographic fresco entitled *Omnipresence* from 1993 and 1994. *Omnipresence* paired two kinds of images that ran vertically across a long wall. On the bottom was a running collage of images of female beauty culled from Western painting. These had been digitally combined with Orlan's own face, suggesting the absorption of Western ideals of beauty. Running above these images were a set of photographs of her face that documented the slow process from operation to healing. The bruises, discoloration, and scars of the latter presented the normally hidden side of plastic surgery. In this they looked ahead to the self-hybridizations in which the grotesque becomes inseparable from the beautiful.

The *Self-Hybridations* are often monstrous to Western eyes. In these works, Orlan's unmistakable eyes peer from faces characterized by elongated necks and noses, strange protuberances, flattened foreheads, elaborate ornamental markings, and helmet-like hair arrangements. They seem to exist somewhere between flesh and stone, yet their lively expressions give them an eerie animation.

One of Orlan's points here is that the distortions which look so strange and "unnatural" to our eyes reflect deliberate alterations performed on the body in various pre-Columbian and African cultures. In some ways, they are not so different from the Western practice of cosmetic surgery and the use of make-up to enhance individual beauty. However, there is an important distinction. In Mayan, Olmec, and African societies, such alterations serve a variety of more social functions—they operate as markers of important matters like tribal allegiance, hierarchy within the tribe, and marital status. To return to Orlan's notion of the Flesh made Word, they can often literally be read. As art historian Marek Bartelik points out, scarifications of African Luba peoples serve as mnemonic devices to retain memories of the ornamented person's life.[9]

The notion that one's life might literally be written on one's face offers another context for Orlan's recreation of identity through surgery. In her self-hybridizations, her own history inscribed in her reworked features, and especially the bumps on her forehead blend seamlessly with the ritual deformations practiced by other cultures. In *Cimier ancien de danse Ejagham Nigéria et visage de femme Euro-Stéphanoise* (Old Nigerian Ejagham Dance Crest with Face of Euro-Saint-Étienner Woman), for instance, her head sprouts the elaborate coils which distinguish masks from this Nigerian tribe. Another work, *Masque de société d'initiation Fang Gabon et photo de femme Euro-Stéphanoise* (Gabonese Fang Initiation Mask with Photo of Euro-Saint-Étienner Woman) blends Orlan's features with the Fang masks' distinctive heart-shaped face and arching eyebrows. In *Statuaire Ifé et visage de femme aux gants Euro-Forèzienne avec bosses facio-temporales* (Ife Statuary with Face of Gloved Euro-Forezian Woman Bearing Facio-Temporal Bumps) the whole face area, including Orlan's forehead bumps, is covered with narrow rows of parallel ridges thought to represent face markings.

In blending the face, as her titles remind us, of a European woman with those of the masks from various "primitive" cultures, Orlan also recapitulates the origins of modernism. As is now well known, early modernists like Picasso and Matisse were deeply influenced by African sculptures and ritual objects which they encountered in the ethnographic museums of Paris. In effect the kinds of physical deformations and alterations apparent in Orlan's work gave these artists permission to undertake the formal experiments that led to Cubism and modernist abstraction.

Unlike the early modernists, however, Orlan is interested in more than the formal aspects of these masks and sculptures. Instead, she uses them to explore non-Western notions of the relationship of body and soul. In contrast to the post-Enlightenment tendency to separate the physical and the spiritual into distinct spheres, these works convey a sense of identity in which the two are firmly linked. As ritual objects, such sculptures often are believed to contain real magical powers. They also embody a worldview in which the body contains powers that extend beyond death. One thinks, for instance, of the belief common to Mayan and certain African cultures that through cannibalism one ingests not just the body of one's adversary, but also his strength. This is body knowledge of the most extreme sort. (It is also quite strangely reminiscent of the Christian practice of Holy Communion in which the faithful consume the body of Christ.)

Thus, when Orlan absorbs these alien faces, she offers us the spectacle of the artist literally becoming a ritual object. As in her appearances as Saint Orlan, she inhabits an intermediary space between different realms of experience. In the process, she transcends our conventional sense of time and space. She says, "One of my favorite maxims is: 'remember the future' as it deals with the crossing of time in the series of my *Self-Hybridizations* in which the memories of past sculptures—sometimes belonging to cultures that have disappeared—make it possible to construct images that anticipate tomorrow, because here and now they question possible futures that are not lost in the ready-made thought of our time, and are not glued to it. This time is not my favorite perfume. Today is already a thing of the past."[10]

Nothing could be further from our contemporary fixation on linearity and cause and effect. By drawing on the embodied consciousness of pre-modern and non-Western cultures, Orlan points a way out of the dilemmas created by our overly rationalistic, Cartesian-dominated culture. Throughout her career she has explored models of body knowledge that eschew the limitations imposed by a culture which divides body from mind, man from woman, the beautiful from the grotesque, the real from the virtual, and the virgin from the whore.

Taken together, Orlan's work is a triumphant affirmation of the magnificent "And" which may indeed, if we are lucky, help us chart a path to the future.

1 Orlan, "The Complex Dialectics of Virtuality and Reality," in *Orlan, 1964–2001*, Artium (Salamanca: Ediciones Universidad Salamanca, 2002), 227.

2 Orlan, "Manifesto of Carnal Art," in *Orlan 1964-2001,* 218.

3 Quoted in Charles Scribner III, *Bernini* (New York: Harry N. Abrams, 1991), 92.

4 Caroline Walker Bynum, *The Resurrection of the Body* (New York: Columbia University Press, 1995).

5 Orlan, "Orlan's Speech," in *Orlan 1964-2001*, 221.

6 Ibid.

7 Orlan, "Complex Dialectics," 228.

8 Simon Penny, "The Virtualization of Art Practice: Body Knowledge and the Engineering Worldview," *Art Journal* (Fall 1997): 34.

9 Marek Bartelik, "Re-Figuring Beauty: Notes on Orlan," in *Orlan* (Paris: Editions Al Dante, 2001).

10 Orlan, "Complex Dialectics," 228.

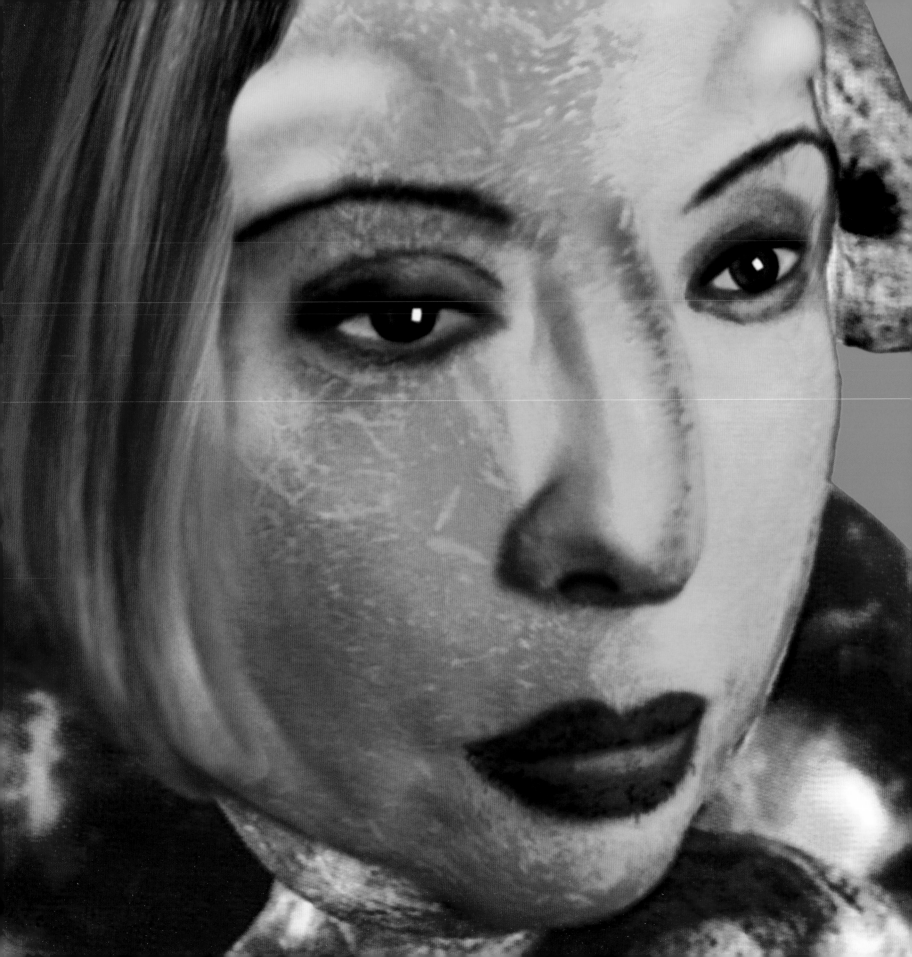

A Conversation
between Christine Buci-Glucksmann and Bernard Blistène

CBG: Among the multiple approaches to Orlan's work is one which is frequently underestimated, when not forgotten: her relationship with art history and with contemporary art. Although over the last thirty years there have of course been numerous intermittent transformations, I believe it is important here that we attempt to question ourselves Orlan's relationship with art in general and that we restore her to her proper place.

BB: We should really begin by taking a look at the basic facts. Orlan started working in the mid-sixties, in 1964 to be exact, in an atmosphere which, let's be honest, was completely alien, even hostile, to the practice later to become generically known as performance art. And this despite the fact that Fluxus, and with them Ben or Filliou, or all of those involved in the Happenings of Jean-Jacques Lebel and the Festival of Free Expression, made an active, incisive, and essential contribution to comprehension of the radical mutations to appear in the years to come. There was, in short, a sort of peculiar loathing to enter this area of art, which was acquiring gradual definition thanks to actions such as those on which Orlan was working at the time. Projects like *Peint/Pas Peint* (Painted/Not Painted), the subtitle of which was a complete program in itself given its requirement that *Orlan accouche d'elle-m'aime* (Orlan Gives Birth to Her Loved Self)[1] indicated that the screenplay was "taking shape." We see Orlan in the nude, set against a background of masks, mannequins, and easels in which we would have great difficulty finding any kind of connection with the field of visual arts as defined at that time in France. Then, suddenly, Orlan started using photography—a medium for which she still

Self-hybridation précolombienne No. 28 (Pre-Columbian Self-Hybridization No. 28, detail), 1998,
39 ⅓ x 59 in. (100 x 150 cm) aluminum-backed cibachrome, frame. Michel Rein collection.

has a strong predilection today. Orlan's work is radically etched on a modern history consisting of essential gestures, gestures which, without having to go as far back as the Dadaists, we find in John Cage and Rauschenberg, in the Gutaï group, which even in 1955 was characterized by a strong gestural and anthropomorphic component, and obviously in Yves Klein, but also in George Brecht, in Allan Kaprow, in Piero Manzoni, in Vostell, or in Arman; expressions which are also those of the Austrians who, from Nitsch to Otto Mühl, celebrated the "Fiesta of Naturalism" and created the "Orgiastic Mystery Theater," the profound ritual tone of which I would like to think has an obvious connection to Orlan's work. The list could go on forever and would show the extent to which France has ostracized most of her work. This was therefore the period in which Orlan,[2] playing on words with the name she has given herself—this "slow *or*" which is still the subject of discussion—created her *Marches au ralenti* (Slow March) series. It was also the gestation period of Roman Opalka's project, and of course a few years later, that of *Vingt-quatre heures de la vie d'une femme ordinaire* (Twenty-four hours in the life of an ordinary woman) where Michel Journiac confronted us with the alienation of the ordinary woman at the time of the [France's] "Golden Age" [1945–1975] or of *La Messe pour un corps* (The Mass for a Body), a veritable ceremony mimicking that of Holy Communion. The list, as you can see, would be long, and even more fascinating considering that it obliges the reconstruction of another history, another theology in which Orlan participates, and which was and still is rejected by the majority of the historians of contemporary art for the period in question. Right from the very beginning Orlan took her work and placed it in a space, which was not the space of what is commonly termed contemporary art. Thus, from the beginning, she aimed to place her work in this broad and heterodox field which no longer surprises us today, but which is much older than the 1976 *Le Baiser de l'artiste* (Kiss the Artist), normally taken as a reference point.

CBG: Ever since the very beginning, Orlan has had a true critical conscience, and this criticism has been expressed in action in the profound sense of the art. It was precisely during these years before and after 1968 that this critical conscience literally exploded. And yet, during the transformations which Orlan may have undergone, there has always been what I call a "triple criticism": a criticism of art in its institutional reality through a plurality of media; a criticism of the cultural rules and artifacts that surfaced at a very early stage—her *Tableaux vivants* based on Manet, depicting nude men and referring to the subject of Orlan's birth, date from 1967; and a self-criticism, fed by the numerous transformations of her identity, but also by jokes and games. Moreover, I think that if we start with the first works of the second half of the sixties—unconventional works like *Les Draps du trousseau* (Sheets from the Trousseau), which she embroidered with her lovers' sperm—the first performances, we will see that very early on Orlan affirmed herself in what we should call a critical attitude in the broad sense of the term.

BB: To cover all of these fields in a period which continued to think in Manichean terms that the space of visual arts only developed within the painting–sculpture binomial, but which at the same time denied and renounced the true specificity of the historical avant-garde, and to succeed in restoring her own practice to this space, was in itself an aspect of Orlan's resistance. Orlan soon affirmed this critical and political awareness, like for example in her

commitment to the circles of Saint-Etienne, of Lyon, and later of Paris. I would undoubtedly say that this was a case of political activism, of a deliberately refractory practice, and of that which the critics much later went on to call "attitude art." Because, from the outset, Orlan gave preference to a strongly-pronounced presence in the world while cultivating singularity to extravagance. Orlan's stance is congenially diverging and cultivates marginality, detachment, and disobedience. I like that statement by Paul Ardenne, when analyzing Orlan's work, in which he says that attitude art is imposing and imposes itself due to the necessary updating of "another body": "an unusual body," he wrote, "different in its irruption from the body than that which is accepted and segregated by society and its rules of community life." In Orlan's late sixties works, and obviously in her seventies creations, I can already recognize this critical attitude that you describe as being closely related to the need to take the body to a scenario of art experienced like theater. *Le Baiser de l'artiste*, which caused such a commotion and sparked off a chain reaction, starting with her being fired from her job as a socio-cultural educator-organizer, is in many ways the expression of a body that offers itself for observation, like that of an actor would do. Thus, to introduce the work of art to corporal topography, to put, in the Baudelairian sense, "the body in the nude," to substitute the body for a classic object of transaction, to produce the body like an artistic and material object, to make oneself into this body, to present it and exhibit it in the "arena," as described by Harold Rosenberg, marks in my opinion the essential and pioneering step forward which Orlan has taken in her search for a new social relationship that she finally wanted to set free. Something like the echo of Simone de Beauvoir's famous assertion in *The Second Sex*, where, as well as the famous "We are not born women, we become women," she wrote: "It is civilization in general that produces the intermediate product between the macho and the castrato which is called the feminine."

CBG: Yes, and it is because there is a veritable rejection of women that Orlan has always maintained that "women have to reinvent themselves." Throughout the entire period when she used the Baroque to create a personal syntax, she even went as far as to say that what women have to do is give birth to themselves, a sort of self-birth, a self-production of themselves. This said, Orlan has gone about this process while criticizing the rules, starting with the way the feminine and the masculine are distributed, the social dualisms—the saint and the whore—and, more globally, with a criticism that puts at the forefront a dimension of art which I believe to be underestimated and which I would call the "rite." Orlan has attacked rites and built her own rituals. Rites—and anthropologists won't contradict me on this—are always a kind of mechanism that permits the construction of relative identities. In Orlan's art there is a thread that refers to this kind of relationship, in the image and based on her own body, with the relative othernesses, the adopted otherness of models and the Baroque paradigm, othernesses of a carnal art, othernesses taken from the virtual, and now from cinema. In order to show her opposition to certain conformisms, Orlan has occupied an area that is ritual and mythological in the West.

BB: There are admittedly rites in Orlan's work and in that of some of her contemporaries. There are rites in Michel Journiac's parody of the Eucharist when he invites the public to take Communion by drinking his blood. There are

rites in the drills—let's call them that!—of Vito Acconci masturbating himself to exhaustion in public. There are rites in the silent meetings of Gina Pane as she subjects her body to injury and, undoubtedly, in the tale of art history told by Joseph Beuys to a dead hare behind the glass of a window in a Düsseldorf gallery. There is a rite in watching Gilbert and George exhibit themselves like live sculptures, in attending the religious masquerades of Herman Nitsch. There are rites, and even protocol, since these kinds of practices could not exist without transgressing such a regulated or formatted space. "Burlesque body" or "catastrophic body," "mechanical body" or "Narcissus body," in the words of Antoine de Baecque on referring to the body on the stage, since, for all of these artists, it is a question of searching for a liberating dimension that cannot be expressed without being highly symbolized, without the construction of a "personal mythology" as opposed to the institutions and the places that embody them.

CBG: It is obvious that 1968 marked the period of criticism vis-à-vis the institutions and the places that represent them. How could we ever forget Buren? To take the body of Saint Teresa, as done by Orlan in 1970 in her work based on Bernini, and, basically, on the entire scenography staged around herself, was to take a model completely rejected by those years when society was receiving the brunt of Marxist criticism. To make a construction of oneself, to inject dynamics into the shape, to build a—let's say—Baroque "figural" body for oneself, was undoubtedly to participate in the current criticism of female stereotypes, but that has little in common with the triumphant feminism that was to appear in subsequent years. What Orlan was to find in the Baroque and what brought us together on the book *The Triumph of the Baroque* is, in short, everything that revolves around the Venetian proverb: "creating effects generates affection and beings." What really is interesting is a theater piece literally set around the chronological progress of her metamorphosis after a series of operations, where Orlan was capable of placing herself outside of the culture, even then demonstrating a number of esthetic touches that were to mark twenty years of history: on the one hand, development of the sublime, and on the other, the following stage, the radical "desublimation" of art.

BB: Prior to the triumphant feminism for which North America has appointed itself spokesperson with the appearance of "gender studies," we should remember the works of Shigeko Kubota or Mary Kelly, mocked in their day, or those of Hannah Wilke or Eleanor Antin, which caricatured the stereotypes of social codes in the late sixties. We should remember the performances of Carolee Schneemann playing out "personal disorder" and "the persistence of feelings" as they appeared on the piece of paper she was pulling out of her vagina. We should remember the performances of Adrian Piper or those of Rose English and Sally Potter, to mention but a few of the artists who, way before feminism became an excuse and a stereotype, had taken to the front line of the stage a series of actions and gestures combining repulsion and fear, which, in my opinion, always refers us to primitive cultures. Let's recall the tales of James G. Frazer in *The Golden Bough,* or even older writings like Pliny's *Natural History;* let's recall those tales and those myths, their rituals not yet destroyed by rational knowledge and replaced with the forms of our everyday routine. I think Orlan's art comprises a sort of double movement leading her to base her project on a close relationship with the founding myths while similarly destroying them, to mark the transsexualism of the saints and the

sacred, but also of the profane, to reinterpret, as from 1974, the infinite progress of the metamorphoses in an incredible number of performances set around *Le Drapé et le baroque* (Drapery and the Baroque), surrounded by cherubs, borne on a reliquary, cross-dressed as the Madonna, but still not simplifying the task of understanding whether her intention was to deny these myths or affirm their symbolic presence in the present day. As if, as pointed out by Jean-Michel Ribettes, Orlan were creating "a heterodox, complex, paradoxical work, simultaneously laced with contradictory decisions" which, in a word, are the expression of the ubiquity of our time.

CBG: Orlan has underlined the fact that she spent twenty years researching the Baroque and Judeo-Christian iconography. In fact, she made a meticulous study of Bernini's folding and carried out an observation study that took her as far as Rome. In this field she has sought an "alternative" scenography, in the broadest sense of the word, both in the performances in which she mingles with the processions and in which, as you said before, she has herself carried, like in that "alternative" theater designed as if a process. The idea that art is a process is important for her, and she in fact finds her specific realization in this manner of staging the body that leads her to search for an alternative identity.

BB: Orlan sees art as a "process." We could even say that she mainly bases this opinion on experience. Which would moreover be a simple way of considering her work from an angle set apart from that of "body art," a movement to which she has moreover never belonged nor wanted to belong. Her work seems to have a certain connection with the belated definition set down by François Pluchart in his 1974 *Manifesto*. But the term is somewhat vague and I often find the meanings it encompasses contradictory, even antithetical. It is also true that for Orlan, while the body is both an essential detail and a language, it has to be the necessary expression of her subversive will. This said, Orlan's work has nothing communal about it as far as I can see, nor does it have this somber and painful dimension so often observed in most body art proposals. Quite the opposite, Orlan's art is very amusing when taken to the stage. She loves gambling and excess. She thrives on jokes and games. Didn't she bring along a magician for that marvelous work entitled *La Femme avec tête* (Woman with Head)? Hasn't she tried to make use of all of the possibilities offered by illusionism? Her theater is cheerful even if it looks a bit like a rictus depending on the operation in question. Her theatre is a continuous exaltation of the happening, she rejects the minimalism promulgated by some of her contemporaries. She subsists on "over-exposure." And that is also what nourishes what you call her "alternative scenography" and which emerges with all of its strength in the exaltation of the Baroque space.

CBG: All of the artistic expressions used by Orlan have always had, based on specific media, "an art of the happening"—a Baroque category *par excellence*. This is what the Baroque world called "the opportunity," "*l'occasione*," an art of the time consisting of what you call "over-exposure." Baroque time is increasingly less scatological and more focused on what Walter Benjamin calls "the value of exhibition." This "over-exposure" in the photographs, dressed like a saint, this practice of the double—remember Harlequin or Narcissus—engenders a space which is that of the plural hybridization of oneself, but which establishes an extremely ambiguous relationship with feminism—if we

are to understand by feminism the ideological feminism of gender destruction. Orlan has always said "I am a man *(f)* and I am a woman *(m),*" that is, she recognizes that we are basically bisexual in the Freudian sense. But the question she raises on becoming Orlan and with Orlan's invention is, basically, that of becoming a woman in our society. A process of constructing oneself that does not only raise ideological questions, but a sort of dramaturgy of oneself through the metamorphoses themselves.

BB: I agree with you regarding the idea that everything in Orlan's art comes from metamorphosis. But this metamorphosis is not so much the one evoked by the classical references to which Orlan points us, but rather the one that refers to the constant attempt to update these said references. With Orlan the myth is not only the classical, Baroque space, that of the draped body evoking the different styles of figures that come alive, in living paintings, during the scenes as they rearrange themselves. The myth is updated by a wide variety of tales, but also by the modern means and techniques with which Orlan enriches her work. The experience directed by Orlan is not, therefore, a simple recollection of the figures of the past, but an attempt to give them a contemporary aspect, involving neither nostalgia nor romanticism, in the era of a machined humanity, of a body mechanized and rebuilt, in a period which Jeffrey Deitch, at an exhibition that mainly interested me because of its title, called *Post-Human* in 1991.

Besides, Orlan constantly reminds us that she defines herself above all as an "interdisciplinary and/or pluridisciplinary multimedia artist," a way of telling those who believe that her work does nothing but prolong the ghosts and the effects of the past that for her everything takes place in the present. In the present, true, but also live. Look at her 1990 operations, filmed and broadcast from New York by satellite. Look at the interference of the contemporary media in what you call "a dramaturgy." There would, on the other hand, be a great deal of food for thought in the fact that Orlan's models, although they undoubtedly originated in the theater—look at Artaud's influence throughout her work—update themselves, even live, so that they are no longer a "corporal art," but rather what she herself would like to define as a "carnal" art. Orlan's territory was undoubtedly, in the beginning, that of the classical and Baroque theater that dwells within it, but it continues to evoke and defy the models of the present, to think in and take the shape of the image. Orlan is an artist "in the age of mechanical reproduction." Her body is a "found object" of *ready-made* essence, which recovers during the numerical and virtual era in the operating theater by means of "surgical–operations–performances."

CBG: But the fourth dimension, the one brought to mind by Duchamp in *Le Grand Verre,* is the virtual dimension! And Orlan's work comes from a sort of "undressing," dressed like a saint and a whore, starting with a breast and ending completely in the nude. However, this genealogy that passes in my opinion through Duchamp and Warhol is that of an art of the "beauty of indifference." When it comes down to it, Orlan may have passed from what I would call "the art of doubles" originating in the Baroque culture, to Western metaphysics, and, obviously as a result of psychoanalysis, to a truly Deleuzian art of multiplicities. I think this is the nucleus of her present work. Her numerous fictions emerge

at the bottom of a fiction which, as you said, is not a romantic fiction, it doesn't come from the projection of the interior. Orlan is not often considered to be a "feminist" artist. Quite the opposite, Orlan produces a reverse movement that would correspond to either Blanchot or Foucault inasmuch as the double is an exterior experience, the true fiction is an exterior experience that makes the skin change in all senses of the term. It is one of the threads that we find in works like *Donkey Skin*, or in making oneself a new skin and showing what is to be found under it by means of operations carried out within this incredible temporality you were evoking: the self in a temporary sequence that dismantles images of beautiful and ugly alike, incorporating the exterior and, therefore, the otherness.

BB: Perhaps this would be a good time to remember that Orlan invented her name, a name with a masculine ring to it that reminds us, as Sarah Wilson says, that "the post-modern body is above all a text," a name with echoes of Virginia Woolf's *Orlando*. A fictitious name, a fictional name that is unknown, a name to know and to discover. Orlan adopts a position—you called it "a process"—that incites one to enter the folds, to penetrate all of this: a violent and chaotic process accentuated by the fact that it takes place in real life, that it is not a question of acting. Because Orlan is no longer a whole body, a body simply made up or disguised as it was in her earlier performances. Orlan is now a transformed body, a body-prosthesis, the physiognomy of which escapes (or more exactly has escaped) the canons and rules of our culture, a body of a "disturbing rareness." "Not flesh made into a performance, but quite the opposite," in the words of Paul Ardenne, "a performance made into flesh." The operations that Orlan invents and has people perform on her have reshaped her body, taking to an extreme the feminist slogan "our bodies ourselves." You've got to read the incredible text that Orlan entitles "from carnal art to the artist's embrace." You've got to understand the extent to which this body-instrument has finally become a body-matter, disfigured and later re-figured thanks to prostheses and silicone, and understand how, over and above the immediate references laced through the history of her performances, Orlan once again, physically and really, appropriates this body for herself. Here we find a sort of denial of hope and, besides, the whole distance separating, in my opinion, what you were saying about the Baroque model from which she initially took her inspiration and that, for example, currently dictated in the discourse of an artist like Matthew Barney, whose work is set around a rococo or fairytale universe which prefers narration and a half-human, half-animal body artifice to any real transformation and hybridization of oneself.

CBG: From this point of view, Orlan has invented, in addition to a number of poses and a ritual, what I would call, quoting Michel Foucault, "new forms of subjectivization." The question of being like someone else or like a double, the idea of giving way to this double as though it were an ambidextrous knowledge that had led her to create forms of "subjectivization," where the identity is not actually the central axis as such, but only one of the aspects. A bit like *Le Plan du film* (A Shot at a Movie) or "the outline of the film" where the fictional names are part of the story line and one's own fiction is the condition. "Fictionalizing" herself and defining different kinds of transformations deep in the heart of an operating theater conveyed as a laboratory showing live images of her own transformation, was bound to lead her to explore the mechanisms involved in making a film.

BB: Before the film itself was, as you said, the intrusion of the camera at the moment of operating. Because what Orlan wants is not so much that her operations be filmed, but to be able to control the evolution of the transformations she imposes upon her body. Orlan is both the actor and director of her evolution. "Carnal Art," as she said in her 1997 conference, "does not go against cosmetic surgery, but is against the models this surgery transmits." Thus, apart from demolishing the borders separating the private from the public, Orlan has decided to control everything, to succeed in returning the body, her own body, "to the ownership of the person who lives in it," drawing its outline and sculpting it. At this point I would like to stress that Orlan herself covers all of the esthetic disciplines and categories, that drawing, sculpture, and painting are one and the same thing and that the image, over and above these separations, takes over from them, making it possible to start over from scratch, to authorize a new schedule and the invention of a new surface.

CBG: The thing is that with Orlan you have to take the surface in quickly—and that's something I do. In the Warholian sense, in the mirror that Warhol so magnificently informs us is empty. Remember that beautiful sentence by Nietzsche according to which you've got to have "the value of the surface." Nietzsche says this because he knows that beneath the surface lie Dionysus, life, and pain. You've got to "make yourself a skin out of art" says Orlan, with the hybridization of cultures, the beauty canons of which, whether they be African or Aztec, do not coincide with those of Western culture. Orlan literally changes her skin and her surface. She changes appearance. Orlan passes, in the Duchampian sense, from appearance to apparition. And there are two poles in these virtual relations. On the one hand is a virtual work of the mock kind, of mass kitsch, of games, of what Walter Benjamin calls inorganic "sex appeal." But there is also another kind of virtual with which Orlan is familiar, the transformation of that which is real. She appropriates this kind of virtual with "strength," which is one, or rather *the* meaning, of *virtus*. We should reflect on Orlan's relationship with new technologies. She re-figures herself, she con-figures with otherness. She is on the same side as Villiers de l'Isle Adam's model of "The Future Eve." Orlan has always been a "Future Eve." I have always thought that she echoed the idea introduced by Donna Haraway in her famous "A Cyborg Manifesto" that the cyborg is a figure born of interfacing and autonomy. Orlan's hybrid self-portraits are born from her extraordinary autonomy, from her ability to socially assume even the derisory aspects of this "screened" interface which becomes increasingly more fictional with its passage to cinema. Orlan is basically a mutant who is now recognized as such. I'd say that she's always been one.

BB: Orlan is undoubtedly a mutant of the "body cult" era, and of what Michel Foucault calls "the care of oneself." We are, of course, puzzled by the purely strategic reasons which led Jeffrey Deitch to ignore Orlan's work when organizing the "Post Human" exhibition in Lausanne. Because Orlan would have held an outstanding and far more transgressive place than that of many of the artists brought together in this exhibition, marked by a critical detachment illustrated with works by Charles Ray, Robert Gober, and even Cindy Sherman. Because when North America exhibits itself, it has no fear of voluntary amnesia. Orlan should therefore be restored to her rightful place as pioneer and it should be

demonstrated how, in the body-art/art-body relationship, Orlan escapes all puerilities such as "the estheticization of oneself" or "art is life." "Orlan practices identity and remains distant," you said a moment ago. Orlan bears the results of her operations on both her face and body. Prostheses, implants, a wig.... But at the same time, she keeps herself at arm's length from it all, treating it with a certain amount of amusement, with jokes, in a relationship where the accessories populating her images are not there as much because of the irony and the unspeakable that they bring to mind, but in order to demonstrate the whole relativism of the image.

CBG: This "relativism of the image" is undoubtedly at the bottom of Orlan's film work. Her posters—in which I find myself named as scriptwriter—the construction of which gives the utmost credibility, demonstrate that the starting point lies in the mixture of the known and the unknown. Moreover, Orlan refers to Godard, saying that "films have got to be made backwards," as Godard himself meant this statement to be understood, i.e. that films should be created from back to front. Are we ourselves not in a kind of advertising poster, that is, in this space occupied by Orlan with her creation, somewhere between being and not being, a kind of "semiformal" energy as the Japanese say? "To say, is to do." These posters, which take the shape of fixed images, announce fictions and a film, which will very probably eventually be made. This is the dimension of Orlan's work-process: to schedule fictions and undoubtedly a film, not ready-made fictions, but fictions to be created in the future. Scheduling fictions based on a new kind of image reminds me of Borges. You said that we all have something of the unspeakable. Each one of us has "a fictional labyrinth" capable of finding the energy to be screened in numerous scenes and, in Orlan's case, with surprising professionalism. Orlan has been painting the images since 1985. She prepared them in India. She made the posters. This variety of scenes has now led to what she calls *Le Plan du film* (A Shot at a Movie) or "the outline of the film." "The outline of the film" is a new outline, an outline-transference, which is neither the interface nor the photograph nor the performance. It is undoubtedly a screening, but it is also an outline of life, the outline of future films, of what could be a commercial film based on this kind of rhizome of possible fiction, a process open to the Borgesian infinite.

BB: We agree on this point: Orlan "is putting on a film." I see, among other things, an infiltration strategy to be achieved, based on Nelson Goodman's magnificent formula of "creating worlds." But I also see an infinite possibility of approaches. Cinema means that Orlan is going public. She is building her own audience. An audience that she will obviously subjugate in the etymological sense of that word: by forcing it to "put on the yoke." But, when done "live," I believe that Orlan increases the irreversible strength of the impact of her performance, which from now on is found in the field of communication. Her body, here even more than in the performances and her other forms of action, becomes a vector of communication. Orlan sees cinema as the spectacular venue *par excellence*. It is the place where the creative process becomes a happening, where dramaturgy and dramatization take place before our eyes. Besides, the space of the show turns the artist into a star—you were talking about Warhol—transforming Orlan, at a time when most stars are working at obtaining a standard body and face. It is for her, once again, a double way of struggling from the interior. From her own interior, obviously . . . from the interior of the system by taking over the screen and the media.

A double game.... Even more so when the "mutant" body that Orlan works at achieving and to which she gives birth, this "body-show" which she has operated on before our eyes, causing effects that trigger off as many effects again, acts like a living metaphor influencing both images and the body. On searching beneath the skin of a body-cum-image, Orlan is searching, to paraphrase Godard, "above and below communication."

CBG: With cinema, Orlan becomes a fiction of herself. You've only got to read the titles of the posters we have here as if they were the enunciators and Annunciations, promises of films to come, of light boxes like, for example, *Catarsys,* a film by David Cronenberg featuring a photograph of one of Orlan's operations, *Le Baiser* with Josiane Balasko, or *Corporis Fabrica* with Jean-Claude Dreyfus. It is the metaphysical dimension of fiction in Orlan's art. Because she herself has become her "real" fiction.

BB: I also believe that Orlan incites us to think with her about the place of the work, as the painted body becomes the artist's own body. In fact, she obliges us to do so, hence obviously surpassing the simple performance. Moreover, what Orlan endeavors to stigmatize is the location of her own body in both space and play. Orlan, on the other hand, has taken this step, which I believe is fundamental, between the theater space and the film space. This point, in my opinion, is the determining factor in understanding the ruptures in her work. It is not a question of cinema for cinema's sake. It is a question of cinema for everything that sets it apart from theater, a question taken to the extreme of underlining the present impotence of the theater message and raising an interrogation comparable to that which cinema is capable of signifying. I also think that, whether we are talking about "body-theater" or "body-cinema," Orlan has never stopped exhibiting, even showing off, at the mercy of the accessories and even of the "do-it-yourself" aspect of the work, what I would call, as described by Antoine de Baecque, a "funfair body," this caricatured body that offers a kiss "for five francs": "the fair price" for an attraction. Orlan also reminds me of those funfair heroes to whom cinema has continuously paid tribute ever since it came into being. Besides, de Baecque has superbly demonstrated that these screen bodies replaced the great corporal entertainment of the time when whole families would go to the public bathhouses that abounded in the kind of bodies to be found at the funfair. I think that cinema, for Orlan, has really become a part of this continuity and that the chronology of her works proves and confirms this claim. On the other hand, it is important to point out that in the beginning almost all burlesque shows were populated by acrobats, by caricatured, made-up figures, as if they had escaped from the worlds of theater and pantomime. It is also interesting to stress the fact that the first picture houses were located in the Concert Cafés, sometimes in whorehouses or gymnasiums. There was also a real "thirst for monsters" and for the incredible during the Belle Époque, almost certainly because the audiences had the confused feeling that bodies were going to disappear with the progress of science. The historical function of cinema is, to a certain extent, that of prolonging these exceptional bodies, of reconstituting them, of maintaining them and imposing them in images, even though they were destined to disappear from the live shows. I think that Orlan's work is following a similar movement and tends to eternalize, in and for cinema, what in her own work initially took place on the stage rather than on the screen.

CBG: Orlan has the "opportunity" in the Baroque sense of the word to capture the image in its just time. The just time of the image. "Just an image" as Godard says. It is the capacity of the image as the scenography of oneself, the image of the body, but this time as a real body, a demonstrated image. The whole process of the "image-movement" and of the "image-time" is demonstrated. Orlan is located somewhere in the area of a cinema corresponding to the "end of cinema," in the words of Godard, moreover being a great reader of Walter Benjamin. Fixed images: photographs. Image-time: the sequence of the operations and of the performances. I think that this dialectic of "image-time" and "image-movement" has been her objective right from the very beginning. Orlan has attempted to capture the permanent capacities of each of the image's historical moments. For example, she has rapidly assimilated the hybridization of oneself by the virtual, the virtual as a transformation of oneself, as cultural transit, as the destruction of norms, but also, obviously, the hybridization on a "flashy" background that testifies to the search for a true culture of artifice, almost Baudelairian, in the strictest sense of the term, and which basically means that the passage to shooting a movie and to cinema is undoubtedly implicated in this art of time that I consider to be one of the threads running through her work.

BB: Another of the threads of her project is, in my opinion, the continuous relationship which she establishes between language and image, to the extent of forming a kind of "physicality" of language, to the point of impeding it, even manipulating the phonation of the voice. One aspect of Orlan's contemporaneity would lie in this intertextual playing with the ruptures existing between images and the word, and on the basis of which she has created her project. For Orlan, entering time is also—as Heidegger explains, "time repairs everything"—the idea that everything regenerates. Orlan's time is neither logical nor chronological. It is a time of which Benjamin, whom you quoted a moment ago, called the "now," a constellation of time.

CBG: Yes, and that is undoubtedly why Orlan lays claim to the phrase "remembering the future." I think that Orlan has, returning to the words of Ernst Bloch, "an anticipating ability" which is not Utopian. She lives in the present time, but in all of its possibilities, of the present time inasmuch as it contributes to the liberation of art.

BB: This said, shouldn't we try to capture the relationship of suffering in a manner other than that provoked by the images, in such a way that it would make us understand that any act of creation, at the very moment it is constituted, is suffering? Everything exhibited in Orlan's work and which may appear to be physical pain is suffering of another kind.

CBG: But Foucault, and also Blanchot, have made us understand that fiction is an exterior experience, a remote kind of suffering. This was moreover always very clear in Orlan's operations. She wanted to keep the smile on her face. She didn't, deep down, want to show the suffering while she was experiencing it. Look at her polyptic assemblies. I also know that she would stop the operations when the exhaustion got to be too much. At the end of the day,

suffering is bipolar. It has its way of residing in language and is to be found in the body. It is one of the most interesting explanations of Orlan's relationship with cinema. Why cinema? Why now this commitment that will lead her to play her own self in a film by Cronenberg? Why the process if it is not because of the comment made by Deleuze to Godard: "It's not us who make cinema, it's the world that makes cinema." And in fact, as Godard says, the question of belief reappears in cinema. *Je vous salue, Marie:* you've got to believe in the body. It is perhaps this cross between language and the body that you were analyzing just a moment ago. The posters will eventually evolve into the screenplays that she will be able to fill with everything imaginary and later, if a film is finally made as a result of this labyrinthine process and rhizome, a body will have been created.

BB: There is also a "self-corporal" cinema comparable to the "self-sculptural" principle which Orlan turns to her own use. There is a cinema in which the director completely identifies with the film, a bit like when Godard, to whom you and I both refer, due to the fact that Orlan has found something of the mentor in him, writes about Nicholas Ray: "he is a person who carries a subject along with him, but a subject that is actually inside himself." The cinema that comes to mind, when I try to underline Orlan's kind of models, is also the cinema which refuses to be a cinema of innocent bodies. It is the cinema of Welles, of Cassavetes, or of Nicholas Ray. I would similarly like to point out that, by means of her project, Orlan also renounces the rationalized, hygienized, or cybernetic body of Hollywood cinema, that she prefers the cinema that has experienced death, perhaps a cinema which, from Tim Burton to Zemeckis, Cameron, or obviously Cronenberg, is a cinema of numerous experimentations, a cinema of metaphors, a cinema of pleasure and of fear, a cinema which, on the other hand, is at the base of all fictional construction.

CBG: "Continuing to believe in the body," in a contemporary period in which we could easily come to the conclusion that the body is already obsolete, transformed, when trends are turning towards cloning, the prosthesis body, the artificial robot body. In this society that rejects the body, we are now experiencing this technological revolution that permits the creation of artifices and "second bodies." This said, Orlan's entire work consists of "incorporating" this question of the "post-human" in order to recreate a body, with her own, to create "existence."

BB: That's the case of Cronenberg's *Existenz*, a celebration of the virtual that for Orlan is certainly emblematic. In the film, the virtual connection leads to a new voyage within oneself and inside the body, with a sort of loss of the border....

CBG: Yes, a border we already came across in that marvelous film, *M. Butterfly*, where Jeremy Irons doubted the object of love and didn't want to accept the idea that he loved a man when he thought he loved a woman, finally dying on the stage. This doubting of "Existenz" is the question asked by Cronenberg in *La Mouche* and *M. Butterfly* among other films. Orlan has already made a light box for a film signed by Cronenberg. She is to play her own self in one of his upcoming films. All of this invariably shows the true scope of her work.

BB: In this "anatomical" proximity to Cronenberg, in Orlan's work, there have been, for some time, various influences by cinema in general that do not interest me because of their resemblance to the subjects or even to the screenplays as such, but above all because cinema always praises the omnipotence of the collage, of the montage, it transforms images, changes them, transfers them. That's why, among other reasons, Orlan's art, like cinema, is a constantly mutating art. An art that adopts the basic idea behind cinema that everything transforms itself. It is a conceptual body, a traumatic and unstable parable that rejects the balance dreamt of by society, a subversive body that never stops cutting, removing, recomposing images, putting the "monstrous" in the place where our society dreams of peaceful reflection, a disturbed body which, by means of a series of transformations, mixes different ethnic groups, different minorities, different cultures a priori incompatible with one another, something, in fact, approaching the *Self-Hybridations* of 1998–99. Antoine de Baecque produced, in a beautiful text, "the praise of the scar" for cinema, praise of the impurity and heterogeneity of the stitching. I believe that the scar, in Orlan, is the most enriching metaphor of contemporary art, undoubtedly because it experiences exchanges, meetings, and has something of the primitive about it. Look at Frankenstein. . . . The scarred body is not a smooth body. Orlan's body is a creation from now on. It's not what Lautréamont tells us: "If I exist, I'm not another." Orlan fixes herself image by image. Her whole being is a metaphor of creation, the idea of a visual and virtual presence based on the flesh.

CBG: In fact, what the virtual contributes to the visual is a new concept of the image. Remember what Deleuze called "the image-glass" of modernism and what I would like to call the "image-flow." The "image-flow" is an image of the virtual, it is a new kind of abstraction. In visual arts, the strength of art "in the virtual era," in a parody of what Benjamin said about photography, sends us back to cinema in order to reinvent a new relationship with the image. This is currently a key question in the visual arts. It is this moment captured by Orlan, that of cinema as a model, of cinema rejected as an art in the twentieth century, and which has had to wait a century to finally be recognized as such. Orlan's art is, to a certain extent, the desire to demonstrate this transversality and to be, as Duchamp would have said of his stripping bare, this transversality "even."

BB: I also believe that in the moment when the illusion of the show disappears in favor of the increasingly more real body, the mechanical body of cinema, and with it, that of Orlan, she uses her excess and her performances, choosing to exhibit herself in order not to disappear. It is undoubtedly one of the dimensions of the metaphysical beauty of her work to which you previously referred, one of the dimensions that led me in seeing Orlan and her work coming towards us, to the words of Balzac when looking for an unknown masterpiece, "more than a creature, a creation."

1 Play on words with *elle m'aime* (she loves me) and *elle-même* (she herself): "Orlan gives birth to Orlan"/Orlan gives birth to she loves me."

2 "Orlan" consists of *or*, meaning *gold* or *however/nevertheless* and *lan*, which is pronounced "lon," and means "slow."

Biography

Orlan was born on May 30, 1947, in Saint-Étienne, France. As she wrote in a poetic "bio" for a multimedia CD-ROM monograph: "Her father spoke Esperanto (a language she learned) and was an anti-clerical anarchist, a libertarian Resistance fighter—in the electricity field—who functioned in tandem with her mother: mother always behind, pedaling hard … a mothering mother, a blouse-sewing mother in her spare time; yet both were nudists who went to nudist camps…." Since 1983, Orlan has lived and worked in Paris.

1964

Orlan had already been painting, sculpting, writing poetry, and doing dance, yoga, and theater for several years when she began taking her first photographs, which treated her body as a piece of sculpture. At the same time, she performed her first street actions in her home town; these *Marches au ralenti* (Slow-Motion Walks, 1964–1966) involved taking the town's major rush-hour routes at an extremely slow pace. This idea already suggested that Orlan's work would go against the grain of usual behavior. Next, she began carrying out *MesuRages* (MeasuRages) of places and institutions, using her own body as a unit of measure (the *Orlan-corps*, or Orlan-body); she would dress in sheets that originally came from her "future bride's trousseau," sheets that she also employed as canvases for her paintings. Many photos survive from these performances, which continued into 1983.

1967

Orlan published *Prosésies écrites* (Written Proems), an illustrated collection of poetry written from 1962 to 1966. At this time, she would recite her poems in the street and in cabarets, or stamp them on the hands of passers-by, viewing this process as the publication of "scores" of her texts for subsequent recitation. Orlan then began a series of *Tableaux vivants* in which she adopted the poses of emblematic female figures in the history of art: Ingres's *Grande Odalisque*, Velasquez's *Nude Maya*, and so on. She also extended the series of pieces and performances that made subversive use of her trousseau sheets, and she continued her photographic work. In Saint-Étienne, she campaigned for the right to contraception and abortion, attempting to make her male friends realize that if they were truly democratic then they must be feminists.

1969

Orlan joined a group of artists who ran art workshops at the Maison de la Culture (Cultural Center) in Saint-Étienne. From 1969 to 1973 she was heavily involved in theater (Théâtre des Trois Frères Kersaki with Alain Françon and André Marcon) and in modern dance (with Hélène Steiner). She enrolled in the local conservatory of dramatic art where she was awarded first prize for tragedy and diction.

1971

Still painting, Orlan performed the action *Je suis une homme et un femme*. (I Am a Man and a Woman would be the literal translation, but in the original title Orlan introduces a gender confusion by coupling the masculine article with *femme* and the feminine article with *homme*) in Paris, Toulouse, Saint-Étienne, and Toulon. In Saint-Étienne she participated in a group show of street art (*L'Art dans la rue*). She began to travel a great deal, notably to Africa.

1972

Orlan was invited by Artias, an artist with whom she taught drawing and painting, to show at Expo 63/42, held at Saint-Étienne's cultural center, then run by Jean-Louis Maubant.

1973

Orlan continued to paint while taking acting lessons from Jean Dasté at the local theater. She went to Paris several times, making contact with feminist movements there; she thus met Françoise Eliet, Monique Veaute, Léa Lublin, Véra Molnar, Françoise Janicot, and the women who ran Le Lavoir. She also met Michel Journiac, Gina Pane, Jean-Jacques Lebel, Bernard Heidsieck, Henri Chopin, Nyl Alter, Aline Dallier, Franck Popper, Alexandre Bonnier, Anne Dagbert, and Georges Boudaille.

1974

After a reconnaissance trip to Italy, Orlan devised her first self-portraits as a Madonna: *Strip-tease occasionnel à l'aide des draps du trousseau* (Incidental Strip-Tease Using Sheets from the Trousseau). This composition of eighteen photographs depicted a progressive stripping of the artist until she arrived at the nude pose of Botticelli's Venus, followed by a chrysalis of sheets that prefigured the birth of some unknown body. Orlan participated in the annual theater festival in Avignon with a street show in which she recited her own texts. In the Odile Guérin Gallery (Avignon) and the Salon de Peintures du Sud-Est (Lyon), she exhibited a sculpture giving birth to her collection of poetry, *Le bon ventre, le mauvais coeur et toutes ses épines* (Right Belly, Wrong Heart with All its Thorns).

1975

Orlan exhibited work at the triennial painting show at the Maison de la Culture in Saint-Étienne.

1976

Orlan developed the first version of her performance *Le Baiser de l'artiste* (Kiss the Artist) in Caldas de Rainha, Portugal, where she also performed *Vendre son corps en morceaux sur les marchés* (Selling Herself on the Market, Piecemeal). At the same time, she continued carrying out *MesuRages*. At the invitation of the artist Ben Vautier, she participated in a Fluxus concert at the municipal theater in Nice. Orlan and Jacques Halbert attended the inauguration of the Centre Georges Pompidou in Paris by carrying out individual performance–actions that caused them both to spend the night in a paddy wagon.

1977

This was the year of the great public revelation of Orlan, who notoriously presented *Le Baiser de l'artiste* at the Foire Internationale d'Art Contemporain (FIAC) in Paris. Sitting behind a life-sized photo of her naked torso, alongside a full-length image of herself as a Madonna, Orlan sold "an artist's kiss" in exchange for five francs. The famous kiss created a huge scandal with various chain-reactions—Orlan was fired from the socio-cultural training college where she taught, and subsequently ran into numerous difficulties.

1978

Orlan founded an association called Environnement–Comportement–Performance (Environment–Behavior–Performance) and organized an international video and performance symposium in Lyon in collaboration with Hubert Besacier. She carried out a *MesuRage* of the Musée Saint-Pierre in Lyon. As part of the Action-Minute event organized by Jean Dupuis at the Louvre, Orlan performed *À Poil sans poil* (Bare No Hair) in which she mocked the clean-shaven female genitals depicted throughout the history of painting.

1979

Orlan produced a video montage based on her three-hour performance at the Schaerbeek market in Brussels, Belgium. While running the annual performance symposium in Lyon, she had to undergo emergency surgery for an ectopic pregnancy, but had just enough time to place a photographer and video camera in the operating theater. As soon as a full cassette was recorded, it was dispatched by ambulance to the art center in Lyon where it was screened for the public. Orlan's first contact with surgery would prove to be highly inspiring.

In collaboration with Besacier, Orlan ran the Lyon video and performance symposium for five years, recruiting many well-known friends and artists from the international contemporary art scene, such as Jan Fabre, Klaus Rinke, Jacques Lizene, Michel Journiac, Joël Hubaut, and Tom Marioni. Orlan was thus the first person to bring the likes of Paul McCarthy and Carolee Schneemann to France. She began working on the series of photographs, installations, sculptures, and performances that would be known as *Le Drapé, le Baroque, sainte Orlan* (Drapery, the Baroque, Saint Orlan).

1981

Orlan exhibited at the *Made in France* show in Lyon, where a large chapel was erected in honor of Saint Orlan. She was also given a solo show by two Italian galleries—Studio Carrieri Martina Franca and Galleria Peccolo—featuring an installation with marble sculpture, sculpted drapery using sheets from her trousseau, and collages.

1982

On France's precursor to the internet, known as the Minitel, Orlan founded the first on-line magazine of contemporary art, *Art-Accès Revue*.

Participating artists included Nam June Paik, Daniel Buren, Jochen Gerz, Joël Hubaut, and others. In Milan, the Sixto/Notes Center presented a solo show of Orlan's work. She broadened her professional activities, which henceforth ranged from teacher (visual arts, physical expressiveness and diction, theater, yoga, drawing) to store-window designer, costume designer, interior decorator, and radio and TV host. She also embarked on adventurous trips to Morocco, sub-Saharan Africa, the United States, and elsewhere.

1983

Orlan moved to Paris, having been granted a residential studio at the Cité des Arts. At the Centre International de Création Vidéo (CICV) she made a video piece called *Mise en scène pour son grand Fiat* (Staging Her Great Fiat). She participated in numerous group shows abroad. Orlan also carried out a *MesuRage* of the Guggenheim Museum in New York, and presented a multimedia installation, *Sainte Orlan bénit la performance* (Saint Orlan Blesses Performance) at the Festival International de Performance in Lyon.

1984

Orlan passed a competitive exam to teach at the École Nationale des Beaux-Arts in Dijon. She showed *Mise en scène pour une assomption* (Staging an Assumption) at the J. and J. Donguy Gallery in Paris, while her video *Mise en scène pour un grand Fiat* was shown at the Video Festival in Locarno, Switzerland. In addition to many events in France and abroad, Orlan's work was included in a selection of French video at the Tate Gallery in London.

1985

Orlan produced *Madone au Minitel ou les chiens ramènent des puces pour Canal+* (Minitel Madonna or the New High-Tech Media Hounds) with the collaboration of actor Jean-Christophe Bouvet. Bernard Marcadé and Guy Scarpetta organized appearances of Orlan and Léa Lublin at a theater and school of fine arts in Cergy-Pontoise, France.

1986

Through telecommunications and *Art-Accès*, Orlan participated in a piece by Daniel Buren, *Mouvement-Recouvrement*, in Reims. She also presented a gigantic video and laser projection on the walls of a vast post-office building in Rennes during the Festival des Arts Électroniques. A retrospective of her videos was organized by Dorite Mignot in Amsterdam.

1987

The Centre Georges Pompidou in Paris asked Orlan to participate in Polyphonix 11 (an international festival of concrete poetry, music, and performance) as well as in an exhibition titled *Télématique et Création*, also held in the Centre.

1988

Orlan gave a performance titled *Hommage à Robert Filliou* at the Danaé Foundation in Pouilly-en-Auxois, France.

1989

Orlan participated in *Femmes cathodiques* (Cathodic Ladies) at the Simone de Beauvoir International Video Festival.

1990

For the *Art and Life in the 90s* event in Newcastle, England, Orlan launched her series of surgery–performances titled *La Réincarnation de sainte Orlan* (The Reincarnation of Saint Orlan). The operating theater became an artist's studio for the production of artworks (drawings in blood, reliquaries, texts, photos, videotapes, films, installations, etc.). Orlan was the first artist to use surgery for artistic ends and to decry the social pressures placed on the human body, especially women's bodies. That same year, in collaboration with Dr. Chérif Kamel Zaar, she carried out four surgery–performances on July 21 and 25, September 6, and December 8.

At the Centre d'Art Contemporain de Basse Normandie, Joël Savary organized a solo show of Orlan's work, titled *Les 20 ans de pub et de cinéma de sainte Orlan* (Twenty Years of Advertising and Movies by Saint Orlan). It was Savary who provided the financial resources for Orlan's first surgery–performance. She also participated in several group shows, including *Le Corps/le Sacré* (The Body, The Sacred) in Carcassonne, France, and *Désir et désordre* (Desire and Disorder) in Milan, Italy.

1991

Orlan conducted her fifth surgery–performance on July 6, with Dr. Chérif Kamel Zaar.

1992

Sixth surgery–performance in February. A grant from the Fonds d'Incitation à la Création (FIACRE) enabled her to spend four months in India (December 1991–March 1992), where she produced movie posters with specialized Indian poster artists, as part of her project *Le Plan du film* (A Shot at a Movie). At the invitation of Tony Bond, she devised a piece for the Sydney biennial of contemporary art, *Vidéo installation pour le plafond* (Video Installation for Ceiling).

1993

Orlan married Raphaël Cuir on July 14.

On a French television show hosted by Christophe Chavanne, Orlan presented Madonna with a reliquary containing a few grams of her flesh. "It looks like caviar," commented Madonna. Orlan spent six months in New York (September 1993–February 1994). On November 21, during her seventh surgery–performance, conducted in New York, she had two lumps of silicone, normally used to heighten cheek bones, implanted on each side of her forehead. The surgery–performance was broadcast live by satellite to the Centre Pompidou in Paris, the Sandra Gering Gallery in New York (during a show of Orlan's work), the Multimedia Center in Banff, and the MacLuhan Center in Toronto. That same year, Orlan organized two

other surgery–performances in New York, on December 8 and 14, with Dr. Marjorie Cramer. The series came to an end with the ninth operation.

1994

Jean de Loisy included Orlan in the *Hors limites* exhibition at the Centre Pompidou in Paris; he chose *Omniprésence* (Omnipresence), a work produced in New York during Orlan's show at the Sandra Gering Gallery. Jean-Michel Bouhours curated a retrospective of Orlan's video work at the Centre Pompidou. The Chassie Post Gallery in Atlanta mounted a solo show based on Orlan's surgical operations.

1996

Orlan was invited by Georges Rey, Thierry Raspail, and Thierry Prat to show work in Lyon's biennial of contemporary art. She was also included in *Endurance*, a group show that traveled across the United States.

1996

Orlan à Rome, 1966–1996 (Orlan in Rome, 1966–1996) was the first exhibition to provide an overview of Orlan's oeuvre. Hosted by various venues in Rome, it was accompanied by a catalog published by Carta Secrete/Diagonale, featuring articles by Achille Bonito Oliva, Mario Perniola, and Vittorio Fagone.

At the *Totally Wired* festival in London, Orlan performed *Femme avec tête* (Woman with Head). In Marseille, she was included in the group show *L'Art du corps*; curator Philippe Vergne made arrangements, in conjunction with Bernard Blistène, for the restoration of *Le Baiser de l'artiste*.

1997

In London, Orlan exhibited *Ceci est mon corps … ceci est mon logiciel* (This is My Body, This is My Software); the show was accompanied by a book and CD-ROM of the same name. Orlan had two other solo shows that year, in Cardiff, Wales, and Brussels, Belgium, as well as various group shows.

1998

Orlan launched her worldwide tour of differing standards of beauty in various civilizations down through history. She began with pre-Columbian cultures following several stays in Mexico, inspired by Mayan and Olmec attraction for deformed skulls, cross-eyed vision, and false noses, as well as by sculptures of the god Xipe Totec (depicted as a priest who dons the flayed skin of a sacrificial victim). Taking such imagery and crossing it with images of herself, Orlan created the series of digital photos titled *Self-Hybridations* (Self-Hybridizations). Several fashion designers have been influenced by her work, including Jeremy Scott and Walter van Bereindonck, whose models pay Orlan tribute by sporting protuberances similar to the ones she had implanted on her forehead.

Patrick Raynaud invited Orlan to present a solo show at the school of fine arts in Nantes, while

in Paris she showed at the J. & J. Donguy and the Yvonamor Palix galleries during the month-long photo event known as Mois de la Photo. She was also included in a group show called *Out of Actions: Between Performance and the Object, 1949–1979*, organized by Paul Schimmel in Los Angeles and subsequently hosted by Vienna and Barcelona.

1999

Orlan was awarded two prizes for her series of digital self-hybridizations: First Prize at the Griffel-Kunst in Hamburg and the Hewlett-Packard Foundation's Arcimboldo Prize for her show at the Maison Européene de la Photographie in Paris. Orlan also had a solo exhibition at the Institut Français in Buenos Aires, Argentina, and was appointed professor at the École Nationale des Beaux-Arts at Cergy, just outside Paris.

2000

Michèle Barrière and Les Éditions Jériko published a multimedia CD-ROM monograph on Orlan's oeuvre that can be updated through her web site (www.orlan.net). Orlan then began a new series of digital photographs based on African standards of beauty.

She also executed resin sculptures, *Mutants hybrides* (Hybrid Mutants), shown for the first time at the Lyon biennial dubbed *Partage d'exotismes* (Shared Exotics). Michel Enrici organized a solo show in Marseille on the triumph of the Baroque, featuring Orlan's series of Madonnas; a catalog with essays by Enrici and Christine Buci-Glucksmann was published by Les Éditions Images en Manoeuvre. During the FIAC show in Paris, the Palix gallery devoted its stand to a show of Orlan's self-hybridizations. *Le Plan du film* (A Shot at a Movie) represented a new stage in Orlan's work, inspired by a comment by Godard: "The only great thing about *Montparnasse 19* is that it was not just made back to front, but represents the flip side of cinema." Orlan exploited her own image bank to produce a series of movie posters for fictitious films. *Le Plan du film* was displayed in the contemporary art section of the underground shopping mall in Paris known as Le Forum des Halles; as part of this project, Orlan was invited to organize an evening's event at the Fondation Cartier pour l'Art Contemporain.

2002

The first retrospective of Orlan's work was organized and co-produced by Olga Guinot and Juan Guerdiola in Salamanca, Spain. The catalog essays were written by Juan Antonio Ramirez, Olga Guinot, Julian Zugazagoita, Bernard Blistène, and Christine Buci-Glucksmann. Orlan collaborated on a dance project with Karine Saporta at the Musée des Arts d'Afrique et d'Océanie in Paris, designing sets and masks based on her own work on mutant bodies. Extending *Le Plan du film*, she produced trailers and sound tracks for non-existent films. She also had a series of shows in several New York galleries.

2003

The first monographic exhibition of Orlan's work to be held in France, titled *Éléments favoris* (Favorite Items), was conceived and organized by Jean-François Taddei for the Fond Régional d'Art Contemporain (FRAC) in the Loire region. Another solo show, *Tricéphale* (Three-Headed), at the Michel Rein gallery, included vintage black and white photos from the years 1964–1966, recent digital images from the *Self-Hybridations africaines*, and a video installation (for which Frédéric Sanchez did the sound).

Minister of Culture Jean-Jacques Aillagon conferred the honorary title of Chevalier de l'Ordre des Arts et des Lettres on Orlan; she turned the ceremony into an artistic event by decorating the minister with a little artist's pan of paint thinner transformed into a reliquary containing some of her flesh preserved in resin.

2004

Régis Durand, for his final show as curator at the Centre National de la Photographie in Paris, organized a retrospective of works titled *Orlan 1964–2004, méthodes de l'artiste*. One specific part of the retrospective, "1993," was curated by Alain Julien Laferrière at the Centre de Création Contemporaine in Tours, France, while another part, "2003–2004," was organized by Olga Sviblova for the Museum of Photography in Moscow.

Since 1990, Orlan has delivered many lectures in Europe and the United States.

Orlan writes a short poetic text almost every evening.

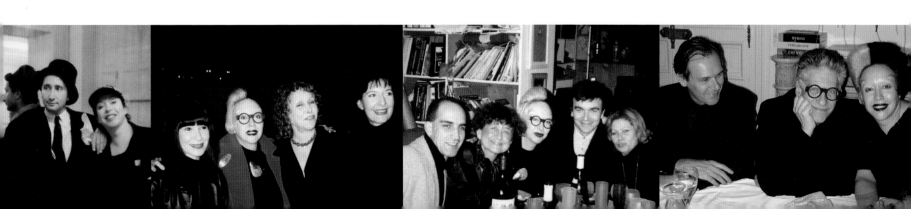

PANORAMA OF AN ARTISTIC ITINERARY

PERSONAL EXHIBITIONS

1964
After painting and writing poems for some years, Orlan created her first performances, *Les Marches au ralenti*, *Le Gueuloir*, *Femme sur le trottoir* and took her first photographs.

1965
École Municipale des Beaux-Arts, *Parcours*, Saint-Étienne, France.
Unité Le Corbusier, *Action-Orlan-corps* and *Module-Or*, *MesuRage*, Firminy, France.
Les Marches au ralenti, *Les Marches à rebours* and *Les Sens interdits*, Saint-Étienne, France.

1966
Action-Orlan-corps, *Parcours masqués*, Saint-Étienne, France.

1967
Atelier Peagno, exhibition and signing of *Prosésies écrites*, Saint-Étienne, France.

1969
Atelier Claude Delaroa, *Corps-sculpture*, Saint-Étienne, France.

1970
Atelier Claude Delaroa, *Les Tableaux vivants: situation-citation*, Saint-Étienne, France.

1973
L'Art et la Vie, *Œuvres en tissus*, Lyon, France.
La Mulatière, *Les Tableaux vivants: Situation-citations*, Lyon, France.

1974
Galerie Odile Guerin, presentation of *Sculpture accouchant du bon ventre et du mauvais cœur*, Festival d'Avignon, France.
Festival d'Avignon, *MesuRage de rue*, central square, Avignon, France.

1975
Théâtre du Huitième, paintings, Lyon, France.

1976
Culture House, *MesuRage d'institution*, Caldas da Rainha, Portugal.
Contemporary Art Center, *Première version du Baiser de l'artiste*, Caldas da Rainha, Portugal.
Performance Festival, *Vendre son corps en morceaux sur les marchés*, Caldas da Rainha, Portugal.
Christian Bernard's apartment, *MesuRage à façon privé*, Strasbourg, France.
Galerie Rousset Altounian, rue Lamartine, *MesuRage de rue*, Mâcon, France.

1978
Galerie La Différence. Curator: Ben, Nice, France.
Galerie Lara Vincy, *Bigeard-bise-art* (with Gérard Deschamps), Paris, France.

1980
TNP, *Flagrant délit de traces*, Lyon, France.
ICC, *Rétrospective-MesuRage de rue et d'institution.*

Curator: Flor Bex, Antwerp, Belgium.
Nouveau Musée Atrium Tour Caisse d'Épargne, *Orlan*, Deuxième Symposium International d'Art Performance, Lyon, France.

1981
Peccolo Gallery, *Installation avec sculpture en marbre et sculpture de pli en drap du trousseau*, Livorno, Italy.
Studio Carrieri Gallery Martina Franca, Italy.
Gn Gallery, exhibition and *MesuRage*, Gdansk, Poland.

1982
Espace Sixto/Notes, *Orlan*, Milan, Italy.

1984
Arleri Gallery, scholarship awarded to aid with creations for the exhibition, Nice, France.
Galerie J. and J. Donguy, *Mise en scène pour une assomption*, photographs and multimedia installation, Paris, France.

1985
Théâtre et École des Beaux-Arts, *Histoires saintes de l'Art*, Orlan and Léa Lublin. Curators: Pierre Restany and Bernard Marcadé, Cergy-Pontoise, France.
FACLIM, *Les Métaphores du sacré*, Limoges, France.

1989
Galerie Koffman, painted cinema posters and painted ceiling works, Cologne, Germany.

1990
Arcade, *Le Corps/ le Sacré*, paintings and video installation, Carcassonne, France.
First surgical operation-performance *Art charnel* (July 21, 1990), and second surgical operation-performance *Opération dite de la licorne* (July 25, 1990, text by Julia Kristeva), Paris, France.
Third surgical operation-performance (September 11, 1990), Paris, France.
Centre d'Art Contemporain de Basse Normandie, *Les Vingt ans de pub et de cinéma de sainte Orlan*. Curator: Joël Savary, Hérouville Saint-Clair, France.
Galea Gallery, *Le Bonheur du jour, vendre du vent... vendre du bonheur*, Caen, France.
Fourth surgical operation-performance *Opération réussie* (December 8, 1990, text by Eugénie Lemoine-Luccioni), Paris, France.

1991
Institut Français. Curator: Jean-Michel Phéline, Cologne, Germany.
Fifth surgical operation-performance, *Opération-opéra* (July 6, 1991, text by Michel Serres), Paris, France.

1992
Interzone, *Le Lieu*. Curator: Richard Martel, Quebec, Canada.
Alliance Française. Curator: Joël Raffier, Madras, India.
Alliance Française, Bombay, India.

1993
Sandra Gering Gallery, *Omniprésence 1*, New York, USA.
Cirque Divers, *Sacrifice*, sixth surgical operation-performance (text by Antonin Artaud) and multimedia exhibition, Liège, Belgium.

Penine Hart Gallery, *My Flesh, the Text and the Languages*, New York, USA.
Webster Hall, *Vidéo Party*. Curator: Jacques Ranc, New York, USA.
Biennale of Contemporary Art, *Private Exhibition*, Jean-Claude Binoche. Curator: Jacques Ranc, Venice, Italy.
Sandra Gering Gallery, *Omniprésence*, seventh surgical operation-performance (December 8, 1993) and ninth surgical operation-performance (December 14, 1993), New York, USA. Satellite broadcast to Centre Georges Pompidou, Paris, MacLuhan Center, Toronto, and the Multimedia Institute, Banff, Canada.

1994
Haines Gallery, photograph and video exhibition, San Francisco, USA.
Lab Gallery, video installation, San Francisco, USA.
Camerawork Performance, videoconference, San Francisco, USA.
Chassis Post Gallery, *Omniprésence*, Atlanta, USA.

1995
Centre Georges Pompidou, *Rétrospective vidéo performance*. Curator: Jean-Michel Bouhours, Paris, France.

1996
Zone Gallery, *Ceci est mon corps... ceci est mon logiciel*, Newcastle, England.
Portofolio, *This is My Body... This is My Software*, Edinburgh, Scotland.
Institut Français, Photokina Festival, Cologne, Germany.
Espace ex Thérésa, Mexico City, Mexico.
SALA 1, retrospective, Rome, Italy.
University Museum-Laboratory, Rome, Italy.
Studio Stefania Miscetti, Rome, Italy.
Carte Secrète, *Diagonale*, Rome, Italy.

1997
Chapter Gallery, *Radical Body*, Cardiff, Wales.
Camerawork, *This is My Body... This is My Software*, London, England.
Art Kiosk Gallery, Brussels, Belgium.

1998
École Régionale des Beaux-Arts de Nantes, *L'Atelier*. Curator: Patrick Raynaud, Nantes, France.
Maison de la Culture, *Violence*, Dieppe, France.
Galerie J. and J. Donguy, *Le Mois de la photo à Paris*, Paris, France.
Galerie Yvonamor Palix, *Refiguration-Self-hybridation*, Paris, France.

1999
Galerie Chelouche, *Omniprésence 2*, Tel-Aviv, Israel.
Art Kiosk Galerie, *Orlan et Oleg Kulig*, Brussels, Belgium.
Institut Français, *Omniprésences*. Curator: Sonia Becce, Buenos Aires, Argentina.

2000
Bregenzer Kunstverein Magazin 4, Bregenz, Austria.

Galerie de l'École Régionale d'Art de Marseille, *Orlan, triomphe du baroque*. Curator: Michel Enrici, Marseille, France.
FIAC, Galerie Yvonamor Palix stand, *One Woman Show*, Paris, France.

2001
Sejul Gallery, *Orlan, Self-hybridations précolombiennes*, Seoul, Korea.
Forum des Halles, Espace Créateurs, *Le Plan du film*, sequence 1, Paris, France.
Fondation Cartier, *Le Plan du film*, sequence 2, Soirées Nomades, Paris, France.
Le Parvis Centre d'Art Contemporain, *Orlan, triomphe du baroque*, Ibos, France.
Galerie Bellecour, *Self-hybridations*, Lyon, France.

2002
FRAC des Pays de la Loire, *Éléments favoris*, retrospective. Curator: Jean-François Taddei, Carquefou, Nantes, France.
Centro de Fotografía of the University of Salamanca, *Retrospective 1964–2001*. Curator: Olga Guinot, Abrantès Palace and the Church of Segonda Palace, Spain.
Basque Museum of Contemporary Art (Artium). Curator: Juan Guardiola, Vitoria, Spain.
Cannes Film Festival, *Le Plan du film*, sequences 3 and 4, Hôtel Le Martinez, Cannes, France.
Artcore Gallery, *Self-hybridations précolombiennes*, Toronto, Canada.

2003
Galerie Michel Rein, *Tricéphale*, photographs and video installation, Paris, France.
FRAC des Pays de la Loire, *Éléments favoris*, retrospective. Curator: Jean-François Taddei, Carquefou, Nantes, France.
AFAA, *Le Plan du film*, Paris, France.

2004
Centre National de la Photographie (CNP), *Orlan 1964–2004... Méthodes de l'artiste*, retrospective exhibition. Curator: Régis Durand, accompanied by a monograph published by Flammarion, Paris, France.
Centre de Création Contemporaine (CCC), *Orlan, 1993*. Curator: Alain Julien-Laferrière, Tours, France.
Moscow House of Photography, *Orlan, 2003–2004*, retrospective held in conjunction with *Photobiennale 2004*, Moscow, Russia.

COLLECTIVE EXHIBITIONS

1966
Auberge de Dargoire, *Peintures-Matières*, Dargoire, France.

1967
Action-Orlan-Corps: "Les Draps du trousseau, souillures," Nice, Saint-Étienne, Rochetaillée, France.
Action Le Père Noël, Saint-Paul-de-Vence, Saint-Tropez, Saint-Étienne, France.
Action Le Déjeuner sur l'herbe, men naked, Orlan dressed. Rochetaillée, France.

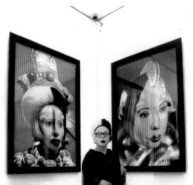

1968
MesuRage Performance, Saint-Chamond, France.
Atelier Claude Delaroa, *Couture en clair obscur, broderies des taches de sperme sur les draps du trousseau*, blindfolded performance, Saint-Étienne, France.
Place des Ursules, *Les Peintres dans la rue*, Saint-Étienne, France.
Street actions, *Contraventions de la brigade anti-norme*, itinerant, France.

1969
Festival de Peinture, La Ricamarie, France.
Action contravention, Saint-Étienne, Lyon, Bourges, Marseille, Avignon, France.

1970
Salon du Sud-Est, *Peinture, abstractions géométriques*, Saint-Étienne, France.

1971
L'Art et la vie, Lyon, France.
University of Toulouse, Mirail Action, *Je suis une homme et un femme*, feminist colloquium, France.
Atelier Claude Delaroa, *Situation-citation*, Saint-Étienne, France.
L'Art dans la rue, Saint-Étienne, France.

1972
Maison de la Culture, *MesuRage dans Expo 63/42*. Curator: Lydia Artias, Saint-Étienne, France.
Atelier Claude Delaroa, *Les Tableaux vivants: Situation-citation*, Saint-Étienne, France.
Performance of *Vendre son corps en morceaux sur les marchés*, Saint-Étienne, Firminy, La Ricamarie, France.

1973
Wuppertal Museum, *Expo 63/42*. Curator: Lydia Artias, Wuppertal, Germany.

1974
Salon du Sud-Est, paintings and lyrical abstractions, Lyon, France.

1975
La Mulatière, *Les Tableaux vivants: Situation-citation*, Lyon, France.
Basel, Pellegrino Gallery stand, Switzerland.
Maison de la Culture et des Loisirs de Saint-Étienne, *Triennale de la Peinture*. Curator: Lydia Artias, and *MesuRage*, Saint-Étienne, France.
Atelier Claude Delaroa, *Strip-tease occasionnel à travers les draps du trousseau*, Lyon, France.

1976
Galerie des Ursulines, with the group Untel, Mâcon, France.
Municipal Theater, *Concert Fluxus*. Curator: Ben, Nice, France.

1977
Espace Lyonnais d'Art Contemporain, *Tendances contemporaines Rhône-Alpes*. Orlan presents the installation *1000 et une façons de ne pas dormir*. Curator: Jean-Louis Maubant, Lyon, France.
Galerie NRA, *Piège, casserole et chaîne* and *Panoplie de la mariée mise à nue*, Paris, France.
Grand Palais – Foire Internationale d'Art Contemporain, *Le Baiser de l'artiste*, Paris, France.
Studio d'Ars. Curator: Pierre Restany, Milan, Italy.

1978
Musée d'Angoulême, *Les Artistes sur les pavés*. Curators: Monique Bussac and Joël Capella-Lardeux.
Espace Lyonnais d'Art Contemporain, *Langages au féminin*. Orlan presents *Le Baiser de l'artiste*. Curator: Jean-Louis Maubant, Lyon, France.
Galerie NRA, *Livre d'art et d'artiste*. Curator: Christian Parisot, Paris, France.
MesuRage de rue. Curator: Ben. Nice, France.
Musée du Louvre, *Action minute*. Performance of *À poil sans poils*. Curators: Jean Dupuy and A. Lemoine, Paris, France.
Musée d'Art Moderne, *MesuRage*, Strasbourg, France.
Neue Galerie Sammlung Ludwig, *Symposium International de Performance*, Aix-la-Chapelle, Germany.

1979
Centre Georges Pompidou, *Rencontre Internationale d'Art Corporel*. Orlan is delivered to the Centre in a container, like a work of art. Curator: Jorge Glusberg, Paris, France.
Symposium International de Performance, surgical operation *Urgence GEU*, Lyon, France.
Bologna Fair, Galerie Pellegrino stand, Bologna, Italy.
Palazzo Grassi, *Rencontre Internationale de Performance*. Curator: Jorge Glusberg, Venice, Italy.

1980
Musée d'Art Moderne de la Ville de Paris, *Vidéo à l'ARC*. Curator: Dany Block, Paris, France.
Goethe Institut, *Manifestation vidéo performance*, Paris, France.
Symposium International de Performance, Lyon. Curators: Orlan and Hubert Besacier, Lyon, France.
Centre Georges Pompidou, *Exposition photocopie*. Curator: Alain Sayag, Paris, France.
Espace Lyonnais d'Art Contemporain, *Made in France*. Orlan presents a multimedia installation *Mise en scène pour une sainte*. Curator: Marie-Claude Jeune, Lyon, France.
Art Biennale de Paris, Paris, France.
Musée Chéret, selection from the Biennale de Paris, Nice, France.

1981
Espace Lyonnais d'Art Contemporain, *Made in France*. Curator: Marie-Claude Jeune, Lyon, France.
Pinacoteca. Curator: Renato Barilli, Ravenna, Italy.
Sofitta Theater. Curator: Renato Barilli, Bologna, Italy.
Ariosto Reggio Municipal Theater. Curator: Renato Barilli, Reggio Emilia, Italy.
Museum of Fine Arts. Curator: Renato Barilli, Piacenza, Italy.
Performance Festival, Wuppertal and Cologne, Germany.
Centre Georges Pompidou, *L'Autoportrait*. Curator: Alain Sayag, Paris, France.
Gulbenkian Foundation. Selection from the Biennale de Paris, Lisbon, Portugal.
Espace Lyonnais d'Art Contemporain, *Événement Orlan*, Lyon, France.
Drawing Triennale, Wroclaw, Poland.
Art Forum Gallery, Lodz, Poland.

1982
Alain Oudin Gallery, *Autoportraits de femmes*, Paris, France.
Art-Prospect, actions in the urban landscape, "Avenir Publicité" advertising posters, Lyon, France.
Contemporary Art Fair, Bilbao, Spain.
Festival d'Albi on technology of the future and the future of culture, video, and laser projection, Albi, France.
Modern Art Museum, selection from the Biennale de Paris, Helsinki, Finland.
Centre Georges Pompidou, *Revue parlée*, Paris, France.
Bari Fair, Galerie Lattuada stand, Bari, Italy.
La Chambre Blanche, Quebec, Canada.
Living Art Festival, Almada, Portugal.

1983
Rheinisches Landesmuseum, photo-installation, Bonn, Germany.
Palazzo dei Diamanti, *Argillière presse*. Curator: Lea Bonora, Ferrrara, Italy.
Ars Viva Gallery. Curator: Pierre Restany, Milan, Italy.
Festival International de Performance de Lyon, *Sainte-Orlan bénit la performance*, Multimedia installation, Lyon, France.
Guggenheim Museum, *MesuRage d'institution*, New York, USA.
Andata Ritorno, Festival de Genève, laser show and giant slideshow accompanied by opera orchestra, Geneva, Switzerland.
Moderna Museet, *L'Art expérimental*, Stockholm, Sweden.
Konstmuseet, Norrköping, Sweden.
Deuxièmes Rencontres Vidéo, Roubaix, France.

1984
National Fine Arts Society, *Corperformance 84*. Curator: Manoel Barbosa, Lisbon, Portugal.
Lantaren Perfo 2 Festival, Rotterdam, The Netherlands.
Ubu à Saint-Vorles, contemporary art show, *Sainte-Orlan multi faces*, Châtillon-sur-Seine, France.
Grand Canal Vidéo Documentary Study, n° 2: *La Lumière baignant les anges baroques*; n° 11: *Mise en scène pour un grand Fiat*, Paris, France.
Locarno Festival. Curator: Pierre Restany, Locarno, Switzerland.
Musée d'Art Moderne de la Ville de Paris, Electra Documentary Study, n° 101: *La Lumière mise en scène pour un grand Fiat*. Curator: Dany Block, Paris, France.
Tate Gallery, *Sélection French Video*, London, England.

1985
Electronic Image Congress, Bologna, Italy.
Centre Georges Pompidou, *Les Immatériaux*. Curator: François Lyotard, Paris, France.
Vidéo Belvédère, Geneva, Switzerland.
Ars Machina Festival, Torino, Italy.
Cultural Center of Belgrade, Yugoslavia.
Festival International de Poésie de Cogolin, Cogolin, France.
Locarno International Video Festival. Curator: Pierre Restany, Locarno, Switzerland.
FIAC Grand Palais, Paris, France.
Créatique, Saint-Quentin-en-Yvelines, France.
Modern Art Museum, *Kunst mit eigensinn*, Vienna, Austria.

1986
Festival des Arts Électroniques, *Light Show, laser graphique*, Rennes, France.
Venice Biennale of Contemporary Art, section "Art et Science." Curator: Dan Foresta, Venice, Italy.
Troisième Festival International de Poésie de Cogolin. Curator: Julien Blaine, Cogolin, France.
École Nationale Supérieure des Beaux-Arts, *Art Com 86*. Curator: Robert Fleck, Paris, France.
Gare de l'Est, *Culture-future*, Paris, France.
Stedelijk Museum, *Rétrospective vidéo*, Amsterdam, The Netherlands.
Art Jonction, Nice, France.
FAUST, Toulouse, France.
Buses and bus shelters, *L'Élan avec le M.I.T.*, Paris, France.
Mouvements-recouvrements. Collaboration in the play by Daniel Buren with the help of Art-Accès, Reims, France.

1987
Centre Georges Pompidou, *Polyphonix 11*, an international festival of live poetry, music, and performance, Paris, France.
Galerie Chambre Claire, *Baroques photographiques*, Paris, France.
ELAC, videos and art films. Curator: Georges Rey, Lyon, France.
FNAC, *Nuit de la vidéo*. Curator: Brigitte Castel, Lyon, France.
Les Troisièmes Rencontres photographiques de Saintes. Curator: Christian Gattinoni, Abbaye-aux-Dames, Saintes, France.
CCI Centre Georges Pompidou, *Télématique et création*, Paris, France.
Fondation Danaé, *Espaces affranchis*, Pouilly-en-Auxois, France.

1988
Centre Français du Commerce Extérieur, pour la Cité des Sciences et de l'Industrie, *Tran Interactifs*, artistic videoconference, Paris-Toronto, Paris, France.
Galea Gallery, *Bande à part*, Caen, France.
Le Lieu, installation. Curator: Richard Martel, Quebec, Canada.
Fondation Danaé, *Hommage à Robert Filliou*, Pouilly-en-Auxois, France.

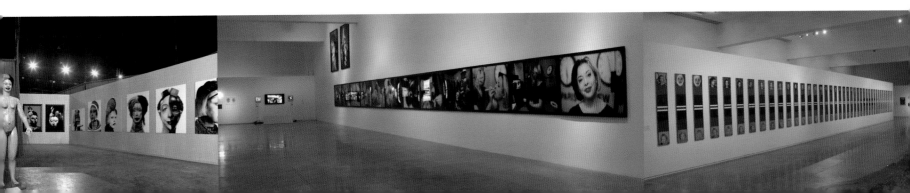

1989

International Video Festival Simone de Beauvoir, *Femmes cathodiques*, Paris, France.
Espace d'Art Brenne, *Écrans-icônes*, Concremiers, France.
Palais de Tokyo, *La Madone au minitel*, Paris, France.
Bilder Streit, Cologne, Germany.
Grand Palais, *Europe des créateurs*, Paris, France.
ISELP, *Utopies 89*, Brussels, Belgium.
Galerie J. and J. Donguy, *Performances mais encore*, Paris, France.
Centre Georges Pompidou, *Polyphonix (Fluxus et Happenings)*. Curators: Jean-Jacques Lebel and Jacqueline Cahen, Paris, France.
Fondation Camille Claudel, selection, Fort-de-France, Martinique.
Fondation Danaé, *Espaces affranchis*, Pouilly-en-Auxois, France.
Sixièmes Rencontres Internationales de Poésie Contemporaine. Curator: Julien Blaine, Tarascon, France.
Video Festival, San Francisco, USA.
ISELP, *Pages d'artistes hors mesure*, Brussels, Belgium.
MacLuhan Science Center, *Les Transintéractifs*. Curator: Fred Forest, Toronto, Canada. Performance broadcast by satellite to Paris, France.
Atelier 03, *Fin de siècle et début de mois*, Ivry-sur-Seine, France.
Le Palace, *Le Palace, l'acte pour l'art*. Curator: Arnauld Labelle-Rojoux, Paris, France.
Rencontre Vidéo-Art-Plastique, Hérouville Saint-Clair, France.
Locarno Video Festival. Curator: Pierre Restany, Locarno, Switzerland.
University of Louvain-la-Neuve, Atelier Télématique, Louvain-la-Neuve, Belgium.

1990

FIAC Grand Palais. Curator: Éric Fabre, Paris, France.
Edge Festival, *L'Art et la Vie dans les années 90*, Newcastle, England.
Beginning of surgical operation performances: *La Réincarnation de sainte Orlan ou Image(s) nouvelle(s)* (May 30, 1990)
Biennial of Innovative Visual Art, Glasgow-London, Great Britain.
Edge, Rotterdam, The Netherlands.
Grand Palais, *Europe des créateurs*, Actuel magazine, Art Planète stand, Intermaco advertising agency, video-fax-telematic installation with Jean-Christophe Bouvet and François Berheim, Paris, France.
The Gallery, *Désir et désordre*. Curator: Jean-Jacques Lebel, Milan, Italy.
Centre de Wallonie, *La vidéo casse le baroque*, paintings and video installation, Paris, France.
Espace Paul Ricard – Fondation Camille, Paris, France.
La Manufacture, Ivry-sur-Seine, France.
CREDAC, *Un peu de temps et vous ne me verrez plus... encore un peu de temps et vous me verrez*.
Curator: Thierry Sigg, Ivry-sur-Seine, France.
Performance of *La Réincarnation de sainte Orlan ou Image(s) nouvelle(s)*, Paris, France.
L'Enlèvement d'Europe, Project *Caravane et Container sept et demi*, Sète, France.
Centre Georges Pompidou, performance of *Art et Pub*, Arzapub, Paris, France.
G. Descossy Gallery, *Salon*, Paris, France.
L'Enlèvement d'Europe, Project *Caravane et Container sept et demi*, Tangiers-Casablanca, Morocco.
Espace Lamartine-Fondation France Télécom, Paris, France.

1991

Musée de la Poste, *Les Couleurs de l'argent*. Curator: Jean-Michel Ribettes, Paris, France.
L'Espace d'un instant. Curators: Emmanuel Javogue and Édouard Fabre, Paris, France.
Molkerei-Werkstatt Performance Multi Media, Cologne, Germany.
L'Artiste en représentation. Curators: Arnauld Labelle-Rojoux and Guy Scarpetta, Avignon, France.
Espace Art-Brenne, *Écran icône*. Curator: Christian Gattinoni, Concremiers, France.
Galerie de l'École Régionale des Beaux-Arts, Clermont-Ferrand, France.
Fondation Cartier, *Vraiment faux*, Munich, Germany.

1992

Sydney Biennial of Contemporary Art, *Vidéo installation pour le plafond*. Curator: Anthony Bond, Sydney, Australia.
Lallit Kala Academy, Scholarship from the FIACRE for a trip to India, Madras, India.
Buro performance and video, Koning, Poland.
Emily Harvey and Pat Hearn Gallery, New York, USA.

1993

Musée de la Villette, *Van Gogh TV Piazza Virtuale*. Curator: Christian Van der Borgh, Paris, France.
Penine Hart Gallery, *Bodily*, New York, USA.
Ars Electronica, Landesmuseum, Linz, Austria.
Bali, Amsterdam, The Netherlands.
Rijksakademie van beeldende kunsten, *Orlan*, Amsterdam, The Netherlands.
Postmuseum Frankfurt, *Borderlines*. Curator: Hildegard M. Wilms, Photography Biennial, *Fototage*, Frankfurt, Germany.
Nederlands Filmmuseum, Festival Video and Film Skrien, Amsterdam, The Netherlands.
V2, video installation *The Body in Ruin*, Hertogenbosch, The Netherlands.
Galerie Satellite, *De l'amour*, Paris, France.

1994

Kariya City Museum, *French Portrait Art in the Nineteenth and Twentieth Centuries*. Curator: Jean-Michel Ribettes, Aichi, Japan.
La Giarrina Gallery, *Shape your Body*. Curator: Francisco Conz, Verona, Italy.
The Shoto Museum of Art, *French Portrait Art in the Nineteenth and Twentieth Centuries*. Curator: Jean-Michel Ribettes, Tokyo, Japan..
Galleria d'Arte Moderna, *French Art from 70 to 90*. Curators: R. Barilli and Pierre Restany, Bologna, Italy.
ICA, *The Body as Site*, video performance, London, England.
Nexus Center, Atlanta, USA.
Onomichi Municipal Museum of Art, *French Portrait Art in the Nineteenth and Twentieth Centuries*. Curator: Jean-Michel Ribettes, Onomichi, Japan.
Kunstverein, *Suture*. Curator: Sylvia Eiblmayr, Salzburg, Austria.
Art and New Technologies, Tour du Roi René, *Brouillard précis*, Marseille, France.
Kunsthalle of Kiel. Curator: Beate Ermacora, Kiel, Germany.
NGBK *Fabricated realities* (Bec, Stelarc, Orlan), Berlin, Germany.
San Francisco Museum, *Mirror Mirror*. Curator: Terri Cohn, San Francisco, USA.
Akita Museum of Modern Art, *French Portrait Art in the Nineteenth and Twentieth Centuries*. Curator: Jean-Michel Ribettes, Hiroshima, Japan.
Centre Georges Pompidou, *Hors limites*. Curator: Jean de Loisy, Paris, France.
Parc Floral, *Actuel*, all-night performance, Paris, France.

1995

Galerie Satellite, *Paquets*, Paris, France.
Galerie Janos, *Extrême limite*. Curators: Joël Hubaut and Arnaud Labelle-Rojoux, Paris, France.
Illinois State University, *Endurance*, Normal, USA.
Galerie Satellite, *Riquiqui*, Paris, France.
Kunsthalle of Kiel, *Positionem zum Ich*. Curator: Beate Ermacora, Kiel, Germany.
Kamerabilder, Berlin, Germany.
Museo Reina Sofia, *Art futura*. Curator: Agnès de Gouvion Saint-Cyr, Madrid, Spain.
Clark & Co. Gallery, *Fat Form and Taste*, Washington, DC, USA.
Atelier Brouillard Précis, *Art transit*, Marseille, France.
California College of the Arts, *Mirror Gender Roles and the Historical Significance of Beauty*, San Francisco, USA.
Festival of New Technologies, Warwick, England.
Triple X Festival, Amsterdam, The Netherlands.
Locarno Video Festival. Curator: Pierre Restany, Locarno, Switzerland.
Studio Stefania Miscetti, *L'Arte "Riparte."* Curator: Achille Boniti Oliva, Rome, Italy.
Galerie Agnès b., *Les Tétines noires*, Paris, France.
Sculpture Biennale, *Oltre di scultura*. Curator: Ernesto L. Francalanci, Padua, Italy.
Virginia Beach Center, *Endurance*, Virginia Beach, USA.
Biennale d'Art Contemporain et de Nouvelles Technologies. Curators: Georges Rey, Thierry Raspail, and Thierry Prat, Lyon, France.

1996

Spaces, *Is it Art*. Curator: Linda Weintraub, Cleveland, USA.
Beaver College, *Endurance*, Beaver, USA.
Kunsthallen Brandts Klaedefabrik, *Body as Membrane*, Odense, Denmark.
ICA, *Totally Wired – Live Arts – Femme avec tête*. Curator: Lois Keidan, London, England.
Zacheta, *J'ai donné mon corps à l'art*, Warsaw, Poland.
Multi Link, Bari Festival, Bari, Italy.
Ivan Dougherty Gallery, Sydney, Australia.
Contemporary Arts Center, *Is it Art*. Curator: Linda Weintraub, Cincinnati, USA.
Rencontres de la Photographie d'Arles, *Le Masque et le Miroir*. Curator: Anatxu Zaballeascoa, Arles, France.
Basel Fair, Palix Gallery stand, Basel, Switzerland.
De Appel, *Hybrids*, Amsterdam, The Netherlands.
Dr Richard Kimble Syndrom, *Wolfgang Mentzel*, Berlin, Germany.
NGBK Gallery, *Der Körper und der Computer*. Curator: Richard Wagner, Berlin, Germany.
Musée d'Art Contemporain, *L'Art au corps*. Curators: Philippe Vergne and Bernard Blistène, Marseille, France.
Salle Gaveau, Brut de Culture, *Schizophrénies*, Paris, France.
École Supérieure des Beaux-Arts de Paris, *Plastic*. Curator: Robert Fleck, Paris, France.
Art Space, *Orlan Carnal Art*, Auckland, New Zealand.
International Art Fair of Guadalajara, Galerie Palix and FIAT stand, Guadalajara, Mexico.
Museum of Contemporary Art, *Endurance*, Helsinki, Finland.
Proton ICA, *Endurance*, Amsterdam, The Netherlands.
The Katonah Museum of art, *Is it Art*. Curator: Linda Weintraub, Katonah, USA.
GAK, *Endurance*, Bremen, Germany.
La Ferme du Buisson, *Fluctuations fugitives*. Curators: Chantal Cuzin-Berche and Andrieu Sina, Marne-la-Vallée, France.
Kulturhusset, *Endurance*, Stockholm, Sweden.
FIAC, Galerie Palix stand, Paris, France.
Espace Belleville, *Le Corps dans tous ses états*, Paris, France.
Maine College of Art, *Endurance*, Portland, USA.
La Laverie Automatique and Galerie Lara Vinci, *Laver l'art*, Ben and Youri, Paris, France.
Nikolaj Church – Contemporary Art Center, *Nemo*. Curator: Elisabeth Delin-Hansen, Copenhagen, Denmark.
Gallery 400, *Endurance*, Chicago, USA.

1997

Venice Biennale of Contemporary Art, *Unimplosive Art Exhibition*, Zitelle, Venice, Italy.
Serpentine Gallery, *Art Vidéo*. Curator: Anthony Howell, London, England.

The Community Museum of Art, Palm Beach, *Is it Art*. Curator: Linda Weintraub, Palm Beach, USA.
Miami State University, *Endurance*, Miami, USA.
ARCO, Galerie Palix stand, Madrid, Spain.
Vancouver Art Gallery, *Endurance*, Vancouver, Canada.
MACBA, *Le Masque et le Miroir*. Curator: Anatxu Zabalbeascoa, Barcelona, Spain.
Laguna Museum of Art, *Is it Art*, Laguna, USA.
Fondacion Miró, *Corps et technologie*, Barcelona, Spain.
Community Museum of Art, Lakeworth, *Is it Art*. Curator: Linda Weintraub, Lakeworth, USA.
Belem Contemporary Art Center, Atlantico Festival, Lisbon, Portugal.
Lattuada Gallery. Curator: Francesca Alfano Miglietti, Milan, Italy.
Contemporary Art Fair, Milan, Italy.
Magazin Général. Curator: Francesca Alfano Miglietti, Milan, Italy.
Le Magasin, *Vraiment: féminisme et art*. Curator: Laura Cottingham, Grenoble, France.
Musée Saint-Pierre, *Hommage à R. Déroudille*, Lyon, France.
University of Washington, video and conference, Seattle, USA.
CAPC, *Orlan comme figure de la chimère*, Bordeaux, France.
Exogène. Principe d'extériorité. Exhibition held with the aid of police forensic services and internet. Curators: Bruno Grignonti and Morten Selling, Copenhagen, Denmark.
Galerie Gilles Peyroulet, *Le Tose de la vie*, Paris, France.
Museum voor Hedendaagse Kunst, video and conference, Ghent, Belgium.
Champ Libre, Troisième Manifestation Internationale Vidéo et Art Électronique, Montreal, Canada.
FIAC, Galerie Palix stand, Paris, France.
Kunstforening af 1847, *SUM*, Arhus, Denmark.
Contemporary Art Museum of Trento, *Trash*. Curator: Lea Vergine, Trento, Italy.
Café-crème, *The Mimeties: A Family of Man*, Luxembourg.
New Media Department Faculty of Fine Arts, *Symptoms and Home Remedies*, Hi-Tech/Art Brno, Czech Republic.
Albany Institute of History and Art, *Is it Art*. Curator: Linda Weintraub, Albany, USA.
Horsens Kunstmuseum, *Woman å*. Curator: Christin Juerstesens, Horsens, Denmark.
Lichthaus Center. Curator: Claudia Ruche. Bremen, Germany.

1998
MOCA, *Out of Actions: Between Performance and the Object 1949–1979*. Curator: Paul Schimmel, Los Angeles, USA.
International Short Film Festival, Cologne, Germany.
MAK, *Out of Actions: Between Performance and the Object 1949–1979*. Curator: Paul Schimmel, Vienna, Austria.

ARCO, Galerie Palix stand, Madrid, Spain.
La Consciencza Luccicante. Curator: Carmelo Strano, Cefalù, Sicily, Italy.
Chicago Fair, Galerie Palix stand, USA.
Observatoire de l'Image, *Made in Corpus*, Toulouse, France.
Galeries Contemporaines Sextius, *L'Art dégénéré II: Des artistes contre l'extrême-droite*, exhibition conceived and realized by the CAAC (Collectif Aix Art Contemporain), Aix-en-Provence, France.
"Living Art Museum," Reykjavik Festival, *The Human Body*. Curator: Hannes Sigurdsson, Reykjavik, Iceland.
Palazzo Branciforte, *Disidentico*. Curator: Achille Bonito Oliva, Palermo, Italy.
Galerie Palix, *Hygiène*, Paris, France.
By the Way, *Mutation*, Paris, France.
Galerie Passage de Retz, *Fétiche-fétichisme*. Curator: Jean-Michel Ribettes, Paris, France.
Galerie Cargo, Marseille, France.
Palazzo des Expositions, *La Consciencza Luccicante*, electronic art. Curator: Carmelo Strano, Rome, Italy.
Art Kiosk Gallery, *Flesh and Field*, Brussels, Belgium.
Histories of the Present Fourth South African Qualitative Methods, Johannesburg, South Africa.
Expo Arte, Galerie Palix stand, Guadalajara, Mexico.
FIAC, Galerie Palix stand, Paris, France.
MACBA, *Out of Actions: Between Performance and the Object 1949–1979*. Curator: Paul Schimmel, Madrid, Spain.

1999
Contemporary Art Pavilion, *Rosso, Transfiguration and Blood in Contemporary Art*. Curator: Francesca Alfano Miglietti, Milan, Italy.
MOCA, *The One Hundred Smiles of Mona Lisa*. Curator: Jean-Michel Ribettes, Tokyo, Japan.
Maison du Citoyen, *L'Invention des femmes*. Curator: Marie-Madeleine Dumas, Fontenay-sous-Bois, France.
The Israel Museum, *Skin-Deep*. Curator: Suzanne Landau, Jerusalem, Israel.
National Museum, *The One Hundred Smiles of Mona Lisa*. Curator: Jean-Michel Ribettes, Osaka, Japan.
Art Brussels, Galerie Palix stand, Brussels, Belgium.
Städtische Kunsthalle, *Heavenly Figures*, Düsseldorf, Germany.
Tate Gallery of Liverpool. Curator: Doreet LéVitté-Harten, Liverpool, England.
Galerie Enrico Navarra, *Corps mutant*. Curator: Jacques Ranc, Paris, France.
Musée de l'Élysée, *Le Siècle du corps/Photographie 1900–2000*, Paris, France.
Maison Européenne de la Photo, first prize of the Prix Arcimboldo, Paris, France.
LACMA *Ghost in the Shell*. Curator: Robert Sobieszeck, Los Angeles, USA.
Encontros da imagem Photography Festival, Braga, Portugal.

Galerie Khan Strasbourg, *Photographies portraits de corps*, Strasbourg, France.
Neue Galerie am Landesmuseum, *Anagrammatical Body*. Curator: Peter Weibel, Graz, Austria.

2000
Palazzo Reale, *Arte in vivo*. Curator: Francesca Alfano Miglietti, Torino, Italy.
Deste Foundation. Curator: Daniel Abadie, Athens, Greece.
Musée de l'Élysée, *Le Triomphe de la chair*, Lausanne, Switzerland.
Le Printemps, *Excentrique, un manifeste de l'apparence*. Curator: Florence Müller, Paris, France.
Artists in the City Festival, Bregenz, Austria.
Galerie Verney Carron and Maison du Livre, de l'Image et du Son, Villeurbanne, France.
Studio Stefania Miscetti, *Anableps*. Curator: Mario de Candia, Rome, Italy.
Artothèque Amiens, *Résonance*, Amiens, France.
Passage de Retz, *Narcisse blessé*. Curator: Jean-Michel Ribettes, Paris, France.
Galerie Enrico Navarra, *Le Corps mutant*. Curator: Jacques Ranc, Paris, France.
Arken Museum of Modern Art, *Man*, Arken, Denmark.
Kulturamt Stadt Oldenburg, *Reality Checkpoint-Körperszenarien*, Oldenburg, Germany.
Biennale d'Art Contemporain de Lyon, *Partage d'exotisme*. Curator: Jean-Hubert Martin, Lyon, France.
Staatliche Kunsthalle. Curator: Silvia Eiblmayer, Baden-Baden, Germany.
Culturgest, Lisbon, Portugal.
Metropolitan Museum of Tokyo, *The One Hundred Smiles of Mona Lisa*. Curator: Jean-Michel Ribettes. Tokyo, Japan.
Zentrum für Kunst und Medientechnologien, *Anagrammatische der Körper und seine mediale Konstruktion*. Curator: Peter Weibel, Karlsruhe, Germany.
Anne Faggianato Gallery, *Art and Anatomy*, London, England.
Art Kiosk Gallery, *Zizi 2000*, Brussels, Belgium.
Sapporo Prefectoral Museum, *Focus on Genes*. Curator: Jean-Michel Ribettes, Sapporo, Japan.
Kunsthaus-Galerie im Lenbachhaus and Kunstverein, *The Wounded Diva: Hysteria, the Body and Technology in Art*. Curator: Silvia Eiblmayer, Munich, Germany.
Centre Georges Pompidou, *La Grâce* (with Michel Maffesoli), *Revue Parlée*, Paris, France.
Centre d'Art Contemporain d'Auvers-sur-Oise, *L'Invention des femmes*. Curator: Marie-Hélène Dumas, Auvers-sur-Oise, France.
Château Pommery les Crayères, *Stratégies charnelles*. Curator: Adrien Sina, Reims, France.
Kunstsammlung NRW 235 Media Vidéo, *The Self is Something Else*, Düsseldorf, Germany.
Galerie im Taxispalais. Curator: Silvia Eiblmayer, Innsbruck, Austria.

Shizuoka Prefectoral Museum, *Focus on Genes*. Curator: Jean-Michel Ribettes, Shizuoka, Japan.

2001
Museum voor Modern Art, *Between Earth and Heaven, New Classical Movements in Art Today*, Ostende, Belgium.
Luis Adelantado Gallery, Valencia, Spain.
Borusan Sanat Galerisi, *Arzulananlar/Les Voluptés*, Istanbul, Turkey.
Marella Gallery, *Metamorfosi del corpo*, Milan, Italy.
Borusan Foundation, *Les Voluptés*. Curator: Elga Wimmer, Istanbul, Turkey.
Chicago Fair, Galerie Yvonamor Palix stand, Chicago, USA.
Festival E-Phos 2001, *The Hybrid Body and the Monster*, Athens, Greece.
Musée de Cholet, *Jocondissima*, Cholet, France.
Casa del Mantegna Museum, *Totemica*, Mantua, Italy.
Musée d'Art Contemporain d'Anvers, *Mutilate Mode et Body Art 2001 Landed/Geland*, Antwerp, Belgium.
Centro Bice Piacentini per le Arti Visive, *Le Arti della Criticasan*, San Benedetto del Tronto, Italy.
Rencontres de la Photographie d'Arles, Abbaye de Montmajour. Curator: Alain Sayag, Arles, France.
Le Parvis Centre d'Art Contemporain, *Réjouissez-vous*, Ibos, France.
FIAC, Galerie Yvonamor Palix stand, Paris, France.
Festival des Arts Électroniques, Rennes, France.
ISELP, *Le Clonage d'Adam*, Brussels, Belgium.
Musée de la Villette-Cité des Sciences et de l'Industrie, *L'Homme transformé*, Paris, France.
Musée d'Art Contemporain de Roubaix-Tourcoing, *Sous le drap, les temps des plis*, Roubaix-Tourcoing, France.

2002
Center Hall of the National Museum of Contemporary Art, Seoul, Korea.
Chicago Fair, Galerie Artcore stand, Chicago, USA.
The Jewish Community Center in Manhattan, *Dangerous Beauty*, New York, USA.
Kunsthalle Wien, *Tableaux vivants*, Vienna, Austria.
Modern Art Museum, *International Contemporary Art*, Mexico City, Mexico.
Magazin 4, Vorarlberger Kunstverein, Bregenz, Austria.
Shock & Show. Reality & Alternatives, 78 International Contemporary Art of Trieste, Italy.
Cologne Fair, Artcore stand, Cologne, Germany.
Art Basel Miami Fair, Artcore stand, Miami, USA.

2003
Espacio Liquido Gallery, *Fragiles*, Gerona, Spain.
University of Paris-VIII-Saint-Denis, *Campus Euro(pe) art*. Curator: Claude Mollard, Saint-Denis, France.
Cologne Fair, Galerie Michel Rein stand, Cologne, Germany.
University of Champagne Ardennes, *Campus Euro(pe) art*. Curator: Claude Mollard, Reims, France.

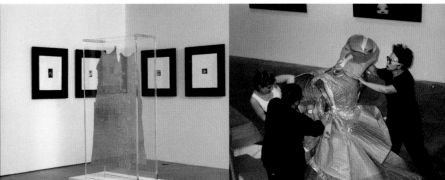

FIAC, Galerie Michel Rein stand, Paris, France.
University of Aix-Marseille III, *Campus Euro(pe) art.*
Curator: Claude Mollard, Aix-en-Provence, France.
Musée de l'Élysée (Musée de la Photographie),
Face, Lausanne, Switzerland.
University of Grenoble library, *Campus Euro(pe)
art.* Curator: Claude Mollard, Grenoble, France.
Culturgest, *Cara a Cara*, Lisbon, Portugal.
University of Marne-la-Vallée, *Campus Euro(pe)
art.* Curator: Claude Mollard, Marne-la-Vallée,
France.
Musée des Beaux-Arts du Québec, *Doublures*,
Quebec, Canada.
Free University of Belgium, *Campus Euro(pe) art.*
Curator: Claude Mollard, Brussels, Belgium.
Valencia Biennale of Contemporary Art, *La Ciudad
Ideal.* Curator: Lorand Hegyi, Valencia, Spain.
Galleria d'Arte Moderna, *La Creazione ansiosa,
da Picasso a Bacon*, Verona, Italy.
Briggs Robinson Gallery, *9 Women in the Same
Coat.* Curator: Nicola L. New York, USA.
Rencontres de la Photographie d'Arles, 2003,
Saint-Anne Chapel, *Les 20 ans des FRAC.* Curator:
Bernard Blistène, Arles, France.
David Gill Gallery, *Made in Paris: Photo/Vidéo*,
London, England.
Le Divan, *LHOOQ*, Paris, France.
University of Littoral Côte-d'Opale, *Campus
Euro(pe) art.* Curator: Claude Mollard, Dunkirk,
France.
Sorbonne chapel, University of Paris IV, *Campus
Euro(pe) art.* Curator: Claude Mollard, Paris, France.
CRDP de Poitou-Charentes, *Campus Euro(pe) art.*
Curator: Claude Mollard. Poitiers, France.
University of Angers, Library gallery, *Campus Euro(pe)
art.* Curator: Claude Mollard, Angers, France.
Galerie der HGB, Academy of Visual Arts,
Bellissima, Leipzig, Germany.
Musée Départemental d'Art Ancien et
Contemporain, *Art contemporain*, Épinal, France.
Le Plateau, *Des voisinages*, Paris, France.
Prisme Escape, Les Voûtes, *Orlan, Carnal art*, Paris,
France.
La Galerie des Galeries, Galeries Lafayette, *Avatars*,
Paris, France.
Elga Wimmer PCC, *Body Politics*, New York, USA.
Art in General, *Time Capsule*, New York, USA.
Zabriskie Gallery, *Role Play in Self-Portrait
Photography*, New York, USA.
Institut d'Art Contemporain, *Collection 001*,
Villeurbanne, France.
Hungarian Photography House, *La Fabrication du
réel*, Budapest, Hungary.
Place Saint-Sulpice, *Rencontres A3*, Paris, France.
2004
UNESCO, *In Movement: UNESCO Salutes Women
Video Artists of the World*, Curator: Hans-Werner
Kalkmann, Bad Salzdetfurth, Germany.
Luxembourg, *Moi! Autoportraits du xxe siècle.*
Curator: Pascal Bonafoux, Paris, France.
Washington University Gallery of Art, St. Louis, USA.

ZKM, *Media Art Net*, Karlsruhe, Germany.
Musée de l'Élysée (Musée de la Photographie),
Je t'envisage. La disparition du portrait, Lausanne,
Switzerland.
Galleria d'Arte Moderna, *La Creazione ansiosa,
da Picasso a Bacon.* Curator: Giorgio Cortenova,
Verona, Italy.
Month of Photography in Bangkok. Curators: Ark
Fongsmut and Philippe Laleu, Bangkok, Thailand.
Musée des Moulages, *Immobilis.* Curator: Céline
Moine, Lyon, France.
Deichtorhallen, *Révélation.* Curator: Nissam Perez,
Hamburg, Germany.
Palazzo Strozzi, *Moi! Autoportraits du xxe siècle.*
Curator: Pascal Bonafoux, Florence, Italy.
Museum of Art & Design, *Identity*, New York, USA.

BIBLIOGRAPHY

MONOGRAPHS

Alfano Miglietti, Francesca. *Orlan.* Milan: Virus
Productions, 1996.
Alfano Miglietti, Francesca. *Orlan.* Exhibition
catalog. Milan: Lattuada Studio, 1997.
Baqué, Dominique, Marek Bartelik, and Orlan.
*Orlan, Refiguration Self-hybridations. Pre-
Columbian Series.* Paris: Al Dante, 2001.
Bataille, Marie-José, Christian Gattinoni, Bernard
Lafargue, Orlan, Lydie Pearl, Isabelle Rieusset
Lemarié, and Joël Savary. *Une Œuvre d'Orlan.*
Marseille: Éditions Muntaner (coll. Iconotexte),
1998.
Becce, Sonia, Roberto Jacoby, and Serge François.
Orlan. Omniprésence. Buenos Aires: Galérie
L'Alliance, 1999.
Blistène, Bernard, Christine Buci-Glucksmann,
Juan Guardiola, Olga Guinot, Juan Antonio
Ramirez, and Julian Zugazagoita. *Orlan
1964–2001.* Catalog of the retrospective at the
Centro de Fotografía of the University of
Salamanca, Salamanca: Artium, 2002.
Blistène, Bernard, Christine Buci-Glucksmann,
Caroline Cros, Régis Durand, Eleanor Heartney,
Laurent Le Bon, Hans Ulrich Obrist, Vivian
Rehberg, and Julian Zugazagoita. *Orlan* (English
language version, *Orlan: Carnal Art*). Paris:
Flammarion, 2004.
Bonito Oliva, Achille, Bernard Ceysson, Bruno Di
Marino, Vittorio Fagone, Ulla Karttunen, and
Mario Perniola. *Orlan 1964–1996.* Rome:
Diagonale, 1996.
Bourgeade, Pierre. *Orlan, Self-hybridations.*
Romainville: Al Dante, 1999.
Buci-Glucksmann, Christine, and Michel Enrici.
Orlan, triomphe du baroque. Marseille: Images
en Manœuvres, 2000.
Ceysson, Bernard, and Joël Savary. *Orlan,
l'ultime chef-d'œuvre. Les 20 ans de pub et de
cinéma de sainte Orlan.* Exhibition catalog.
Hérouville Saint-Clair: Éditions du Centre

d'Art contemporain de Basse-Normandie,
1990.
Fabre, Gladys, and Dorine Mignot. *Orlan.
Art Access* online revue, Stedelijk Museum,
Amsterdam, The Netherlands, 1986.
Fabre, Gladys, Dominique Gilbert-Laporte,
and Jacques Donguy. *Skaï and Sky et Vidéo.*
Paris: Tierces, 1994.
Fabre, Gladys, Flor Bex, Sarah Wilson, Bernard
Ceysson, Julien Blaine, David Moos, Ulla
Karttunen, Malgorzata Listewicz, Philippe
Vergne, August Ruhs, Patrick Desmons,
Parveen Adams, Louis Bec, Jean-Michel Ribettes,
Michel Onfray, Hubert Besacier, Alain Charre,
Jacques Donguy, Christian Gattinoni, Linda
Weintraub, Catherine Millet, and Françoise Eliet.
Orlan, de L'Art charnel au Baiser de l'artiste.
Paris: Jean-Michel Place & Fils (coll. Sujet-Objet),
1997.
Ince, Kate, and Orlan. *Millennial Female.* Oxford:
Berg Publishers, 2000.
Yun, Jin-Sup, and Dominique Baqué. *Orlan.
Refiguration Self-hybridations.* Catalog from
Sejul Gallery, Korea, 2001.
Raffier, Joël. *L'Art Ushuaïa, l'extrême Orlan. Gervais
Lescure ou l'art somatique.* Auroville: Éditions
ACI, 1994.
Rehm, Jean-Pierre. *Le Plan du Film. Séquence 1.*
Book accompanying the audio CD of the group
Tanger. Romainville: Éditions Laurent Cauwet/
Al Dante, 2001.
Wilson, Sarah, Michel Onfray, Allucquére Rosanne
Stone, Serge François, and Parveen Adams. *Orlan.
Ceci est mon corps, ceci est mon logiciel.* London:
Black Dog Publishing, 1996.

CATALOGS OF GROUP EXHIBITIONS

Seventh Paris Biennial, France, 1971.
Artias, Lydia, *63/42*, Maison de la Culture et des
Loisirs, Saint-Étienne, France, 1972.
Artias, Lydia, *Triennial, Sculptures, Paintings*, Maison
de la Culture et des Loisirs de Saint-Étienne,
1975.
Gérome, Élyane, *Tendances Contemporaines
Rhône-Alpes*, ELAC, Lyon, France, 1977.
Orlan, Renato Barilli, Hubert Besacier, Maria-José
Corominas, Roberto Daolio, Ernesto de Sousa,
Vittorio Fagone, Sarah Kent, Helena Kontova,
Malitte Matta, Tadeusz Pawlowski, and
Francesco Poli, First International Symposium
for Performance Arts, Lyon, France, 1979.
Made in France, with *Mise en scène pour une sainte*,
ELAC, Lyon, France, 1980.
Identité : illusion-allusion nº 1, Eleventh Paris
Biennial, National Gallery of Art, Lisbon,
Portugal, 1981.
Alvaro, Egidio, *Performances, rituels, interventions
en espace urbain. Art du comportement au
Portugal*, edited by the Symposium International
d'Art-Performance de Lyon, Éditions du Cirque
Divers/Centre Georges Pompidou, France, 1981.

Exhibition catalog of the Eleventh Paris Biennial in
Nice, France, 1981.
Publication on visual arts by performance artists,
ELAC, Lyon, France, 1981.
Roche, Denis, *Brèves rencontres (l'autoportrait en
photographie)*, self-portrait photographs, Centre
Georges Pompidou, Herscher, Paris, 1981, p. 63.
Orlan, Hugh Adams, Hubert Besacier, Jean de
Breyne, Enrico Crispolti, René Déroudille, Vittorio
Fagone, Elisabeth Jappe, Gray Watson, Fourth
International Symposium of Performance Arts,
Édition Association Comportement-
Environnement-Performance, Lyon, France, 1982.
Popper, Frank, *Electra, l'électricité et l'électronique
dans l'art du xxe siècle*, Musée d'Art Moderne de
la Ville de Paris, 1983.
Ubi à Saint-Vorles, contemporary art event,
Châtillon-sur-Seine, France, 1984, pp. 27–28.
Fagone, Vittorio, *Vidéo d'artistes*, Geneva,
Switzerland, 1985.
Gilbert-Laporte, Dominique and Pierre Restany,
"Obsession du corps, obsession du langage,"
Revue télématique, Art Accès, France, 1985.
Restany, Pierre and Vittorio Fagone, *Histoire sainte
de l'art: Orlan, Léa Lublin*, Lacertidé, exhibition in
Cergy-Pontoise, France, 1985.
"ORLAN," *Cahier Danaé*, nos 4–5, France, 1989.
*Video Ch'ti choc de Roubaix, Deuxième Rencontres
de vidéo de Roubaix*, France, 1989.
Situation(s), exhibition catalog, CREDAC, Centre
d'Art Contemporain d'Ivry, Ivry-sur-Seine, France,
1990.
Buci-Glucksmann, Christine and Christian
Gattinoni, *Écrans-icônes*, Espace Art, Édition
Argraphie, Brenne, France, 1990. (Cover photo of
Orlan.)
"Art and Life in the Nineties," *Mediamatic*, vol. 4,
no. 4, Edge, Newcastle, England, 1990, p. 236.
Ribettes, Jean-Michel, *Les Couleurs de l'argent*,
Éditions La Poste, Musée de la Poste, France,
1991–1992.
Spotkania Sztuki aktywnej, Konin, Poland, 1992.
Bond, Anthony, *The Boundary Rider*, Ninth Sydney
Biennial, National Library of Australia, Australia,
1992–1993.
*The Body in Ruin, Manifestatie voor de instabiele
Media, Orlan: My Flesh. The Text and the
Languages*, The Netherlands, 1993.
Pusch Huskes Werbeage Natur, Performance Orlan,
Kunstlerhaus Bethanien Berlin, Germany, 1993,
pp. 90–92.
Blaine, Julien, *Dix ans de poésie directe
(1984–1993): Attendez-moi, je reviens*, Musée de
Marseille, RMN, France, 1993, p. 91.
Sex Quake Show: Art after the Apocalypse, First Art-
Genes Portable Museum, USA, 1993.
Wilms, Hildegard M., *Borderlines*, Fotomuseum,
Frankfurt, 1993.
Eiblmayr, Silvia, *Suture Fantasies of Totality*,
Salzburg, Austria, 1994, pp. 3–15.
Ermacora, Beate, *Positionen zum Ich, Kamerabilder*,

Kunsthalle zu Kiel, Germany, 1994, pp. 35–37.

Restany, Pierre and Renato Barilli, *Art en France de 1970 à 1993*, Mazzota, Bologna, Italy, 1994, pp. 146–149.

Ribettes, Jean-Michel, *L'Art du portrait aux XIXe et XXe siècles en France*, 1994, pp. 132–133.

Stiegler, Bernard, Ines Linder, and Nathalie Ergino, *Neuen Gesellschaft für Bildende Kunst*, exhibition catalog, NGBK, Berlin, Germany, 1994, pp. 91–92.

De Loisy, Jean, Arnaud Labelle-Rojoux, and Jacques Donguy, *Hors limite : L'Art et la vie, 1952–1994*, Éditions du Centre Georges Pompidou, Centre Georges Pompidou, Paris, 1994–1995.

Straus, Marc J., *Orlan, Inside Out, Psychological Self-Portraiture*, The Aldrich Museum of Contemporary Art, Ridgefield, USA, May–September 1995.

Le Grand Jardin du paradoxe et du mensonge universels, 18 ans de la galerie du Cirque Divers, Musée d'Art Moderne et d'Art Contemporain de la Ville de Liège, Éditions du Cirque Divers, Belgium, 1995, p. 131.

Klaniczay, Júlia, *Video Expedition in the Performance World*, Szerbesztetti, Italy, 1995, pp. 8–15.

Raspail, Thierry, Thierry Prat, Georges Rey, and Gladys Fabre, *Installation, cinéma, vidéo, informatique*, Third Contemporary Art Biennial of Lyon, RMN, Paris, 1995.

Francalanci, Ernesto L., *Scultura e oltre, sedicesima biennale internazionale del bronzetto piccola scultura Padova*, Il Poligrafo, Scultura e Oltra, Padua, Italy, 1995, pp. 225–226.

Wilson, Sarah, *Féminin=Masculin, le sexe de l'art*, exhibition catalog, Centre Georges Pompidou, Éditions du Centre Georges Pompidou, Gallimard-Electa, Paris, 1995, p. 302.

Video Expedition in the Performance World, Artpool, Budapest, Hungary, 1995, p. 15.

Orlan, Tom, *Triple X*, Amsterdam, Holland, 1995.

Vergne, Philippe and Jacques Donguy, *L'Art au corps, le corps exposé, de Man Ray à nos jours*, Galeries Contemporaines des Musées de Marseille, France, 1996.

Eiblmayer, Silvia and August Ruhs, *Body As Membrane*, Kunsthallen Brandts Klædefabrik, Denmark, 1996, pp. 60–65.

Parent, Francis, *Le Corps dans tous ses états*, exhibition catalog, Espace Belleville, CFDT, Paris, 1996, pp. 37, 54.

Weintraub, Linda, Arthur Danto, and Thomas McEvilley, *Art on the Edge and Over: Orlan, Self-Sanctification*, Art Insights, Inc., New York, 1996, pp. 77–83.

Nemo, *Drommen om det ny menneske: The Dream of New Man*, Copenhagen Contemporary Art Center, Copenhagen, 1996, pp. 22–23, 64–66.

Zabalbeascoa, Anatxu, *Réels, fiction, virtuel,*

Rencontres internationales de la photographie, Éditions Actes-Sud, Arles, France, 1996.

Fontcuberta, Joan and Anatxu Zabalbeascoa, *Màscara i Mirall*, Museum of Contemporary Art, Barcelona, Spain, 1996, pp. 44–45.

Expoarte – Guadalajara, Guadalajara, Mexico, 1996 – p. 104.

Art charnel, Orlan, Internationale Photoszene Köln, Cologne, Germany, 1996, p. 56.

Übergangsbogen und Überhöhungsrampe, naturwissenschaftliche und künstlerische Verfahren, Symposion I und II, Hochschule für Bildende Künste, Lerchenfeld 2, Material-Verlag, Hamburg, Germany, 1996.

Hommage à René Déroudille, Un combat pour l'art moderne, Musée des Beaux-Arts de Lyon, RMN, France, 1997, pp. 16, 43, 166.

Lunghi, Enrico and Paul di Felice, *The 90's "A Family of Man"? Images de l'homme dans l'art contemporain*, Café-Crème, Casino, Luxembourg, 1997.

Cottingham, Laura, *Vraiment féminisme et art*, Centre National d'Art Contemporain de Grenoble, France, 1997.

Eurokaz, Festival novog kazalista, Frakcua, Macedonia, 1997.

Sum, Århus Kunstbygning, Jubilæumsudstilling II, Denmark, 1997, pp. 24–27.

Strano, Carmelo, *Unimplosive Art*, Venice Biennial, Italy, 1997.

Blessing, Jennyfer, *Rose is a Rose is a Rose: Gender Performance in Photography*, Solomon R. Guggenheim Foundation, USA, 1997, p. 150.

Luces, càmara, accion (...) !Corten !: Videoaccion: el cuerpo y sus fronteras, MNCARS Library, Valencia, Spain, 1997.

Van Duyn, Edna, *Hybrids*, exhibition catalog, Appel Foundation, Amsterdam, The Netherlands, 1997.

Martinez, Rosa, *On Life, Beauty, Translations and Other Difficulties*, Fifth Istanbul Biennial, Istanbul, Turkey, 1997.

Hagedorn-Olsen, Claus, Birgit Hessellund, Tove Nyholm, and Anette Lerche Trolle, *Kvinden*, Horsens Kunstmuseum, 1998.

Baqué, Dominique, *La Photographie plasticienne. Un art paradoxal*, Éditions du Regard, Paris, 1998.

Schimmel, Paul and Kristine Stiles, *Out of Action (1949–1976): Between Performance and the Object*, Moca-Thames & Hudson, New York, 1998.

Oliva, Achille Bonito, *Distentico, Maschile Femminile e Oltre*, Panepinto Arte, Rome, Italy, 1998.

Troncy, Eric, *Le Colonel Moutarde dans la bibliothèque avec le chandelier (textes 1988–1998)*, Les Presses du réel, France, 1998.

L'Art dégénéré, Éditions Al Dante/CAAC, Aix-en-Provence, France, June 1998, p. 98.

Strano, Carmelo, *Europe-U.S.A. and the Epoch of Unimplosive Art*, Venice Biennial, 1997, Cefalù, Palermo, Sicily, 1998.

Van Beirendonck, Walter, *Wild and Lethal Trash,*

Believe, Kiss the Future, Boijmans Van Beuningen Museum, Rotterdam, The Netherlands, 1998.

Prosser, Jay, *Second Skins, The Body Narratives of Transsexuality*, Columbia University Press, New York, 1998, pp. 61–64, 242.

Lamarche-Vadel, Bernard and Marie-José Mondzain, *Mois de la Photo à Paris*, Éditions Paris Audiovisuel, November 1998,.

Griffelkunst-Vierter Graphikpreis der Mitglieder, Kunst und Computer, Hamburg, Germany, 1998, pp. 103–109.

Sega, Paola, Serra Zanetti, and Maria Grazia Tolomeo, *La Coscienza luccicante, dalla Videoarte all'arte Interattiva*, Palazzo delle Esposizioni, Gangemi, Rome, Italy, 1998, p. 139.

ERBAN/Patrick Raynaud, *La Nouvelle Interlope*, École Régionale des Beaux-Arts de Nantes, France, 1998.

De la monstruosité, expression des passions, Espace D. René Harrison, Éditions Jaune-Fusain, Montreal, Canada, 1998, p. 21.

Sigurdsson, Hannes and Jón Proppé, *Flögó og fögur skinn*, Ritstjó, Flögd, Rekjavik, Iceland, 1998, pp. 234–238.

Sobieszek, Robert, *Ghost in the Shell: Photography and the Human Soul, 1850–2000*, Lacma-Mit Press, Los Angeles, 1999, pp. 273–285.

LKW Kunst in der Stadt 4, exhibition catalog, Kunsthaus Bregenz, KUB, 2000, pp. 152–157.

Miglietti, Francesca Alfano, *Rosso vivo, mutazione, trasfigurazione e sangue nell'arte contemporanea*, Electa, Milan, Italy, 1999.

Skin-Deep, Surface and Appearance in Contemporary Art, The Israel Museum, Jerusalem, Israel, 1999.

Ribettes, Jean-Michel, *Fétiches et fétichisme, Le Défaut de l'objet religieux, économique & sexuel*, Éditions Blanche, Passage de Retz, Paris, April 1999.

Combalia, Victoria and Jean-Jacques Lebel, *Jardin d'Eros*, Institut de Cultura, Electa, Barcelona, Spain, 1999.

Jeux et simulacres, MNCARS Library, Madrid, Spain, 1999.

Levitté Harten, Doreet, *Heaven, an Exhibition That Will Break Your Heart*, exhibition catalog, Kunsthalle Düsseldorf, Hatje Cantz Publishers, Germany, and Tate Gallery, Liverpool, England, 2000.

ISEA 2000, Tenth International Symposium of Electronic Arts, exhibition catalog, co-edited by Musica Falsa and Art3000, Paris, 2000.

Navarra, Enrico, Jacques Ranc, David Le Breton, Nicolas Bourriaud, Pierre Restany, Florence Müller, Hugues Marchal, Serge Grünberg, and Axel Kahn, *Le Corps mutant*, exhibition catalog, Galerie Enrico Navarra, Paris, 2000, pp. 148–155.

Labelle-Rojoux, Arnaud, *Leçons de scandale, Yellow Now – Côté Arts*, Paris, 2000.

de Candia, Mario, *Anableps*, Studio Stefania Miscetti, Rome, Italy, 2000.

Eiblmayr, S., D. Snauwaert, U. Wilmes, and M. Winzen, *Die Verletzte Diva, Hysterie, Körper, Teknik in der Kunst des 20. Jahrhunderts*, Kunstverein München, Germany, Galerie Im Taxispalais, Oktagon, Innsbruck, Austria, 2000.

Beauty Now, Die Schönheit in der Kunst am Ende des 20. Jahrhunderts, Hirshhorn Museumhaus für Kunst, Mönchen Hatje Cantz, Germany, 2000.

Delarge, Alexandre, and Évelyne Coutas, *Résonances ou Le Musée au risque de l'art*, Écomusée de Fresnes, France, 2000.

Martin, Jean-Hubert, *Partage d'exotisme*, Fifth Lyon Biennial of Contemporary Art, RMN, Lyon, France, 2000.

Yun, Jin-sup and Sun-hoan Hong, Seoul International Performance Art Festival, catalog SIPAF, South Korea, 2000, pp. 32–33, (cover photo of Orlan).

Dumas, Marie-Hélène, editor, *Femmes & art au XXe siècle : le temps des défis*, 2000, pp. 102, 120, 127, 153, 188.

Ribettes, Jean-Michel, *Les 100 Sourires de Mona Lisa*, Nihon Keizai Shimbun, Japan, 2000.

Dumas, Marie-Hélène, *L'Invention des femmes*, catalog published by the Municipal Department of Culture, Auvers-sur-Oise, France, 2000.

McDonald, Helen, *Erotic Ambiguities: The Female Nude in Art*, Routledge, London and New York, 2001.

Mutilate, exhibition catalog, Flanders Fashion Institute, Belgium, 2001.

Between Earth and Heaven, Museum voor Moderne Kunst, Drukkerij Lannoo, Tielt, Oostende, Belgium, 2001.

Sojcher, Jacques, Gita Brys-Schatan, and Ben Durant, *Le Clonage d'Adam*, exhibition catalog, ISELP, Brussels, Belgium, 2001, p. 31.

Margat, Jean, *Jocondissima*, exhibition catalog, Éditions des Musées de Cholet, Cholet, France, 2001.

Vezzosi, Alessandro, *Raffaello e l'idea della bellezza, Raffaello vive*, Relitalia studi editoriali, exhibition at San Benedetto del Tronto and in Rome, Italy, 2001.

Mennesket, *Et halvt arhundrede set gennem kroppen*, exhibition catalog, Arken Museum of Modern Art, Denmark, 2001, p. 174.

Riva, Alessandro, *Totemica, Feticci e rituali del contemporaneo*, Casa del Mantegna, Mantua, Italy, 2001.

Abadie, Daniel, *Tongue in Cheek*, Deste Foundation, Athens, 2001.

Wimmer, Elga, *Arzulananlar/Les Voluptés*, Borusan Sanat Galerisi Istanbul, Turkey, 2001.

Le Breton, David, *Signes d'identité, tatouages, piercing et autres marques corporelles*, Métailié, Paris, 2002.

Degott, Ekatérina, *Corps et mouvements*, Fourth International Month of Photography, Photobiennale 2002, exhibition catalog,

Moscow Institute of Photography, Moscow, Russia, 2002.

Morsillo, Sandrine, Richard Conte, and Alain Douté, *L'Art contemporain au risque du clonage*, Publications de la Sorbonne, Paris, 2002, pp. 178–181.

Babel 2002, National Museum of Contemporary Art, Seoul, South Korea, 2002.

Perez, Nissan N., *Corpus Christi: Les représentations du Christ en photographie, 1855–2002*, Marval, Paris, 2002.

FIAC 02, Galerie Rabouan Moussion, Paris, 2002, p. 320.

Campitelli, Marina, Lorenzo Michelli, and Nicoletta Vallorani, *Shock & Show*, exhibition catalog, Trieste, Italy, 2002.

Electric Body. Le corps en scène, exhibition catalog, Beaux-Arts Magazine and Cité de la Musique, Paris, 2002.

Luc, Virginie, *Art à mort*, Éditions Léo Scheer, Paris, 2002.

Polyphonix, Éditions Léo Scheer, Éditions du Centre Georges Pompidou, Paris, 2002, pp. 204–205.

Mießgang, Thomas, *Dem Absurden Sinn geben, Magazin im Magazin-Revisited*, vol. 2, Magazin 4, Vorarlberger Kunstverein, Bregenz, Austria, summer 2002.

Folie, Sabine, Michael Glasmeier, Christine Buci-Glucksmann, and Mara Reissberger, *Tableaux vivants, Lebende Bilder und Attitüden in Fotografie, Film und Video*, Kunsthalle Wien, Austria, 2002, pp. 140–141.

Dangerous Beauty, exhibition catalog, The Jewish Community Center in Manhattan, New York, 2002.

Mondadori, Bruno, *Fotografia*, First International Festival of Rome, SIAE, Rome, Italy, 2002.

Buci-Glucksmann, Christine, *Le Temps des plis*, Musée des Beaux-Arts de Tourcoing, France, 2002, p. 17.

Deschamps, Gérard, *Retrospective 1956–2003*, Musée de l'hospice Saint-Roch, Issoudun, Musée des Beaux-Arts, Dole, 2003, p. 53.

Galán, Fernando Martin, Nuria Fernández, and Fernando Castro Fragiles, exhibition catalog, Galerie Espacio Liquido, Gerona, Spain, 2003.

Perez, Nissan, *Révélation, représentation du Christ dans la photographie*, Éditions Merrell, in association with The Israel Museum, Jerusalem, 2003, p. 140.

Barak, Ami, Katia Baudin, Bernard Blistène, and Olivier Zahm, *Trésors publics, 20 ans de création dans les Fonds régionaux d'Art contemporain*, exhibition catalog, Flammarion, Paris, 2003, p. 310.

Haenning, Marie, Shirley Veer, and Matthieu Gilles, *Art contemporain, 20 ans d'acquisitions avec l'aide du FRAM*, exhibition catalog, exhibition brochure, Épinal, France, 2003.

Rencontres de la photographie d'Arles, 2003, Actes Sud, Arles, France, p. 32.

Lamoureux, Johanne, *Doublures, vêtements de l'art contemporain*, exhibition catalog, Musée National des Beaux-Arts du Québec, Québec, 2003, pp. 46–48.

Cortenova, Giorgio, *La Creazione ansiosa da Picasso a Bacon*, Marsilio, Palazzo Forti, Verona, Italy, 2003.

Durand, Régis, Jean-Louis Milin, and André Pessel, *Fables de l'identité, œuvres photographiques et vidéo de la collection NSM Vie/ABN AMRO*, Centre National de la Photographie, Paris, 2003.

Settembrini, Luigi, Second Valencia Biennial, *La Ciudad Ideal*, Charta, Valencia, Spain, 2003, pp. 204–205.

Késenne, Joannes, *Eva Venus Madonna*, 2002, *Alle deelnemende kunstenaars en bruikleengevers*, Leuven, Belgium, 2003, p. 42.

Bethenod, Martin and Jacques Kerchache, *Portraits croisés*, Gallimard, Musée du Quai Branly, 2003, Paris, p. 163.

Seung-Wan, Kang and Han-Seung Ryu, *New Acquisitions 2002*, National Museum of Contemporary Art, Seoul, Korea, 2003, p. 87.

Katz-Freiman, Tami and Holly Block, *Time Capsule*, Art in General, New York, 2003, p. 11.

Pierret, Stanislas, Daniel Dumont, Jean-Luc Monterosso, Isabelle Chesneau, and Pascal Hoël, *La Fabrication du réel, 1980–2000*, collection of the Maison Européenne de la Photographie, Paris, Hungarian Institute of Photography, Budapest, Hungary, 2003.

Ewing, William (editor) and the Musée de l'Élysée, *Making Faces: the Death of the Portrait*, Thames & Hudson, 2005.

ESSAYS

Abril Ascaso, Osacar. "Art contemporain, musique électronique et 'club culture.'" *Multitudes* 4, March 2001, pp. 112–115.

Adams, Parveen. *The Emptiness of the Image: Psychoanalysis and Sexual Differences*. London/New York: Routledge, 1996.

Alfano Miglietti, Francesca. *Nessun Tempo, Nessun Corpo..., Arte, Azioni, Reazioni e Conversazioni*. Milan: Skira, 2001, pp. 185, 163–169.

Alfano Miglietti, Francesca. *Virus Art*, Milan: Skira, 2003.

Alfano Miglietti, Francesca. *Extreme Bodies: The Use and Abuse of the Body in Art*. Milan: Skira, 2003.

Allara, Pamela. "The Hierarchy of Touch: Reflections on Leora Faber's Four Minor Renovations." n. Paradoxa 111, 2003.

Allie, F., and Patricia Snomsed. *Journal des fous* 4, April 1991.

Anthony, Howell. *A Guide to Its Theory and Practice. The Analysis of Performance Art*. London: Harwood Academic Publishers, 1999, pp. 22, 106, 111, 176, 187.

Antoine Poupel: The Illusion and Sensuality of Paris, Tokyo: Metropolitan Museum of Photography 2001–2002.

Ardenne, Paul. *L'Âge contemporain. Une histoire des arts plastiques à la fin du xxe siècle*. Paris: Éditions du Regard, 1997.

Ardenne, Paul. *L'Image corps, figure de l'humain dans l'art du XXe siècle*. Paris: Éditions du Regard, 2001, pp. 34, 172, 298, 403, 408, 419, 420–425.

Ardenne, Paul. *Un art contextual*. Paris: Flammarion, 2002, pp. 162, 215.

"Art à contre corps." *Quasimodo* 5, Spring 1998, pp. 95–101.

Auslander, Philip. "Orlan's Theater of Operations." *Theater Forum*, Spring 1995.

Auslander, Philip. *From Acting to Performance. Essays in Modernism and Postmodernism*. London/New York: Routledge, 1997. Orlan on cover.

Balkema, Annette W., and Henk Slager (ed.). *Exploding Aesthetics*. Amsterdam/Atlanta: Rodopi (coll.: Lier en Boog, Series of Philosophy of Art and Art Theory), 2001.

Baqué, Dominique. *Mauvais genre(s), figures de l'érotisme dans l'art des années 90*. Paris: Éditions du Regard, 2002.

Benthien, Claudia. *Skin, on the Cultural Border Between Self and the World*. New York: Columbia University Press, 2002, p. 2.

Best, Victoria, Peter Collier, and Kate Ince. *Powerful Bodies, Performance in French Cultural Studies*. Berlin/New York/Vienna: Peter Lang, 1999, pp. 11, 51–53, 55, 57–66, 68, 68, 184.

Bethenot, Martin (ed.). *Jacques Kerchache, portraits croisés*. Paris: Gallimard/Musée du Quai Branly, 2003, p. 162.

Bory, Jean-François, and Jacques Donguy. *Le Journal de l'art actuel 1960–1985*. Paris: Ides et Calendes, 1985.

Bouscayrol, Marie-José, and Marc Partouche. *Femmes et artistes*. Pau, 2002, pp. 302–305.

Bousso, Daniela. *Acima do bem e do mal*. Sao Paulo: Paço das Artes, 2000.

Brand, Peg. *Beauty Matters*/foreword by Eleanor Heartney. Bloomington: Indiana University Press, 2000, pp. 14, 15, 79, 289–293, 290, 292, 293–311.

Brand, Peg. "Virtual Beauty: Orlan and Morimura." In *Exploding Aesthetics*/Annette W. Balkema and Henk Slager. Amsterdam/Atlanta: Rodopi (coll.: Lier en Boog, Series of Philosophy of Art and Art Theory), 2001.

Buci-Glucksmann, Christine. *La Folie du voir. Une esthétique du virtuel*. Paris: Galilée, 2002.

Buci-Glucksmann, Christine. *Histoire florale de la peinture. Hommage à Steve Dawson*. Paris: Galilée, 2002.

Busca, Joëlle. *Les Visages d'Orlan, pour une relecture du post-humain*, Brussels: La Lettre volée, 2002.

"Les bonheurs de l'art." *Cahiers de Psychologie de l'Art et de la Culture* 17, 1991, pp. 123–126, 149.

Capucci, Pier Luigi. *Il Corpo Technologico*. Bologna: Baskerville, 1994.

Capucci, Pier Luigi. *Arte e tecnologie, comunicazione estetica e tecnoscienze*. Bologna: Edizioni dell'Artica, 1996.

Caronia, Antonio. *Il Corpo Virtuale, dal Corpo Robotizzato al Corpo Disseminato*. Milan: Nelle Reti/Franco Muzzio, 1996.

Charles, Daniel. "Esthétique de la performance." In *Encyclopaedia Universalis*, Paris: Universalis, 1984.

Collection of the FRAC Île-de-France. Videomuseum for CD-ROM, 2001.

Collection of the FRAC Rhône-Alpes. Publication financed by the Rhône-Alpes region. 1992.

Couchot, Edmond, and Norbert Hillaire. *L'Art numérique. Comment la technologie vient au monde de l'art*. Paris: Flammarion, 2003.

Davis, Kathy. "My Body is My Art." *European Journal of Women's Studies* 4(1), February 1997.

Declerck, Lies. "Self-portrait as Anti-Mode." *Janüs*, Spring–Summer 2002, pp. 38–42.

Dery, Mark. *Escape Velocity, Cyberculture at the End of the Century*. New York: Grove Press, 1996

Dietrich, Andrea, Julia Draganovic, and Justus H. Ulbricht. *Uber Menschen*. Conference proceedings. Weimar: Autoren und Künstler, 2003.

Domaszewicz, Krysia. *Body & Society* [interview]. London: Sage Publication Ltd, 1999.

Duckett, Victoria. "Orlan. Beyond the Body and the Material Morph." *Meta-Morphing, Visual Transformation and the Culture of Quick-Change*. Minneapolis: University of Minnesota Press, 2001.

Dulot, Stéphanie. "Le corps à l'œuvre," and Gilles-François Picard. "Les surenchères de la chair." *Le Magazine de la Gazette* 9, 1 March 2002, pp. 24–35.

Esthétique et philosophie de l'art. Repères historiques et thématiques. Brussels: De Boeck & Larcier, 2002, pp. 277–278.

Gattinoni, Christian, and Yannick Vigouroux. *La Photographie contemporaine*. Paris: Scala, 2002, p. 109.

Gear, Rachel. *All those Nasty Womanly Things: Women Artists, Technology and the Monstrous-Feminine*. Cambridge: Elsevier Science, 2001.

Gispert, Carlos, and Rosa Martinez. *Historia del Arte*. Barcelona: Instituto Gallach, 1996, pp. 2915, 2960.

Goldberg, Rose Lee. *Performance Art: From Futurism to the Present*. London: Thames & Hudson, 2001.

Grosenick, Uta. *Women Artists, femmes artistes du xxe et du xxie siècle*. Cologne: Taschen, 2001, pp. 414–419.

Guggémos, Alexia. *Le Sourire*. Paris: Musée du Sourire, 1995.

Hennig, Jean-Luc. *Obsessions*. Paris: Albin Michel, 1985.

Heuze, Stéphanie (ed.). *Changer le corps?* Paris: La Musardine, 2000, pp. 72–74, 198.

Høgh-Olesen, Henrik. *Personlighedens Positioner, Angst og graenseloshed i person og kultur*. Copenhagen: Dansk Psykologisk Forlag, 2001, p. 240.

Hovagimyan, G. H. "Art in the Age of Spiritual Machines." Ninth New York Digital Salon, *Leonardo* 34 (5), 2001, pp. 453–458.

Huin, Bernard. *Collection Camille, signatures de femmes*. Épinal: Musée Départemental d'Art Ancien et Contemporain, 1997.

Les Imaginaires du corps II. Proceedings of the Interdisciplinary Colloquium in Grenoble, December 2002. Paris: Harmattan (coll. Nouvelles Études Anthropologiques), 2002.

Isaak, Jo Anna. *Feminism and Contemporary Art: The Revolutionary Power of Women's Laughter*. London/ New York: Routledge, 1996.

ISEA 2000. Catalog of the Tenth International Symposium on Electronic Arts. Paris: Musica Falsa/ Art 3000, 2000, p. 173.

Janicot, Françoise (ed.). *Poésie en action*. Issy-Les-Moulineaux: Loques/ NÈPE, 1984.

Jappe, Elisabeth. *Performance Ritual Prozess, Handbuch der Aktionskunst in Europa*. Munich/ New York: Prestel/ Verlag, 1993.

Jaquet, Chantal. *Le Corps*. Paris: Presses Universitaires de France, 2001, pp. 211–218.

Jeudy, Henri-Pierre. *Le Corps comme objet d'art*. Paris: Armand Colin, 1998, p. 95.

Jeudy, Henri-Pierre (ed.). *Art de chair*. Brussels: La Lettre Volée, 1999.

Joncquet, Thierry. *Moloch, série noire*. Paris: Gallimard, 1998.

Jones, Amelia. *Body Art/ Performing the Subject*. Minneapolis: University of Minnesota Press, 1997, p. 235.

Jouannais, Jean-Yves. "L'Idiotie, art, vie, politique – méthode." *Beaux-Arts Magazine*, 2003, p. 22.

Kauffman, Linda S. *Bad Girls and Sick Boys, Fantasies In Contemporary Art and Culture*. Los Angeles/ Berkeley: University of California Press, 1998, p. 64.

Kauffman, Linda S. "New Art, Old Masters and Masked Passions." In *The Public Intellectual*. Oxford: Blackwell Publishing, 2002, pp. 153–154.

Kemp, Martin, and Wallace Marina. *Spectacular Bodies: The Arts and Science of the Human Body from Leonardo to Now*. Los Angeles/ Berkeley/ London: University of California Press, 2000, p. 154.

Kockelkoren, Petran. *Technology: Art, Fairground and Theater*. Rotterdam: Nai Publishers, 2003.

Labelle-Rojoux, Arnaud. *L'Acte pour l'art*. Paris: Évidant, 1988.

Labelle-Rojoux, Arnaud. *L'Art en scenes*. Paris: Évidant, 1992.

Lafargue, Bernard. *Quatre fameux cons*. Saint-Pierre-du-Mont: Eurédit, 2000.

Laneyrie-Dagen, Nadeije. *Lire la peinture dans l'intimité des œuvres*. Paris: Larousse, 2002, p. 179.

Le Breton, David. *L'Adieu au corps*. Paris: Métailié, 1999.

Lemoine-Luccioni, Eugénie. *La Robe, essai psychanalytique sur le vêtement*. Paris: Seuil (coll. Le Champ Freudien), 1983.

Lucie-Smith, Edward. *Visual Arts in the Twentieth Century*. New York, Harry N. Abrams, 1997.

Lucie-Smith, Edward. *Art Tomorrow*. Paris: Vilo International, 2002.

Macri, Teresa. *Il Corpo postorganico – sconfinamenti delle performance*. Genoa: Costa & Nolan, 1996, pp. 53–76.

Martel, Richard. *Art Action 1958–1998*. Quebec: Intervention, 2002.

Mayeur, Sylvie. *Guide opérationnel de la qualité. Faut-il tuer la qualité totale?* Paris: Maxima/ Laurent du Mesnil, 2003.

Michaud, Stéphane. *Muse et madone. Visage de la femme de la Révolution française aux apparitions de Lourdes*. Paris: Seuil, 1985.

Millet, Catherine. *L'Art contemporain*. Paris: Flammarion (coll. Domino), 1997, pp. 91, 93, 103.

Millet, Catherine. *Qu'est-ce que l'art moderne?* Paris: Gallimard, 2001.

Minière, Claude. *L'Art en France, 1960–1995*. Paris: Nouvelles Éditions Françaises, 1995, p. 27.

Müller, Florence. *Excentriques*. Paris: Éditions du Chêne, 2001, pp. 150, 166, 167.

Nabokov, Dominique. *Paris Living Rooms*. Paris: Assouline, 2002.

Nagy, Pál. *Az irodalom új Múfajai*. Budapest: Magyar Múhely Baráti Kör Füzetek 40–41, 1995, pp. 212, 271, 348.

National Museum of Contemporary Art, New Acquisitions, Korea, 2002.

Oneto, Manuela. *TechnoMutAzioni, Post-futurismi del terzo millennio*. Geneva: Anexia in Stradone, 2002.

Onfray, Michel. *Archéologie du présent, manifeste pour une esthétique cynique*. Paris: Grasset/ Adam Biro, 2003.

Orlan, 1979–1983, Cinq ans d'art-performance à Lyon. Lyon: Éditions Comportement, Environnement, Performance, 1984.

Orlan, "Manifesto of Carnal Art." *Paradoxa* 12, 1993, pp. 44–49.

"Orlan, bunt mutantow mutants' rebellion." *Magazyn Sztuki, Art Magazine* 9, January 1996.

Paparoni, Demetrio. *Il Corpo parlante dell'arte. La nuova scena internazionale: linguaggi, esperienze, artisti*. Rome: Castelvecchi, 1997, p. 132.

Paquet, Dominique. *Miroir, mon beau miroir, une histoire de la beauté*. Paris: Découvertes Gallimard, 1997.

Pearl, Lydie (ed.). *Nouvelles études anthropologiques. Corps, art et société. Chimères et utopies*. Paris: Harmattan, 1998.

Pearl, Lydie. *Corps, sexe et art, dimension symbolique*. Paris: Harmattan, 2001.

Pearl, Lydie, Patrick Baudry, Bernard Lafargue, Henri-Pierre Jeudy, Alain Mons, Alain Gauthier, François Seguret, and Sarah Wilson. *Arts de chair*. Brussels: La Lettre Volée (coll. Essais), 1998, pp. 41–48.

Paintings, drawings, collages, photographs auctioned in aid of "Afganistan-Libre," Nikki Diana Marquardt Gallery, Paris, 10 January 2002.

Perniola, Mario. *Enigmas: The Egyptian Moment in Society and Art* translated from the Italian by Christopher Wordage, London/ New York: Verso, 1995. Orlan on cover.

Phelan, Peggy, and Jill Lane. *The Ends of Performance*. New York: New York University Press, 1998, pp. 5–6, 15–16, 285–314.

Phoenix, Ann. "Identities and Diversities." *Mapping Psychology*. Milton Keynes: The Open University, 2002, p. 49.

Poivert, Michel. *La Photographie contemporaine*. Paris: Flammarion, 2002, p. 80.

Pollock, Griselda. *Generations and Geographies in Visual Arts: Feminist Reading*, London/ New York: Routledge, 1996.

Popper, Frank. *L'Art à l'âge électronique*. Paris: Hazan, 1993.

Ramirez, Juan Antonio. *Corpus Solus, para un mapa del cuerpo en el arte contemporàneo*. Madrid: Siruela, 2003.

Ramirez, Juan Antonio, Manuel Arias, Ma Antonia Garcia Fuertes, Beatriz Del Castillo, Belén Pallol. *Historia del Arte, Bachillerato 2*, Madrid: SM, 1999.

Raney, Karen. *Art in Question*, London: The Art Council of England, 2003, pp. 147–157.

Reckitt, Helena, and Peggy Phelan. *Art and Feminism*. London: Phaidon, 2001, p. 172.

Richard, Alain-Martin, and Clive Robertson. *Performance au/in Canada, 1970–1990*. Québec: Intervention, p. 295.

Roch, Jean, Enrico Navarra, Lolita Pille, Jacques Ranc, and Pierre Reynes. *VIP Room, Part one*. Paris: Enrico Navarra Gallery, 2002.

Schneede, Marina. *Mit Haut und Haaren, der Körper in der zeitgenössischen Kunst*. Cologne: Dumont, 2002, pp. 129–130.

Sederholm, Helena. *Tämäkö Taidetta?* Helsinki: WSOY, 2000.

Sicard, Monique. "Faire face." In *Les Cahiers de Médiologie* 15, Paris: Gallimard, 2002.

Sicard, Monique, and Françoise Gaillard. "Interventions sur le visage." In *Les Cahiers de Médiologie* 14, Paris: Gallimard, 2002.

Smith, Sidonie, and Julia Watson. *Interfaces, Women, Autobiography, Image, Performance*. Ann Arbor: University of Michigan Press, 2002.

Soulillou, Jacques. *L'Impunité de l'art*. Paris: Seuil, 1995.

Stiles, Kristine. "Never Enough is Something Else: Feminist Performance Art, Probity, and the Avant-Garde." In James M. Harding (ed.), *Avant-Garde Performance, Textuality and the Limits of Literary History*. Madison: University of Wisconsin Press, 2000.

Stiles, Kristine. *Uncorrupted Joy: Art Actions, Art History and Social Value*. Berkeley: University of California Press, 2004.

Suture, Phantasmen der Vollkommenheit. Conference proceedings. Salzburg: Salzburger Kunstverein, 1994.

Tarascon 1989. Sixièmes rencontres internationales de poésies contemporaines. Agrippa, 1989, p. 118.

Taylor, Mark C. *Hiding*. Chicago: University of Chicago Press, 1997, p. 141.

Teatro al Sur 12, September 1999, pp. 54–60.

Tilroe, Anna. *De huid van de kameleon*. Amsterdam: Querido, 1996.

Utopia 3, la question de l'art au 3e millénaire. Proceedings of the international conference organized by the University of Paris-VIII and the University of Venice, Brescia, 2002.

Valeriani, Luisa. *Dentro le Trasfigurazione, il dispositivo dell'arte tra cibercultura e vangelo, I Turbamenti dell'arte*. Milan: Costa & Nolan, 1999.

Vasseur, Nadine. *Métamorphoses du corps*. Paris: Seuil, 2004.

Vergine, Lea. *Body Art and Performance, the Body as Language*. Milan: Skira, 2000.

Warner Marien, Mary. *Photography: A Cultural History*. London: Laurence King, 2002.

Warr, Tracey, and Amelia Jones. *The Artist's Body*. London: Phaidon, 2000.

Wilson, Stephen. *Information Arts, Intersections of Art, Science and Technology*. Cambridge, USA: MIT Press, 2002, p. 170–171.

Zwischen Performance und Objekt, 1949–1979, Austrian Museum of Applied Arts, Vienna, 6 September 1998, pp. 99, 241, 256, 271, 272, 296, 297.

Zylinska, Joanna. *The Cyborg Experiments: The Extensions of the Body in the Media Age*. London/ New York: Continuum, 2002.

PUBLIC COLLECTIONS

FNAC, Paris, France / Fondation Pinault Pour l'Art Contemporain, France / Musée Départemental d'Art Ancien et Contemporain d'Épinal, France / Musée des Beaux-Arts du Québec, Canada / FRAC Rhône-Alpes, France / FRAC Pays-de-la-Loire, France / FRAC Île-de-France, France / FRAC Limousin, France / MNAM-Centre Georges Pompidou, Paris, France / Maison Européenne de la Photographie, Paris, France / Fondation Camille, France / Collection Municipale de Marseille, France / Musée de la Photographie de Bièvre, France / Le Magasin, Centre National d'Art Contemporain de Grenoble, France / Centro de Fotografía of the University of Salamanca, Spain / National Museum of Contemporary Art, Seoul, Korea / Halim Museum, Seoul, Korea / Banque NSM Vie ABN-AMRO, France

Conference: *Ceci est mon corps . . . ceci est mon logiciel*

Emilie Harvey Gallery (with the collaboration of Pat Hearn), New York, USA – Penine Hart Gallery, New York, USA – *Art Electronica*, Linz, Austria – *Art Futura*, Reina Sofia Museum, Madrid, Spain – Kunstverein, Salzburg, Austria – Berlin Art Academy, Germany – Literaturhaus, Vienna, Austria – École Nationale Supérieure de Paris, France – ICA, London, England – Kunsthalle, Kiel, Germany – NGBK, Berlin, Germany – Nexus Center, Atlanta, USA – Chassie Post Gallery, Atlanta, USA – Emory University, Atlanta, USA – Galleria D'Arte

Moderne, Bologna, Italy – École Nationale des Beaux-Arts de Dijon, France – Camerawork, San Francisco, USA – Sandra Gering Gallery, New York, USA – École Nationale des Beaux-Arts de Lyon, France – Centre Georges Pompidou, Paris, France – New York University, USA – University of Leeds, Great Britain – Le Parvis, Ibos, France – École des Beaux-Arts de Rueil-Malmaison, France – Cornélus Hertz Gallery, Bremen, Germany – Collège International de Philosophie, Paris, France – École Nationale des Beaux-Arts de Bourges, France – *Virtual Futures*, University of Warwick, Great Britain – Triple X Festival, Amsterdam, The Netherlands – Festival de Vidéo-Art, Locarno, Switzerland – Sculpture Biennale *Oltre di Scultura*, Padua, Italy – Biennale d'Art Contemporain de Lyon, France – Kunsthallen Brandts Faebricks *Body As Membrane*, Odense, Denmark – Beaux-Arts, Hamburg, Germany – FITAC Contemporary Art Fair of Guadalajara – Nikolaj Church, Center of Contemporary Art, Copenhagen, Denmark – Museum-Laboratory of the University of Rome, Italy – Académie Charpentier, Paris, France – Camerawork, London, Great Britain – Accademia delle belle arti di Brera, Milan, Italy – FRAC *Hiatus*, Caen, France – École des Beaux-Arts de Grenoble, France – University of Washington, Seattle, USA – MACBA, Barcelona, Spain – CAPC and Université Crea 3, Bordeaux, France – Festival Atlantico, Lisbon, Portugal – Krypton Theater, Florence, Italy –*Unimplosive Art Exhibition*, Biennale Zitelle, Venice, Italy – Ghent Museum, Belgium – *Foufounes Électriques*, Champ Libre Festival Vidéo, Montreal, Canada – Istanbul Biennial, Turkey – Brno, Czech Republic – Lichthaus Laboratorium, Bremen, Germany – Chapter Gallery, Cardiff, Wales – Casino, Luxembourg – *In Art 97*, Porto de la Cruz, Teneriffe, Spain – École Régionale des Beaux-Arts de Bourges, France – École Régionale des Beaux-Arts de Nantes, France – École Nationale des Beaux-Arts de Cergy-Pontoise, France – École Régionale des Beaux-Arts de Lyon, France – California Institute of the Arts, Los Angeles, USA – Art Center Pasadena, Los Angeles, USA – École Régionale des Beaux-Arts, Marseille, France – De Luminy, Marseille, France – Université de Marseille, France – Maison de la Culture de Dieppe, France – *Made in Corpus Odyssud*, University of Toulouse-Le Mirail, France – Musée du Louvre, *La Mazarine*, Paris, France – *Out of Performance*, Museum für Angewandte Kunst, Vienna, Austria – La Casa Lamm, Mexico City, Mexico – Feminist Studies and Research, University of Bergen, Norway – Palazzo des Expositions *La Coscienza lucciante*, Rome, Italy – University of Leicester, England – École des Beaux-Arts de Tourcoing, France – Université de Paris-IV, Paris, France – Art Institute of Chicago, USA – Université d'Amiens, France – Le Pezner, Villeurbanne, France – Dance 4, University of Nottingham, England – Israel Museum, Jerusalem, Israel – University of Madrid, Spain – Institut Français of Buenos Aires, Argentina – Maison Européenne de la Photographie, Paris, France – Chambre du Commerce Étudiant de Stanford, Paris, France – FRAC, Reims, France – Musée d'Art Contemporain de Marseille, France – École Régionale des Beaux-Arts de Dunkerque, France – Fête de l'Internet, Maison Populaire de Montreuil, France – University of Texas, Austin, USA – University of Arizona, Phoenix, USA – New York University, USA – Institut Français de Valencia, Spain – Festival E-Phos, Athens, Greece – Le Parvis, Centre d'Art Contemporain d'Ibos, France – Festival des Arts Électroniques, Rennes, France – ISELP, Brussels, Belgium – University of Seoul, Korea – Musée des Moulages, Université de Lyon, France – Summer University, Rencontres de la Photographie d'Arles, France – University of Toronto, Canada – Artium Museum, Vitoria, Spain – University of Salamanca, Spain – Forum Le Monde, Le Mans, France – Émergence(s), manifestation d'Art actuel, Vanves, France – *Corps à corps*, AIDEC Association pour le Développement Économie et Culture, Campus of the Université de Pau, France – Rencontres Internationales Artistiques, Teneriffe, Spain – IMAGINA, École des Beaux-Arts de Monaco – Hapax, Musée de la Photographie de l'Élysée, Lausanne, Switzerland – FRAC Pays-de-la-Loire, Carquefou, France – Morra Foundation, Naples, Italy – Biennial of Valencia, Spain – Magazin 4, Cologne, Germany – Musée d'Art Moderne de Saint-Étienne, France.

FILMS ON THE WORKS OF ORLAN

1976
MesuRage de la rue Chateaubriand. Nice.
8 mm, 7'.
Director: Ben.

1980
Vierge noire.
16 mm, B/W, 12'.
Director: Jean-Paul Dupuis.

1981
Mise en scène pour une sainte.
Color, SECAM U, 15'.
Director: Charles Picq.

1990
Opération-Opéra
Super 16 mm
Director: Stéphan Oriach.

1991
Opération-Opéra. Performance à Paris.

1992
Orlan et les peintures d'affiches de cinema.
Madras, India.
Super 16 mm.
Director: Stéphan Oriach.

1993
Omniprésence.
Super 16 mm
Director: Stéphan Oriach.

1993
Opération réussie
4 x 9'.
Co-directors: Orlan and Stephan Oriach;
Coproduction Canal +.

1995
Cyberculture. New York.
16 mm
Director: Iara Lee.

2002
Orlan, Carnal Art
35 mm, 75'.
Director: Stephan Oriach.
Featuring Orlan, Pierre Restany, Serge François, Gladys Fabre, Jean-Paul Fargier, Joël Raffier, Barbara Rose, Connie Chung, Chris McGeachy, Linda Weintraub.
Documentary by Myriapodus Films, with the help of the Centre Georges Pompidou and the French Ministry of Culture.

SELECTED PRESS ARTICLES

FRANCE

1975
Faure, Jean. "Sur les hautes terrasses du Paradou, l'étrange voisinage de Salvador Dali, de Malraux et d'Orlan." *Le Progrès*, Festival d'Avignon, 1975.
Manifestation Internationale des Jeunes Artistes, Neuvième Biennale de Paris, Idea Books, 19 September–2 November 1975.

1977
Concalves, Enrico. "Si vous n'avez pas vu Orlan mesurant la place Saint-Lambert, il n'est pas trop tard." *La Wallonie*, 28 January 1977.
Déroudille, René. "Enfin, l'art aujourd'hui à Lyon, Espace Mermillon." *Dernière Heure*, 30 May 1977.
Errant, J.-J. *Le Progrès*, Lyon, 5 June 1977.
Déroudille, René. "L'art de maintenant a enfin droit de cité à Lyon." *Le Tout-Lyon*, 6 June 1977.
Canty, Colette. "Tout tente la plus protéiforme des Stéphanoises." *Le Progrès*, 28 June 1977.
Bizot, Jean-François. "Le Baiser de l'artiste." *Libération*, 13 August 1977.

Binde, Jérôme. "Dada 77: intervention sur les mass media." *Le Quotidien de Paris*, 21 September 1977.
Agullo, Thierry. "Hétéroclyte." *Bulletin de Budos*, September 1977.
Barzig, J.-Y. "Orlan: n'attendez pas le Père Noël." *Le Courrier de l'Ain*, 7 October 1977.
Canty, Colette. "Orlan comme à la parade." *Le Progrès*, 9 October 1977.
Jaget, Claude. *Libération*, 29 October 1977.
Guth, Paul. "Les naïvetés." *Ouest-France*, 30 October 1977.
Dufrene, Catherine. "L'art vivant." *Le Journal du Dimanche*, October 1977.
Barzig, J.-Y. *La Montagne*, 2 November 1977.
Mossot, Claude. "Baiser d'art." *Studio*, 2 November 1977.
Loude, Jean-Yves. "5 F Le Baiser de l'artiste." *Le Soir Marseille*, 3 November 1977.
Caradot, Christine. "Langage au feminine." *Le Journal*, 10 November 1977.
Gouttenoir. "Le Baiser artistique." *Hebdo*, 16 November 1977.
Gouttenoir. "Actuelles." *L'Humanité*, 16 November 1977.
Breerette, Geneviève. "Du côté des artistes jeunes." *Le Monde*, November 1977.
Belleret, Robert. "Au chômage pour avoir vendu ses baisers." *Le Matin*, 6 December 1977.
Dufresne, Catherine. "Orlan récidive." *Ardennais*, 7 December 1977.
Canty, Colette. "Grève pour un baiser." *Libération*, 9 December 1977.
Dufresne, Catherine. "L'amer Baiser de l'artiste." *Le Monde*, 10 December 1977.
Van De Wolle, Odile. "Femmes entre elles." *Le Quotidien de Paris*, 10 December 1977.
Grindsel. "Le plat du jour." *La Tribune*, *Le Progrès* December 1977.
Rozier, Jacqueline. "Le langage au feminine." *Le Journal*, December 1977.
Binde, Jerôme. "Lutter contre la peur et la récupération." *L'Écho des Savanes* 37, 1977.
Concalves, Enrico. *Coloquio* 34, 1977.
Eliete, Françoise. "Orlan artiste." *Art Press* 14, 1977.
Gerome, Élyane. "Poésie, peinture et actions." *ELAC Magazine*, Lyon, 1977.
Juge, Pascale. "Baiser à 5 F." *Studio* 6, 1977.
Loude, Jean-Yves. "Orlan renvoyée pour un baiser." *Lyon Poche* 298, 1977.
Thedeyre, J.-M. "La poésie sur les marches." *Le Monde*, 1977.

1978
Lervine, Frédéric. "Rétrospective de l'an 77." *L'Express*, 2 January 1978.
Juge, Pascale. "Expo: Sexe en persil." *Libération*, 16 January 1978.
Ferrero, Jean. "Correspondance." *Constat de Carence*, April 1978.
Migletti, Paola. "Orlan." April 1978.
Beaugrand, Catherine. "Orlan Jeanne d'Arc." In *L'art me met l'eau à la bouche*, 1978.

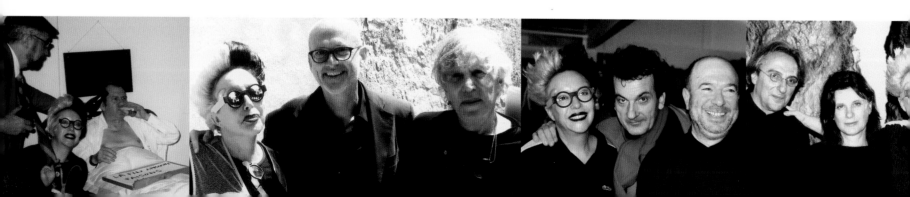

1979

Lauzier. *Pilote*, January 1979.

Gerôme, Élyane. "Symposium d'art-performance." *Le Progrès*, April 1979.

Payot, Martine. "Orlan la magnifique." *Résonance*, May 1979.

Du Vignal, Philippe. "Performance." *Art Press* 30, July 1979.

Besacier, Hubert. "Le trousseau d'une fille à marier." For coming book *Baiser d'un artiste pour 5 francs ou L'art se met l'eau à la bouche d'Orlan*, December 1979.

Hervé, Jocelyne. "La provocation." *Les Cahiers de la Peinture* 58, 1979.

1980

Bosc, Bernadette. "De beaux derniers instants." Second International Symposium on Art-Performance. *Le Progrès*, 28 April 1980.

Gerome, Élyane. "Tendances contemporaines Rhône- Alpes, état 1." Exhibition at the Espace Lyonnais d'Art Contemporain, 18 May–7 July 1980.

Robert, Henri-Marie. "Le triple corps d'Orlan." *Lyon Poche*, 10 June 1980.

Quirot, Odile. "Beaux-arts: querelle d'anciens et de modernes." *Canal* 20, August 1980, p. 13.

Robert, Henri-Marie. "Fabriqué en France." *Lyon Poche*, November 1980.

Deroudille, René. "Made in France à l'Elac." *Lyon Matin*, 18 December, p. 10.

Gerome, Élyane. "Made in France." *Le Progrès*, 18 December 1980.

Gerome, Élyane. "La création feminine." *La Tribune*, 26 December 1980.

Bonnaval, Jacques. "Orlan, mise en scène pour une sainte." Analysis of an installation presented in *Made in France*. Espace Lyonnais d'Art Contemporain, December 1980.

De Breyne, Jean. "Made in France." *L'Humanité*, December 1980.

Cerruti, Stéphane. *Lettre*, December 1980.

Dupuy, Jean. *Collective Consciousness: Art-Performance in the Seventies*, New York: Performing Arts Journal Publications, 1980.

Hennig, Jean-Luc. *Sandwich* [supplement of *Libération*] 60, 1980.

1981

Nadaud, Catherine. *Libération*, January 1981.

Desmaris, Alain. "L'Œil sur elles." *Télé 7 Jours*, February 1981.

Rodes, Christine. "Barocco." *Lyon Poche*, February 1981.

Argence, Guy. "Orlan, psychologie baroque." March 1981.

D., Élisabeth. "Moi je provoque donc j'existe." *Actuel* 17, March 1981, pp. 53–54.

Walter, Renaud. "Exhibitionnisme et video." *Vidéo News*, July 1981.

Morin, Edgar. "Le jeu ambigu de la pose nue." *Photo* 168, September 1981.

Beaugrand, Catherine. "Entre sainte Orlan et la femme forte, d'après l'ouvrage de Mg. Condriot, 1864." 1981.

Donguy, Jacques. "Assomption dans le bleu." 1981.

Donguy, Jacques. "L'Ob-Scène – La fixité du fétiche, variation sur le corps d'Orlan voilé de voile." *Art Press*, 1981.

Grangean, Raymond. *Le Revolver* 1, 1981.

Guth, Paul. *La Montagne* 63, 1981.

1982

Bonnier, Colette. *Marie-Claire*, 1982.

1983

Julien, C. H. "Expo Besançon." *Art Press* 73, September 1983.

Restany, Pierre, and J.-F. Bory. "La vie dans l'art." October 1983.

1984

Charles, Daniel. "La performance." *Encyclopédie Universalis*, 1984.

1985

Tronche, Anne. "Le techno-imaginaire ou les cartes du 'temps' à venir." *Opus International*, 1985.

"Le plus souvent des femmes." *Par Cœur* 2, 1985, p. 13.

1988

Kosmalski, Danielle. "Orlan." *VideoArt Plastique*, December 1988.

1990

"Orlan." *Ici-Paris*, 27 February 1990.

Orlan. "L'art nous met l'eau à la bouche." *Concept* 6, February 1990.

Giroud, Michel. "Orlan, le concept en transe." *Kanal Magazine* 6, March 1990, p. 53.

Gattinoni, Christian. "Célébration d'un corps offert à ses images." *Opus International*, May–June 1990.

Fonval, Jean. "Arts plastiques, expos multiples." *Ivry ma ville*, June 1990, p. 39.

Bretonneau, Yves. "Notes sur Orlan." *Concept* 8, August 1990.

"Orlan, ultime chef-d'œuvre." *Ad Hoc*, Fall 1990.

"Orlan, l'artiste-corps..." *Cirque Divers*, 24 September 1990.

Ceysson, Bernard. "Orlan ultime chef-d'œuvre." *Revue d'Art Contemporain* 57, October 1990.

F., M.M. "Orlan, le dernier chef-d'œuvre." *Elle*, October 1990.

Bousteau, Fabrice. "Orlan, la renommée." *Beaux-Arts Magazine* 84, November 1990, p. 157.

Randal, Joss. "Les Vanités sous l'éclairage de sainte Orlan, petit article bref en forme de lampe à souder." *Caen-Plus* 10, November 1990, p. 34.

1991

Arthèmes 61, December 1990–January 1991; *Arthèmes* 62, February–March 1991.

"Gorgone? Zola?" *Le Canard Enchaîné*, 2 January 1991.

Couturier, Élisabeth. "Happening au bloc opératoire." *Paris-Match*, 3 January 1991, pp. 8–9.

"La métamorphose d'Orlan." *La Montagne*, 6 January 1991.

"Happening." *Gai Pied Hebdo* 453, 17 January 1991.

Bizot, Jean-François. "J'ai donné mon corps à l'art." *Actuel* 178, January 1991.

De Luna, Noëlli. "La femme qui veut faire de son corps une œuvre d'art." *Le Quotidien du Médecin* 4692, 10 February 1991, cover and p. 24.

Guillemard, François. "L'art charnel, œuvre ultime d'Orlan." *Le Bien Public*, 12 February 1991.

Remond, Anne-Caroline. "Elle deviendra la femme de toutes les beautés." *France-Soir*, 12 February 1991, p. 6.

"Elle aura les traits de La Joconde et de Psyché." *Voici* 171, 18 February 1991, pp. 20–21.

Davis, Anne. "Elle apostrophe... Orlan." *Elle*, February 1991.

Devos, Raymond. "Face au miroir." *Fascinator*, February 1991.

Veran, Sylvie. "Le Martyre de sainte Orlan." *Le Nouvel Observateur* 1370, February 1991.

"Chirurgie plastique: le cas Orlan." *Le Quotidien du Médecin* 4705, 11 March 1991.

"Sainte Orlan." *L'Est Magazine* 58, 24 March 1991.

Lohr, Stéphanie. "Demain, je serai la femme idéale du XXIe siècle." *Ici-Paris*, March 1991, p. 19.

Allie, F., and Patricia Snomsed. " *Le Journal des Fous* 4, April 1991.

Thermes, Corinne. "Orlan change de peau au nom de l'art." *Femme Actuelle* 343, April 1991.

Réka, Lili. "Changer de corps, un désir fou?" *Marie-Claire* 465, May 1991, pp. 143–144.

Ribettes, Jean-Michel. "Orlan se libère du corps maternel." *Psychologies* 88, June 1991.

Fourny, Marc. "Orlan ou la sculpture au scalpel." *L'Événement du Jeudi* 352, August 1991, p. 85.

Jeanblanc, Anne. "Chirurgie esthétique, ce qu'il faut savoir avant." *Le Point* 986, August 1991, p. 46.

Bayo, Bernard. "Orlan, la merveilleuse et très édifiante histoire d'Orlan, sainte et putain, chirurgicalement transformée en femme-synthèse." *Demonia*, September 1991.

Nuridsany, Michel. "Art, exhibitionnisme ou provocation?" *Le Figaro*, 9 October 1991.

Ben, Patrice Desmons, Maurice Mallet, Stéphane Napoli, Dr Cherif Zaar, Joël Hubaut, Guy Léandre, Gerard Duchene, Nathalie Dupas, Élisabeth Fiebig-Betuel, and Dr O. Relandt. "Dossier Orlan." *VST*, September–December 1991. Orlan on cover.

1992

Grand, Odile. "Maman m'a bâclée, je recommence tout..." *L'Événement du jeudi* 382, February–March 1992, pp. 60–61.

"Orlan, la chirurgie comme l'École des Beaux-Arts." *Voici* 230, 6–12 April, 1992.

1993

Léandri, "Les allumés de l'art, mais où vont-ils chercher tout ça?" *Fluide Glacial* 209, November 1993, pp. 49–50.

Burreaud, Annick. *Art Press* 186, December 1993.

1994

Art-Transit, June 1994.

L'Évidence 4, 1994.

Delsaux, Jean. "Ceci est mon corps, ceci est mon logiciel." In *L'Atelier Brouillard, réunion de chantier*, 1994, pp. 44–45.

1995

Bandits-Images, May 1995.

Onfray, Michel. "Esthétique de la chirurgie." *Art Press* 207, November 1995, pp. 20–25.

1996

"Orlan Made in Eric & Alberto Sorbelli." *Le Généreux*, July–August 1996.

1997

Rouillé, André. "Orlan, pour un art charnel." *La Recherche Photographique* 20, Spring 1997, pp. 72–77.

1998

Bottari, Marianne. "Les Métamorphoses d'Orlan." *La Mazarine*, March–June 1998.

Rivière, Fabien. "Orlan." *3 Keller* 42, October–November 1998, p. 6.

Wolinski, Natacha. "Images numériques, nouvelle mode ou nouveau monde?" *Beaux-Arts Magazine* 174, November 1998. Orlan on cover.

Dulout, Stéphanie, and Clara Ferré. "Corpus Crisis." *Créations* 16, December 1998, pp. 54–58.

Giquel, Pierre. "Orlan." *La Nouvelle Interlope*, 1998.

École régionale des Beaux-Arts de Nantes, 1998, pp. 43–48.

1999

Le Goff, Hervé. "Orlan, Prix Arcimboldo 99." *Le Photographe*, special issue on digital photographs, January–February 1999, pp. 24–25.

Comte, Béatrice. "L'art chirurgical d'Orlan." *Le Figaro Magazine* 17145, September 1999, pp. 128–130.

"FIAC" *Le Quotidien*, September 1999.

"Orlan suspend ton vol." *Art-Actuel* 4, September–October 1999, p. 66.

Mercier, Clémentine. "Orlan chez les pré-Colombiens." *Sofa, Culture et Grands Coussins* 1, October 1999, pp. 46–47.

Coroller, Valérie. "Orlan, performance très chair." *DS Magazine* 30, November 1999, pp. 20–21.

"Orlan, Prix Arcimboldo." *Gens d'Images*, October–December 1999. Orlan on cover.

Guénée, Pascal. "Orlan l'art charnel numérisé." *Création Numérique*, 1999.

Marchal, Hugues. "Les identités nomades." *La Voix du Regard* 12, 1999.

2000

Soulé, Cécile. "Différentes à tout prix." *France-Soir*, 7 March 2000, p. 2.

De Maison Rouge, Isabelle. "Orlan, l'interactive." *Art Actuel* 1, March 2000.

Chaslot, Philippe. "La 5e Biennale d'art contemporain de Lyon." *Lyoncapitale* 280, July 2000.

Godard, Agathe. "Match de la vie parisienne." *Paris-Match*, 9 November 2000.

Charre, Alain. "Action Orlan-Corps" and "Orlan, mesurage d'institutions." *La Mazarine*, 2000.

2001

Bidault-Waddington, Raphaële. "Option, 50 % satisfaits de la réalité." *Arts*, January 2001.

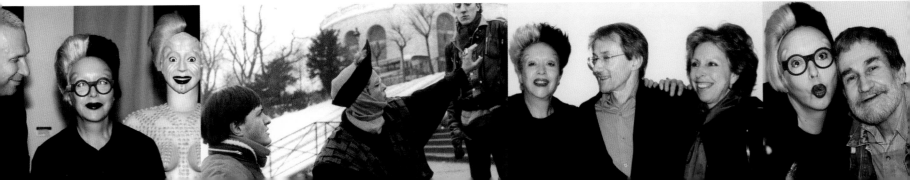

Perruche, Céline. "La crème des femmes artistes des xxe et xxie siècles." *DS Magazine*, January 2001.

Ducler, Patrick. Interview with Orlan. *CRDP Pays de la Loire*, February 2001.

Entriaglo, Frédérique. "Orlan." *Art Press* 265, February 2001.

Dagen, Philippe. "Métamorphose." *Le Monde*, 22 March 2001. Photo of Orlan, p. 1; interview and article, p. 31.

Vendredi, 29 March 2001, p. 8.

Demir, Anaïd. "Les Freaks sont chics." *Jalouse* 10, 10 May 2001.

Luc, Virginie, and Gérard Rancinan, *Paris-Match*, 17 May 2001.

Tournier, Pascale. "Leur corps pour faire une œuvre d'art." *VSD*, May 2001.

Dauvilaire, Blandine. "Orlan: l'esprit ouvert et le corps mutant." *Figaro Rhône-Alpes*, 1 June 2001.

Vergé, Benjamin. "Orlan entre réel et virtuel." *Le Progrès*, 3 June 2001, p. 22.

Orlan. "Mon corps, mon logiciel." *CODA, Musiques et Cultures Électroniques*, June 2001, pp. 24–27.

Masse de Rouch, J.-P. *GUS*, September–October 2001, pp. 32–35.

Cénac, Laetitia. "Orlan la mutante." *Madame Figaro* 4, 13 October 2001, pp. 67–80.

Dubois. "Elles sont devenues accro à la chirurgie esthétique." *Vogue*, October 2001, pp. 144–199.

Luc, Virginie, and Gérard Rancinan. "L'art à mort, performances d'artistes qui ont la cote." *Photo* 383, October 2001, pp. 72–79.

"Orlan triomphe du baroque, Le Parvis, Ibos." December 2001, *Forum*, November 2001, cover and p. 18.

Science et avenir, special issue, December 2001.

Technikart 52, 2001, p. 36.

2002

Amzallag, Joan. *France-Soir*, 7 January 2002.

Télérama, 10 January 2002.

"Tragédies charnelles: nature et écologie, par Orlan." March 2002, pp. 16–49.

Durand, Régis. "Orlan, le corps du manifeste;" Franck Lamy. "Orlan fait son cinéma." *Beaux-Arts Magazine* 216, May 2002, pp. 56–63.

"Chorégraphie et résistance." *Cassandre* 47, May–June 2002.

Mansart, Guillaume. "Orlan: la dynamique de l'envers." *Hors-d'Œuvre* 11, 2 June 2002.

"Les Guerriers de la Brume à Caen." *Dimanche Ouest-France* 235, supplement *Le Guide*, 2 June 2002.

Frétard, Dominique. "Le jeu vidéo chorégraphique de Karine Saporta." *Le Monde*, 9–10 June 2002.

"Les Guerriers de la Brume." *Le Mois à Caen* 380, June–July–August 2002.

Izrine, Agnès. "Karine et les guerriers." *Danser* 212, July–August 2002.

"Souvenez-vous du futur." *Prisme Escape*, Summer 2002.

Bergue, Frédéric. "Une muse nommée multimédia." *Mag'Agence* 6, September–October 2002.

"Pleine page à Orlan." *Rézo International* 9, Fall 2002, p. 29.

"Le Plan du film." *Hors-d'Œuvre* 11, October–December 2002.

Pellet, Christian. "La mise en corps selon Hapax." *Domaine Public* 1537, 15 November 2002.

"Orlan: ceci est mon corps." *L'Hebdo*, 28 November 2002.

Widemann, Dominique. "Sainte Orlan de l'incarnation." *L'Humanité*, 10 December 2002.

Lebovici, Élisabeth. "Orlan offense en corps." *Libération*, 31 December 2002, p. 22.

Coulombe, Maxime. "La maïeutique du corps: rencontre avec Orlan." *ETC*, December 2002, pp. 5, 11–16.

Delos, Soline. "Les meilleurs morceaux d'Orlan." *Elle*, December 2002.

"Les Guerriers de la Brume." *Caen Magazine* 53, 2002.

Dulout, Stéphanie. "Le corps à l'œuvre." *Le Magazine de la Gazette*, 2002, pp. 22–33.

2003

Nurisdany, Michel. "Orlan: tout est (virtuellement) possible." *Le Figaro*, 3 January 2003.

"Le corps critique." *Le Journal des Arts* 162, 10–23 January 2003.

Breerette, Geneviève. "Orlan, une artiste à la lumière de ses métamorphoses." *Le Monde*, 11 January 2003, p. 28.

Prouteau, Eva. "Orlan." *Nantes Poche* 8, 14 January 2003.

"Orlan poursuit son investigation narcissique." *Connaissance des Arts*, January 2003.

Piguet, Philippe. "Orlan: vous n'en sortirez pas indemne." *L'Œil*, January 2003, p. 105.

Tinel, Elodie. "Entretien avec une mutante." *Les Inrockuptibles* 370, December 2002–January 2003, pp. 72–73.

Van Offel, Hugo. "Orlan: tous ses visages." *Art Actuel* 24, January–February 2003, pp. 56–57.

Allain, Patrice. "Sortir du cadre pour entrer en résistance." *Zérodeux* 24, January–February–March 2003, pp. 33–34.

Gui. "Orlan, d'un corps à l'autre." *CinéDVD* 7, February–March 2003, pp. 108–109.

Monnin, Françoise. "Orlan déchire l'écran." *L'Art Aujourd'hui*, 7 March 2003, p. 57.

"Orlan cherche partenaire à la peau noire." *Ouest-France*, 7 March 2003, p. 16.

Morice, Jacques. "Orlan, carnal art." *Télérama* 2784, 21 May 2003, p. 56.

Nevejan, Geneviève. "Pierre Restany, fondateur et théoricien du Nouveau Réalisme." *La Gazette de l'Hôtel Drouot* 21, 30 May 2003, p. 218.

Waintrop, Camille. "Orlan." *Technikart* 72, May 2003, p. 141.

"Le Plan du film." *Positif* 508, June 2003, p. 105.

Caucheteux, Anne-Sophie. "Les FRAC ont 20 ans." *Métro*, 1 July 2003.

Demir, Anaïd. "Le corps, une manière d'être." *Le Journal des Arts* 180, 7–20 November 2003.

Piguet, Philippe. "Orlan, éloge de l'hybride." *L'Œil* 552, November 2003.

Beaux-Arts Magazine 203, 2003, p. 74.

FOREIGN PRESS

AUSTRALIA

Cochrane, Peter. "From France, Artistic Renown at the Cutting Edge." *The Sydney Morning Herald*, 9 December 1992.

Moos, David. "Orlan." *Art+Text* 54, 1996.

Goodall, Jane. "Whose Body?" *Artlink, Art and Medicine*, June 1997.

AUSTRIA

Wienerin, April 1994.

Shellerer, Désirée. "Körperkunst." *Visa*, May 1998, p. 20.

Wailand, Markus. "Knifestyle im Selbstversuch." *Falter* 49, cover and pp. 27–28.

BELGIUM

Declerck, Lies. "Self-Portrait as Anti-Model." *Janus*, pp. 39–42.

CANADA

Bex, Flor. "Orlan, le drapé, le baroque et leurs média déclinaisons." *Intervention*, March 1981, pp. 24–25.

Bex, Flor. "Épidémie de corps." *Intervention*, April 1981.

Develay, Frédéric. "À propos d'Orlan." *Intervention*, Fall 1987, pp. 63–64.

Bordeleau, Francine. "Orlan et les bizarres jeux du corps." *Le Devoir*, 2 November 1992.

Martel, Richard. "Orlan." *Intervention* 55–56, Fall–Winter 1992–1993.

The Medical Post, 30 November 1993.

Brand, Peg. "Raw Shift Assignment." *Shift*, January 1998, pp. 6–8.

"Ceci est mon corps... ceci est mon logiciel." *Art* 49, 1998, pp. 12–17.

"Performance Art." *BorderCrossing* 66, 1998.

Dreyfus, Charles. "Orlan." *Inter Art Actuel* 54.

Petrowski, Nadine. "Image." *La Presse de Montréal*.

CZECH REPUBLIC

Lubiak, Jarostaw. "Kobieta Plastyczna." *Max Magazine* 4, 1999, pp. 88–93.

FINLAND

Weintraub, Linda. *Image*, April 1995.

Sanomat, Helsingin. *Kulttuuri*, October 1995.

GERMANY

Schwarzbauer, G.F. "The Art of Performance: Le Drapé, le Baroque;" Chris Hables Gray. "Cyborgs, Aufmerksamkeit und Ästhetik;" G. F. Schwarzbauer. "22 Interviews." *Kunstform* 32, February 1979, pp. 138, 139, 164.

"Palazzo Grassi." *Kunstform* 34, April 1979.

Schilling, Margaret. "Für die Kunst in den Op." *Stern* 12–14, March 1991, pp. 232–233.

"Verrückte Frau Lässt Sich Zum Kunstwerk Operieren." *Aktuell*, 20 July 1991.

Ermacora, Beate. *European Photography* 56, pp. 16–23.

Glahn, Lucia. "Schön blöd: jetzt wird Liften zum Kunststück." *Die Seite*, 24 July 1991.

"Das lebende Kunstwerk." *Elle*, October 1991, p. 314.

Hartl, Barbara. "Fleisches-Kunst." *Marie-Claire* [German edition], October 1994, pp. 269–274.

Ammann, René. "Kunst Griff." *Das Magazin* 45, November 1994. Orlan on cover.

Kravagna, Christian. "Suture." *Artforum*, November 1994, pp. 96–97.

Weckner, Moritz. *Taz Bremen*, 2 May 1995.

Fisher, Frauke. *Taz Bremen*, May 1995.

Santner, Christoph. "Zukunstmacher." *Connection*, May 1995, pp. 17–22.

Eiblmayr, Silvia. "Die Frau/der Blick." *Springer*, June 1995.

KunstForum International 148, December 1999–January 2000.

Brunner, René. "Meine Arbeit ist keine Selbstverstümmlung." *Sonntagszeitung*, 9 April 2000.

Eisl, Sonja. "Die Skalpellgeborene." *Keks* 29, 2001.

GREAT BRITAIN

Cottingham, Laura. *Frieze*, February 1994.

Lenhard, Elizabeth. "Women in 90's, Orlan Exhibit." *Living*, 14 April 1994.

Fox, Catherine. "Artist's Face Is Her Canvas, Plastic Surgery Is Her Fool." *Living*, 19 April 1994.

McClellan, Jim. *The Observer Magazine*, April 1994.

Ermacora, Beate. *European Photography* 56, Winter 1994, pp. 15–23.

Hirshhorn, Michael. "Orlan: Artist in the Post Human Age of Mechanical Reincarnation." *Versus* 3, 1994.

"Flesh and Fantasy, the Performance Artist." *Options*, February 1995, p. 37.

Armstrong, Rachel. *Mute*, Spring 1995.

Armstrong, Rachel. "Post Human Evolution." *Artifice Magazine* 2, May 1995.

Reitmaier, Heidi. "Orlan on Becoming Orlan: I Do Not Want to Look Like." *Women's Art Magazine* 64, May–June 1995, pp. 4–11.

Smith, Caroline. "Beyond Flesh and Blood." *New Scientist* 2003, November 1995, pp. 28–29.

Price, Anna. "Orlan." *Artifice Magazine*, 1995. Orlan on cover.

Alberge, Dalya. *The Times*, 15 March 1996.

"Orlan, the Shape of Things to Come." *Paint It Red Magazine*, April 1996, pp. 36–37.

The Crack Magazine, April 1996, cover and p. 11.

Hawthorn, Matt. "Orlan and Stelarc." *Live Art Magazine* 6, April–June 1996, p. 8.

Pollock, Griselda. *Portfolio – The Catalogue of Contemporary Photography in Britain* 23, 1996, pp. 1–28, 31, 56–57.

"David Bowie, Duke of Hazard." *Vox Magazine*, 1996, pp. 70–73.

"The First Cut is the Deepest..." *Time Out* 1378, January 1997, pp. 4, 15, 22.

Flash Protz 203, April 1997, p. 32.

Dee. "My Body, My Software: Dee Dissects Orlan."

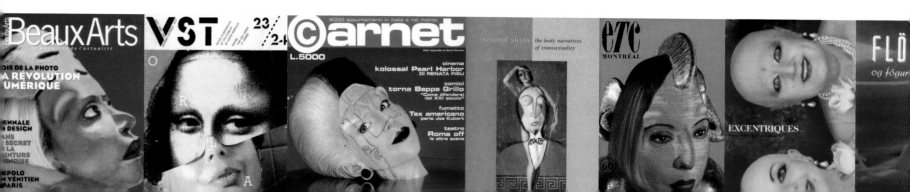

Fringecore, Beyond Trangression 4, April–May 1998.

"Beauty and the I of the Beholder, a Conversation with Orlan." *Bordercrossings* 66, May 1998, pp. 44–47.

Fashion Theory, The Journal Of Dress, Body and Culture 2(2), June 1998.

Ayers, Robert. "Special et inhabituel. En écoutant Orlan." *Live Art and Letters – A Live Art Research Journal* 4, March 1999. Orlan on cover.

Ayers, Robert. "Body Prose/ Mutating Physical Boundaries." *Courage, Complexity and Conviction*, 1999, pp. 175–180.

Orlan. "Artist's Pages." *Paradoxa, International Feminist Art Journal* 12, 2003, pp. 44–48.

"Novikov Lists of Turning Points in the Twentieth Century Art." *Hermitage Magazine.*

Gavin, Dawn. "Interview/Essay." *Transcript* 2(2), pp. 5–17.

HUNGARY

Dárdai, Zsuzsa. "Orlan." *Magyar Narancs*, June 1992, p. 11.

INDIA

News Today, 13 February 1992.

Indian Express, 14 February 1992.

Vikaton, Ananda. [full reference?] 16 February 1992.

The Independent, 28 February 1992.

The Daily, 3 March 1992.

Media Opus, March 1992.

The Telegraph (Calcutta), March 1992.

The Week, March 1992.

The Times Of India, April 1992.

Trends Opus, April 1992.

ITALY

Daolio, Roberto. "Orlan." *La Tradizione del Nuovo* 15, March 1981.

Fagone, Victorio. *Studio D'Ars*, April 1981.

Moda, September 1990.

"Voglio il viso Come La Gioconda." *Giornale di Palermo*, 29 December 1990.

"Un artista si fa operare: 'Voglio assomigliare ad un quadro famoso'." *La Repubblica*, 29 December 1990.

"Un bisturi trasformerà il suo volto in un museo." *La Stampa*, 29 December 1990.

"Orlan, la donna che vivrà due volte." *Donna*, March 1991, p. 52.

"Il corpo estraneo." *Moda* 84, April 1991, pp. 126–130.

Restany, Pierre. "L'angoisse." *D'Ars*, Fall 1992.

Fagone, Vittorio. "Obsession du corps et du langage." ART-ACCES, 1992.

Gandini, Manuela. *Il Giorno*, November 1993.

Bertochi, Davide, and Sabrina Pogliani. *Virus Magazine*, May 1994.

Di Genova, Arianna. *L'Espresso*, November 1994.

Cisotto, Caterina. *Il Gazzettino*, October 1995.

Alfano Miglietti, Francesca. "Orlan." *Virus Mutations Magazine* 6, October 1995. Orlan on cover.

"Il fantastico in arte." *Tema Celeste, Arte Contemporanea* 55, Winter 1995, p. 88.

Conz, Francesco. "Orlan." *Juliet* 75, December 1995–January 1996, p. 46.

"Muse." *L'Espresso*, January 1996, p. 114.

Francalanci, Ernesto L. *La Stanza Rossa*, March 1996.

Elle, March 1996.

"Arte Carnale." *Flash Art Internazionale* 203, 1997.

Alfano Miglietti, Francesca, and Viviani di Biasi. "Walter van Beirendonck." *Virus Mutations Magazine*, December 1998, pp. 19–20.

De Santi, Floriano. "La nuova creatività telematica svela la sua coscienza, luccicante." *Teléma*, Winter 1998–1999, pp. 130–133.

Bulgari Magazine, 1998, pp. 148–153.

Sarti, Alex, and Bifo Franco Berardi, "Virus Mutations Magazine, December–January–February 1998–1999, pp. 46–48.

Virus Mutations Magazine, March–April–May 1999, pp. 31–32.

"Orlan." *Carnet*, 2000.

Cuir, Raphaël. "La chair du virtuel." *Avatar*, 2001.

Viola, Eugenio. "Orlan, éléments favoris." *Segno* 18(191), July–August 2003, pp. 60–63.

JAPAN

"Figure." *Focus*, August 1991.

"The Coming Beauties." *Brutus Magazine*, September 1993.

Tsuji, Hiroko, and Kaoru Yanase. "Orlan." *BT* 6, June 1995.

Rose, Matthew. *Atelier* 795.

NETHERLANDS

Brand, Peg. "Virtual Body, Orlan and Morimura." *Lier & Boog* 16, 2001.

Steenbergen, Renée. "Schoonheid is een monster." *Blvd* 9, October 1994, pp. 38–43.

Tilroe, Anna. *Sunshine*, April 1992.

Ruimte 1, 1994.

POLAND

Leszbowicz, Pawel. "Orlan, Obrazy Kobiet." *Magazyn Sztuk*, January 1995.

"Orlan, Bunt Mutantow Mutants Rebellion." *Magazine Szutk* 9, May 1996, cover and pp. 52–53.

"The Nihilism of the Intellect." *Magazyn Sztuk*, pp. 181–184.

PORTUGAL

De Matos, Miguel. "Orlan, des fulguração da identidade." *Umbigo* 3, 2002.

RUSSIA

"Orlan a Digital Art of Body." *World of Design* 4, 1999.

SPAIN

Gonzàlez, Raùl Benito. "Orlan." *Arte-Facto* 6, pp. 20–21.

Mesquinas, Evelyn. "La Senora Orlan, En Usca De Un Cuerpolo." *Interview* 774, 11–17 March 1991.

Elle, July 1994.

Sas, Myriam. "The Doyenne of Divasection." *Mondo* 13, 2000, p. 108.

Revuelta, Laura. "Las acciones mutantes de Orlan." *ABC Cultural* 454, July 2002.

Goicolea, Anthony. "Arte con el body." *Neo2* 29, June-July-August 2003.

SWITZERLAND

Weidman, Patrick. "Les turbulences d'Orlan." *La Tribune de Genève*, 27 September 1983.

"La femme créa Dieu." *L'Hebdo*, 11 July 1991.

"Art chimique et vague à l'âme." *La Liberté*, 20 July 1991.

"L'amoureuse du scalpel." *Le Matin*, 20 July 1991.

"Orlan expose ses operations." *La Liberté*, 20 July 1991.

Ernst, Michaela. "Die Wienerin." March 1994.

Amman, René. "Kunst griff." *Das Magazin* 45, 12 November 1994, cover and pp. 42–49.

UNITED STATES

B., F. "Orlan." 10 May–6 June 1980.

Huggins, Trevor. "I'm No Oil Painting But I Will Be Soon." *The Express Magazine*, 6 January 1991.

Kent, Sarah. *Sunday Magazine*, February 1991.

"Orlan." *Globe*, May 1991.

Rose, Matthew. *Fashion* 8, June 1992.

ArtForum, December 1992.

Rose, Matthew. "Art Cuts." *The Face* 52, January 1993, p. 96.

Rose, Barbara. "Is It Art?" *Art in America*, February 1993, pp. 82–87, 125.

Waxman, Sharon. "Art by the Slice – France's Orlan Performs in the Surgical Theater." *The Washington Post*, May 1993.

Chicago Post, May 1993.

"Orlan, Quake Sea, Art After Apocalypse." Summer 1993, p. 97.

Saltz, Jerry. "[Missing title?]." *Art in America*, September 1993.

Decter, Joshua. "Orlan." *Artforum*, October 1993.

Greenberg, Keith. *The European*, 19 November 1993.

Fox, Margaret. "A Portrait In Skin and Bone." *New York Times*, 21 November 1993, p. 8.

"Year Selection of Artists." *New York Times*, 25 December 1993.

Miami Herald, December 1993.

Michel, Greppi. "Make a Face/ Like a Surgeon, Going Under the Scalpel is Orlan's Idea for Art." *The New York Post*, December 1993.

Smith, Roberta. *New York Times*, December 1993.

Performance Arts Journal, 1993, pp. 13–25.

Bay Area San Francisco, 1 February 1994. Orlan on cover.

The Guardian, 2 February 1994.

San Francisco Weekly, 2 February 1994.

Rubin, Sylvia. "Her Face is a Work of Art.", *San Francisco Chronicle*, 4 February 1994.

San Francisco Examiner, 4 February 1994.

Helfand, Glen. *San Francisco Weekly*, February 1994.

Robins, Cynthia. "An Artist's Changing Face." *Week End San Francisco Examiner*, February 1994.

"The Illustrated Woman." *San Francisco Bay Guardian*, February 1994, pp. 29–30.

Seward, Keith. "Orlan, Penine Hart Gallery." *ArtForum*, October 1994, pp. 90–91.

Kravagna, Christian. *ArtForum*, November 1994.

Auslander, Philip. "Orlan's Theater of Operations." *Theater Forum*, Spring 1995.

Blashill, Pat. "The New Flesh." *Details*, August 1995, p. 50.

Joao, Ximenes. "Orlan Fala Do Seu Protesto Cirurgico." 9 September 1995.

Lovelace, Carey. *Performing Arts Journal* 49, 1995.

Rose, Matthew. "A Work in Progress." *Art & Antiques*, 1995, p. 16.

Jaffe, Harold. *Fiction International* 29, 1996. Orlan on cover.

Walton, Rob. "Orlan Exhibit." *Creative Loafing* 22(47), 16 April 1996.

Gale, David. "Flesh for Fantasy." *Icon Magazine*, June 1997, pp. 119 & 123.

Du Tan, Stéphanie. "Live Flesh." *Flaunt*, 2000.

Levin, Kim. "The Lyon Biennale Nka." *Journal of Contemporary African Art* 13–14, 2001.

Hovagimyan, G. H. "Art in the Spiritual Machines." *Leonardo* 34(5), pp. 453–458.

MAIN WEB SITES

www.orlan.net
www.michelrein.com / www.mep-fr.org / www.orlan-prod.com / www.film-orlan-carnal-art.com / www.cnp-photographie.com
www.paris-art.com / www.synesthesie.com
www.artcom.tm.fr / www.artmag.com
www.caipirinha.com / www.artandculture.com
www.dundee.ac.uk / www.prism-escape.com
www.panoramix.univ-paris1.fr / www.prix-arcimboldo.com / www.fluctuat.net
www.killthepresident.org / www.rtbf.be
www.oestrogen.dk / www.biografieonline.it
www.maimano.hu / www.horschamp.qc.ca
www.wiu.edu / www.fracdespaysdelaloire.com
www.biennale-de-lyon.org / www.amazon.com
www.cite-sciences.com / www.asu.edu
www.culture.fr / www.jolique.com

TELEVISION PROGRAMS

TF 1 (France)
News item on *Le Baiser de l'artiste* at the F.I.A.C. 1977
Broadcast on October 23, 1977

Antenne 2 (France)
Program presented by Philippe Bouvard, *Le dessus du panier*
Broadcast in November 1977

WDR Fernsehen III (Germany)
Broadcast on October 7, 1979

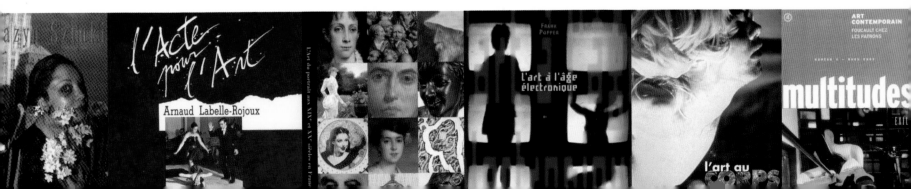

Télévision belge (Belgium)
News item on *MesuRage* at Place Saint-Pierre in Liège
Broadcast in February 1980

Télétest (France)
Claude Villers, *Le Baiser de l'artiste*
Broadcast in July 1980

TF 1 (France)
Program presented by Jacques Martin, *Incroyable mais vrai*
Broadcast in January 1981

Télévision belge (Belgium)
Program on the public aspect of the female body, presented by Michel Suquet.
Broadcast in March 1981

New York Cable (USA)
MesuRage at the Guggenheim Museum in New York
Broadcast on July 26, 1983

FR 3 Bourgogne (France)
Regional news
Broadcast in May and June 1990

FR 3 Lille (France)
Regional news
Broadcast in September 1990

DRS Zurich (Switzerland)
Program *Grell-Pastell*
Broadcast on January 31, 1991

TF 1 (France)
Program presented by Christophe Dechavannes, *Ciel mon mardi*
Broadcast on February 17, 1991

TF 1 (France)
Program presented by Patrick Sabatier, *Si on se disait tout*
Broadcast on February 22, 1991

Antenne 2 (France)
Program presented by Bernard Pivot, *Bouillon de culture*
Broadcast in March 1991

NDR (Germany)
Program *It Happens*
Broadcast on September 28, 1991

Art TV (Australia)
Program *Sydney 30 minutes*
Broadcast on April 12, 1992

New York Cable (USA)
Broadcast three times in June 1992

FR 3 Bourgogne (France)
Regional news
Broadcast in June 1992

Antenne 2 (France)
Program presented by Mireille Dumas, *Bas les masques*
Broadcast on July 12, 1992

CANAL + (France)
Program *L'Œil du cyclone* on "Performance"
Broadcast in October 1992

TF 1 (France)
Program presented by Christophe Dechavannes, featuring Madonna and Orlan
Broadcast in 1993

ARTE (France/Germany)
Hors limites
Broadcast in March 1993

CANAL + (France)
Film *Un peu de temps et vous ne me verrez plus*, with Orlan, Stéphan Oriach, Alain Burosse
Broadcast on April 10, 1993

CBS NEWS (USA)
Program presented by Connie Chung, *Eye to Eye*
Broadcast on December 23, 1993

TF 1 (France)
Program presented by Jean-Marc Morandini, *Tout est possible*
Broadcast in February 1994

TVE (Spain)
Tal Cual
Broadcast on April 29, 1994

TV Show (Switzerland)
Broadcast on 16 October 1994

RAI II (Italy)
Program *Temeraela notte*
Broadcast on March 13, 1996

RAI II (Italy)
Program *2 one 1*
Broadcast on March 18, 1996

ICA (Great Britain)
Woman Without Head
Broadcast on April 17, 1996

France 3 (France)
Program presented by Marc-Olivier Faugiel, *On ne peut pas plaire à tout le monde*
Broadcast in 2001

Télévision Suisse Romande (Switzerland)
Program *Faxculture*
Broadcast on November 3, 2002

Paris Première (France)
Program presented by Thierry Ardisson, *Paris Dernière*
Broadcast on May 30, 2003

THE ARTIST'S WRITINGS

Orlan, *Prosésies écrites* / preface by Henri Simon Faure, Saint-Étienne: Éditions Peagno, 1967.
Le Bon ventre, le mauvais cœur et toutes leurs épines. An anthology of erotic verse inserted in the pubis of the resin sculpture of a woman giving birth to poems. Édition de 5, 1972.
"Correspondance à propos 'd'œuvre' faite avec les draps de mon trousseau (montrer le bout de l'oreille) ou Réminiscence du discours maternel." In the catalog of the Espace Lyonnais d'Art Contemporain, 1977.
"Art et prostitution," and "Face à une société de mères et de marchands." Co-written with Hubert Besacier, from *Le Baiser de l'artiste*, 1978.
Œuvres plastiques des artistes de la performance. Catalog from an exhibition of the same name, Espace Lyonnais d'Art Contemporain. Texts by Orlan, Hubert Besacier, René Déroudille, and Marie-Claude Jeune, 1981.
"L'Art-performance comme performance de l'art, comme pratique artistique dans tous ses états. Performaphobie et Performaphilie."
4e Symposium International d'Art Performance, Lyon: Éditions Association, Comportement, Environnement, Performance, 1982.
"Mère/formare(r) – Père/formare(r)." *Symposium International d'Art Performance*, Lyon: Éditions Association, Comportement, Environnement, Performance, 1982.
"Viva!" In *1979–1983, Cinq ans d'art-performance à Lyon*, Lyon: Éditions Association, Comportement, Environnement, Performance, 1984.
"L'Art charnel." In *Orlan 1964–1996* / texts by Achille Bonito Oliva, Bernard Ceysson, Bruno Di Marino, Vittorio Fagone, Ulla Karttunen, Mario Perniola. Rome: Diagonale, 1996.
"Moteur de recherche: images/nouvelles images: visages." In *Orlan Self-hybridation* / texts by Orlan and Pierre Bourgeade, Paris: Al Dante, 1999, pp. 1–6.
"Virtuel et réel: dialectique et complexité." In *Orlan. Refiguration Self-hybridations, série précolombienne* / texts by Orlan, Dominique Baqué, and Marek Bartelik. Paris: Al Dante, 2001.

MAIN UNIVERSITY STUDIES

USA

Augsburg, Tanya. *Private Theaters on Stage: Hysteria and Female Medical Subjects from Baroque Theatricality to Contemporary Feminist Performance.* PhD dissertation, Graduate School of Emory University Institute of Liberal Arts, UMI Dissertation Services, 1996.

France

Hautbois, Marie-Charlotte. *La Représentation de la femme en tant que corps-marchandise et objet sexuel à travers l'œuvre d'Orlan: artiste féministe à la recherche d'une nouvelle identité.* Contemporary art history *maîtrise* dissertation supervised by Elvan Zabunyan, University of Rennes 2, 2000–2001.
Mansart, Guillaume. *Le Corps en transformation dans l'art occidental des années 1980 et 1990.* Social science DEA dissertation supervised by Valérie Dupont and Andrzej Turowski, University of Bourgogne, 2000–2001.
Ruaux, Nathalie. *Le Corps entre technoscience et technoculture. L'épreuve des certitudes.* Philosophy *DESS* (option: Medical and hospital ethics), University of Marne-la-Vallée, 2002–2003.

Great Britain

Petitgas, Catherine. *Orlan Unveiled: Peering Through Les Draps du trousseau, 1965–1980.* MA Dissertation supervised by Sarah Wilson, Courtauld Institute of Art, University of London, 2000.

Italy

Viola, Eugenio. *Orlan. Art corporel, art charnel.* Contemporary art history dissertation, University of Naples, 2000–2001.

Switzerland

Costantini, Marco. *Orlan: Autofiction pour un corps objet d'art et posthumain.* Art history dissertation supervised by Régine Bonnefoit, University of Lausanne, 2002.

FILMOGRAPHY

1976
MesuRage de la rue Chateaubriand (8 mm B/W, 7')

1978
MesuRage de la Neue Galerie (16 mm color, 15')

1980
Vierge Noire (16 mm B/W, 12', camera: Jean-Paul Dupuis)

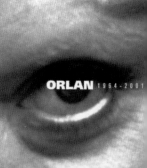

1981
Couronnement et assomption de sainte Orlan (16 mm color, 30')

1982
Assomption de sainte Orlan (16 mm color)
Sainte Orlan et les vieillards (16 mm color and B/W 12').

1983
Apparition et gloire de sainte Orlan (16 mm color, 17')

1990
Opération-Opéra (Super 16 mm, dir.: Stéphan Oriach)

1993
Omniprésence (Super 16 mm, dir.: Stéphan Oriach)

1995
Cyberculture (16 mm, dir.: Iara Lee)

CD-ROMS

Orlan, Multimedia Monograph. Paris: Jeriko, 2000.
Photos, videos, interviews and texts by Marc Partouche, Carole Boulbès, Jean-Michel Ribettes, Norbert Hillaire, Hugues Marchal, Jean-Pierre Nouhaud, Orlan.
Bilingual French-English.
Updates available on web site :
http://www.orlan.net

Le Plan du film, Sequence 1. Romainville: Laurent Cauwet-Al Dante, 2001.
Script by Jean-Pierre Rehm, with an audio CD
Audio by the group Tanger.

Adams, Parveen, Vicki Berger, and Isabel Vasseur. *This is my body... this is my software.* Oxford: Black Dog Publishing, 2002.
2002 reprint with an introduction by David Cronenberg and Serge Grünberg.
Bilingual French-English edition.
1994 edition with CD-ROM no longer available

Exogène, Nikolaj Church Art Center, 1997.

CD-ROM from the catalog of the Biennale d'Art Contemporain de Lyon, 1996.

Artifice Magazine, CD-ROM n° 2, Oxford: Black Dog Publishing, 1995.

Eve. Real World Multimedia, 1994.
Orlan appears as a guest of Peter Gabriel.

Pour tous miracles consultez mes tarifs.
Images of installation first shown at Centre Georges Pompidou for *La Revue Parlée*.

VIDEOGRAPHY

Bien que... oui mais...
Color, 2003.
Video installation in two versions: a monoband version, 30'; an installation version with three projectors, 10'.
Original soundtrack: Frédéric Sanchez.

Un peu de temps et vous ne me verrez plus... un peu de temps et... vous ne me verrez 1.
7', 1994.
Un peu de temps et vous ne me verrez plus... un peu de temps et... vous ne me verrez 2.
7', 1994.
Un peu de temps et vous ne me verrez plus... un peu de temps et... vous ne me verrez 3.
7', 1994.
Un peu de temps et vous ne me verrez plus... un peu de temps et... vous me verrez 4.
7', 1994.

La Peau du 6.
Color, PAL U and NTSC. 3', 1991.

De tous les saints.
Color, PAL U. 30', 1991

Chérif Bloc.
U-matic. 12', 1990

La Madone au Minitel ou les chiens ramènent de puces.
Color, 3'59, 1988.
Video created for Canal+, commissioned by Alain Burosse and Ex Nihilo. Betacam.

Sainte Orlan et les vieillards.
Color, PAL U, 1984.
Filmed with amateur actors met at Ivry Hospital.

Production for Digitel Pixel.
Color, Pal U, 2', 1984.

Sein gauche laser droite.
Color, PAL U, 10', 1984.

MesuRage du Centre Georges Pompidou.
B/W, 30' 1984.

Les Clips de la ménagère de service.
Color, PAL U, 3', 1983.
Experiment for a cable television station from Brest (France).

Mise en scène pour un grand Fiat.
Color, PAL U, 15', 1983.
Film in which Orlan acts and directs.

MesuRage du Musée Guggenheim, New York.
Color, PAL U, 20', 1983.

Mise en scène pour une sainte.
Color, SECAM U, 15', 1981.

Étude documentaire N° 1 urgence GEU
Color, PAL, 45', 1980.

Action du Musée Chéret.
B/W, 30', 1980.

Venice Palazzo Grassi.
Color, PAL U, 30', 1979.

Anges baroques.
Color, PAL U, 9', 1979.

Assomption de sainte Orlan.
Color, Secam U, 1979.

MesuRage du Musée Saint Pierre.
Lyon
B/W, 30', 1979.

Sainte Orlan/Orlan-Corps.
Color, SECAM U, 30', 1978.

Performance Beaubourg.
B/W, 30', 1978.

Etude de Drapé.
Centre Georges Pompidou, Paris
Color, PAL U, 30', 1977.

MesuRage de la Neue Galerie Sammlung Ludwig.
Aix-la-Chapelle
Color, SECAM U, 30', 1977.

MesuRage du Centre Georges Pompidou.
B/W, 30', 1977.

Compilation of video-performances by Orlan for the *Hors Limites* exhibition 1994–1995 at the Centre Georges Pompidou.

MesuRage d'Institution: Centre Georges Pompidou.
12 February 1977, B/W, 13'41.
For the exhibition *3 villes, 3 collections*.

MesuRage d'Institutions: Musée Saint Pierre de Lyon.
25 April 1979, B/W, 17'30.
Images filmed during the *Symposium de Performances de Lyon* created and organized by Orlan in collaboration with H. Besacier from 1978 to 1983.

Le Drapé-Le Baroque.
15 June 1979, color, 2'16.
Documentary on interdisciplinary days dedicated to body art and performance.

Orlan-Corps–Sainte Orlan.
3 November 1979, B/W, 22'43.
Slow-motion version of a five-hour extract of a performance from the Festival of Brussels Theater.

Mise en scène pour une sainte.
1'44, 1981.
Images filmed at l'Espace Lyonnais d'Art Contemporain in the multimedia installation created by Orlan during the exhibition *Made in France*, curated by Marie-Claude Jeune.

Sainte Orlan et les vieillards.
Color, 7'12, 1983.
Video created for Orlan's exhibition at Galérie J. and J. Donguy, Paris.

Mise en scène pour un grand Fiat.
Color, 14'25, 1984.
Produced by the Centre Culturel de Montbéliard.

La Madone au Minitel ou les chiens ramènent des puces.
Color, 3'59, 1985.
Video created for Canal+, commissioned by Alain Burosse and Ex Nihilo.

Opération réussie.
Color, 8'30, 1990.
Surgical operation-performance used by Orlan for the video installation created for the Biennial of Contemporary Art, Sydney 1992.

Omniprésence 1.
Color, 8'30, 1990.
Surgical operation-performance conducted in New York, with a live broadcast to the Sandra Gering Gallery (New York) and a satellite broadcast to the Centre Georges Pompidou (Paris), the MacLuhan Center (Toronto) and the Multimedia Institute (Banff).

Omniprésence 2.
21 November 1993.
Round table on the work of Orlan during the direct broadcast of a performance at the Centre Georges Pompidou, with Norbert Hillaire, Gladys Fabre, Christian Vanderborght, Serge François, Jean-Paul Fargier, Pierre Restany.

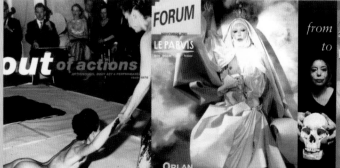

ACKNOWLEDGMENTS

Un baiser d'artiste

The artist's kisses go to

my friend Jean-François Taddei, curator of the first French retrospective of my work, *Élements favoris* at the FRAC des Pays de la Loire, and savior of *Le Baiser de l'artiste* (Kiss the Artist)

and also to

Jean-Jacques Aillagon, Claude Allemand-Cosneau, Joana Anisten, Paul Ardenne, Tanya Ausburg, Vincent Baillet, Dominique Baqué, Renato Barilli, Michèle Barrière, Marek Bartelik, Bernard Blistène, Jean-Michel Bouhours, Achille Bonito Oliva, Fabrice Bousteau, Jean Brolly, Christine Buci-Glucksmann, Jean-Michel Cambilhou, Nadia and Cyrille Candet, Laurent Cauwet, Bernard Ceysson, Anne-Marie Charbonneaux, Miguel Chevalier, Philippe Chiambaretta, Alain Clairet, Dr. Bernard Cornette de Saint-Cyr, Pierre Cornette de Saint-Cyr, Dr. Cramer, Creativ TV, Caroline Cros, Arlette and Marc Couturier, Raphaël Cuir, Chantal Cuzin-Berche, Philippe Dagen, Gabrielle Decamoux, Jacques Donguy, Norbert Duffort, Régis Durand, Éric Duyckaerts, Michel Enrici, Gladys Fabre, Stéphanie Ferrero, Jean-Noël Flammarion, Jean-Michel Forey, Valérie Fougeirolle, Jacqueline Frydman, Isabelle Godefroy, Agnès de Gouvion Saint-Cyr, Henri Griffon, Claire Guezengar, Olga Guinot, Raymond Hains, Penine Hart, Eleanor Heartney, Lorand Hegyi, Jean-Michel Jagot, Marie-Claude Jeune, Henriette Joël, Alain Julien-Laferrière, Jacques Kerchache, Frank Lamy, Luc Lang, Laurent Le Bon, Julien Loustau, Hugues Marchal, Jean-Hubert Martin, Jean-Louis Maubant, Frédérique Medhi, Georges Merguer Ditchian, Jean-Marc Michali, Claude Mollard, Arash Montazami, Jean-Luc Monterosso, Maribel Nadal, Michel Nuridsany, Hans Ulrich Obrist, Jill O'Bryan, Michel Onfray, Stephan Oriach, Marc Partouche, Marisa and Diego Perret, Emmanuel Pierrat, Philippe Pigeard, Jean-Michel and Stéphane Place, Olivier Poivre d'Arvor, Georges Poncet, Thierry Prat, Judith Quentel, Marie Raflin, Jean-Michel Raingeard, Juan Antonio Ramirez, Jacques Ranc, Thierry Raspail, Patrick Raynaud, Vivian Rehberg, Jean-Pierre Rehm, Michel Rein, Alain Reinaudo, Pierre Restany, Georges Rey, Jean-Michel Ribettes, Barbara Rose, Julie Rouart, Laetitia Roux, Anne Samson, Frédéric Sanchez, Emmanuel Saulnier, Joël Savary, Alain Sayag, Bruno Scotti, Aline Silhouette, Adrien Sina, Manon Slome, Catherine Strasser, Sophy Thompson, Christian Vanderborght, Christophe Van Huffel, Georges Verney-Carron, Linda Weintraub, Sarah Wilson, Dr. Chérif Zaar, Julian Zugazagoitia

as well as the Association Française d'Action Artistique (AFAA) and the Hewlett-Packard Foundation for the Arcimboldo Prize and the Griffel-Kunst Prize

and, finally, many thanks to Pierre Zolivé for his technical help with the Pre-Columbian Self-Hybridizations and to Jean-Michel Cambilhou for his technical help with the African Self-Hybridizations.

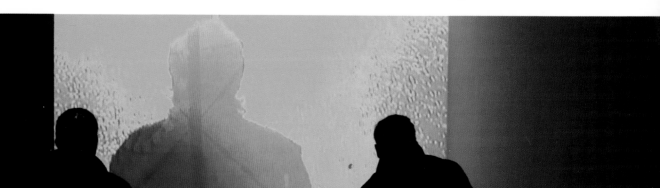